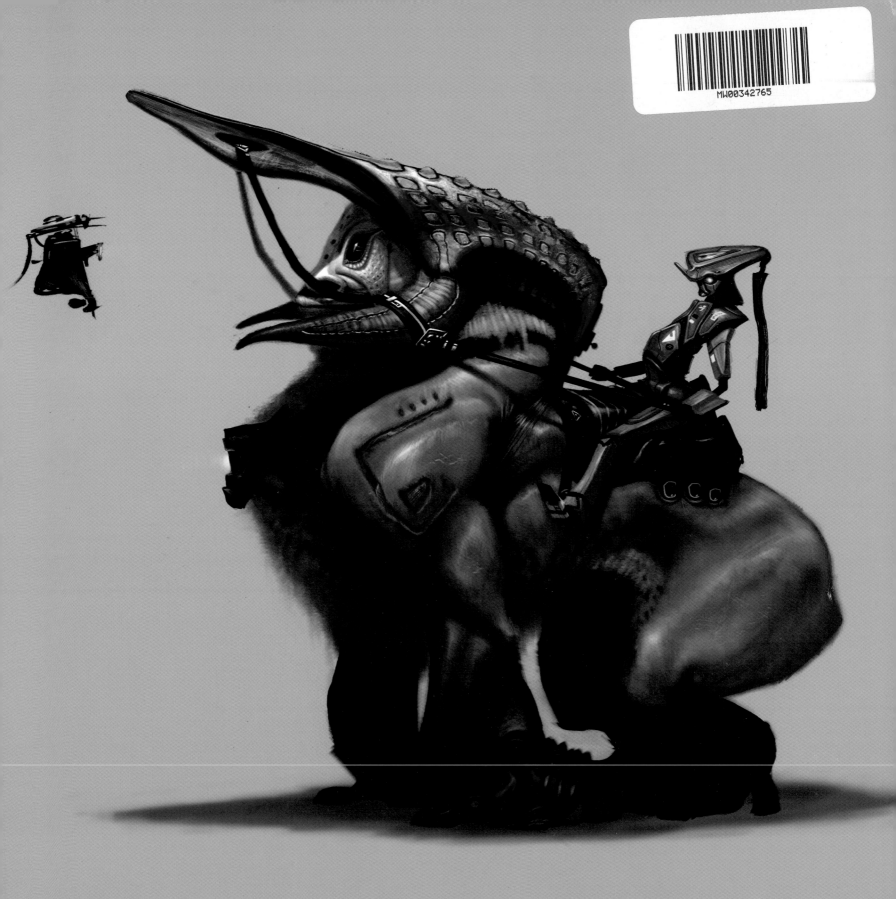

ALIEN RACE - PETER CHAN

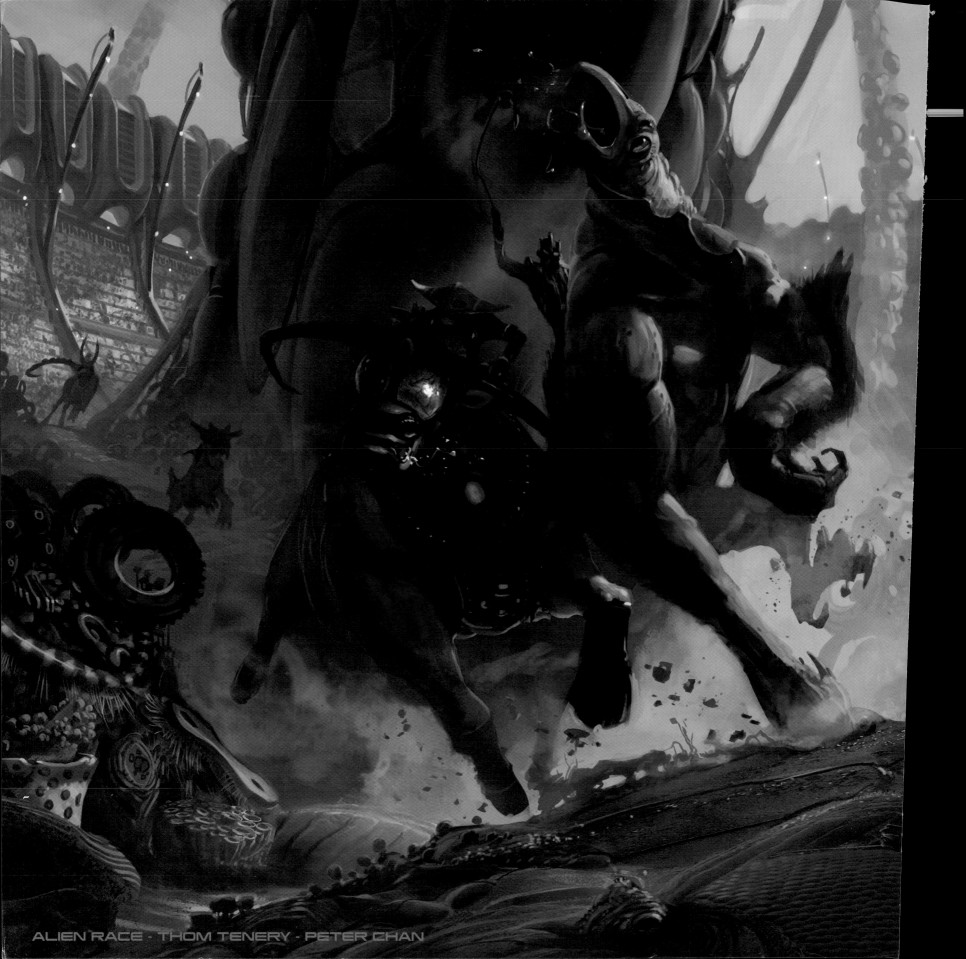

ALIEN RACE · THOM TENERY · PETER CHAN

# ALIEN RACE

visual development of an intergalactic adventure

designstudio|PRESS

## DEDICATION

*"To our friends, families, and Design Studio Press fans, thank you for the support and your patience."*

ALIEN RACE
visual development of an intergalactic adventure

Graphic Design: Scott Robertson
Editor: Scott Robertson

Published by
Design Studio Press
8577 Higuera Street
Culver City, CA 90232

Website: www.designstudiopress.com
E-mail: info@designstudiopress.com
Printed in China: First edition, August 2009

10 9 8 7 6 5 4 3 2 1

soft cover ISBN: 978-1-933492-23-0
hard cover ISBN: 978-1-933492-30-8
Library of Congress Control Number: 2006937849

# CONTENTS

foreword 006
introduction 007

story overview 008

chapter one
**earthling riders** 011

chapter two
**alien riders** 033

chapter three
**bipeds** 077

chapter four
**flyers** 095

chapter five
**quadrupeds** 109

chapter six
**environments** 171

bios 214

art both pages: SCOTT ROBERTSON

# FOREWORD

A sugar rush for the eyes; a caffeine high for the mind.

I have seen this collection of design in the works for quite some time, so when Scott sent over the final layout for my review, it should have been no surprise as to what my reaction would be. However, I was thoroughly impressed on so many levels.

My first impression was simply the success of finishing this undertaking. When we flip through a book like this, it's easy to take for granted how much work goes into it. Each character is first well thought out...in the mind. This is where each artist indulges in the concept cerebrally. Then there is the multitude of concept sketches. And the immersive illustrations...the level of detail! All of this applied to a huge range of characters, beasties and environments, and with a cohesive narrative and aesthetic throughout. Additionally, Scott has made not just a picture book, but a reference you can use (and will want to use). Images will inspire and techniques will provoke.

It would seem that I have said enough in an exclamatory way, but there was a profound reaction that I had that is almost more important than the sheer enjoyment and appreciation of the content. I was (and am) inspired, educated and motivated. I can't wait to put pencil to paper after having looked at this wonderful collection of ideas. I am chomping at the bit to do more "mirrored madness."

I am moved to speak about what a treat it is, what an honor, and what a validation it is to be a teacher. Except for Scott, the artists in this book were all students of mine while at Art Center (although I think Scott would agree that we have both taught one another a thing or two). To see them take the very little I presented as a teacher and bring it to a whole new level.... What a treat. To have shared in their journey and call them associates and friends.... What an honor. But, what a validation it is to be a teacher. By this I mean to say that their success in this book validates the importance of sharing skills and ideas. Scott and I have always believed in sharing all ideas, and possessing no ownership of them. It does no one any good to harbor selfishly concepts, methods nor techniques. It is with this sharing that the community grows. When the instructor becomes the student, when the teacher is learning—that is successful sharing, that is validation.

I thank you Scott, Justin, Thom, Peter, John and Ben for sharing, inspiring, and teaching me!

**Neville Page**
Concept Designer: *Avatar, Star Trek, Cloverfield, Watchmen, Tron 2, Piranha 3-D.*
Los Angeles, March 2009

# INTRODUCTION

It was in the spring of 2006 that I hired three very talented Art Center College of Design interns, Peter Chan, Justin Pichetrungsi, and Thom Tenery, for the upcoming summer. The question was, what would they work on during those four months? We could do a variety of freelance jobs, as I had done with my interns in summers past, or we could devote the time to the visual development of an original Design Studio Press intellectual property. We chose the latter, and so was born the I.P., Alien Race.

As I'm not a creative writer by training, and I wanted to execute not only the pitch art for Alien Race but also a great visual development book for DSP, we decided to work toward creating a world of appealing characters for which a compelling story could then be written at a later time. The basic story, written with the help of Julz Chavez, is printed on the next two pages. But this book is about how the concept, before the story, began.

Knowing I had limited time of only a summer, I designed this project so that almost everything that the team produced could be used for the book. Also at the beginning, I wondered whether characters or vehicles should be the main design subject, and what would the genre of the story be? I'm personally averse to violence as entertainment, so I thought about what genres of stories/video games do I like that might be able to compete in the marketplace. I am a big fan of racing games and the drama that dangerous, hard, competitive racing can create. Of course with my history of designing vehicles, this would have been the natural type of story to develop for our I.P. I was thinking, though, that it would be fun in a racing concept to swap the vehicles for creatures, which I know is a very technologically difficult thing to do with today's game engines, but it would make for a great book of concept art and a potentially strong line of toys and an animated film. On a personal skills level, this is a topic I have not spent much time designing and so I thought by pursuing the development of creatures and characters it would provide me with the right project to broaden my own design skills.

So that sets the stage for how the project was conceived. The design of almost any alien rider, human character, racing creature or alien world would work in the book. This meant that very little of the team's efforts would be wasted on doing art that would not be appropriate for the book. As the art came together, a story could then be created with the help of a good writer, such as Julz, and then some of the pieces could be tweaked and refined into pitch art for an animated film or video game. As we did not start the project with a strong plot beyond the idea of humans being invited to take part in an intergalactic alien race with bioengineered racing creatures, this made the early work very design-driven, which

works well for a strong visual development book, for which Design Studio Press is known. We decided on some basic racing creature skeletal forms to use as our starting point, not only for making the execution of "morphable" video-game models more achievable but also so the creatures from various planets would aesthetically work well next to each other. The same idea held true for the alien riders, as we decided early on to stick to anthropomorphic forms. It's always good to retain some elements of the familiar.

That summer of 2006 progressed quickly. The guys did some great work and I did very little art to help out. With my very busy schedule of teaching at Art Center, chairing the Entertainment Design department there, taking on outside freelance work and running Design Studio Press, I knew it was going to be tough to make time for the completion of this project to the level I had envisioned. So it sat idle for about a year and a half as other books and opportunities bumped it further down the to-do list.

Finally last summer there was a ray of hope that I would have enough time to commit to its completion. I hired John Park, another fabulous Art Center entertainment design student, as my summer intern to help finish the book. Thankfully another terrific Art Center student, Ben Mauro, had a little time to help out before his other internships started, so he became the final contributor to the book. During the month of May 2008 we had a great time cranking out some really fun aliens, utilizing a process Neville Page and I had stumbled upon. It is a design process that uses the Photo Booth application on a Mac laptop. You can see the documentation and examples of this process starting on page 50.

The summer moved along and we got sucked into more freelance work and the development of other books. The final push for this book happened during the winter holidays of 2008 and was being tweaked by the entire team on and off through the end of April 2009 when this book went to press...at last.

We hope you enjoy the characters and creatures we have created for Alien Race. Hopefully, with a little luck, we all might get to see the content of these pages on the big screen someday. For now though, please enjoy it for hours in this form!

**Scott Robertson**
Founder of Design Studio Press
Chair of Entertainment Design, Art Center College of Design
Los Angeles, April 2009

# STORY OVERVIEW

In the middle of the jungle, a radio telescope locks on-target and sounds the alarm. A head emerges from the SETI Lab, revealing young summer intern, Zeno Cruz, the first to receive "alien contact."

On the southern tip of the constellation Capricornus, a strange alien ship surreptitiously slithers through the cosmos. An unidentifiable flag encrypted on its side displays the Galactic Alien Race Federation.

At the SETI Lab, Zeno frantically announces to well-known planet hunter and mentor, Doc Quan, that first contact has been made and to expect the G.A.R.F. "Bio Lab" to appear on planet Earth! Its target: the East River in New York City.

Days later, an enormous, multi-story high, metallic orb floats near the river's edge alongside the United Nations. Hovering news choppers and military vehicles stand by; ready to take aim and fire! The entire city is paralyzed as the news cameras roll.

Then suddenly, in plain sight, the mysterious orb broadcasts in HD-Alien TV via satellite announcing, "The Galactic Alien Race Federation has overwhelmingly elected to invite planet Earth to race for the future and join the Alien Race across the galactic universe!" The one qualifying rule is this: the official earthling race team must have one representative from each continent. No more, no less.

Foreign lands begin to comb their regions for the best talent their continent has to offer.

Back in New York, the city is seized with unrequited excitement. Camera crews surround the floating orb. Meanwhile the White House fears the United States is under alien attack! The Doc and Zeno argue that this must be the Alien Bio Lab and possibly a transport device to the galactic raceway. But the government can't believe that we finally make contact with intelligent life from another universe, and all they're interested in is...RACING? It is simply absurd! The "Bio Lab" must be destroyed!

The United Nations immediately intervenes in search of a peaceful solution, as the world tunes in to HD-Alien TV to find out who will represent planet Earth.

Before the White House can mutter even a word of objection, in walks Chloe DuBois, the French paratrooper from Europe; Shorty Doongara, the ostrich racer from Australia; Alexia St. Clair, the dog trainer from Antarctica; Baktu, the camel jockey from Africa; Jaya Kumar, the elephant whisperer from Asia; and Dogo Berto, the aviator from South America, all ready to take Earth's greatest journey for all humankind. Time is running out to qualify. There are only six candidates, yet seven are required to represent all the continents of planet Earth.

We then see a familiar cowboy hat rise high in the air. It's Zeno announcing he will be the seventh to join the team. "Make us all proud, space cowboy!" cries the Doc as he gathers the team. There's no time to waste.

With just seconds to spare, Doc directs Zeno and the team down the plank, chased by the security officials. Just in time, the Bio Lab shuts its hatch and locks its doors. Inside, a cool blue light reveals the DNA Lab. Now it is time to design their racing creatures.

Dogo eagerly steps forward, the first to do so. From the DNA panel, he selects various traits from the South American gene pool of animal characteristics and behavioral patterns. Once completed, he steps into the blue light to automatically sync with his "creation" to reveal a sight never-before-seen by earthling eyes!

Candidates step into the DNA Lab to design their very own unique creatures. Now, the true test awaits the newbie riders. How will they fare against the very best the universe has to offer?

Mighty Madden announces, "the world is witnessing the latest and greatest ordinary heroes in such extraordinary times." As shocking as it may seem, all seven "oddball" riders successfully qualify, and must now prepare to join the race for the galactic universe. Sponsors eagerly shower each rider with endorsements. Zeno is voted as team captain since he discovered the initial alien contact. For the first time in human history, the world acts as one nation.

HD-Alien TV broadcasts live: the time has come for planet Earth to enter the great Alien Race across the galactic universe. The US Government insists the team is in danger and breaks into the Bio Lab, only to discover that no one is to

be found, not even the Doc. The large overhead screen projects a message for the entire world to see, "Team Earth has been teleported to the Galaxy of Capricornus to represent planet Earth in the Alien Race hosted by the glorious planet Zyonia...please stay tuned."

The entire population of planet Earth is glued to HD-Alien TV.

Soaring through the cosmos, light years away, we see two dimming suns rise over a strange land of towering peaks and vast valleys. We are now in a place in space that is unrecognizable to the mere human eye. Soaring downward, we rest on the wings of a strange flying alien creature guided by the beautiful princess QBQ of the Zyonian species.

Sire Kannak Nakkan, Zyonian Supreme Elder and founder of the Galactic Alien Race Federation, stands with pride as he witnesses his one and only daughter soar through the brisk Zyonian skies. Just then, Secretary Kinnik of the Syntillian species teleports into the royal sky deck announcing Team Earth's arrival.

QBQ and her winged creature personally welcome Zeno and his team to her planet. She sizes up her competition, giving the once-over to the "newbie riders" and their earthling creatures. Team Earth is surrounded by a wide variety of aliens from all corners of the cosmos ready to compete in the race for the galactic universe. Zeno wonders what on Earth they've gotten themselves into? Doc assures Zeno, "We're not on planet Earth anymore."

The roving HD-Alien TV "digi-bots" surround Sire Kannak Nakkan as Mighty Madden interviews him through the cosmic airwaves. The Sire personally shares the history of the Alien Race and how this may be the last time his glorious planet will host the race due to the vast dimming of the Twin Zyonian Suns. The Sire then announces the winner of the great Alien Race will host the "next generation" of the Galactic Alien Race Federation.

Meanwhile, all galactic teams gather in the stadium while Secretary Kinnik announces from the sacred G.A.R.F scrolls that the race will cover a 300-mile course through the toughest terrain in the most remote locations on planet Zyonia. Teams of three Quadrupeds, two Bipeds and two Flyers must race together, non-

stop, using their skills for three death-defying days. The mandatory rule is simple; each team must complete the race together or otherwise the team and its planet will be disqualified. The qualifying team that clocks in at "top speed" during the Alien Race expedition will be crowned the ultimate winner and "supreme beings" of the galactic universe. The Zyonian crowd applauds with a thunderous roar as each team is handed an official contract to sign prior to entering.

It becomes apparent to the Doc that the race would include strategic navigation from the flyers on the team, and fancy footwork from the riders to conquer the alien terrain. Zeno poses one simple question to the Doc before signing the contract. "What if we don't win?" The Doc eagerly signs the alien contract without hesitation and encourages his team to, "Enjoy the ride."

The race begins with dreams of grandeur and excitement in the brisk Zyonian air. The stadium roars with anticipation as one chosen flyer of each of the racing teams is called forth. They are given a GPS to map the Zyonian Swamplands and three RS-Trackers to help guide their team through its alien terrain.

The crowd rises with a thunderous cheer as Chloe, QBQ and all other alien flyers prepare to "take flight." The starting gun fires! The remaining members of each team charge out of the stadium along the racetrack.

Billions of earthling fans join together on pins and needles while glued to HD-Alien TV. In fact, the world is at peace for the very first time since the beginning of time. Meanwhile, Mighty Madden reports back via HD-Alien TV that the Alien Race is simply, "Out of this world!" One small problem, Zeno and his team are now missing in action.

We pull back to Secretary Kinnik holding Earth's contract in his slimy Syntillian hands. He looks up to the Doc, who is being held captive in a locked cell. "You should always read the fine print before you sign your planet away, Doc." Kinnik gives an evil grin and laughs. The Alien Race to take over the galactic universe has begun.

By Scott Robertson & Julz Chavez

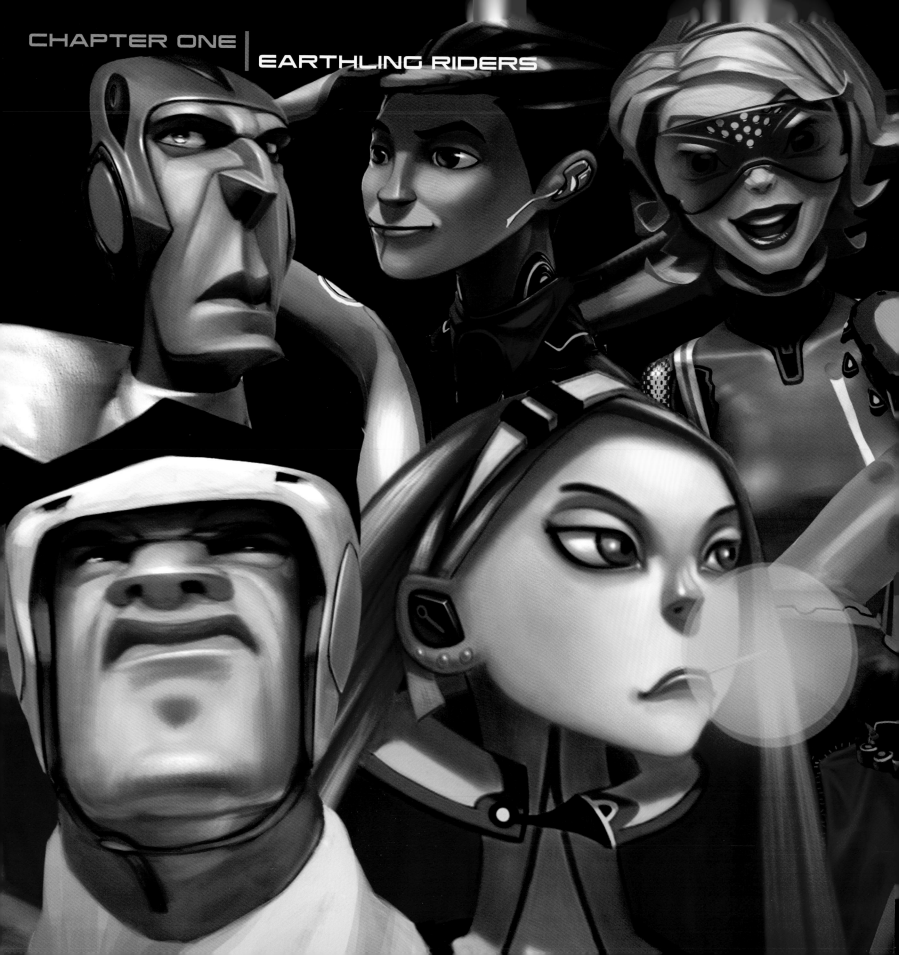

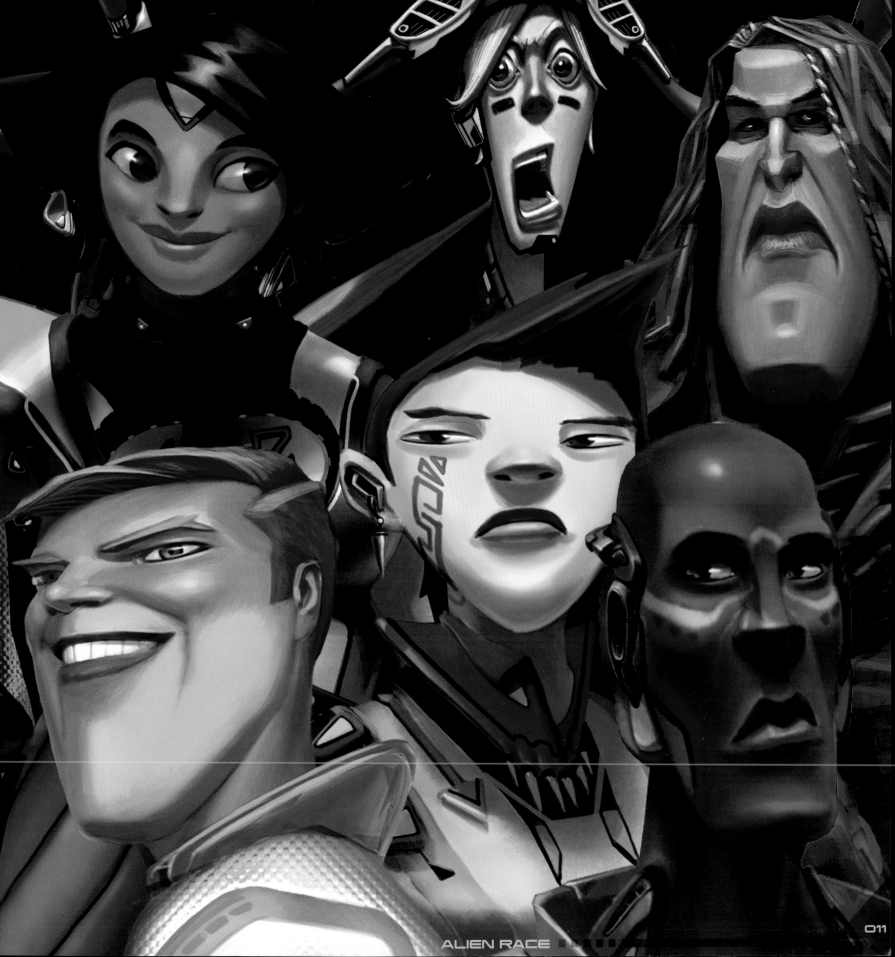

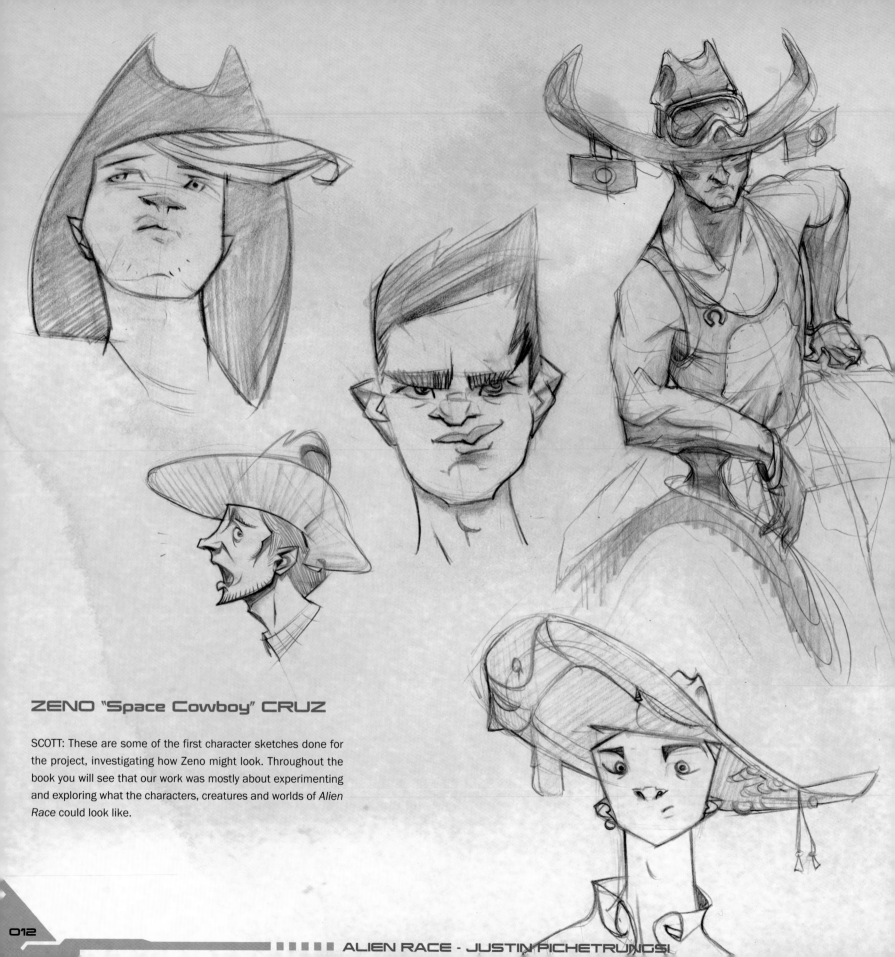

## ZENO "Space Cowboy" CRUZ

SCOTT: These are some of the first character sketches done for the project, investigating how Zeno might look. Throughout the book you will see that our work was mostly about experimenting and exploring what the characters, creatures and worlds of *Alien Race* could look like.

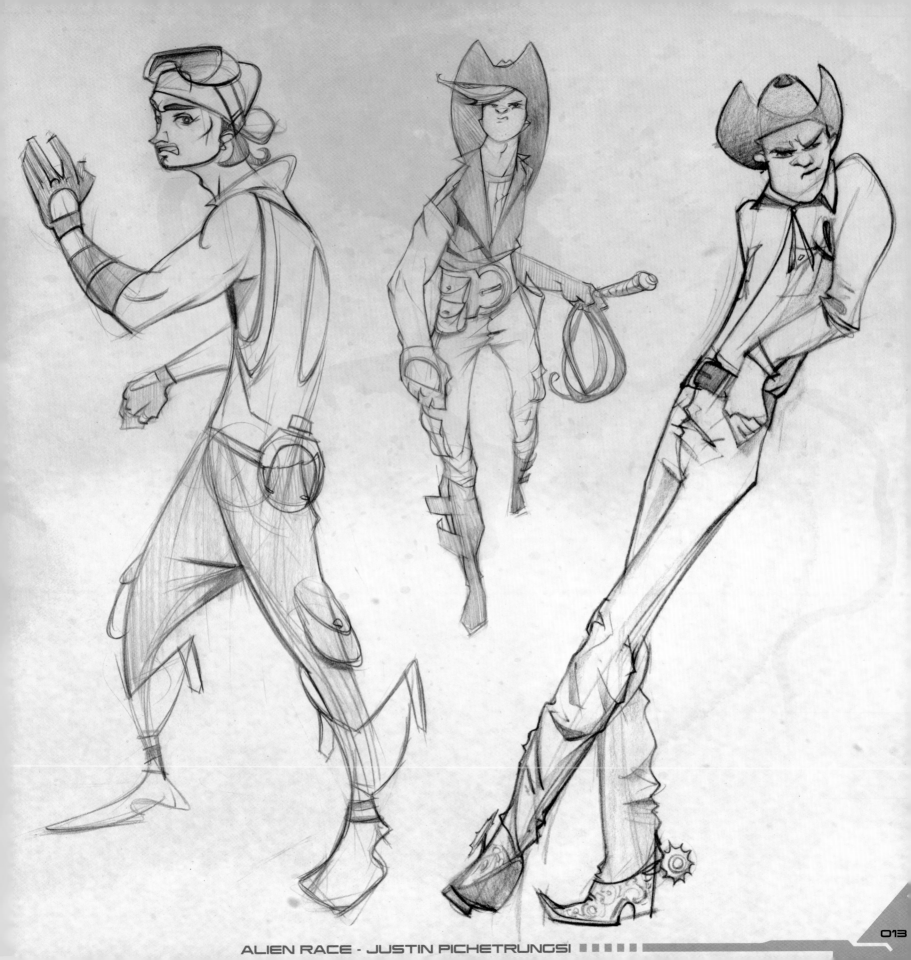

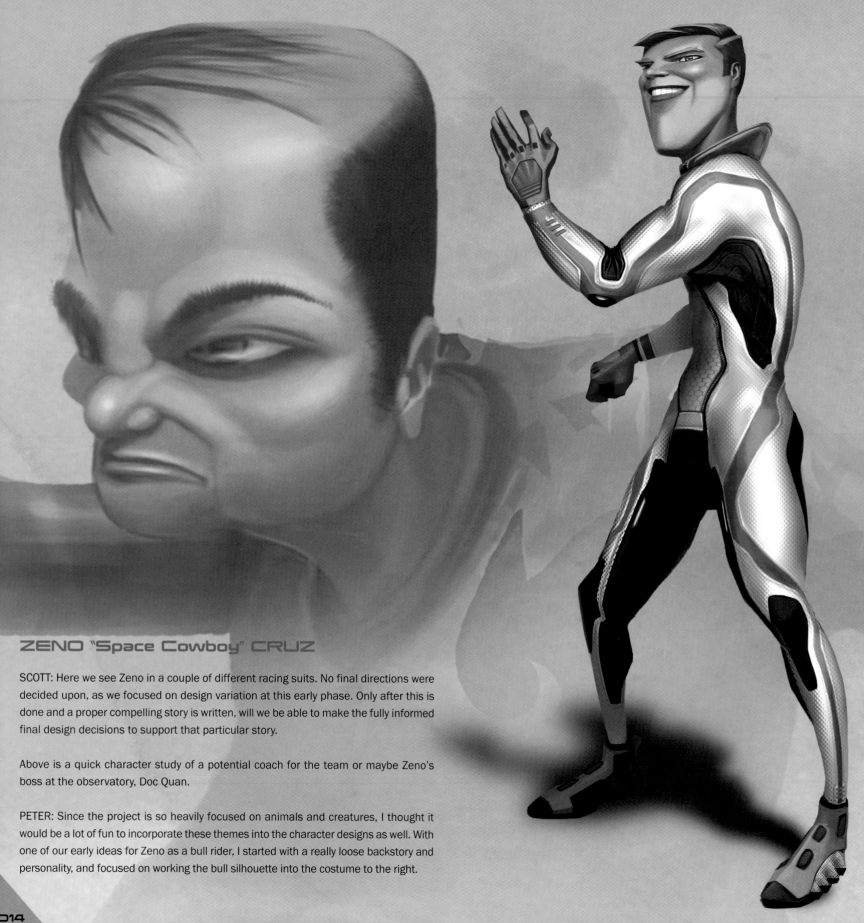

## ZENO "Space Cowboy" CRUZ

SCOTT: Here we see Zeno in a couple of different racing suits. No final directions were decided upon, as we focused on design variation at this early phase. Only after this is done and a proper compelling story is written, will we be able to make the fully informed final design decisions to support that particular story.

Above is a quick character study of a potential coach for the team or maybe Zeno's boss at the observatory, Doc Quan.

PETER: Since the project is so heavily focused on animals and creatures, I thought it would be a lot of fun to incorporate these themes into the character designs as well. With one of our early ideas for Zeno as a bull rider, I started with a really loose backstory and personality, and focused on working the bull silhouette into the costume to the right.

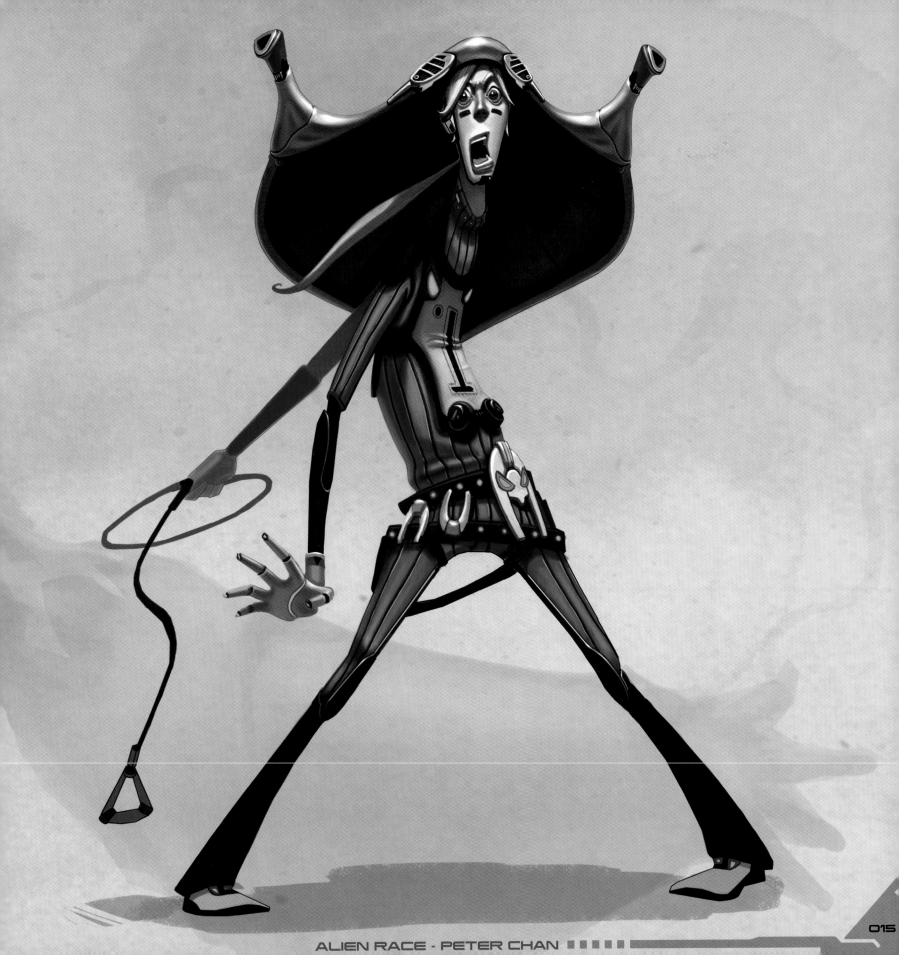

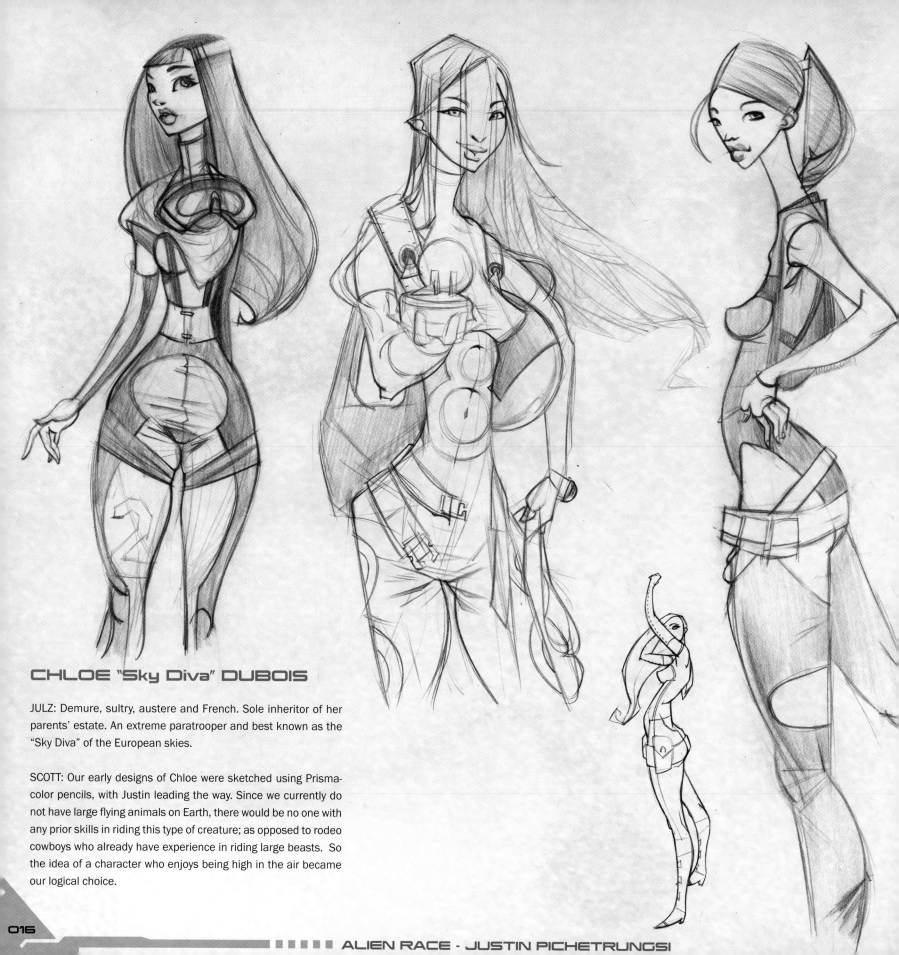

# CHLOE "Sky Diva" DUBOIS

JULZ: Demure, sultry, austere and French. Sole inheritor of her parents' estate. An extreme paratrooper and best known as the "Sky Diva" of the European skies.

SCOTT: Our early designs of Chloe were sketched using Prisma-color pencils, with Justin leading the way. Since we currently do not have large flying animals on Earth, there would be no one with any prior skills in riding this type of creature; as opposed to rodeo cowboys who already have experience in riding large beasts. So the idea of a character who enjoys being high in the air became our logical choice.

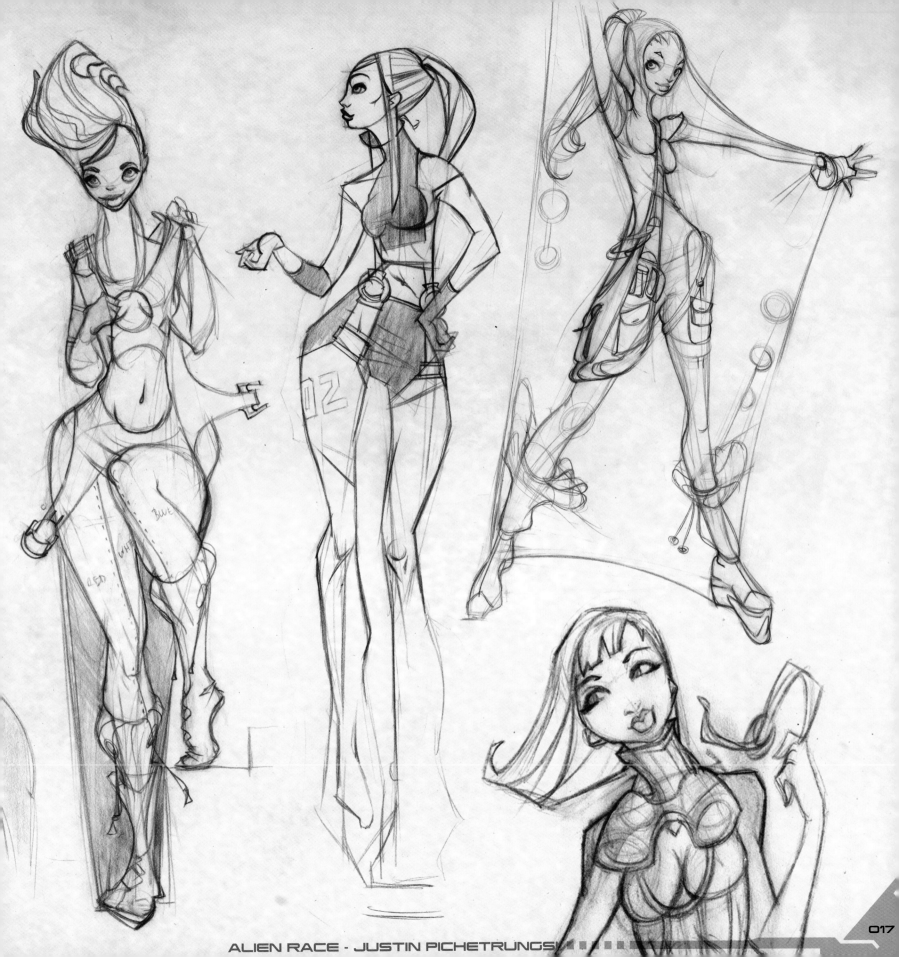

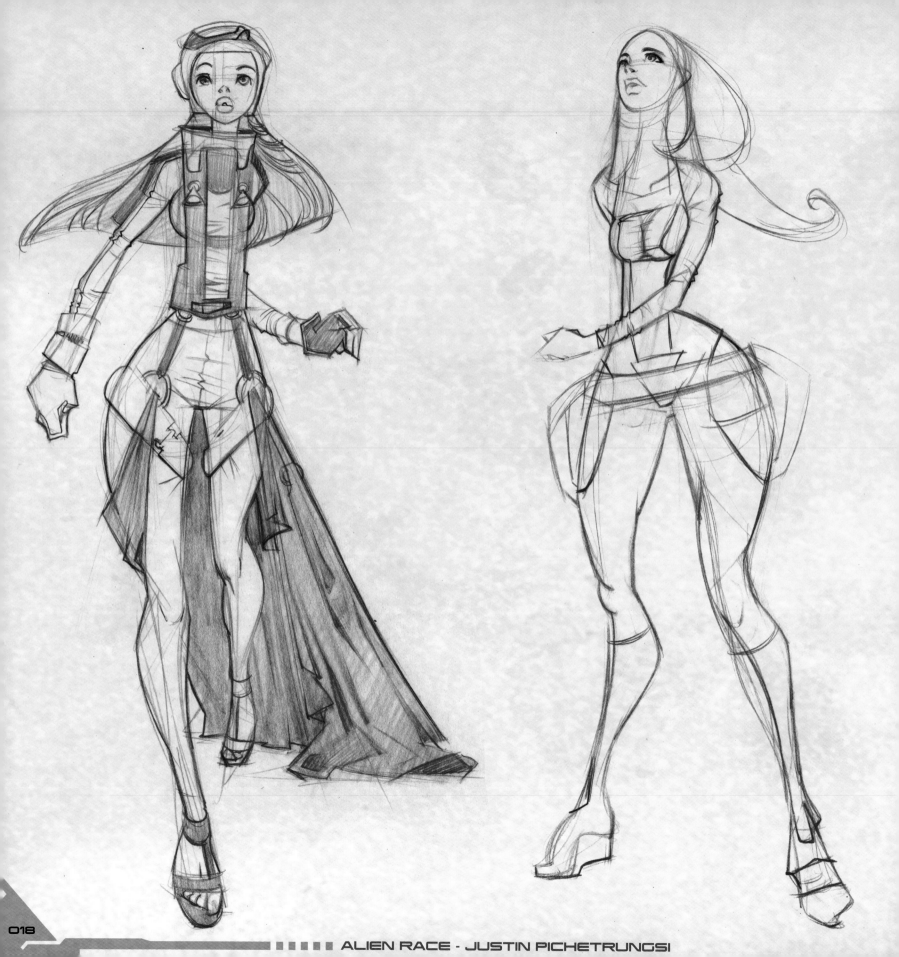

ALIEN RACE · JUSTIN PICHETRUNGSI

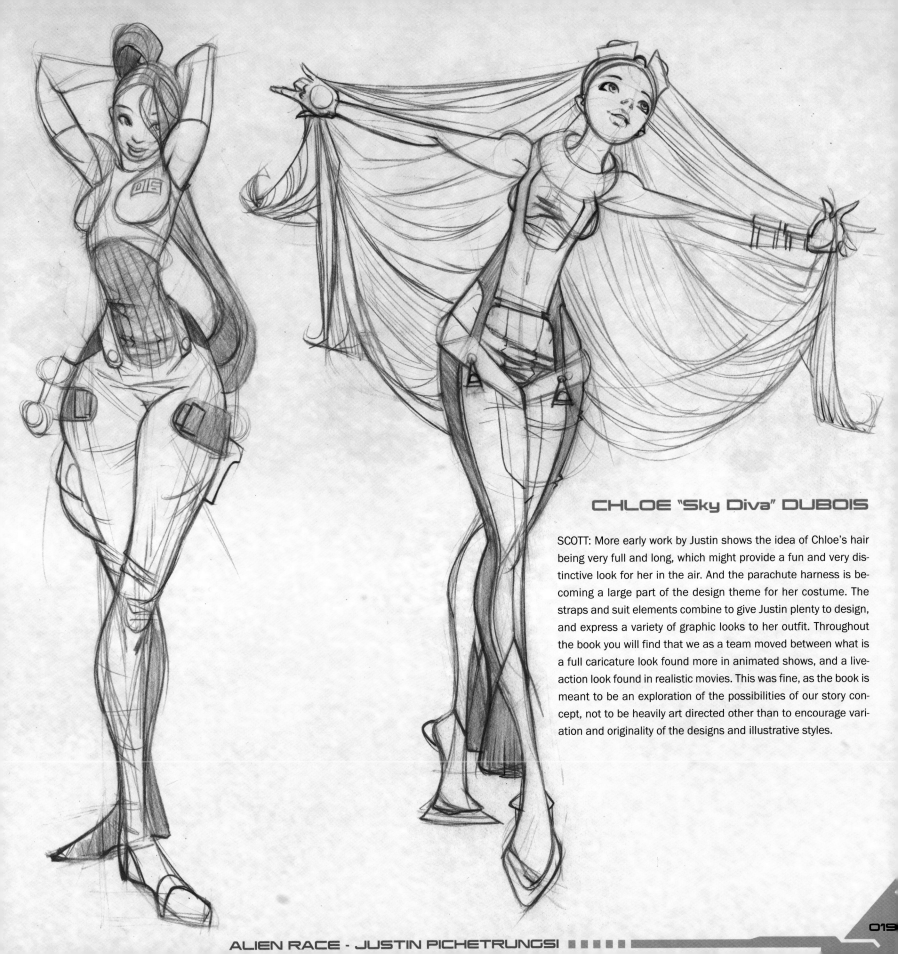

## CHLOE "Sky Diva" DUBOIS

SCOTT: More early work by Justin shows the idea of Chloe's hair being very full and long, which might provide a fun and very distinctive look for her in the air. And the parachute harness is becoming a large part of the design theme for her costume. The straps and suit elements combine to give Justin plenty to design, and express a variety of graphic looks to her outfit. Throughout the book you will find that we as a team moved between what is a full caricature look found more in animated shows, and a live-action look found in realistic movies. This was fine, as the book is meant to be an exploration of the possibilities of our story concept, not to be heavily art directed other than to encourage variation and originality of the designs and illustrative styles.

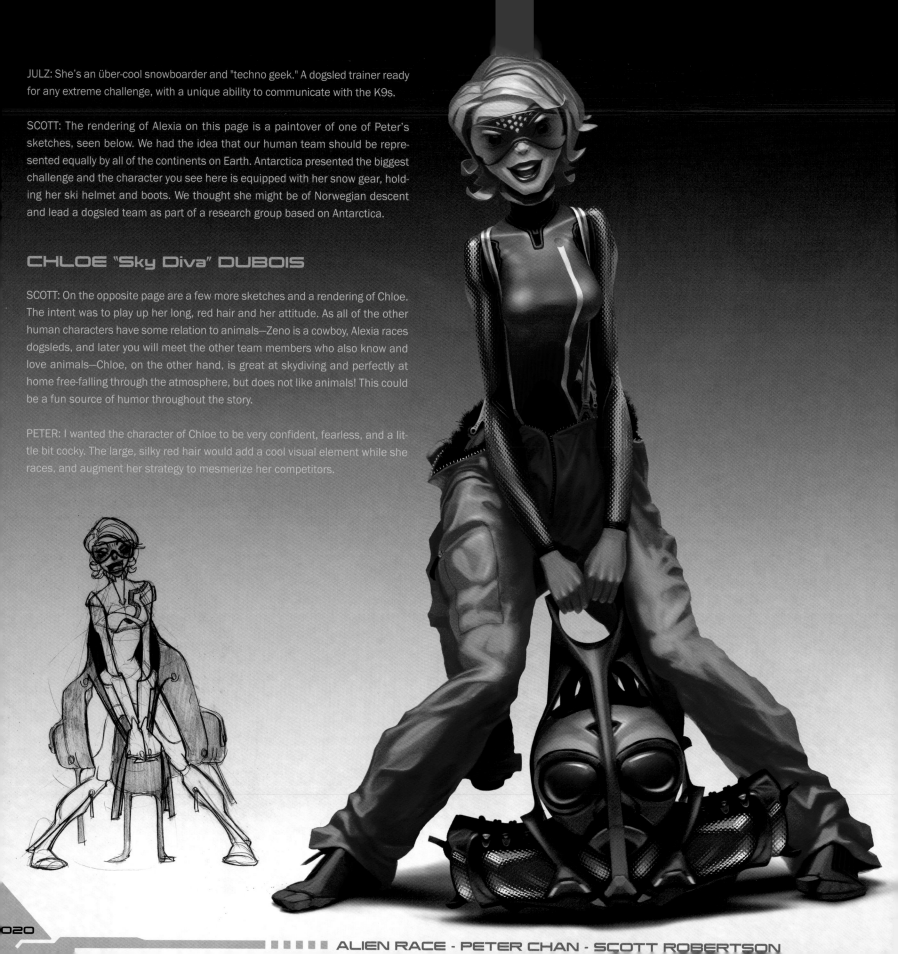

JULZ: She's an über-cool snowboarder and "techno geek." A dogsled trainer ready for any extreme challenge, with a unique ability to communicate with the K9s.

SCOTT: The rendering of Alexia on this page is a paintover of one of Peter's sketches, seen below. We had the idea that our human team should be represented equally by all of the continents on Earth. Antarctica presented the biggest challenge and the character you see here is equipped with her snow gear, holding her ski helmet and boots. We thought she might be of Norwegian descent and lead a dogsled team as part of a research group based on Antarctica.

# CHLOE "Sky Diva" DUBOIS

SCOTT: On the opposite page are a few more sketches and a rendering of Chloe. The intent was to play up her long, red hair and her attitude. As all of the other human characters have some relation to animals—Zeno is a cowboy, Alexia races dogsleds, and later you will meet the other team members who also know and love animals—Chloe, on the other hand, is great at skydiving and perfectly at home free-falling through the atmosphere, but does not like animals! This could be a fun source of humor throughout the story.

PETER: I wanted the character of Chloe to be very confident, fearless, and a little bit cocky. The large, silky red hair would add a cool visual element while she races, and augment her strategy to mesmerize her competitors.

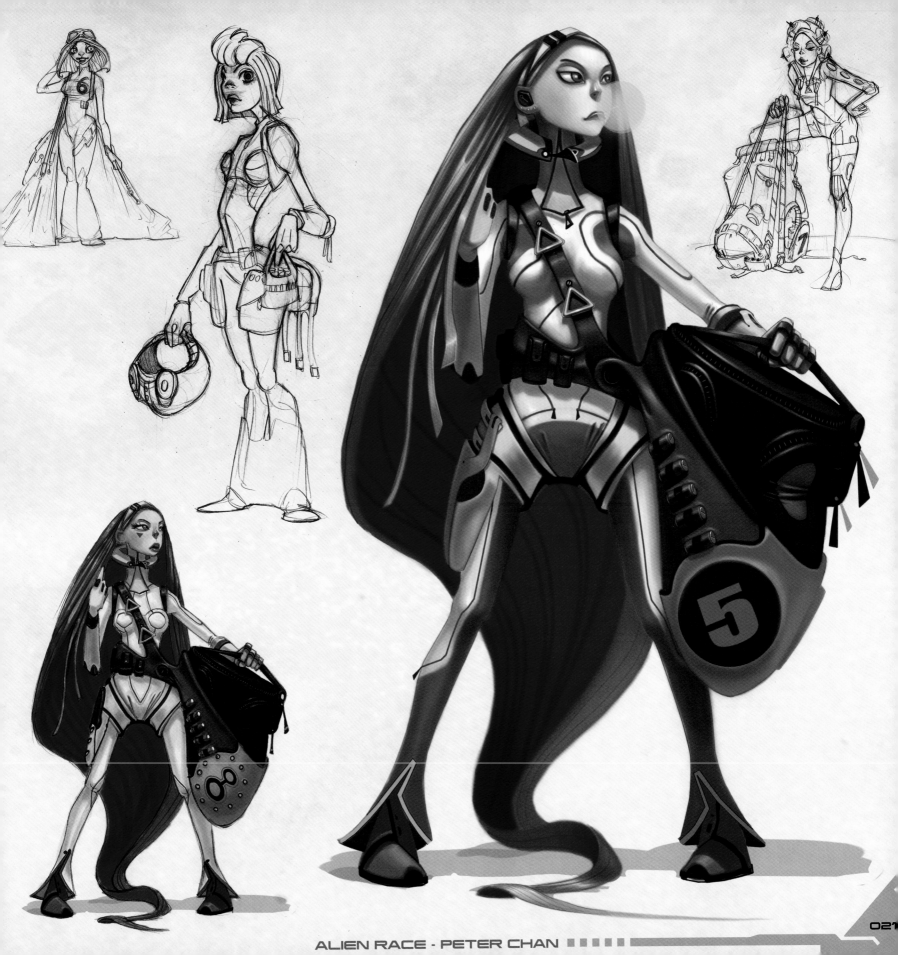

ALIEN RACE · PETER CHAN ||||||

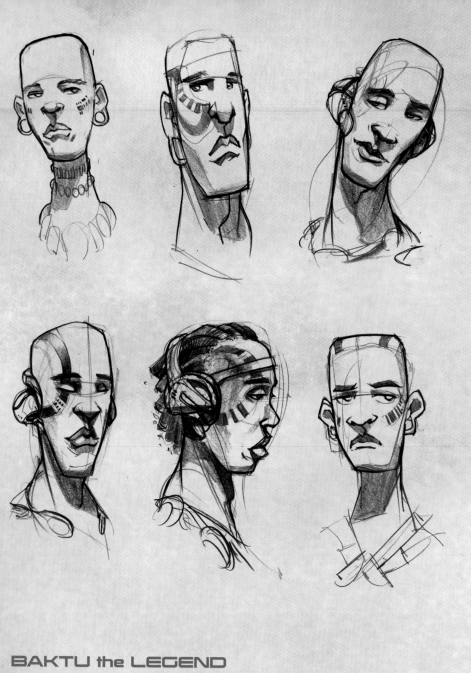

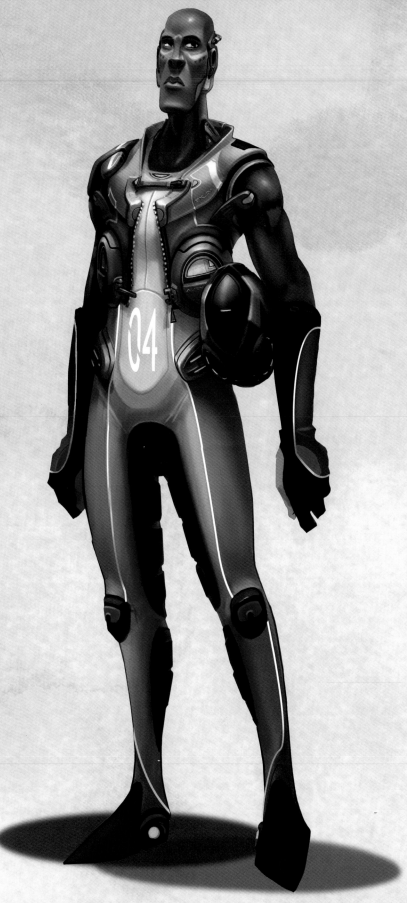

## BAKTU the LEGEND

JULZ: He's a famous nomadic camel jockey from the Taureg Tribe of Timbuktu. Wise beyond words, Baktu knows how to survive for days on end in the desert heat.

SCOTT: John joined this project in the second summer of development and did a great job of rounding out Team Earth. On these pages we took a very stylized approach to the suit and character designs, as we imagined *Alien Race* having appeal as an animated show.

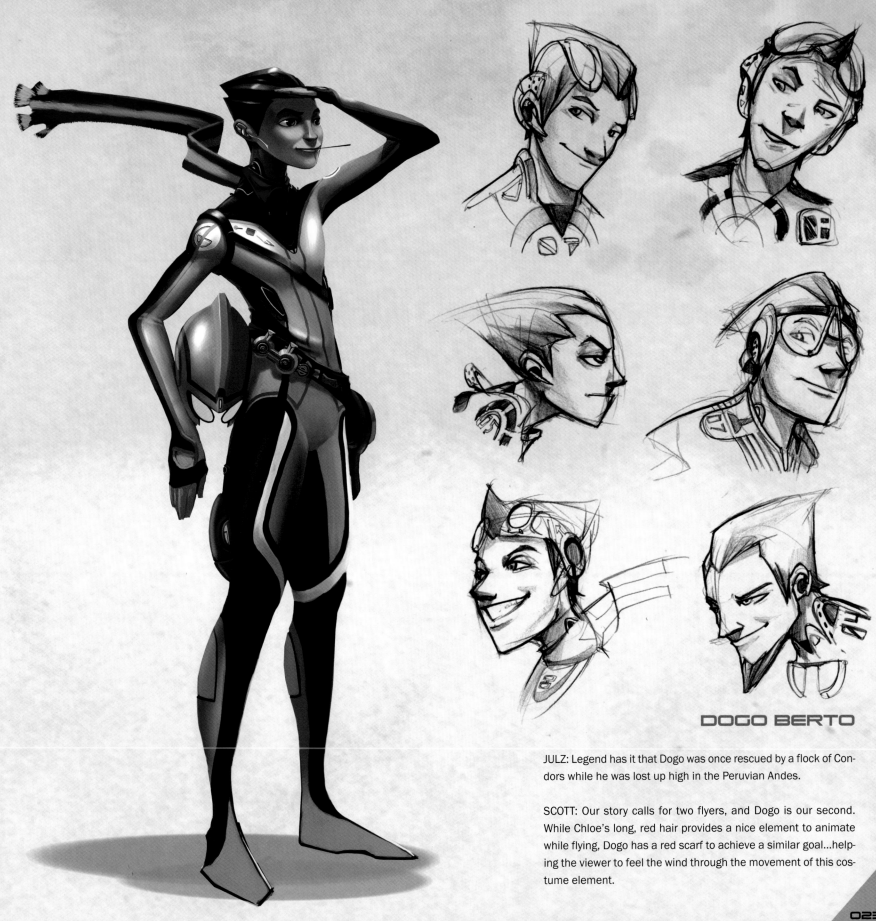

DOGO BERTO

JULZ: Legend has it that Dogo was once rescued by a flock of Condors while he was lost up high in the Peruvian Andes.

SCOTT: Our story calls for two flyers, and Dogo is our second. While Chloe's long, red hair provides a nice element to animate while flying, Dogo has a red scarf to achieve a similar goal...helping the viewer to feel the wind through the movement of this costume element.

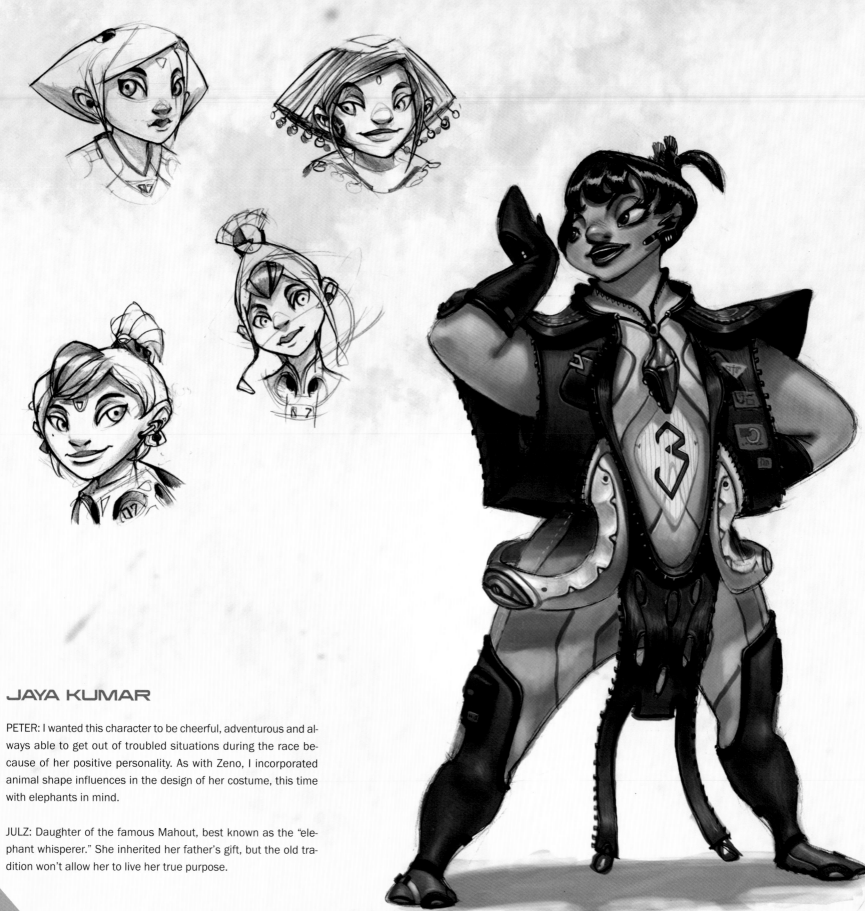

## JAYA KUMAR

PETER: I wanted this character to be cheerful, adventurous and always able to get out of troubled situations during the race because of her positive personality. As with Zeno, I incorporated animal shape influences in the design of her costume, this time with elephants in mind.

JULZ: Daughter of the famous Mahout, best known as the "elephant whisperer." She inherited her father's gift, but the old tradition won't allow her to live her true purpose.

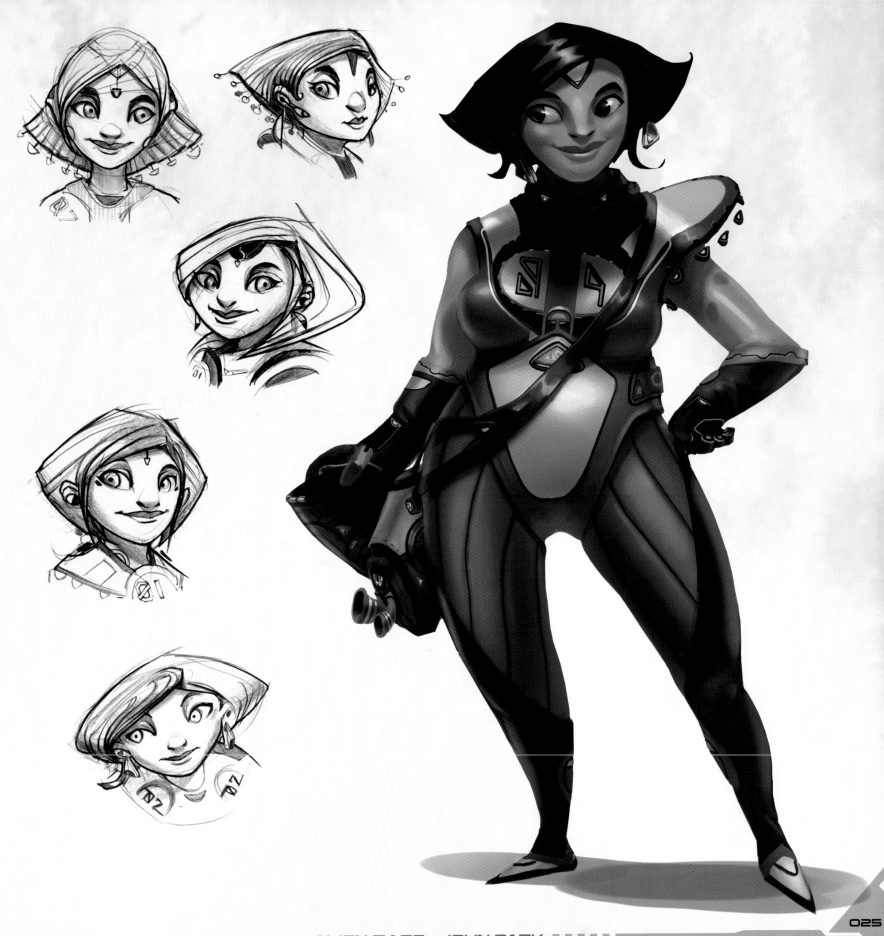

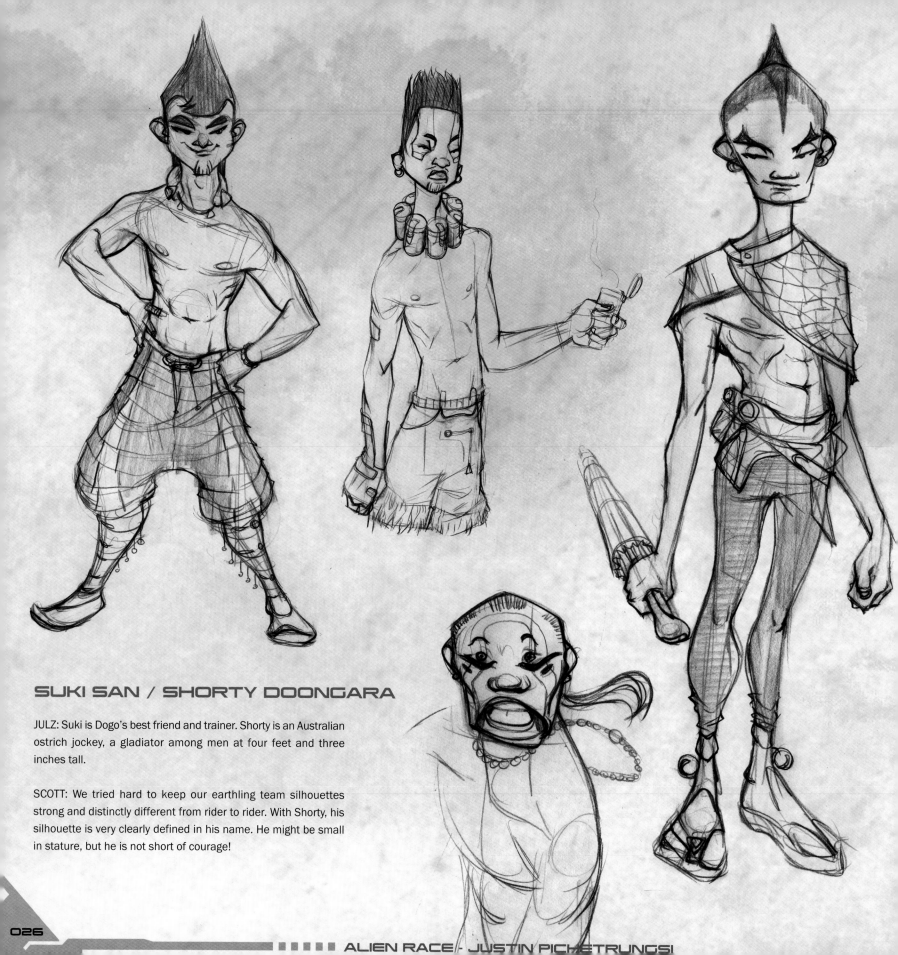

# SUKI SAN / SHORTY DOONGARA

JULZ: Suki is Dogo's best friend and trainer. Shorty is an Australian ostrich jockey, a gladiator among men at four feet and three inches tall.

SCOTT: We tried hard to keep our earthling team silhouettes strong and distinctly different from rider to rider. With Shorty, his silhouette is very clearly defined in his name. He might be small in stature, but he is not short of courage!

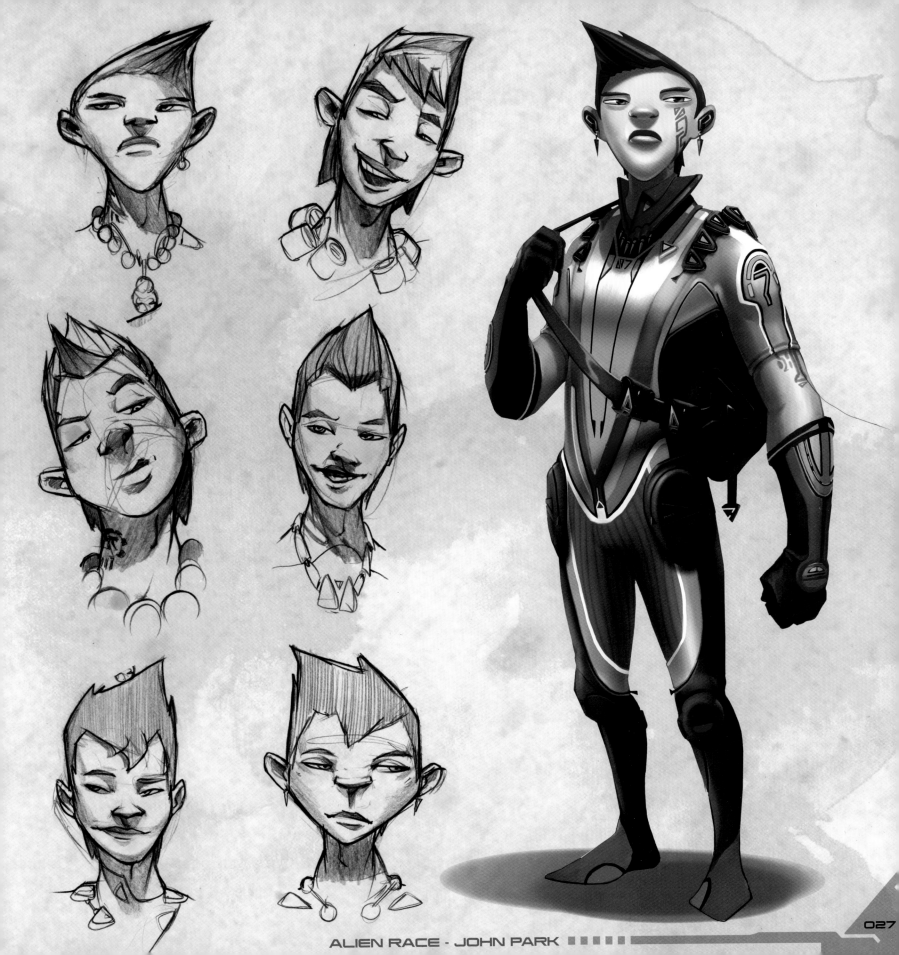

ALIEN RACE · JOHN PARK

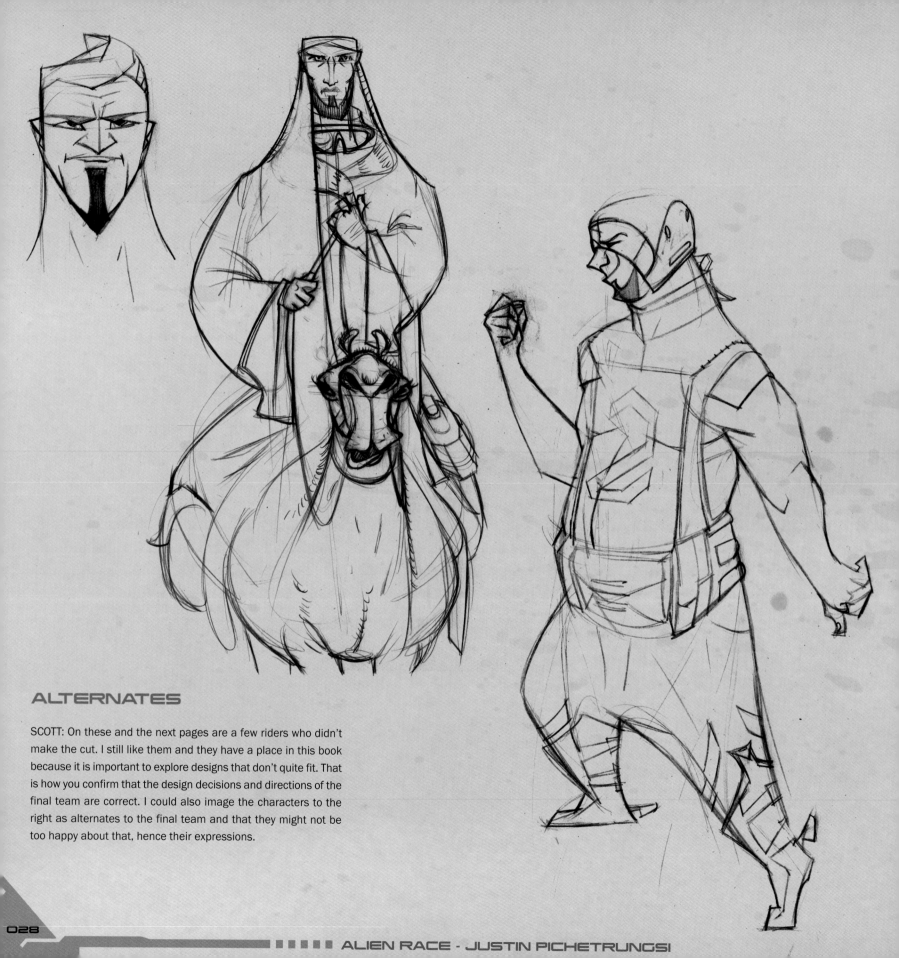

## ALTERNATES

SCOTT: On these and the next pages are a few riders who didn't make the cut. I still like them and they have a place in this book because it is important to explore designs that don't quite fit. That is how you confirm that the design decisions and directions of the final team are correct. I could also image the characters to the right as alternates to the final team and that they might not be too happy about that, hence their expressions.

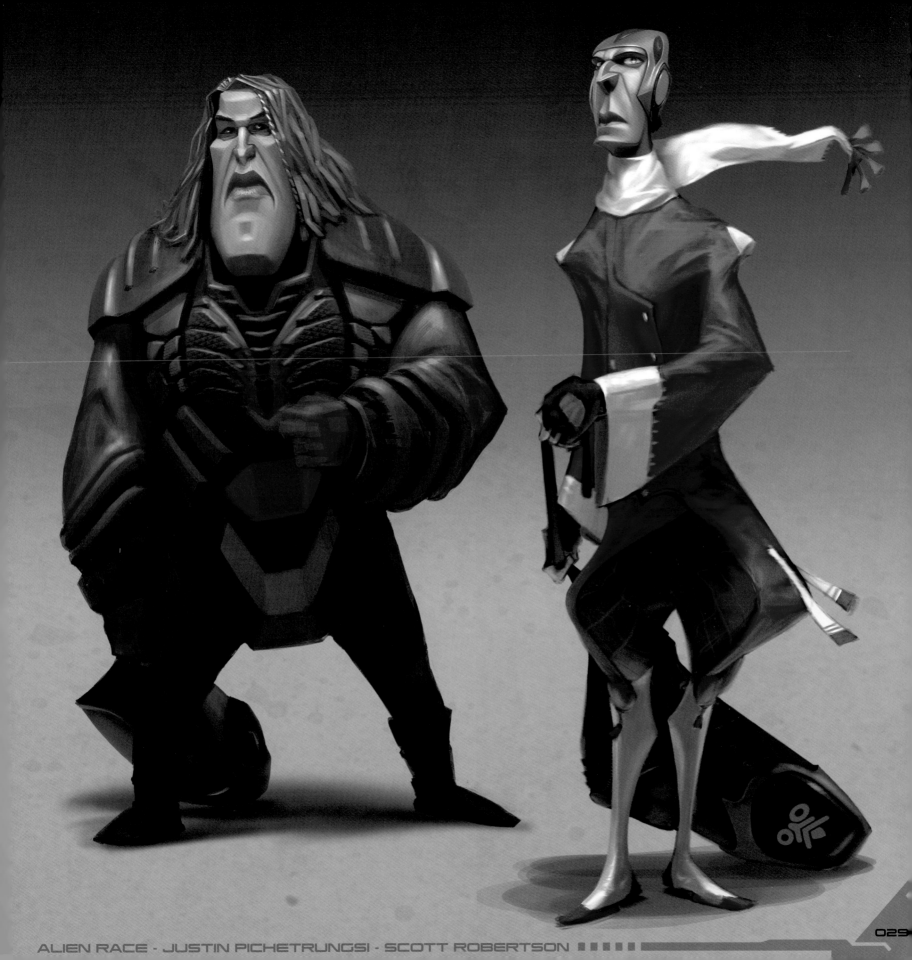

ALIEN RACE · JUSTIN PICHETRUNGSI · SCOTT ROBERTSON ▏▏▏▏▏

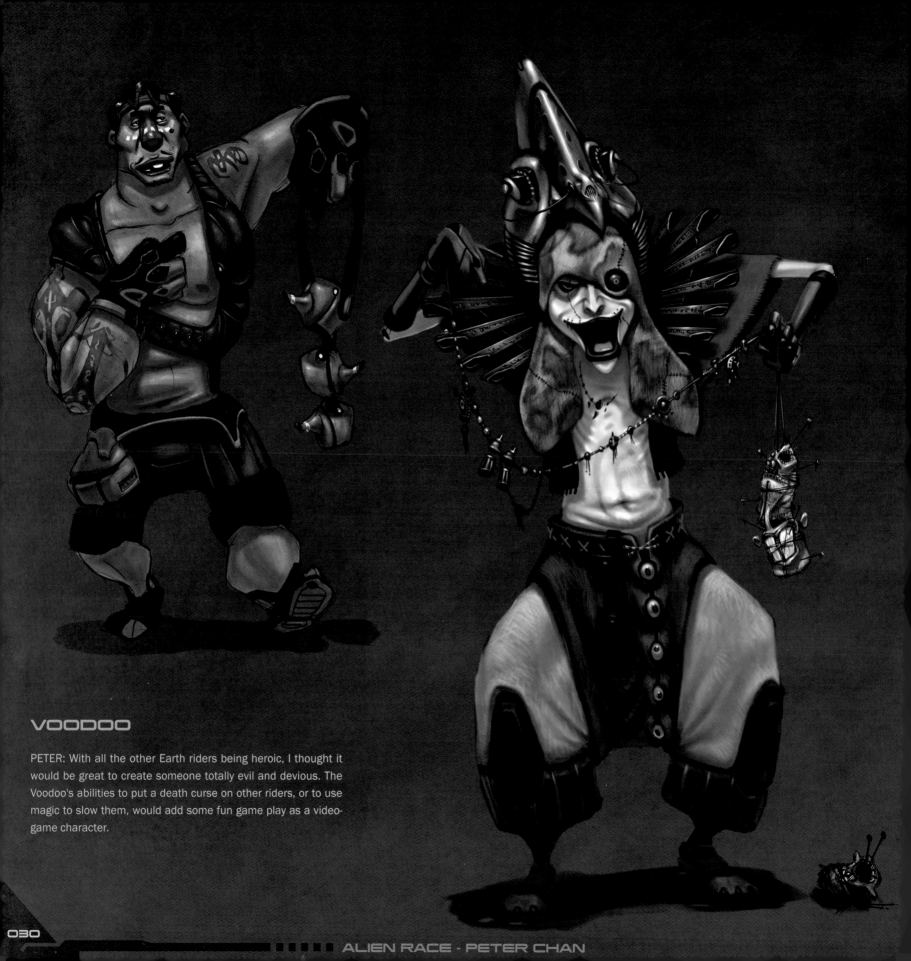

# VOODOO

PETER: With all the other Earth riders being heroic, I thought it would be great to create someone totally evil and devious. The Voodoo's abilities to put a death curse on other riders, or to use magic to slow them, would add some fun game play as a video-game character.

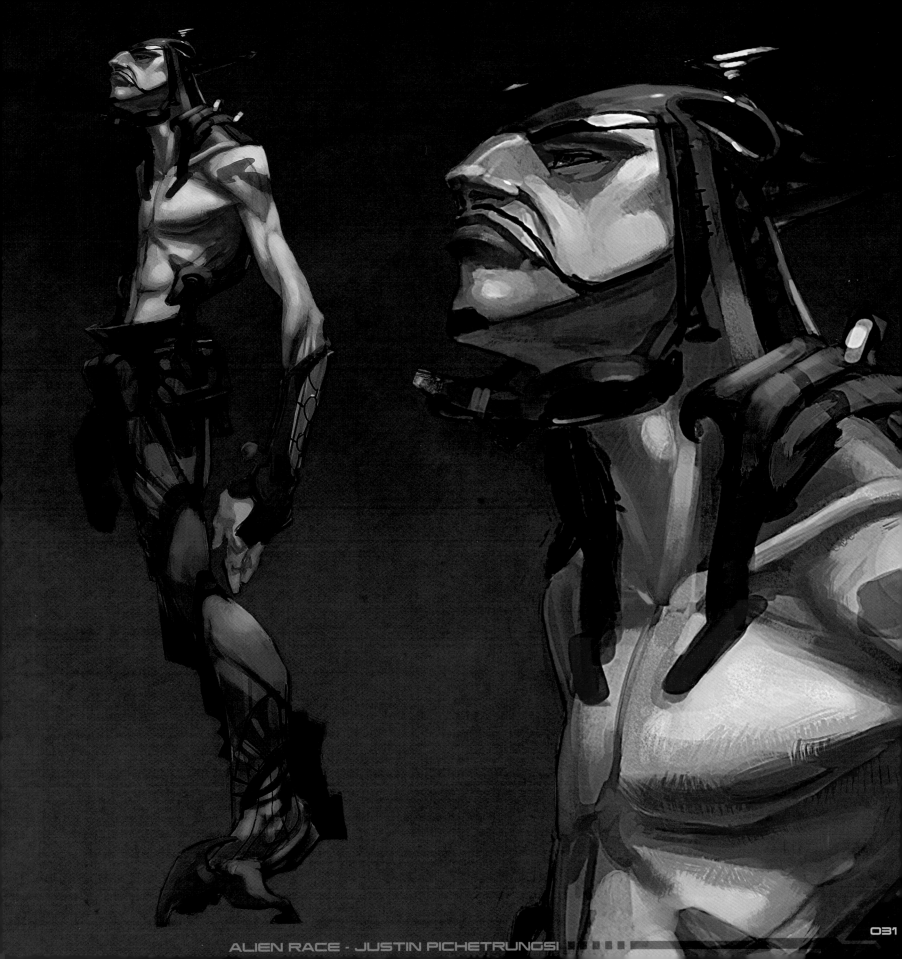

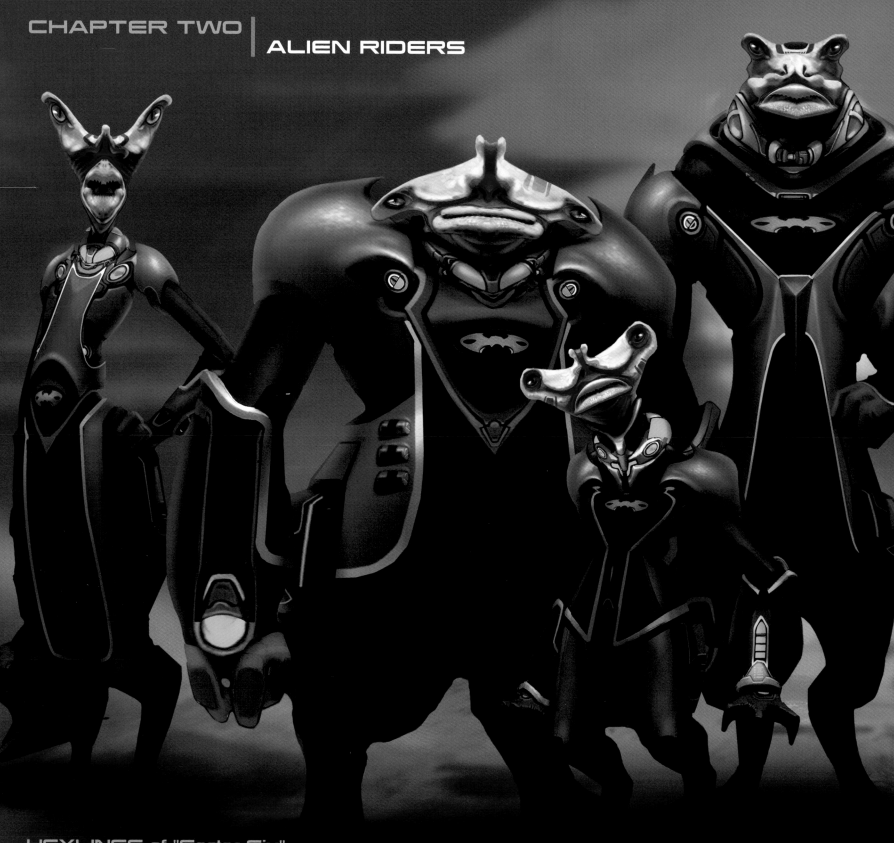

## HEXLINGS of "Sector Six"

JULZ: Data-driven alien species from the six-sided collective holo-gram of planet Hex. Also known as the "bad boys" of the Galactic Universe and most feared species in the galaxy of Capricornus.

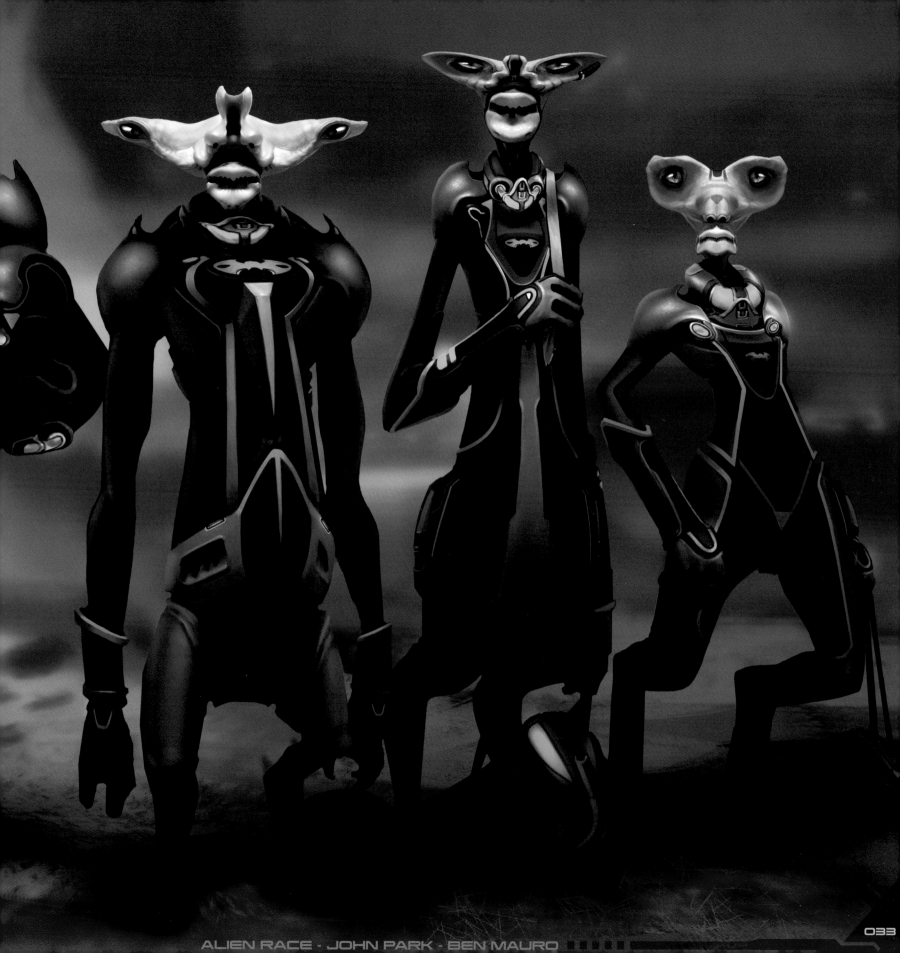

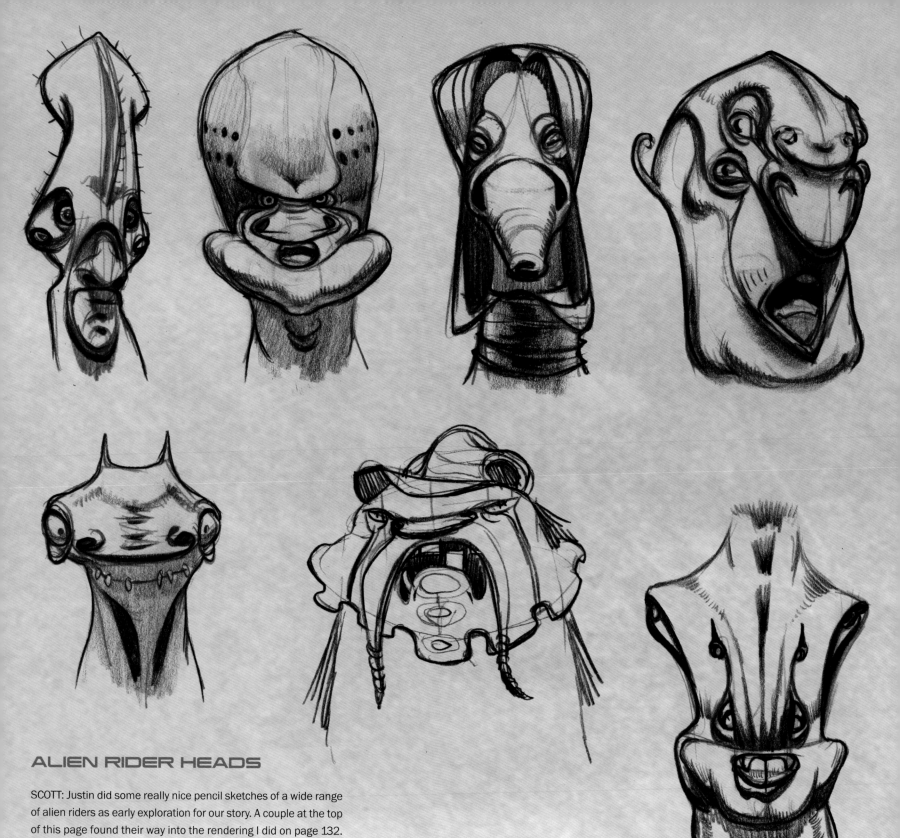

## ALIEN RIDER HEADS

SCOTT: Justin did some really nice pencil sketches of a wide range of alien riders as early exploration for our story. A couple at the top of this page found their way into the rendering I did on page 132.

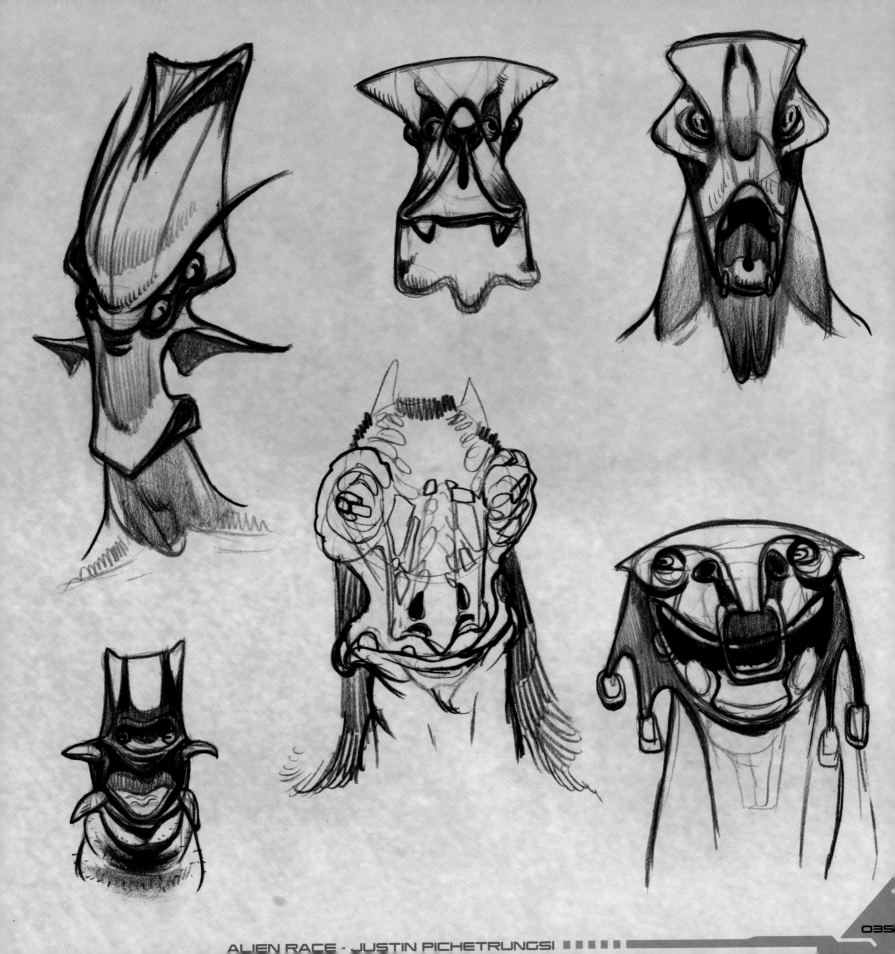

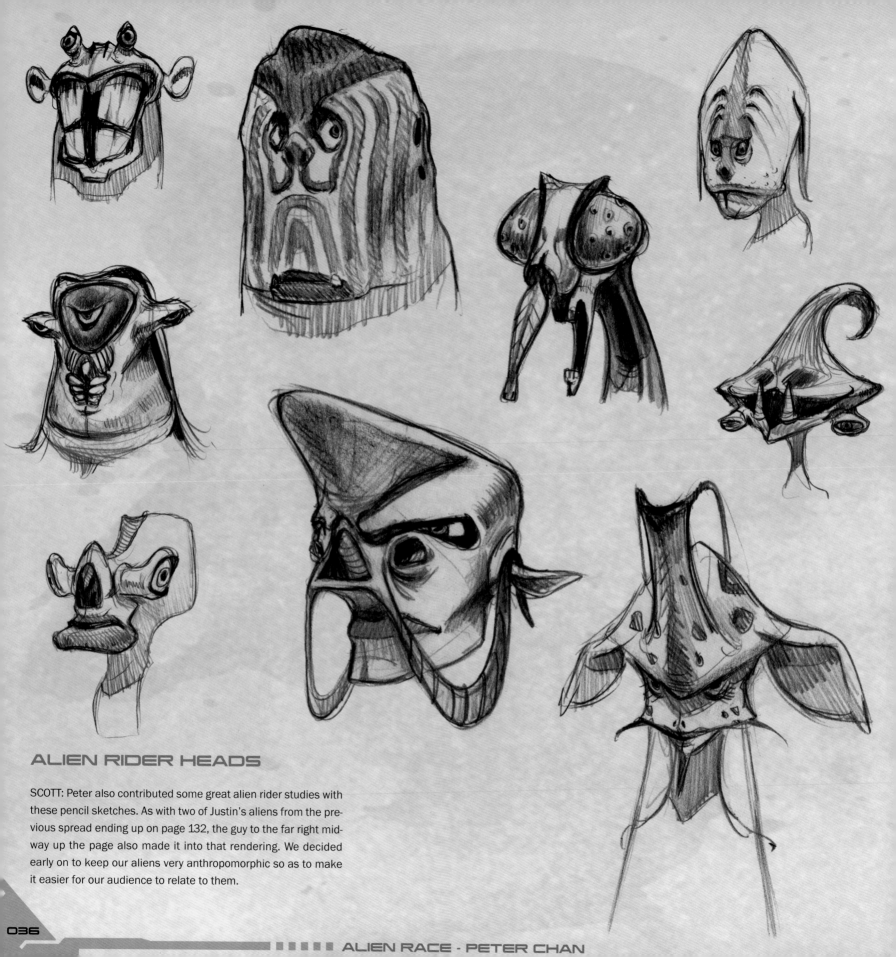

# ALIEN RIDER HEADS

SCOTT: Peter also contributed some great alien rider studies with these pencil sketches. As with two of Justin's aliens from the previous spread ending up on page 132, the guy to the far right midway up the page also made it into that rendering. We decided early on to keep our aliens very anthropomorphic so as to make it easier for our audience to relate to them.

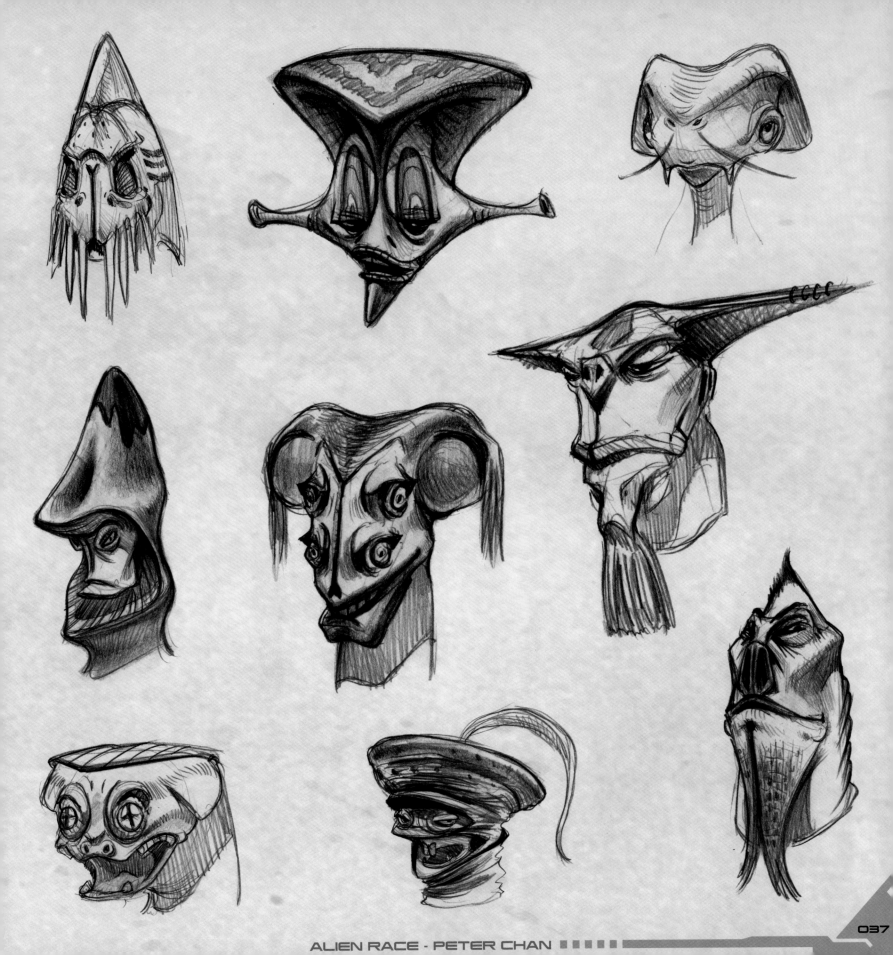

# ALIEN RIDERS

SCOTT: Here are more of the nice design studies Peter contributed. On page 63 these sketches were used as the basis for a few color renderings. I also used the sketch of the lanky alien second from the left, directly below, as the start for the "Syntillian Diva" on page 146. It's a lot fun to work as a team and share sketches and renderings back and forth, to do collaborative pieces that quite often combine to be more successful than any one of us could have achieved on our own. Fresh eyes and energy can sometimes elevate a design to the next level, just as the original designer is running out of steam to pursue the initial design any further.

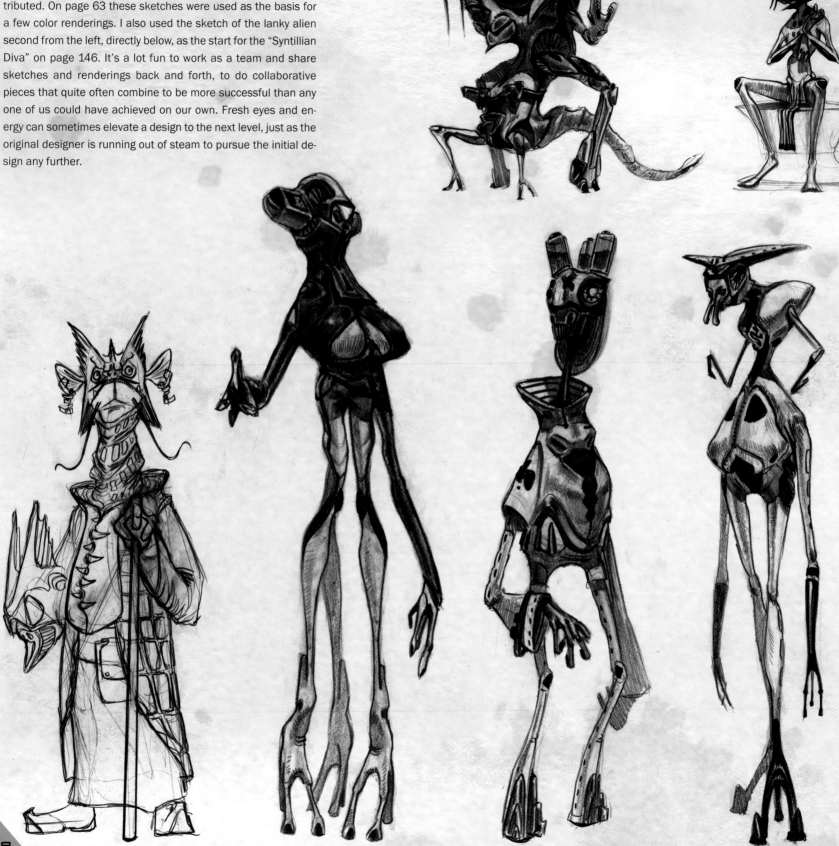

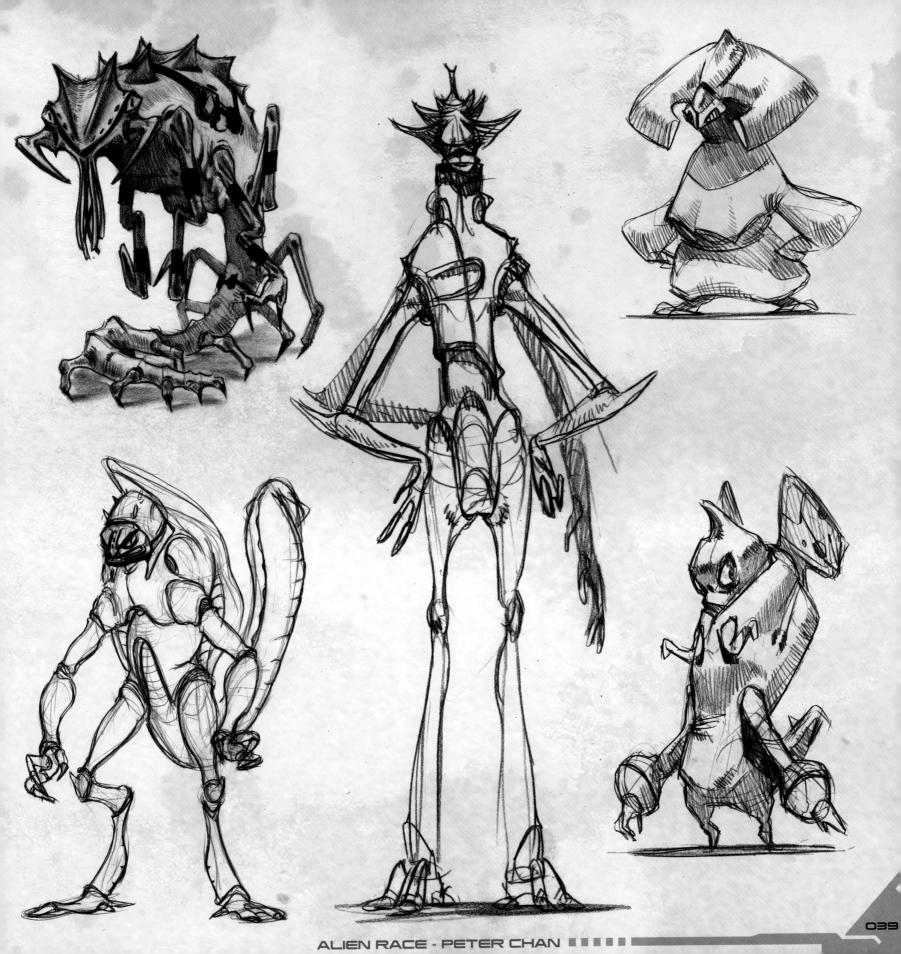

ALIEN RACE - PETER CHAN

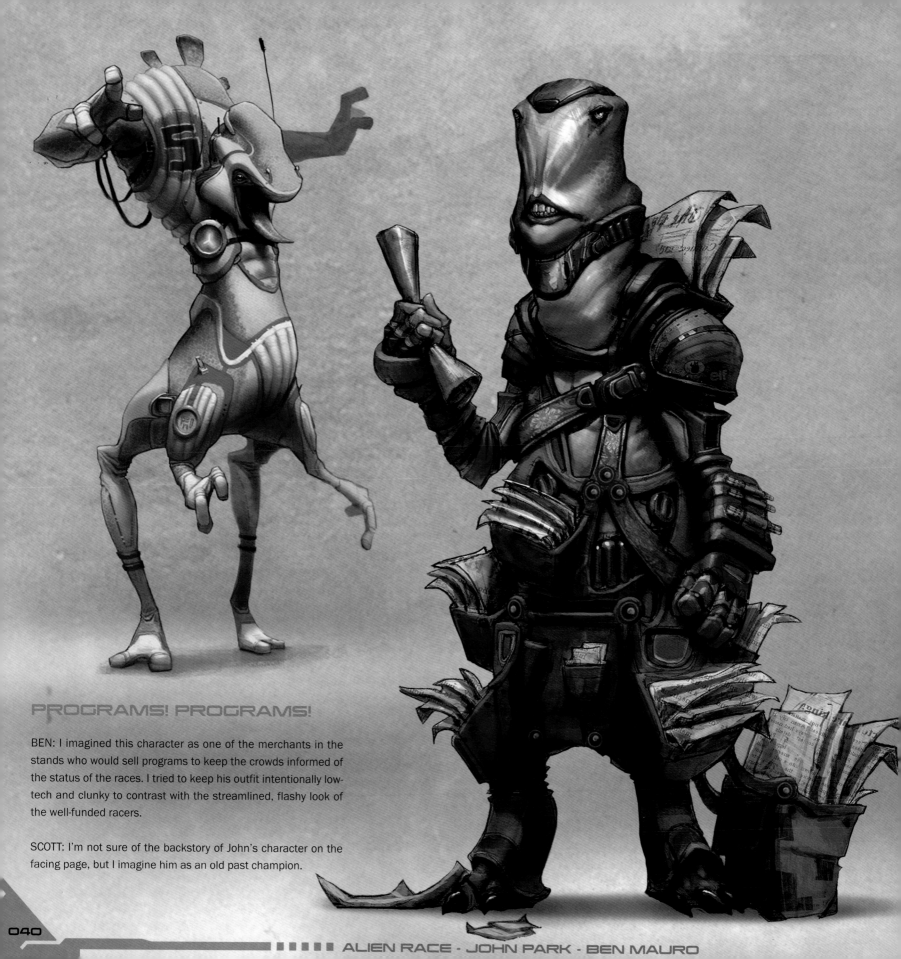

# PROGRAMS! PROGRAMS!

BEN: I imagined this character as one of the merchants in the stands who would sell programs to keep the crowds informed of the status of the races. I tried to keep his outfit intentionally low-tech and clunky to contrast with the streamlined, flashy look of the well-funded racers.

SCOTT: I'm not sure of the backstory of John's character on the facing page, but I imagine him as an old past champion.

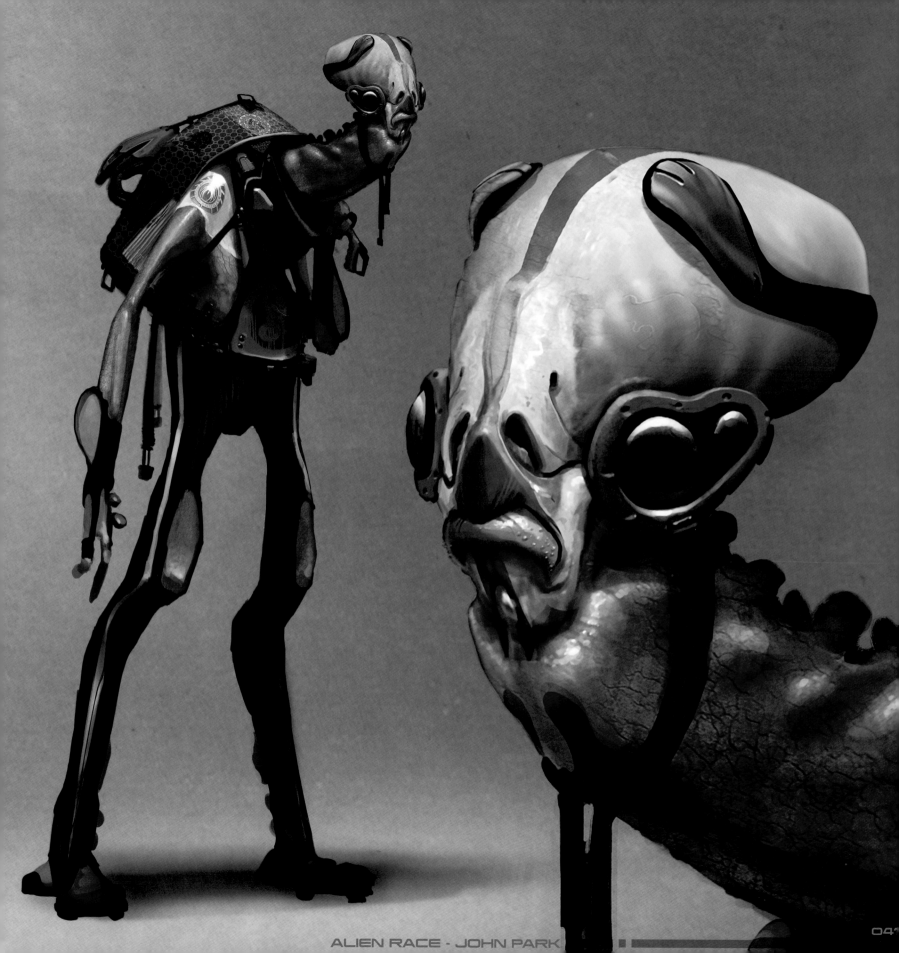

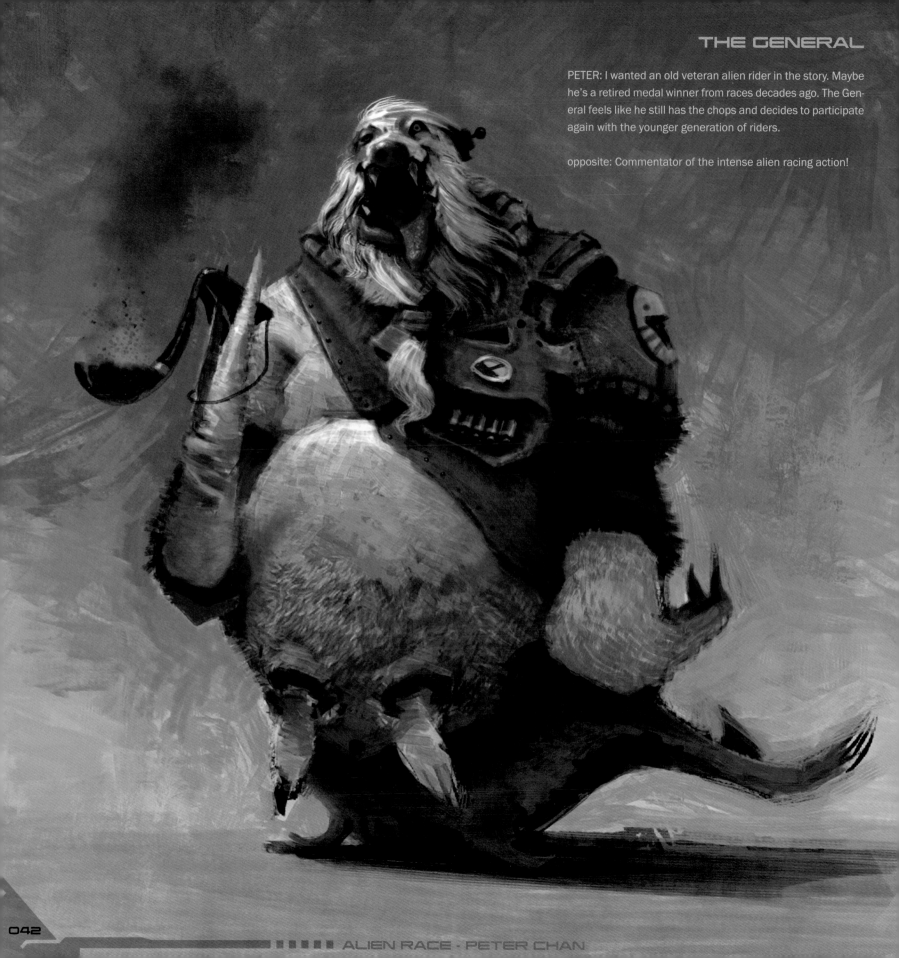

PETER: I wanted an old veteran alien rider in the story. Maybe he's a retired medal winner from races decades ago. The General feels like he still has the chops and decides to participate again with the younger generation of riders.

opposite: Commentator of the intense alien racing action!

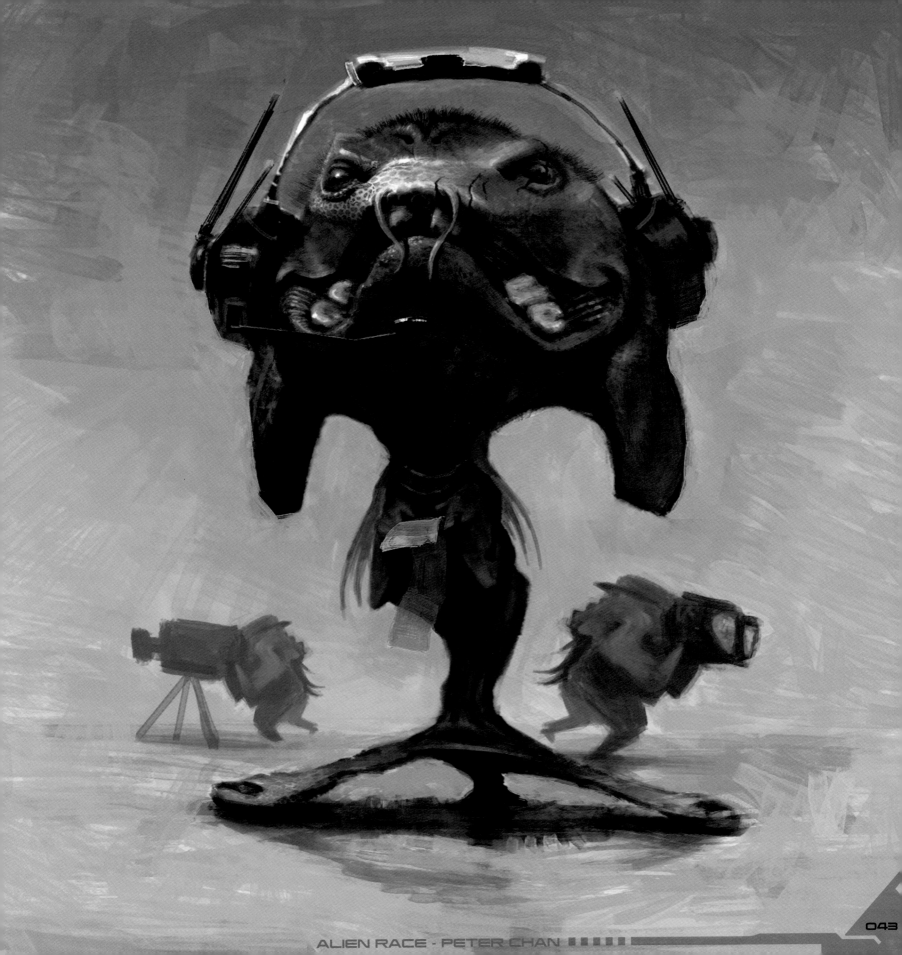

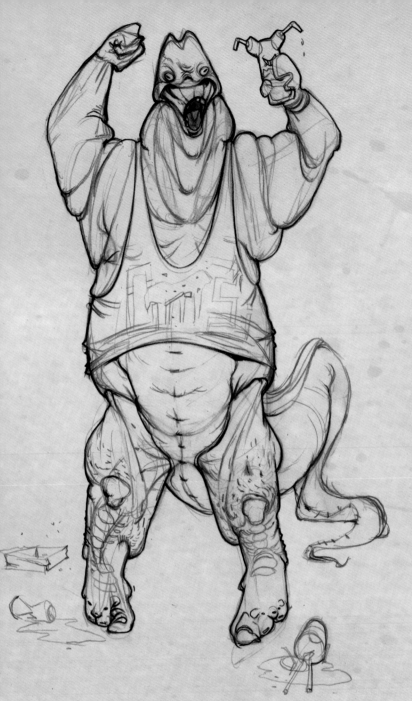

## SYNTILLIAN FANBOYS

SCOTT: These are some of the first sketches done to try to define the design of the Syntillians, who host the Alien Race. I really liked the body that Justin came up with to the right, but I was not that excited about the head. The head study on the opposite page was done by Peter and if you turn the page upside down you will see where we found our design direction for the look of the heads of the Syntillian race. When trying to invent original designs, be sure to look at them in different orientations. Occasionally you will discover the unexpected.

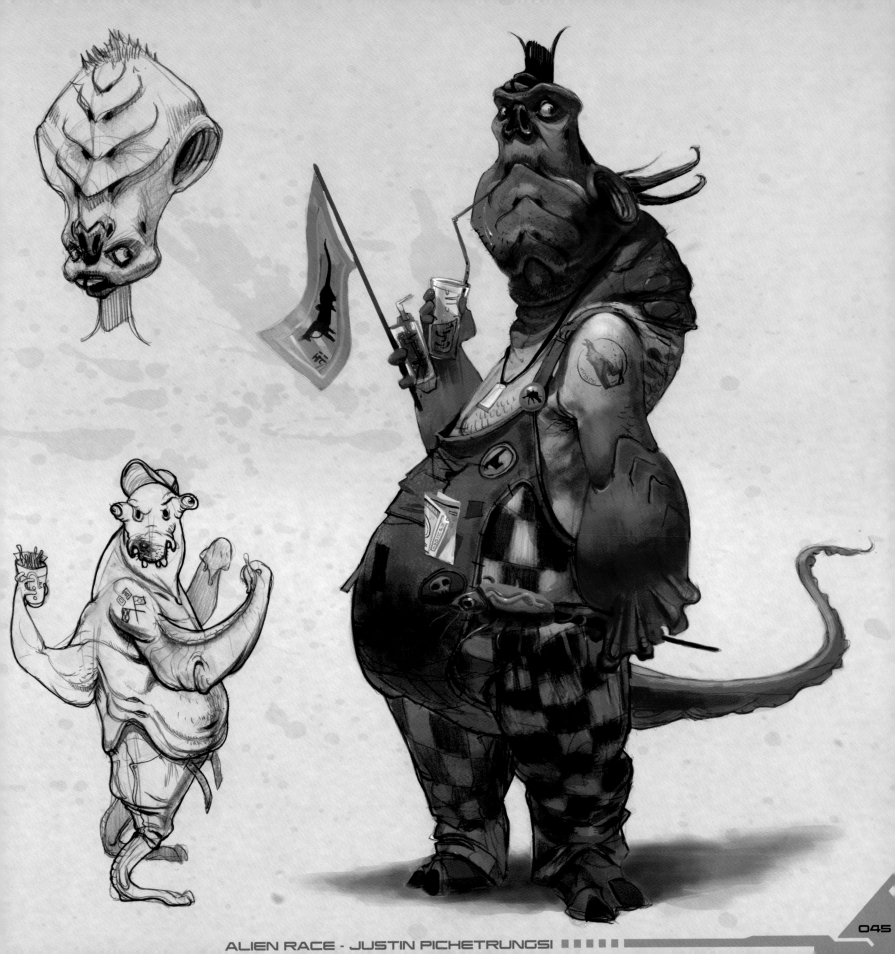

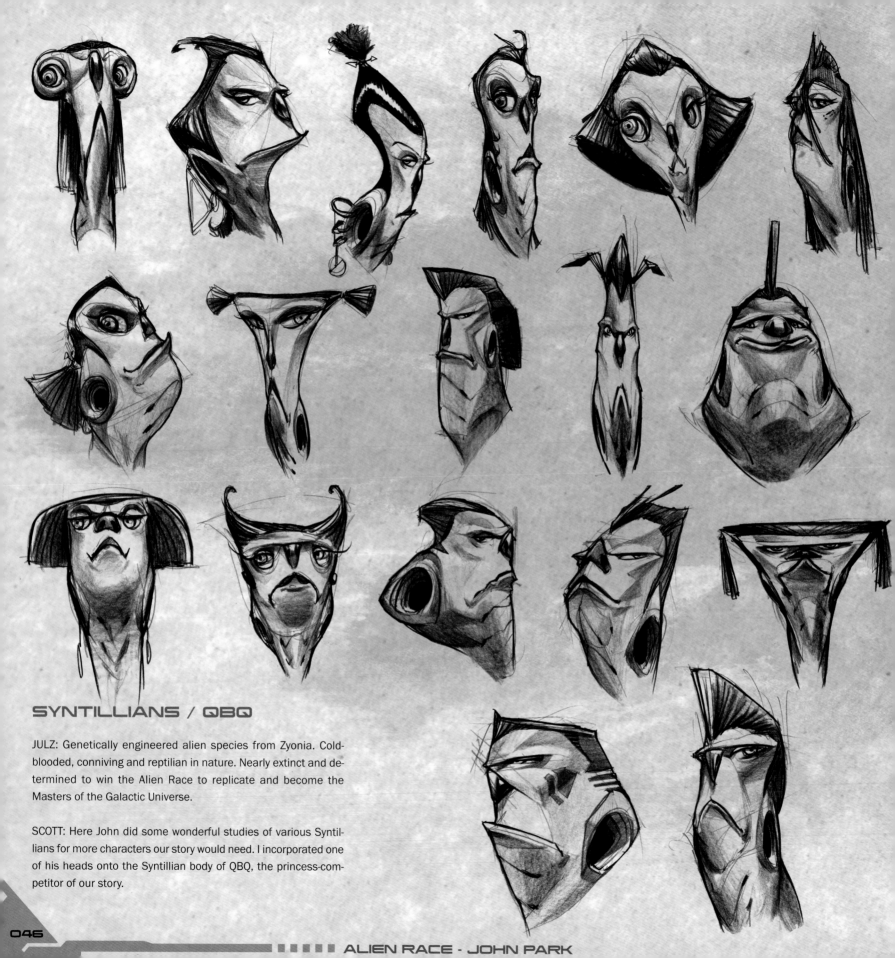

# SYNTILLIANS / QBQ

JULZ: Genetically engineered alien species from Zyonia. Cold-blooded, conniving and reptilian in nature. Nearly extinct and determined to win the Alien Race to replicate and become the Masters of the Galactic Universe.

SCOTT: Here John did some wonderful studies of various Syntillians for more characters our story would need. I incorporated one of his heads onto the Syntillian body of QBQ, the princess-competitor of our story.

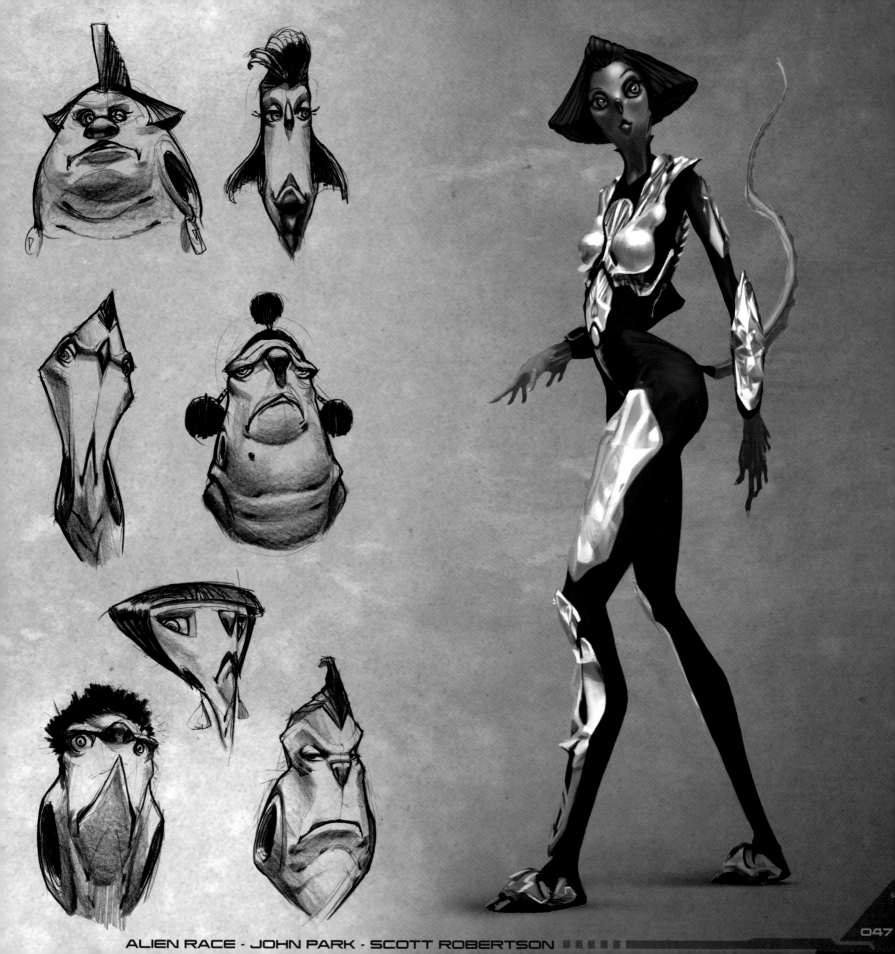

ALIEN RACE · JOHN PARK · SCOTT ROBERTSON

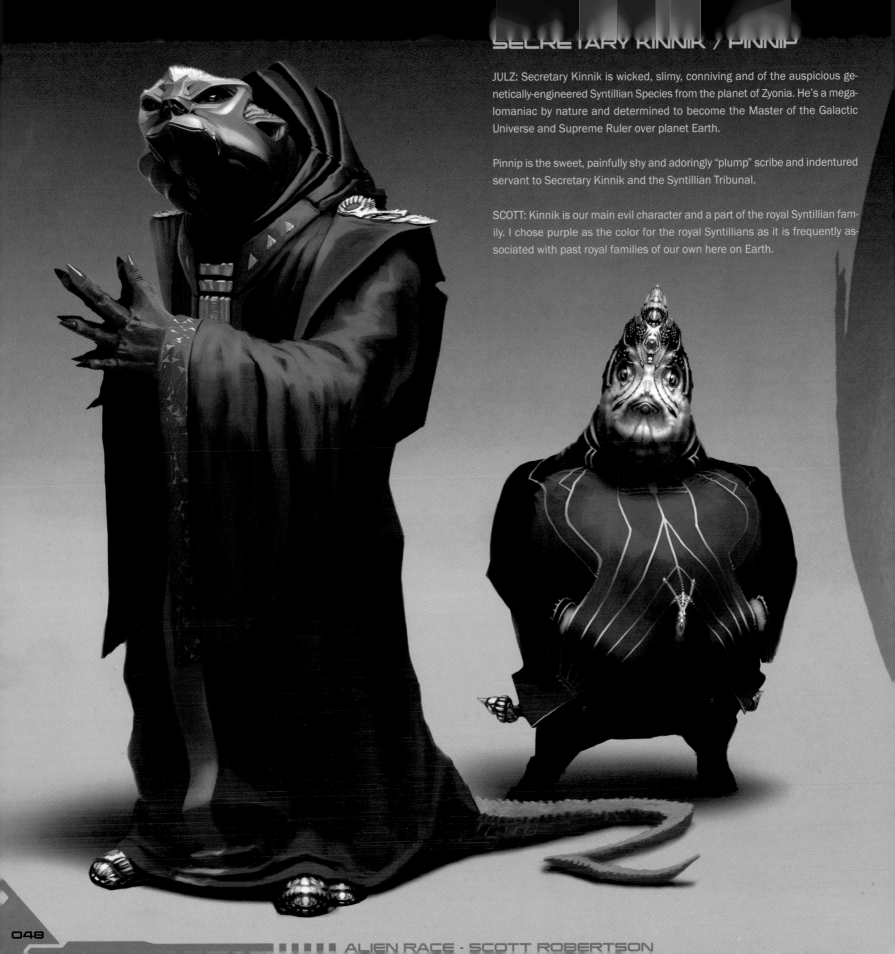

## SECRETARY KINNIK / PINNIP

JULZ: Secretary Kinnik is wicked, slimy, conniving and of the auspicious genetically-engineered Syntillian Species from the planet of Zyonia. He's a megalomaniac by nature and determined to become the Master of the Galactic Universe and Supreme Ruler over planet Earth.

Pinnip is the sweet, painfully shy and adoringly "plump" scribe and indentured servant to Secretary Kinnik and the Syntillian Tribunal.

SCOTT: Kinnik is our main evil character and a part of the royal Syntillian family. I chose purple as the color for the royal Syntillians as it is frequently associated with past royal families of our own here on Earth.

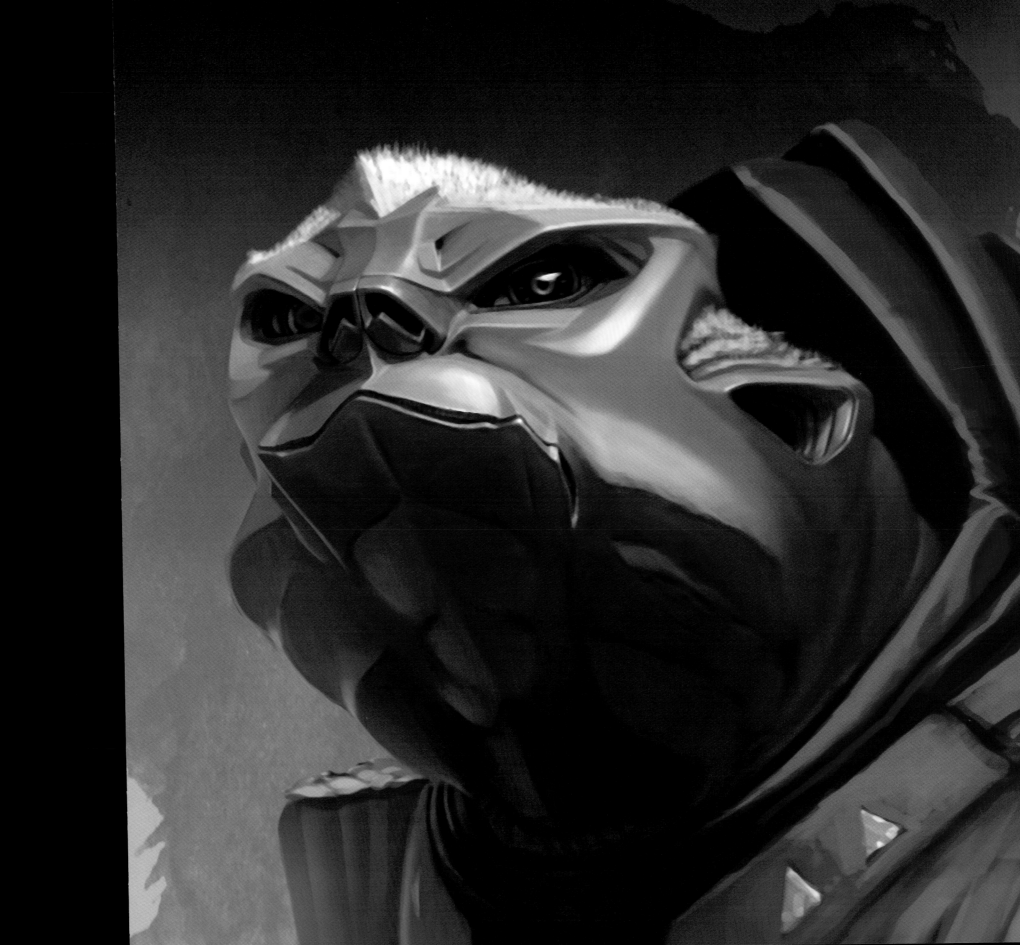

# PHOTO BOOTH CREATIONS

TECHNOLOGY, NATURE, ALIENS?

SCOTT: I was showing my new MacBook Air laptop to Neville Page and we began playing around with the program Photo Booth utilizing the "mirror" effect. At the time I had been aiming to create a large variety of alien designs for the upcoming release of this book. We both immediately saw the potential to quickly create new and unique alien designs. I spent the next several days trying to improve on the alien designs, and to learn how best to use the program to achieve "happy accidents." To the right you can see Ben Mauro and John Park applying this process to create their own alien designs. We called this session of Photo Booth the "meat puppet experiment." Also note the plastic wrap covering my keyboard!

The beauty of using Photo Booth with the mirror effect is that we, as humans, easily see faces in symmetrical objects. By experimenting with a large range of props in front of the camera it became fairly easy to create unique designs in real time. Once I had a design I liked I would hold the prop very still and snap a shot. After several days I had over a thousand snapshots of alien heads, armor, goggles, etc.

After capturing the images, I would open a file in Photoshop and quickly paint on only one-half of the head. After this I would duplicate the layer and apply a horizontal flip. That concluded the design study. In order for the quick rendering of just one-half of the head to work well, stage your lighting dead center so it will be correct when you mirror the layer. We used these renderings to evaluate a design early on. If we liked it, we would draw the character from other views, design the expressions and render a more finished illustration.

A purely symmetrical rendering doesn't make for the most compelling portrait, but it is a great way to realize the design direction quickly, and to determine if that direction should be further developed or not. To see the entire range of aliens created for the book, swing by the Design Studio Press website (www.designstudiopress.com) or my own personal site (www.drawthrough.com) and sign up on the mailing list. You'll be notified when more Photo Booth source images like these will be offered for downloading, to paint over and create your own crazy aliens!

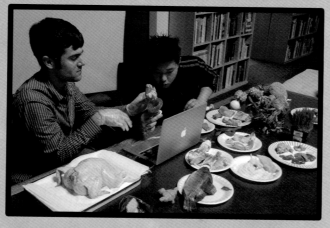

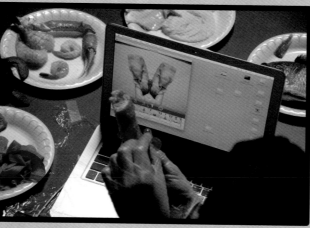

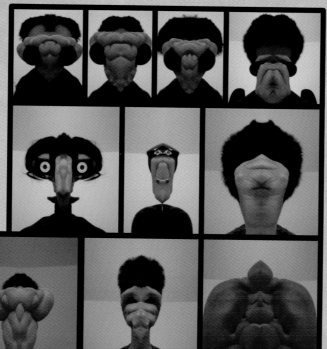

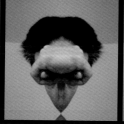

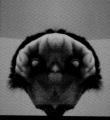

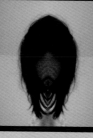

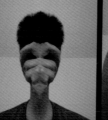

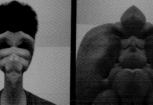

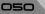

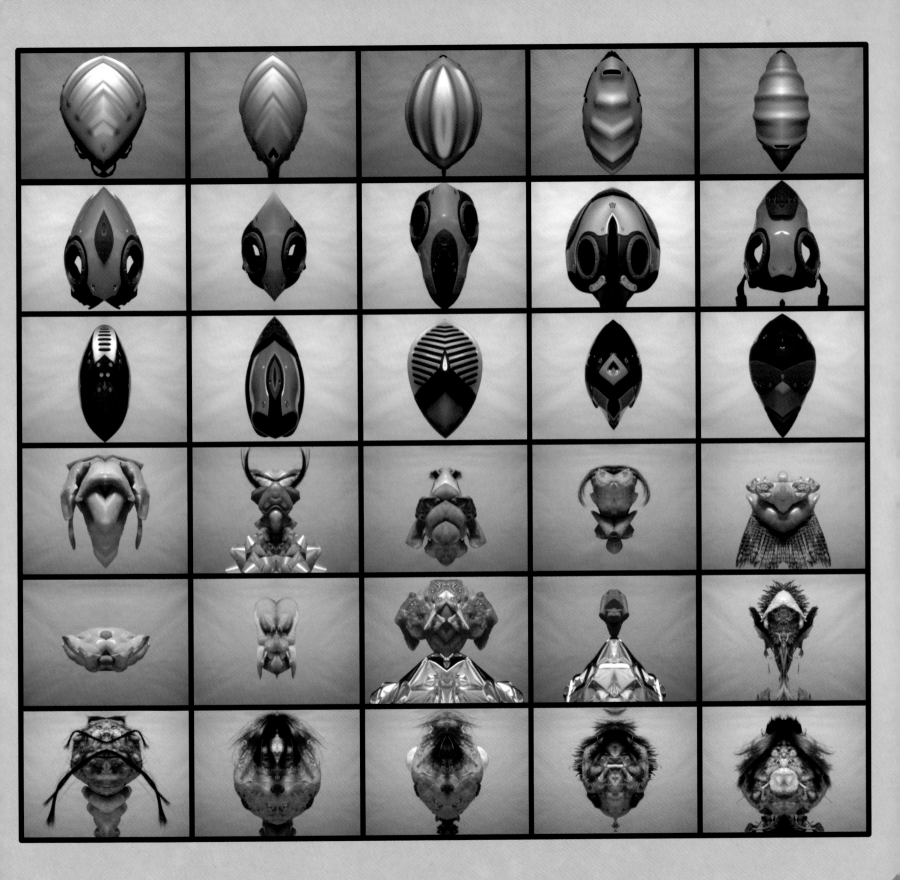

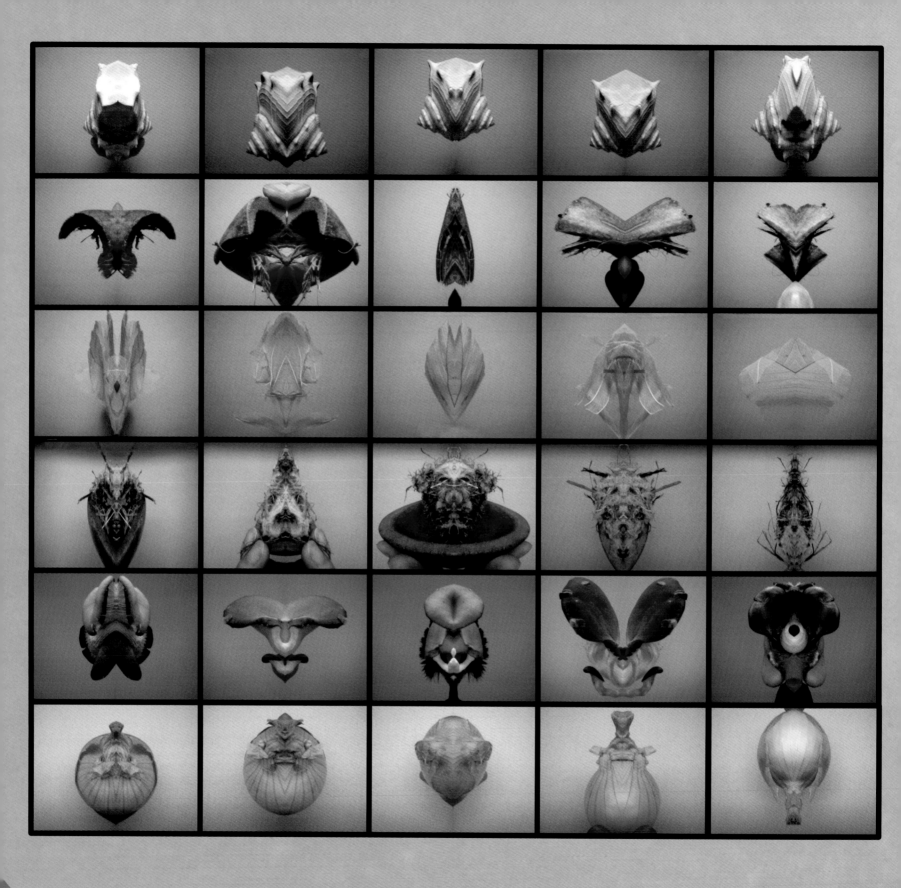

ALIEN RACE · SCOTT ROBERTSON

053

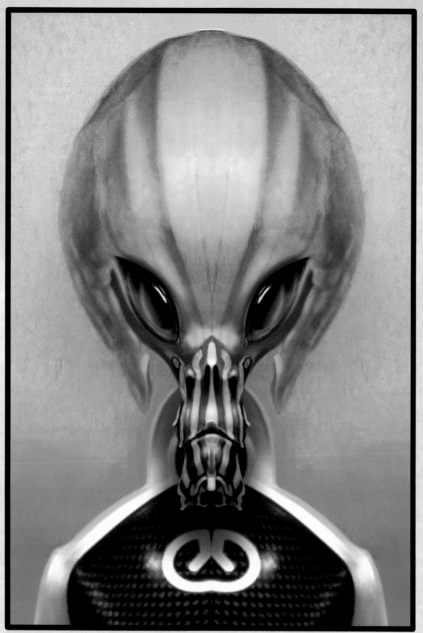

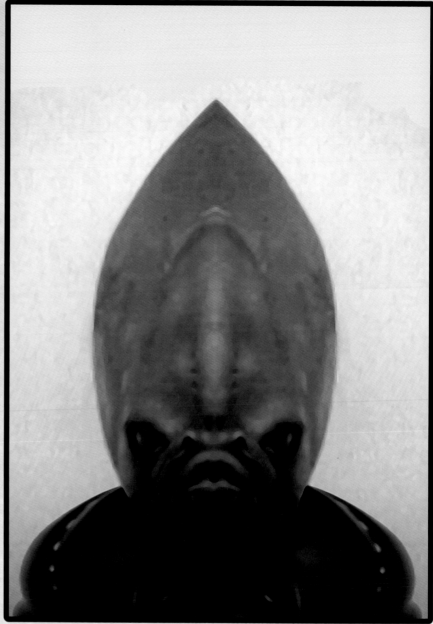

# ONION / BANANA / BARK

SCOTT: These are examples of my quick paintovers on top of the source images. I typically spent between 20 to 40 minutes on each study. What started as the onion photo to the right turned into what I imagine to be a super-athletic alien, above. His or her suit came from another source, I think it was from one of the many bike helmets I've designed over the years. The purple guy came from the great grumpy-faced capture of the end of a banana, the middle photo to the right. I found that a quick overall color tweak in Photoshop would help to create a more other-worldly feel to the source image.

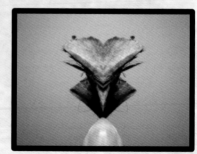

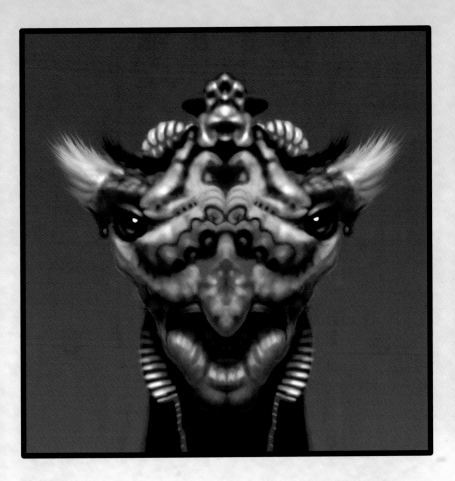
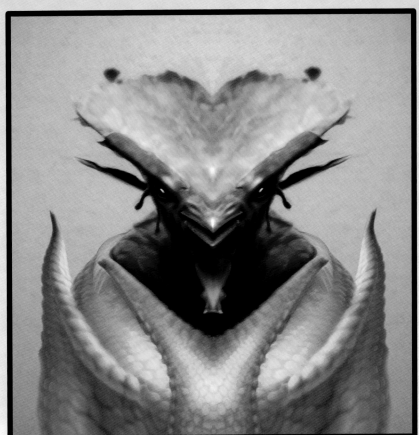
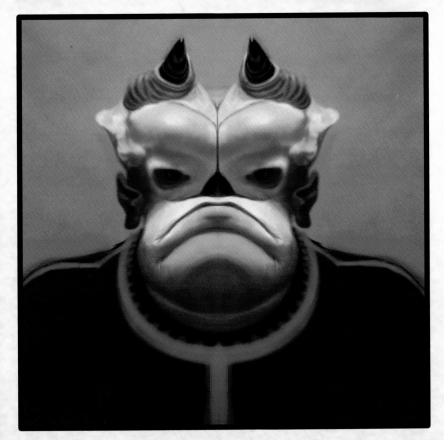
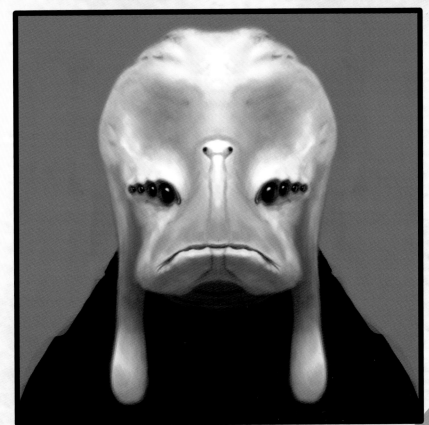

ALIEN RACE · SCOTT ROBERTSON ||||||

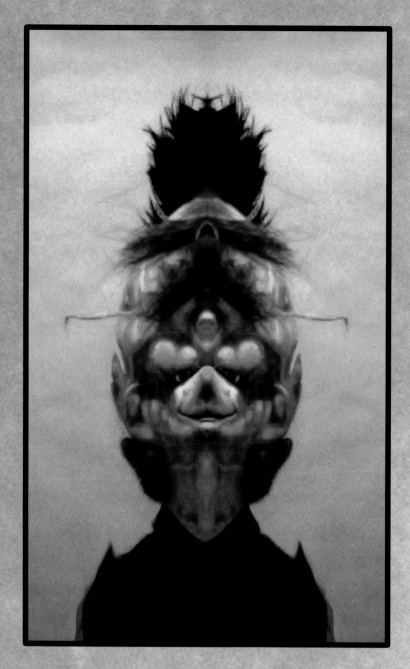

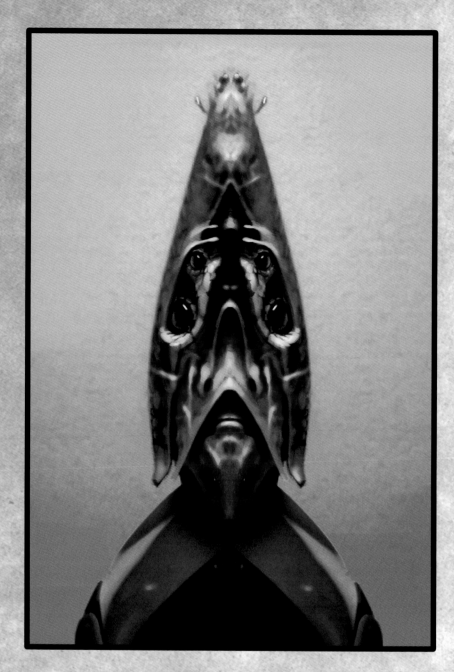

## ROOT / MUSHROOM / MEAT

SCOTT: Some of the source images that we captured needed very little in the way of a paintover to fully realize a design direction. The alien in the upper right-hand corner of the opposite page is an example of one of these images. This alien came from a frog sculpture that Neville had done...thanks to Nev for letting me include it here. It required very little painting on my part to find the direction. Generally I would recommend using very abstract sources for design directions, and I usually make it a point to stay away from objects created by others. Found objects from nature often provide the best, most unique and original directions.

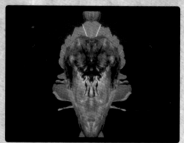

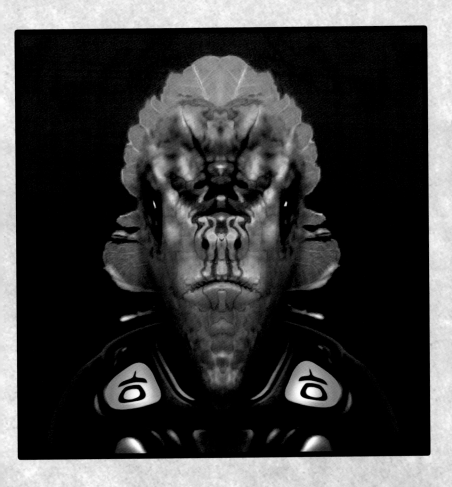
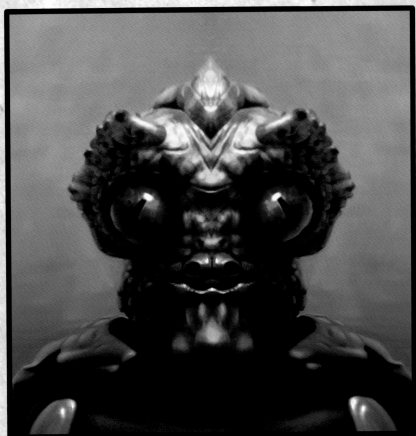
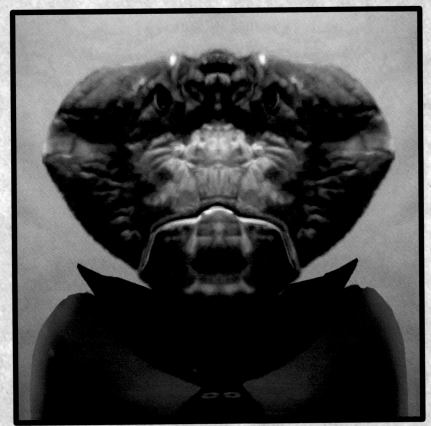
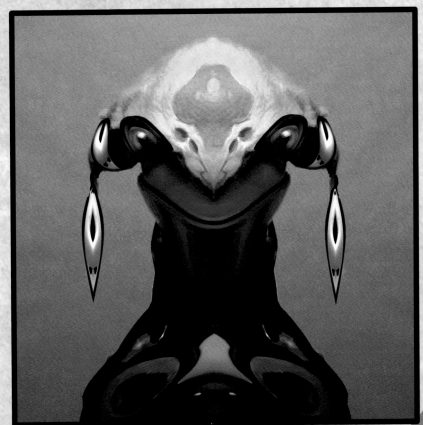

ALIEN RACE · SCOTT ROBERTSON ▮▮▮▮▮

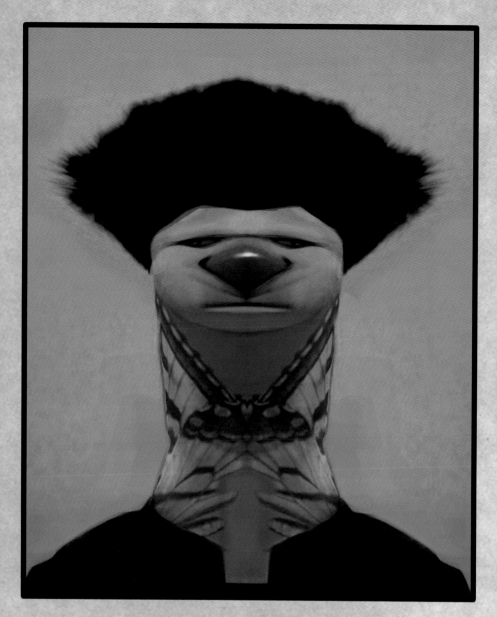

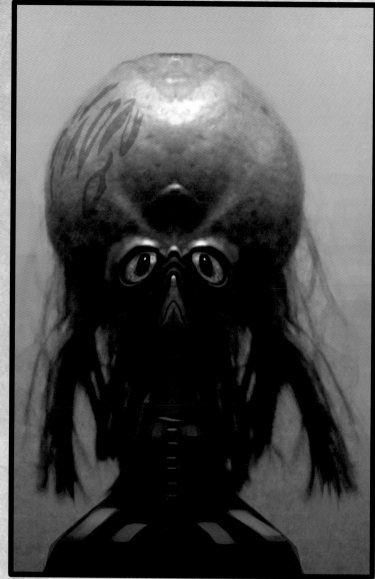

## HUSBAND / WIFE

SCOTT: To the right are photos of my wife and me. Not the type of headshots you would send to Grandma! My beauty shot is of my head tilted almost 90 degrees with my hand in front of my face holding a rubber wine stopper with a small rock in the end for the eyes. Melissa's alien double was a combination of my hand holding an iPod and her head tilted 90 degrees behind that. I did a quick paintover and color tweak and there you have it...instant husband and wife aliens! My head was also the source for the alien directly above; the hair should be the clue.

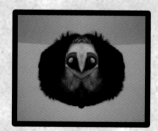

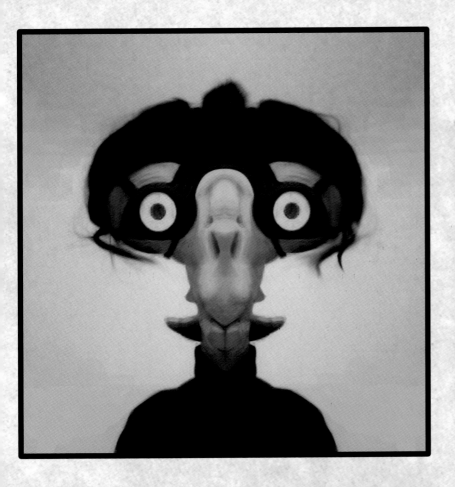
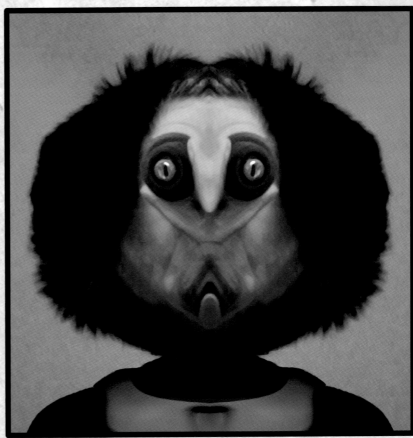
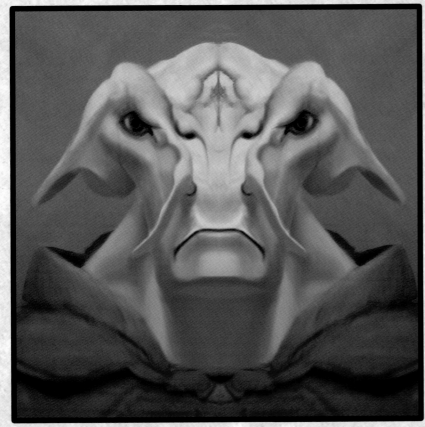
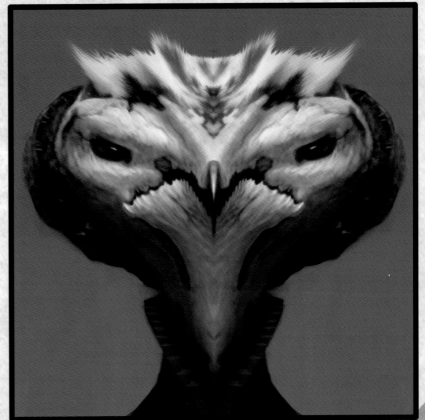

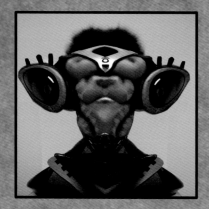
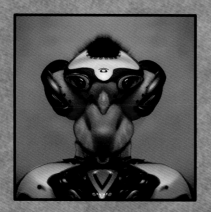
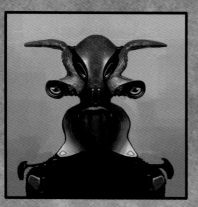
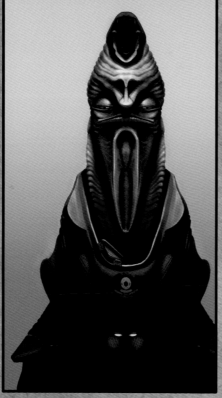
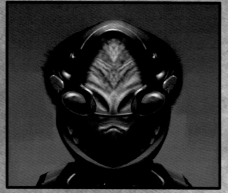
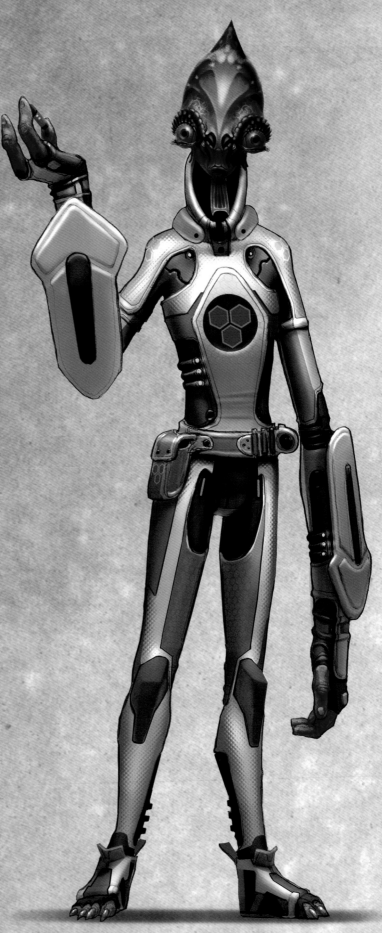

## MEAT / POTATO / SHELL

SCOTT: Ben and John painted the aliens above from a variety of sources; I recognize my foot in the two above left. The head on the full-length alien came from a paintover of a red potato I did, and Ben finished off the suit and body. Ben did a wonderful design study and illustration of the alien on the opposite page starting from a seashell source image. As these pages show, we not only used the Photo Booth technique to find the heads of our characters but also for the start of their costumes.

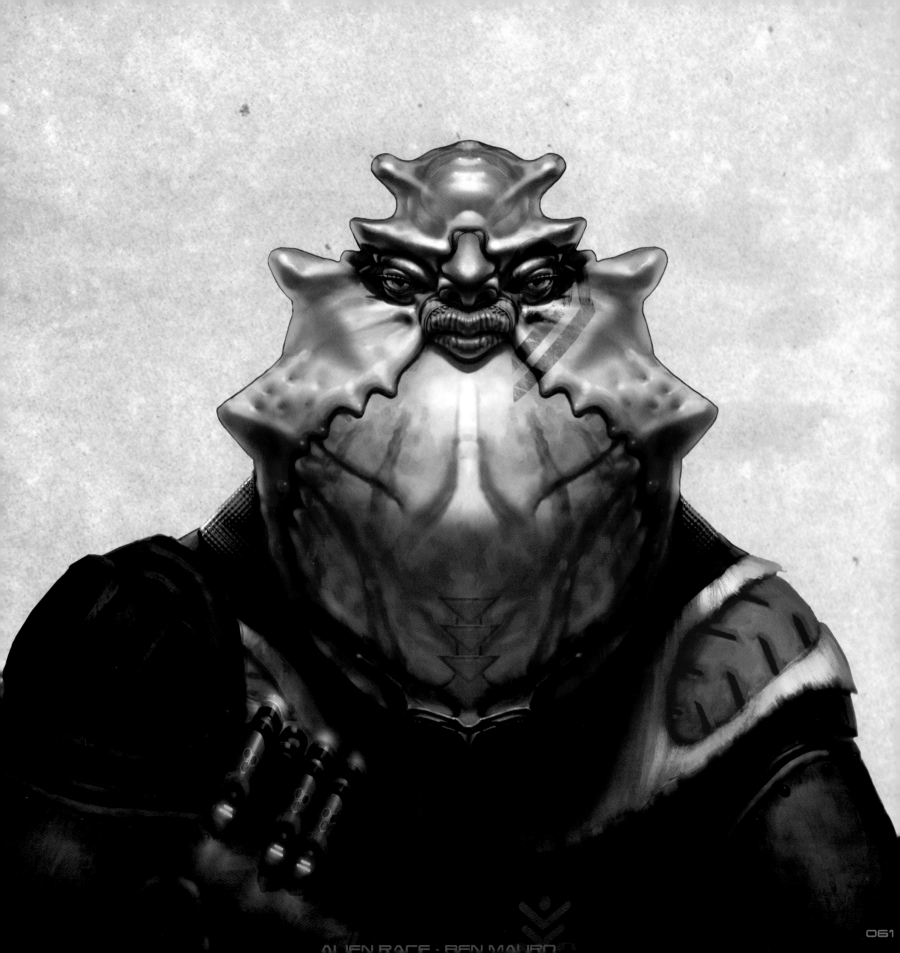

ALIEN RACE - BEN MAURO

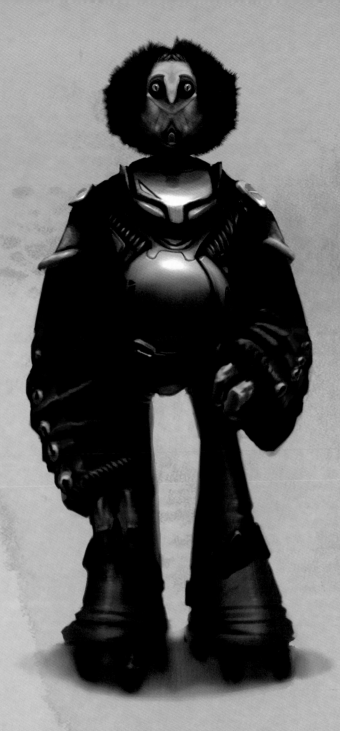

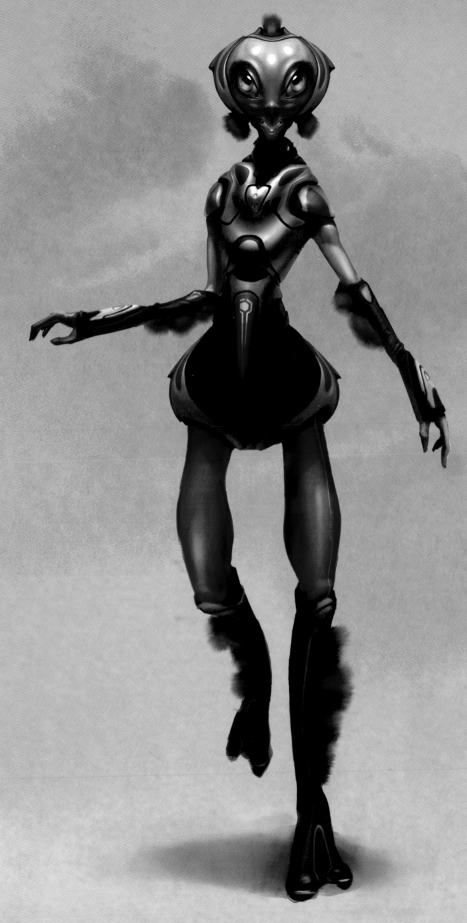

## ALIEN BODY STUDIES

SCOTT: John and I went for the full team effort on these aliens. I had done the heads already and later asked John to figure out what their bodies would look like. Several of these body designs started life as earlier sketches by Peter. I have to admit that my favorite is the green guy above, as it reminds me of myself as an alien posing as an Elvis impersonator! Well done, John.

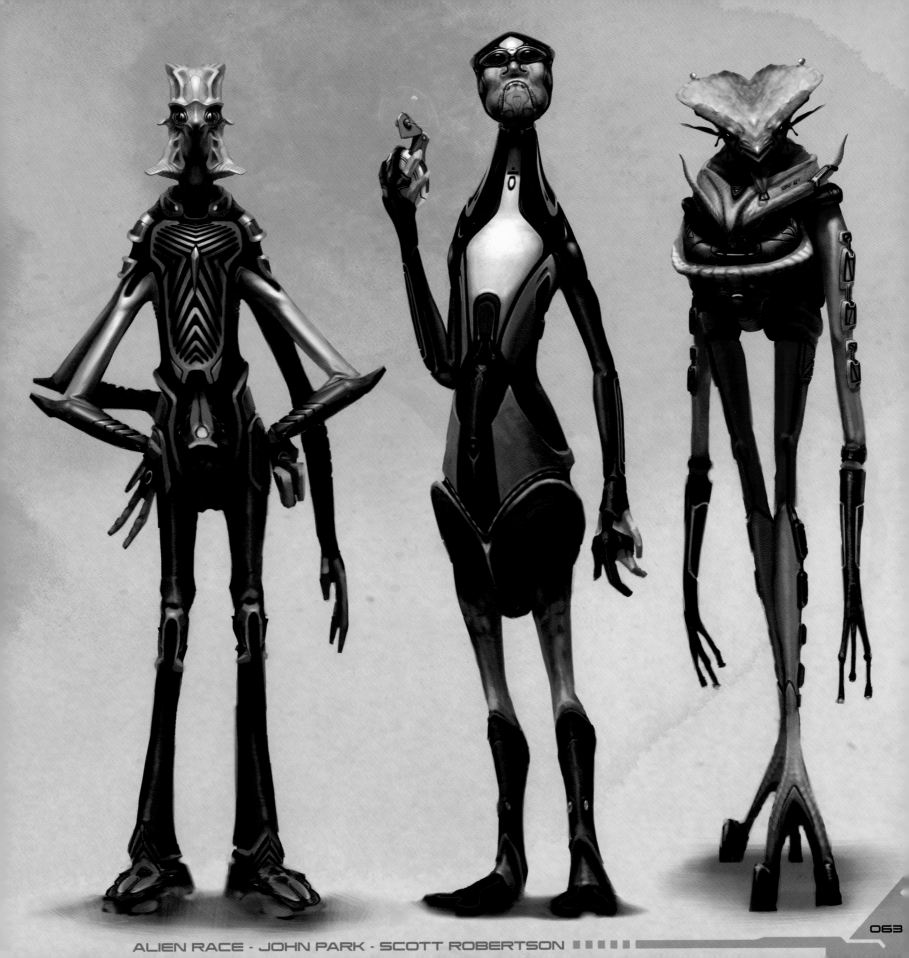

ALIEN RACE · JOHN PARK · SCOTT ROBERTSON ▐ ▌ ▌ ▌ ▌

## REX from HEX

SCOTT: This character started life as the Photo Booth image to the left. It is a seashell I found buried in a basket of shells at my mother's home in Colorado. After a bit of rendering and the addition of a neck, shoulders and a mouth (via more mirroring, this time of a shark ray jawbone), Rex was born. He is the most feared and ruthless rider in the universe, despite his baby blue eyes.

## FANDOOT

SCOTT: I always laugh at this one due to the fact that the source photo was of my wife's hand and foot. Adding a pair of goggles and a helmet that appears to be a bit too small, we now have a blockheaded alien not to be taken lightly, as she appears to have attitude to spare!

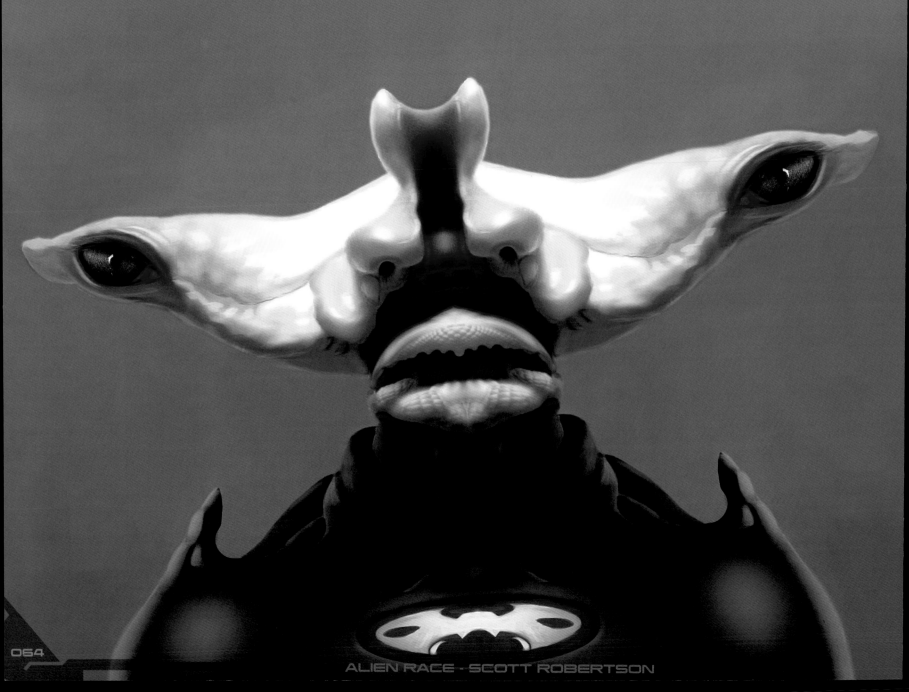

ALIEN RACE - SCOTT ROBERTSON

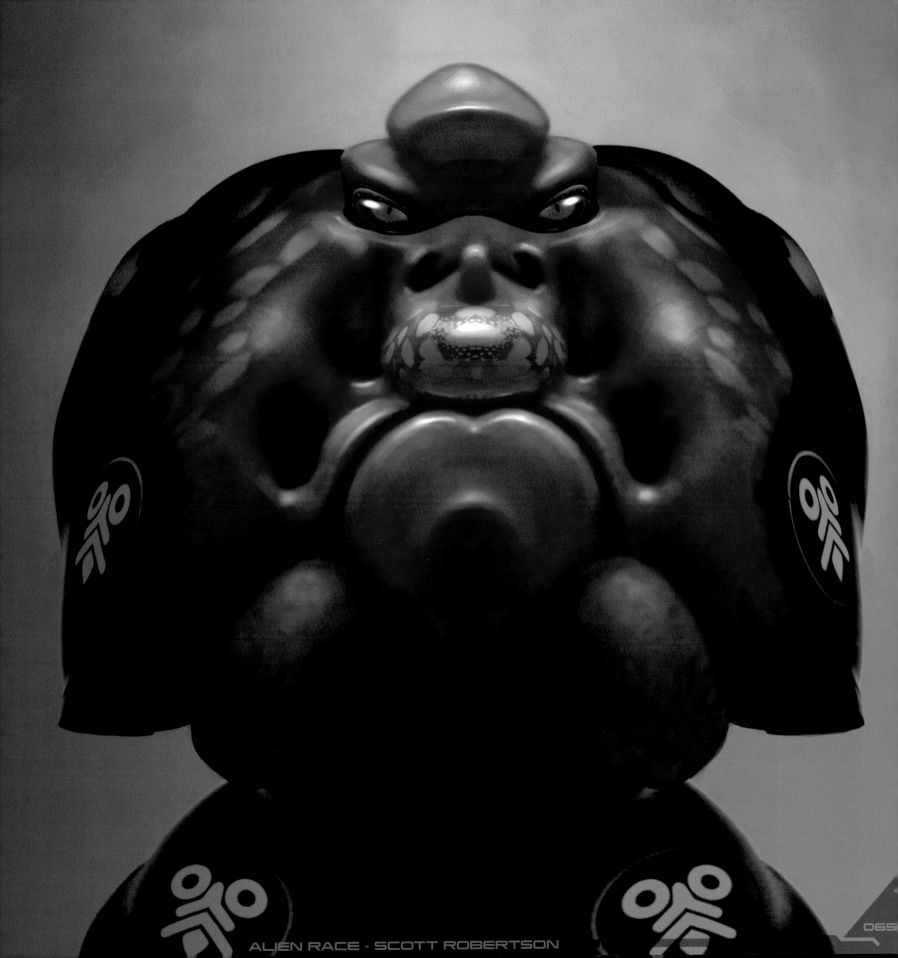

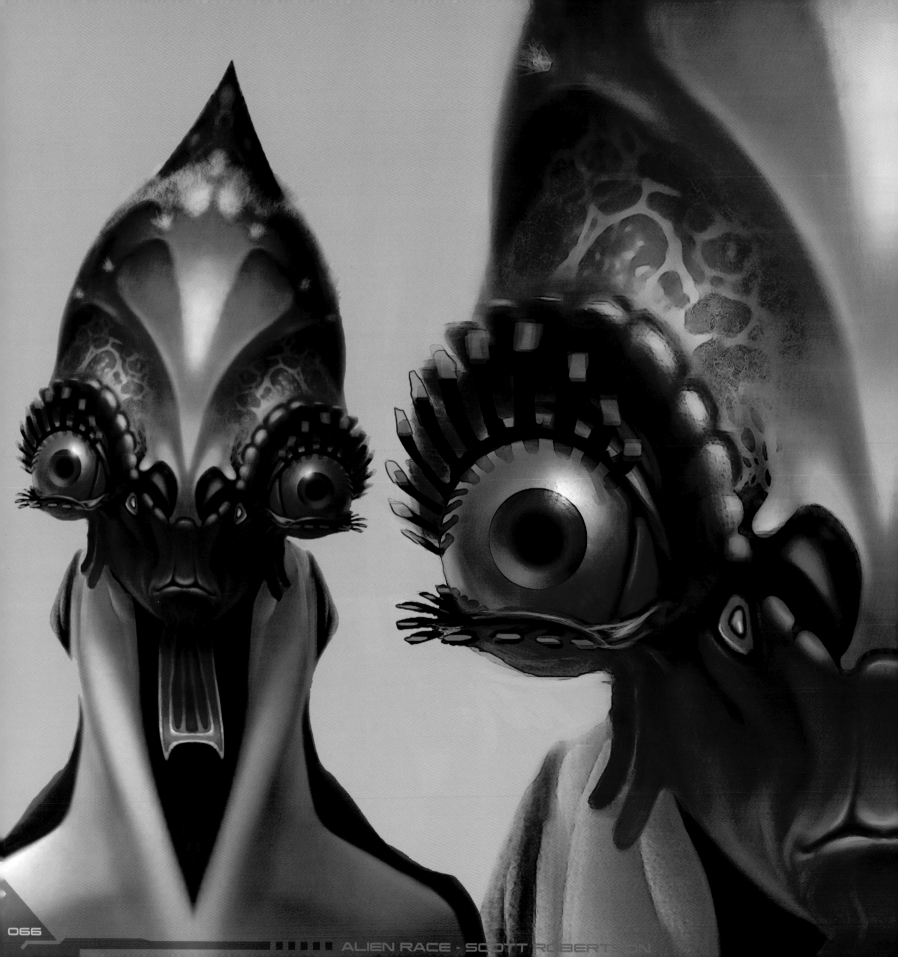

SCOTT: An old red potato provided all the inspiration I needed to find this stylish rider. By adding a suit that came from a bike helmet I had designed, this old potato was transformed into another alien rider. After finding the design direction by painting one side and then duplicating and mirroring it to the other side, it is nice to take a bit of time to go one step further by tilting the head and giving the character a bit more life.

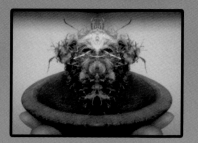

SCOTT: Every good story needs a wise elder. This is one possible direction for that type of character. The source photo in this case was a bird's nest in a wooden bowl. Again, thanks to my mom's shelf of oddities. I left the character study in a symmetrical pose to contrast against the other studies that are tilted and warped a bit. This provides a comparison to illustrate the benefits of manipulating the design direction to add more character.

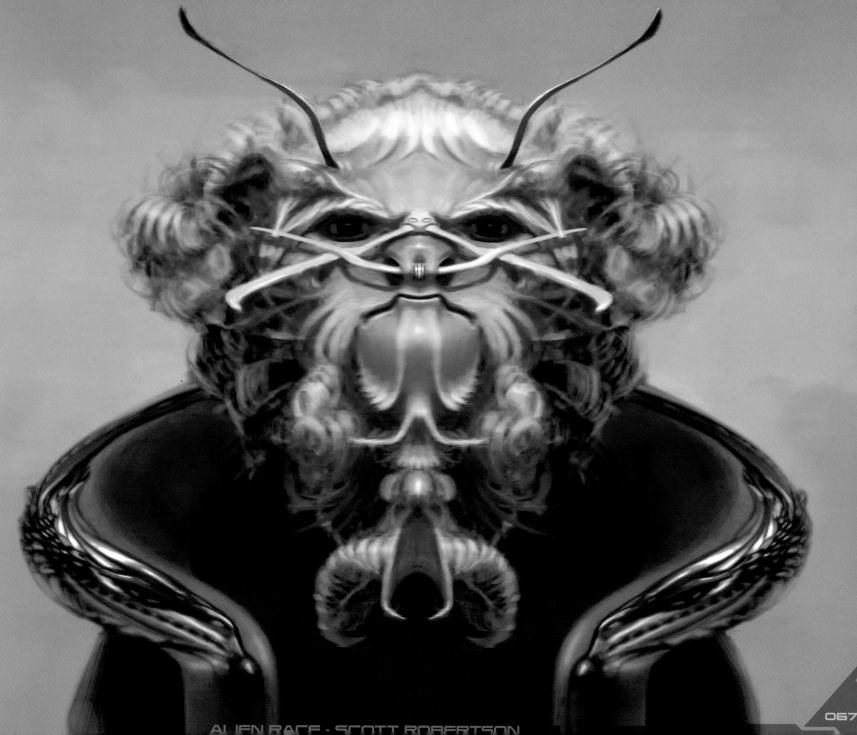

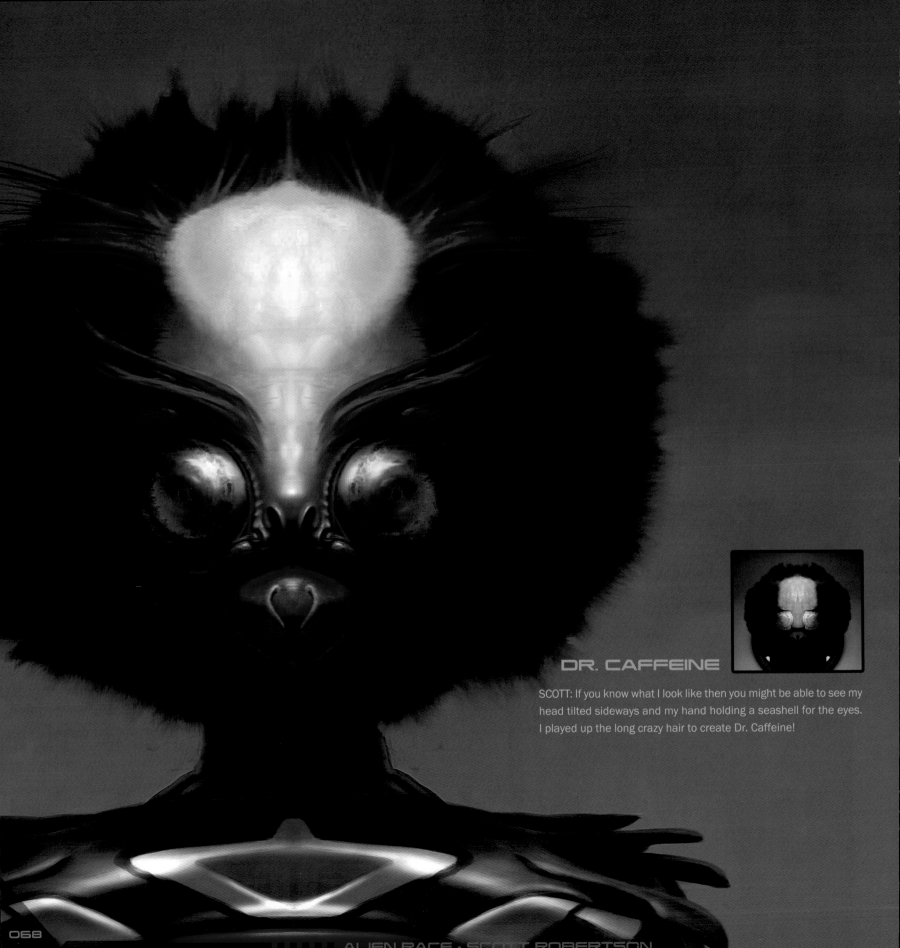

## DR. CAFFEINE

SCOTT: If you know what I look like then you might be able to see my head tilted sideways and my hand holding a seashell for the eyes. I played up the long crazy hair to create Dr. Caffeine!

ALIEN RACE : SCOTT ROBERTSON

# SHELLAZAR

SCOTT: This study remains one of my personal favorites. On the top of page 52 are the other shell source images I had to chose from. Once I had a direction for this race of aliens, I could more easily go to the other shell images and paint over them to round out a team of alien riders for the great race. The armor is from another Photo Booth series of source images seen at the top of page 51. The original source object was a snowboard helmet. I imagine this character to be a noble past champion, strong and fair in his racing techniques.

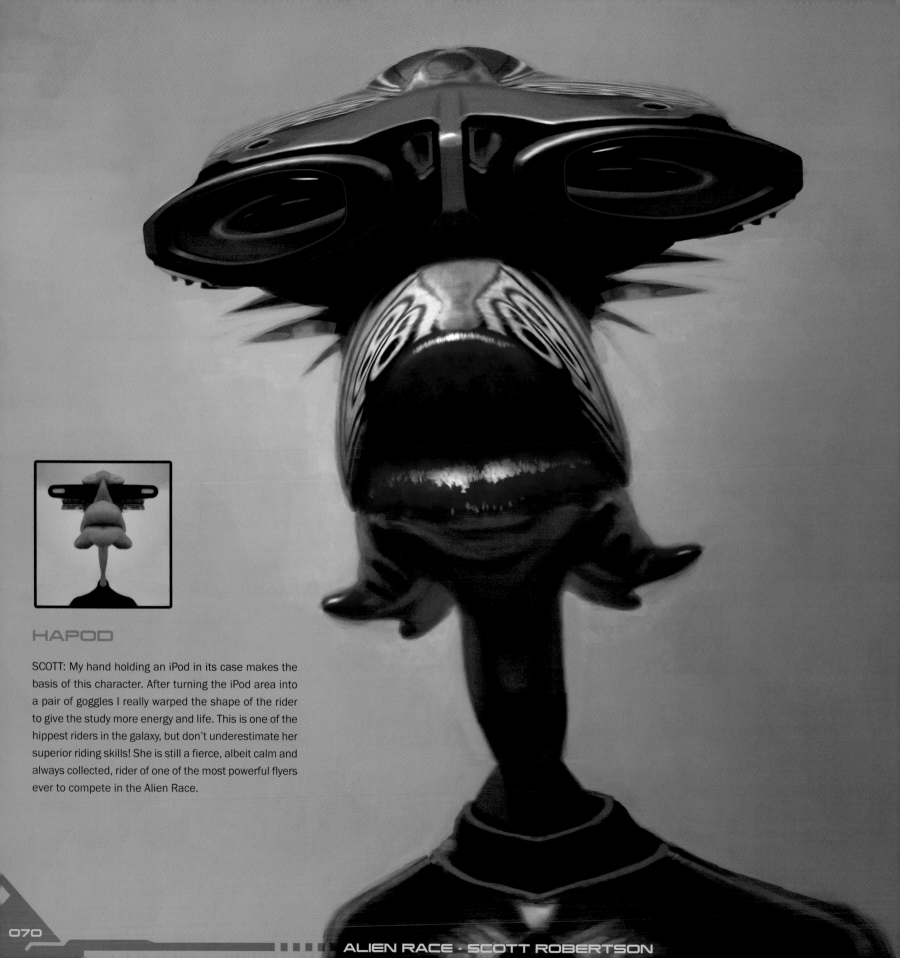

## HAPOD

SCOTT: My hand holding an iPod in its case makes the basis of this character. After turning the iPod area into a pair of goggles I really warped the shape of the rider to give the study more energy and life. This is one of the hippest riders in the galaxy, but don't underestimate her superior riding skills! She is still a fierce, albeit calm and always collected, rider of one of the most powerful flyers ever to compete in the Alien Race.

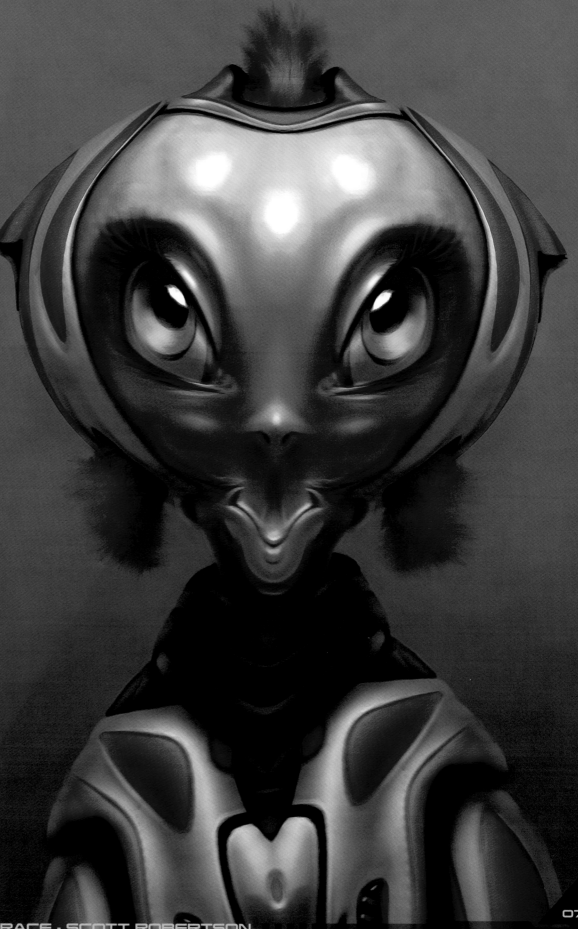

## LIL' SPRITEX

SCOTT: One of the cutest riders around, Spritex can finish with the best of them. The source photo above looks a bit spooky though; it was a human anatomical maquette of Neville's. I did quite a bit of painting over this one, but you can still easily see the inspiration of the basic form: big head, small neck. By going "pink" I was trying to get away from the creepy look of the source image.

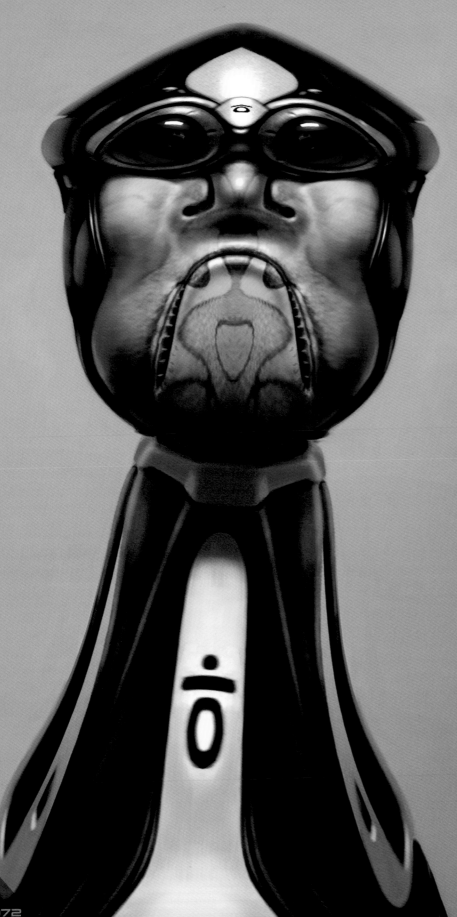

## GREEN BEAN

SCOTT: Nickname provided by Zeno. Ace flyer and very ill-tempered, Green Bean is one of the nastiest competitors around. He's even known to give the Hexlings pause before challenging him. In his aero-suit he can dive faster than the others and uses this ability for an unfair advantage whenever he can. The source above was my hand holding something; I do not even remember what it was. I do know that my ring is what became his collar, and I was drawn to this guy by the fun helmet and goggles I saw in the source. Making him green was a simple way to shift the source image color to something less human-looking.

## ONIONESTA

SCOTT: Yes, you guessed it, this rider started as an onion. By adding a mirrored piece of bark the suit was created. I spent a bit more time rendering this one, adding asymmetry to the face and pose. You can see a lot of the original face in the onion photo. When you get really lucky with a cool photo, the job of refining the character becomes much easier; but at the same time the pressure goes way up with the fear of messing up the source image and losing its original appeal. I have a feeling the perfume from this alien might not be so pleasant.

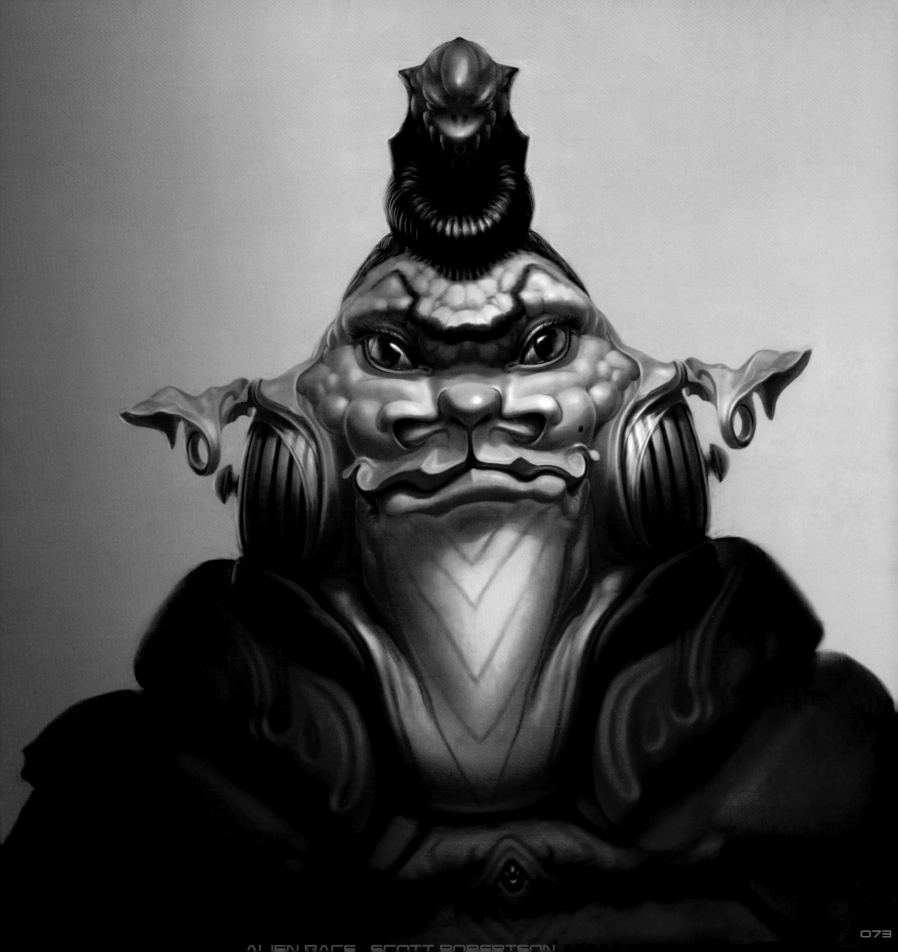

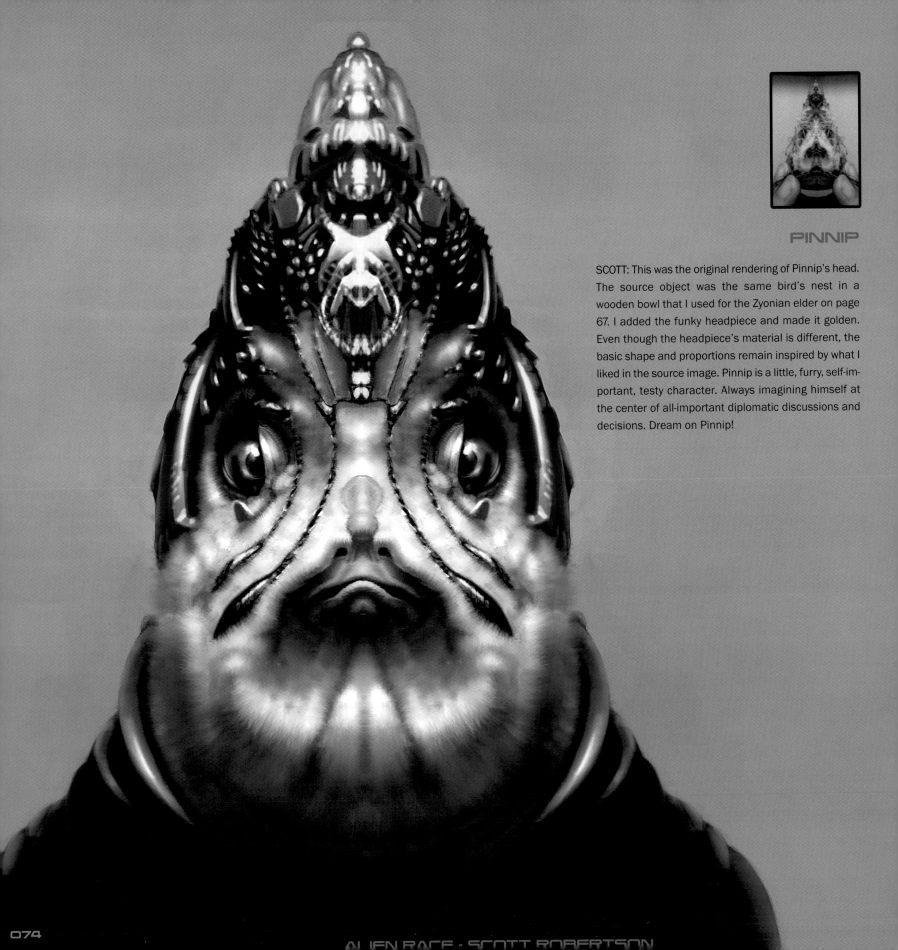

PINNIP

SCOTT: This was the original rendering of Pinnip's head. The source object was the same bird's nest in a wooden bowl that I used for the Zyonian elder on page 67. I added the funky headpiece and made it golden. Even though the headpiece's material is different, the basic shape and proportions remain inspired by what I liked in the source image. Pinnip is a little, furry, self-important, testy character. Always imagining himself at the center of all-important diplomatic discussions and decisions. Dream on Pinnip!

# SHELLA

SCOTT: Another source image from a seashell. The eyes, nose and mouth were very clearly defined, to my eye, in the source photo. The little flippers protruding forward from the sides of the head could still use some refinement, but they also might contribute a humorous element to express his emotions if he were ever to be animated. Of course his overly large, bulging eyes would go a long way to communicate his temperament.

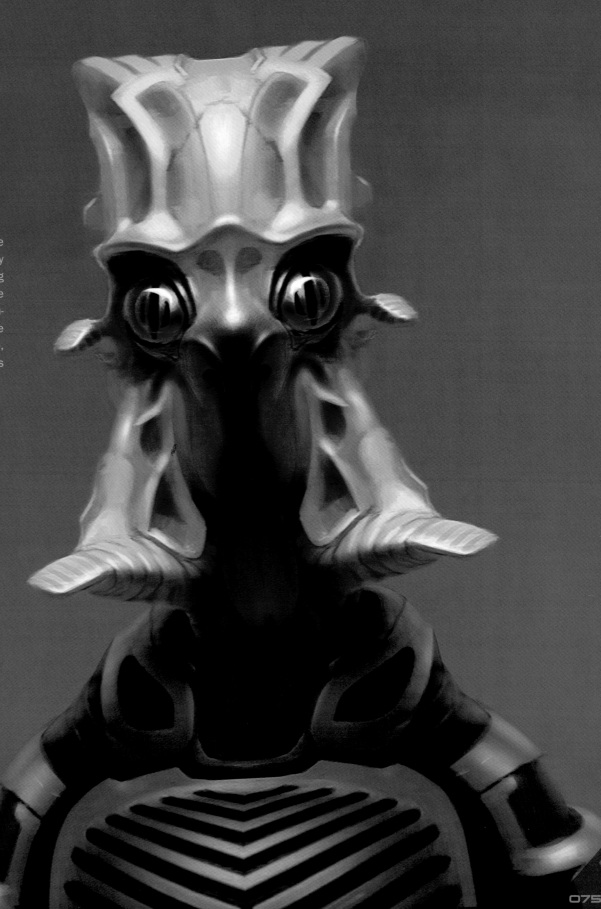

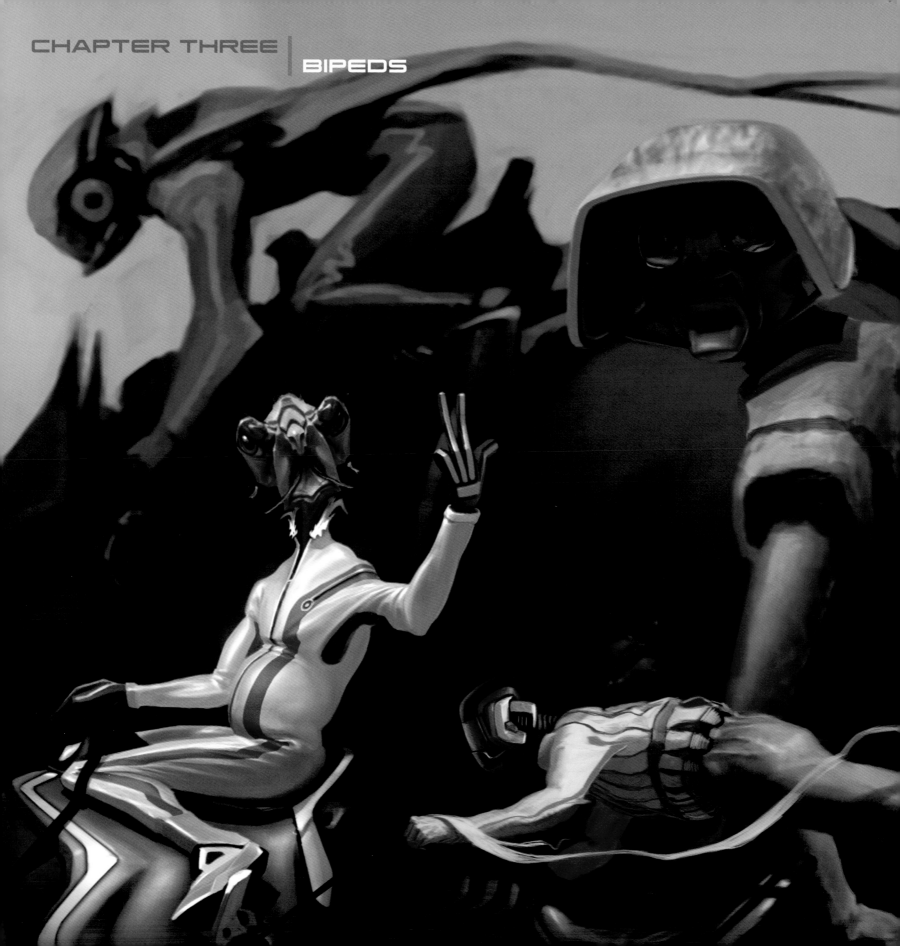

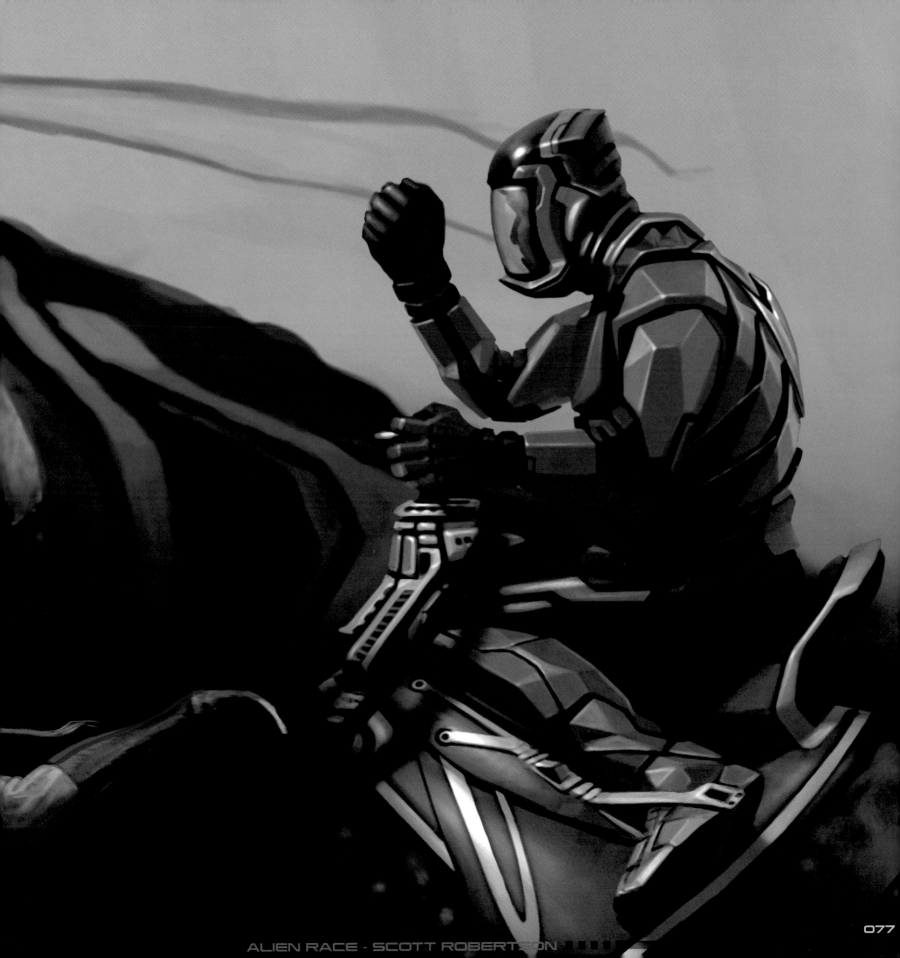

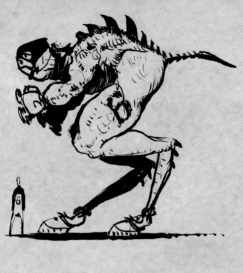

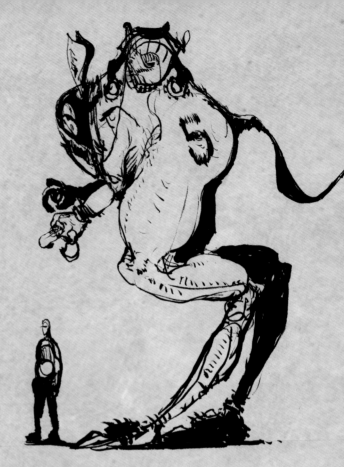
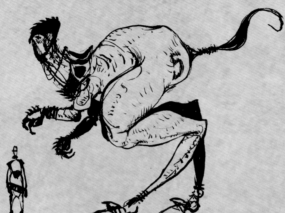

## FIRST BIPEDS

SCOTT: Having spent most of my career designing vehicles, I am not known for my creature and character designs. One of the underlying challenges I created for myself by doing this book was to force myself into designing things outside of my comfort zone. The sketches here represent some of the very first sketches I did for this project. Some are OK, others not so much! Regardless, if I'm not willing to test myself and pursue the design development of new subjects I fear I will stop growing as a designer and an educator.

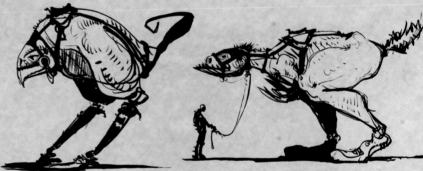
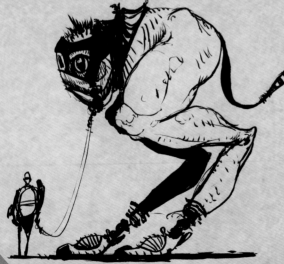
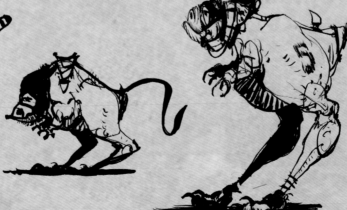
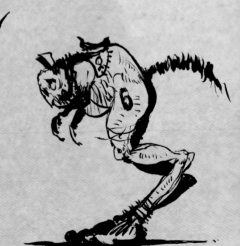

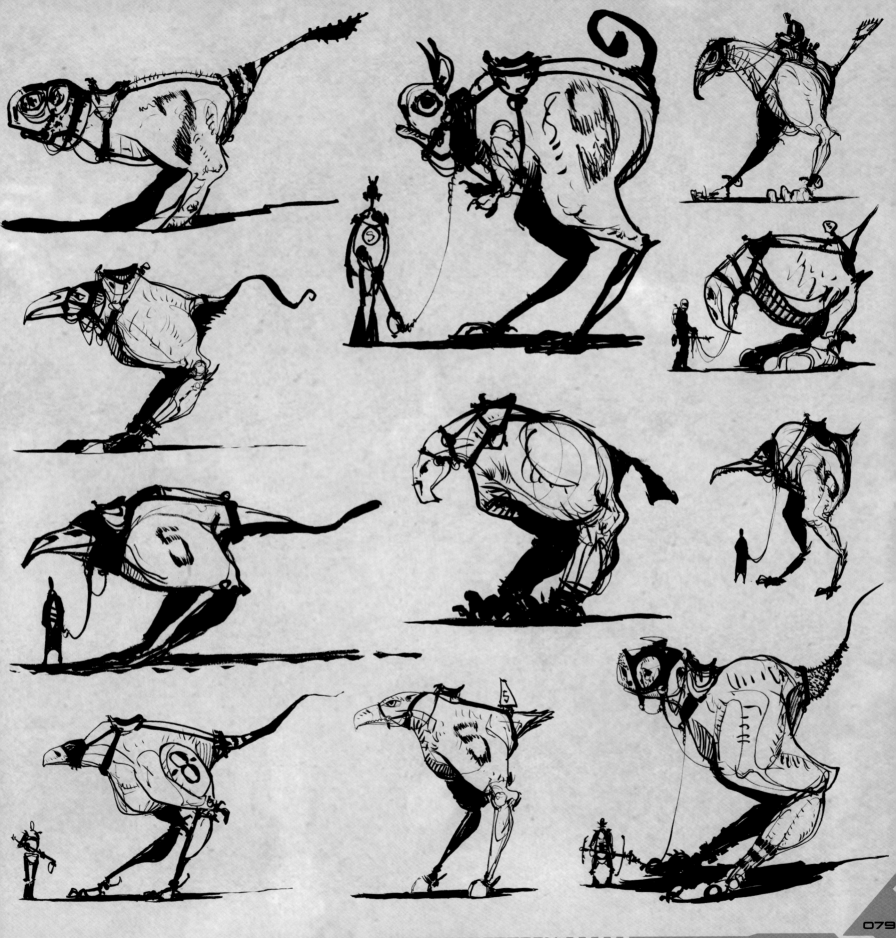

ALIEN RACE · SCOTT ROBERTSON ▮▮▮▮▮

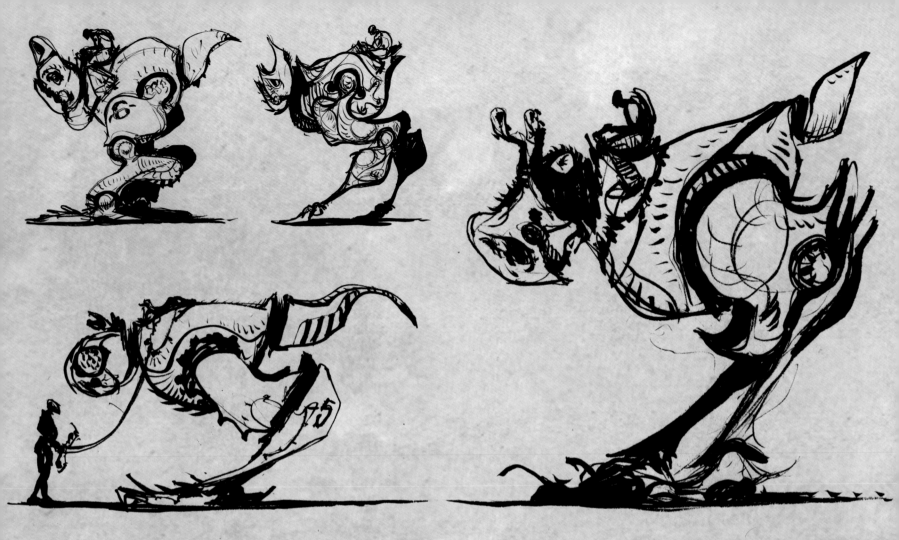

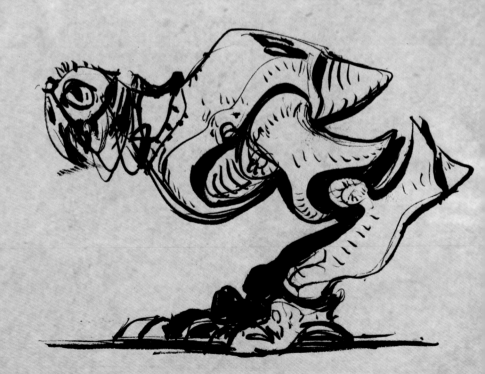

## INSECTOIDS

SCOTT: These were probably some of the easiest racing creatures for me to design as they were the most like vehicles, with hard shells, pivots, etc.... This was a good place to begin as I ventured into the realm of creatures. For our story we set up three skeletal types for the racing creatures: bipeds, quadrupeds and flyers. In the hope that *Alien Race* will eventually become a video game, this should make it easier to morph the same basic skeleton into a wide range of shapes without having to reinvent the animation rig over and over.

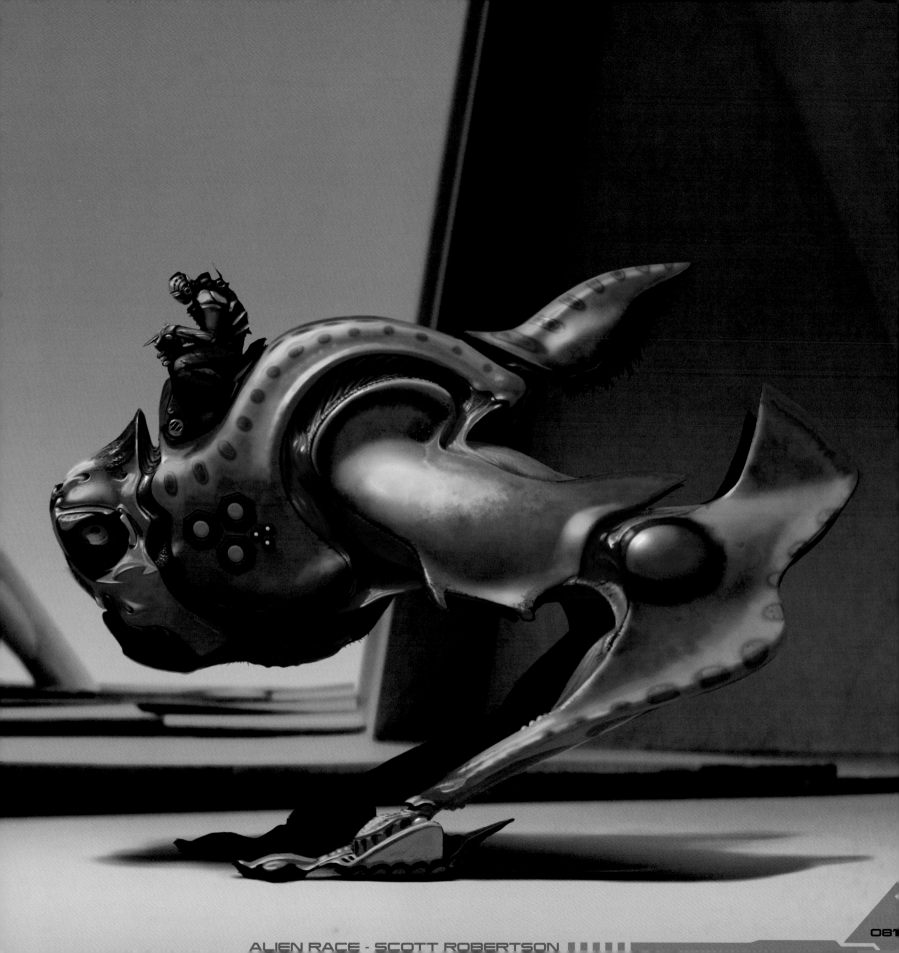

ALIEN RACE · SCOTT ROBERTSON

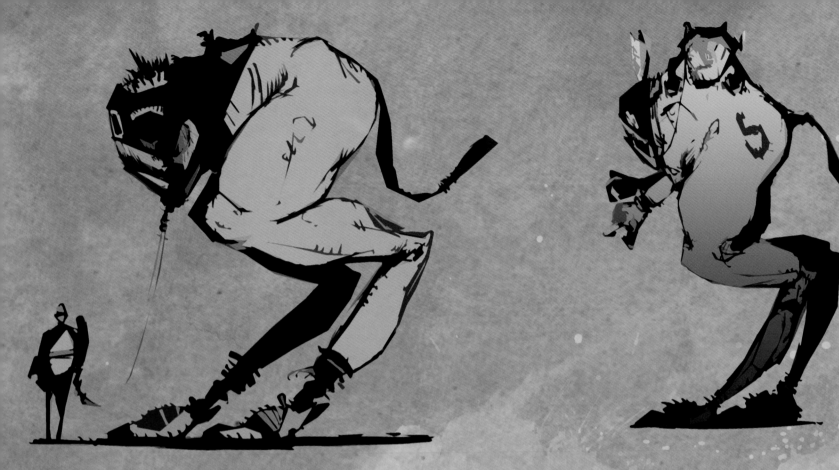

## STYLE TESTS

SCOTT: One of the most enjoyable parts of creating any imaginary world is in exploring the infinite illustrative styles that the artwork can take. The art here started with the brush-pen ink sketches from the previous pages. I then spent an afternoon messing about in Photoshop to achieve the range of styles shown here. I happened upon the artistic cutout filter and after some experimentation, I found that it worked best with my simple black and white sketches. The more graphic they were to start with, the better the abstracted results. After a pass with this filter, I had a stylized sketch with various levels of grey within it where none had existed before. The next step was to apply different colors to the range of values using the color-balance sliders. I tried adding a multiply gradient over a few like the one at the top-right of this page and that was it, from black and white brush-pen ink sketch to stylized, colorful, Photoshop happy accident! The final touch was to composite them onto the background. I selected them off of the backgrounds in their original files and layered them onto this spread. Notice how they have varying levels of opacity and some areas drop out all together to let the background color and texture of the page show through.

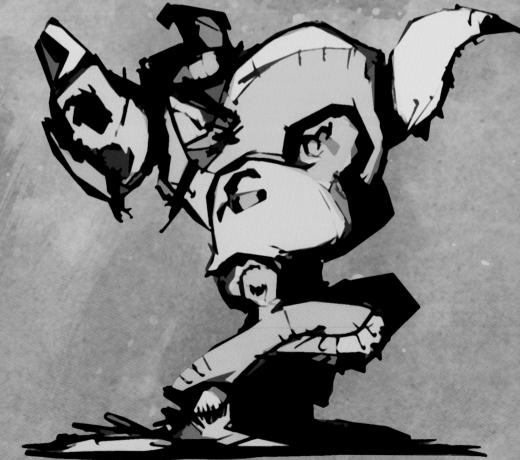

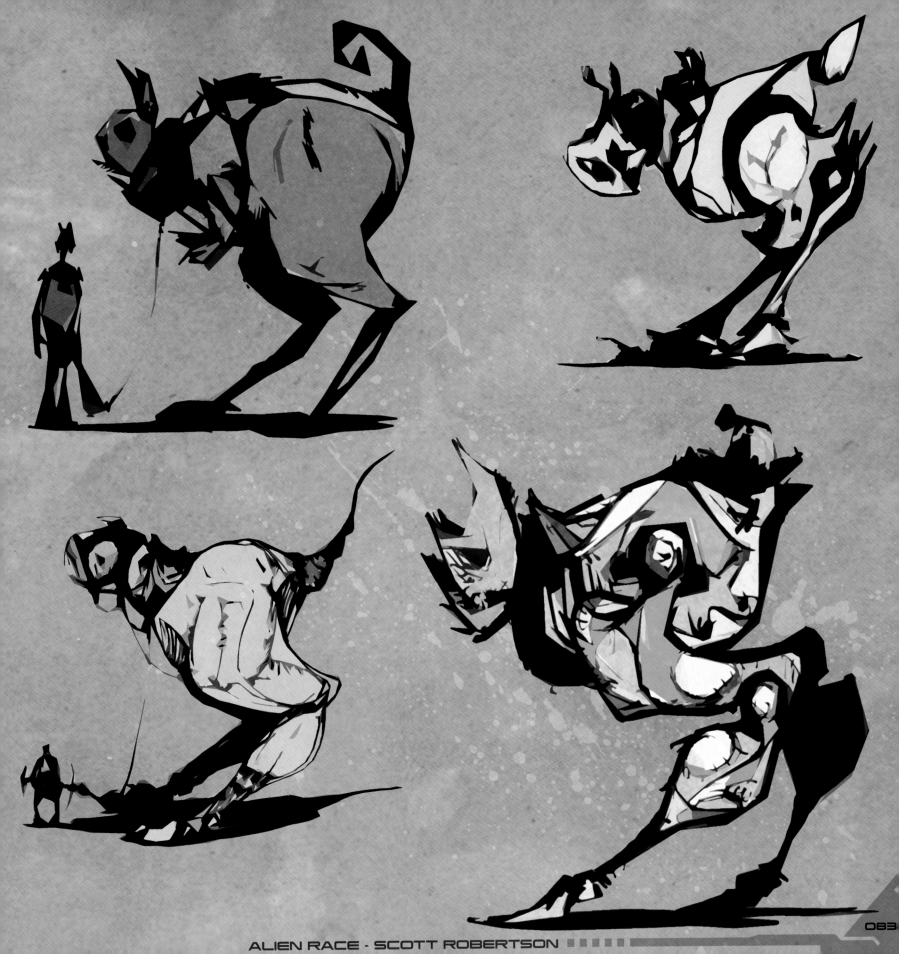

ALIEN RACE · SCOTT ROBERTSON

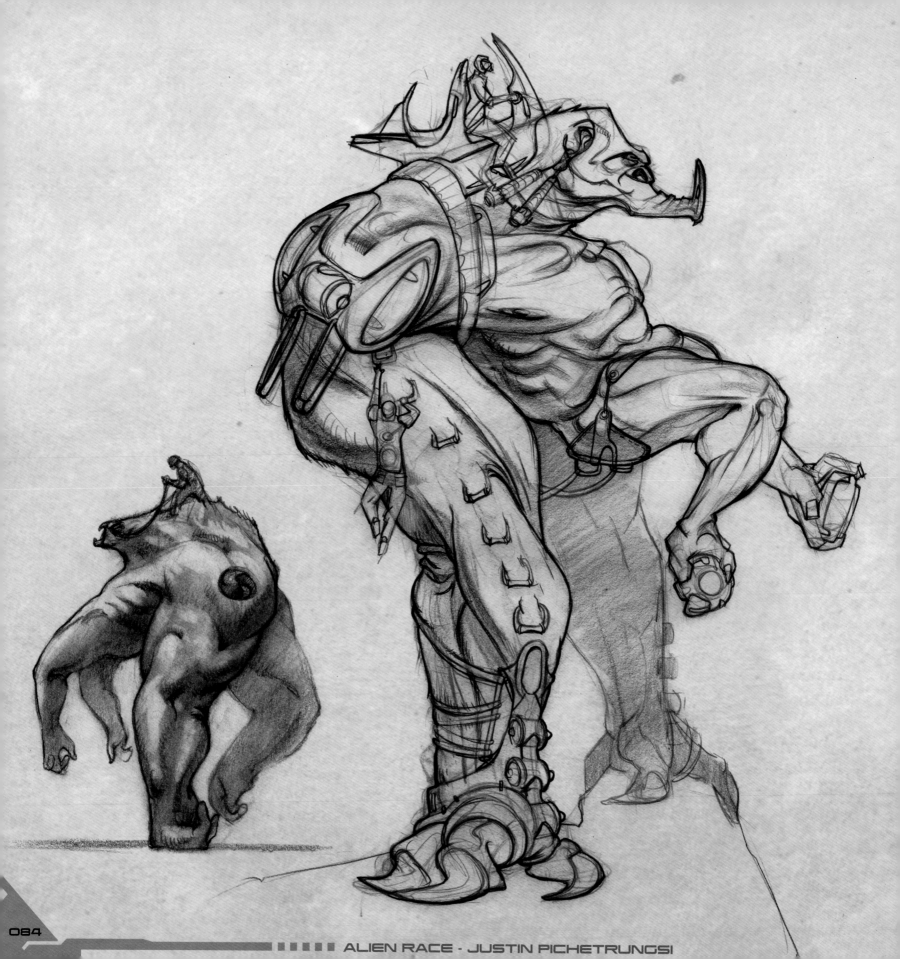

ALIEN RACE · JUSTIN PICHETRUNGSI

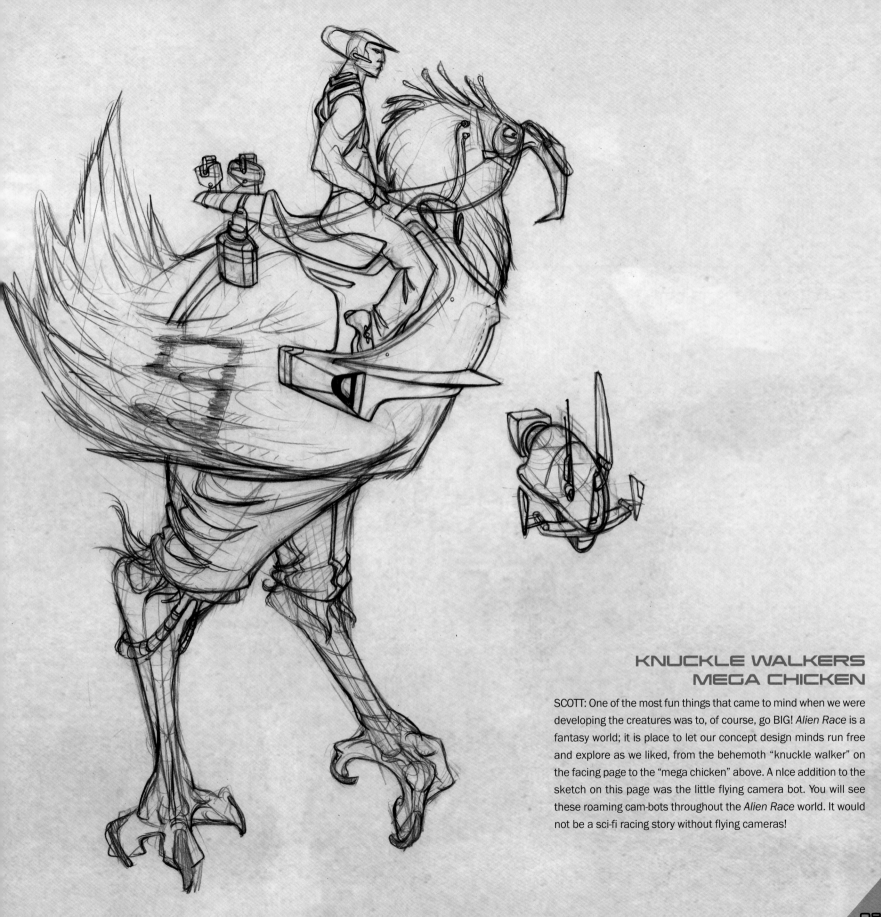

## KNUCKLE WALKERS
## MEGA CHICKEN

SCOTT: One of the most fun things that came to mind when we were developing the creatures was to, of course, go BIG! *Alien Race* is a fantasy world; it is place to let our concept design minds run free and explore as we liked, from the behemoth "knuckle walker" on the facing page to the "mega chicken" above. A nIce addition to the sketch on this page was the little flying camera bot. You will see these roaming cam-bots throughout the *Alien Race* world. It would not be a sci-fi racing story without flying cameras!

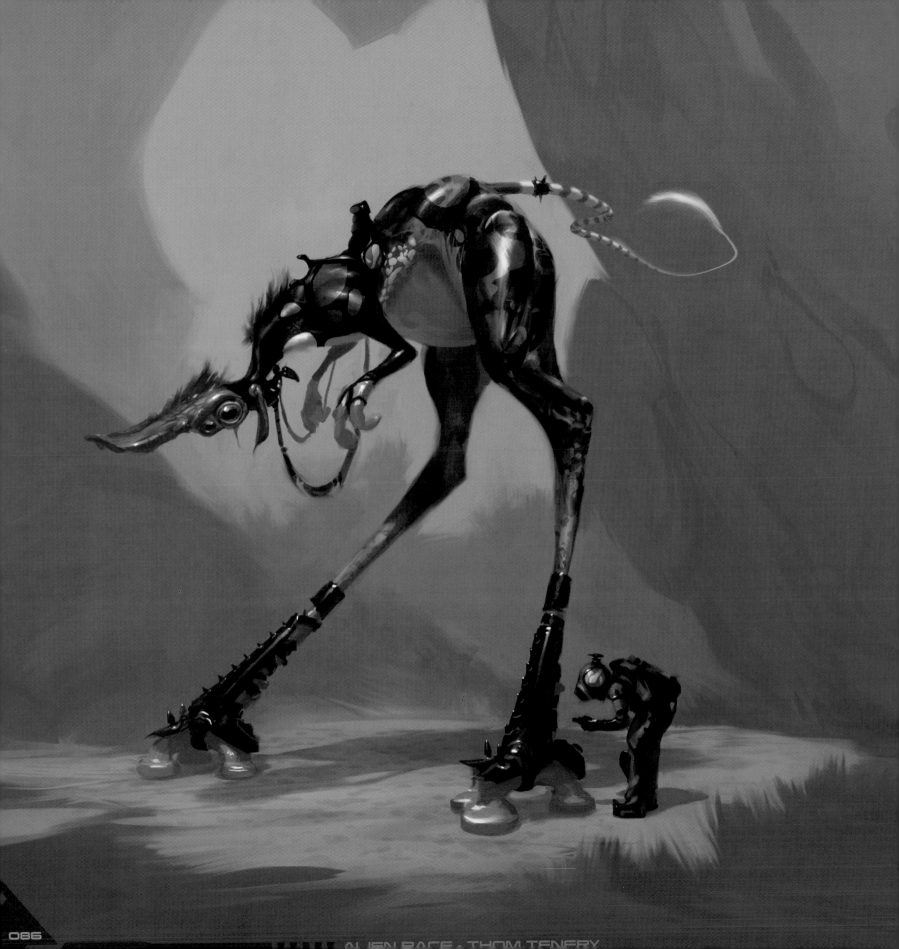

ALIEN RACE · THOM TENERY

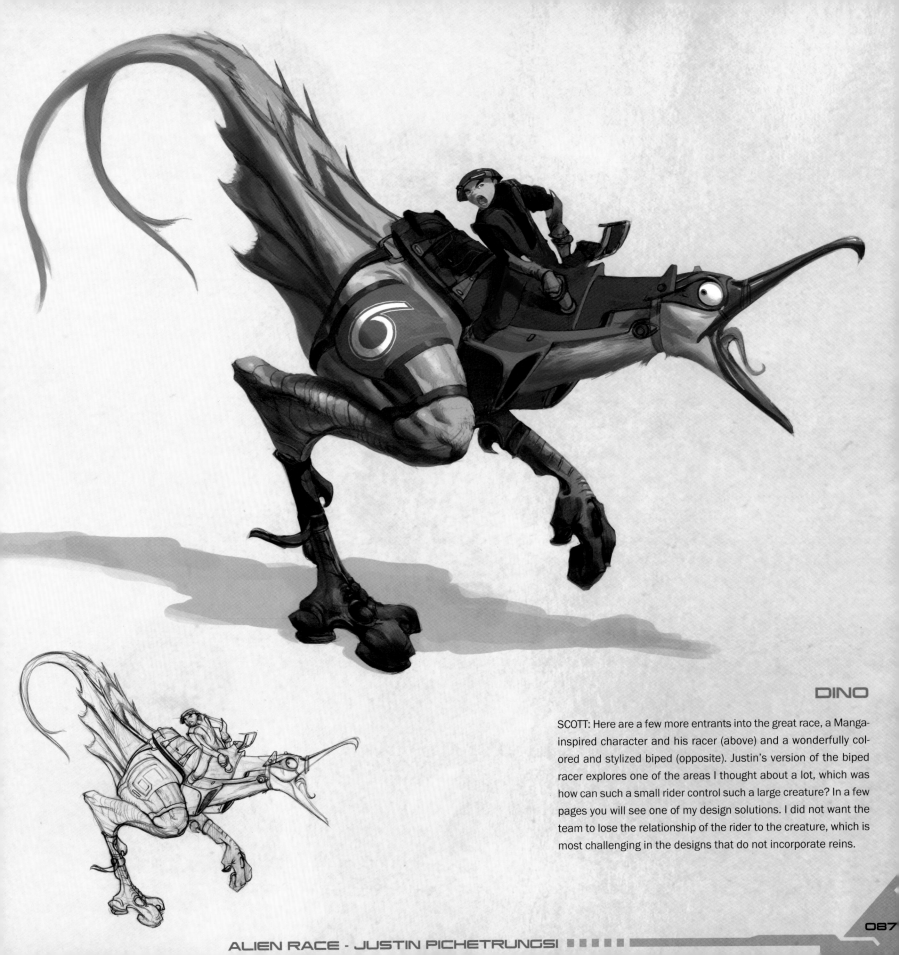

# DINO

SCOTT: Here are a few more entrants into the great race, a Manga-inspired character and his racer (above) and a wonderfully colored and stylized biped (opposite). Justin's version of the biped racer explores one of the areas I thought about a lot, which was how can such a small rider control such a large creature? In a few pages you will see one of my design solutions. I did not want the team to lose the relationship of the rider to the creature, which is most challenging in the designs that do not incorporate reins.

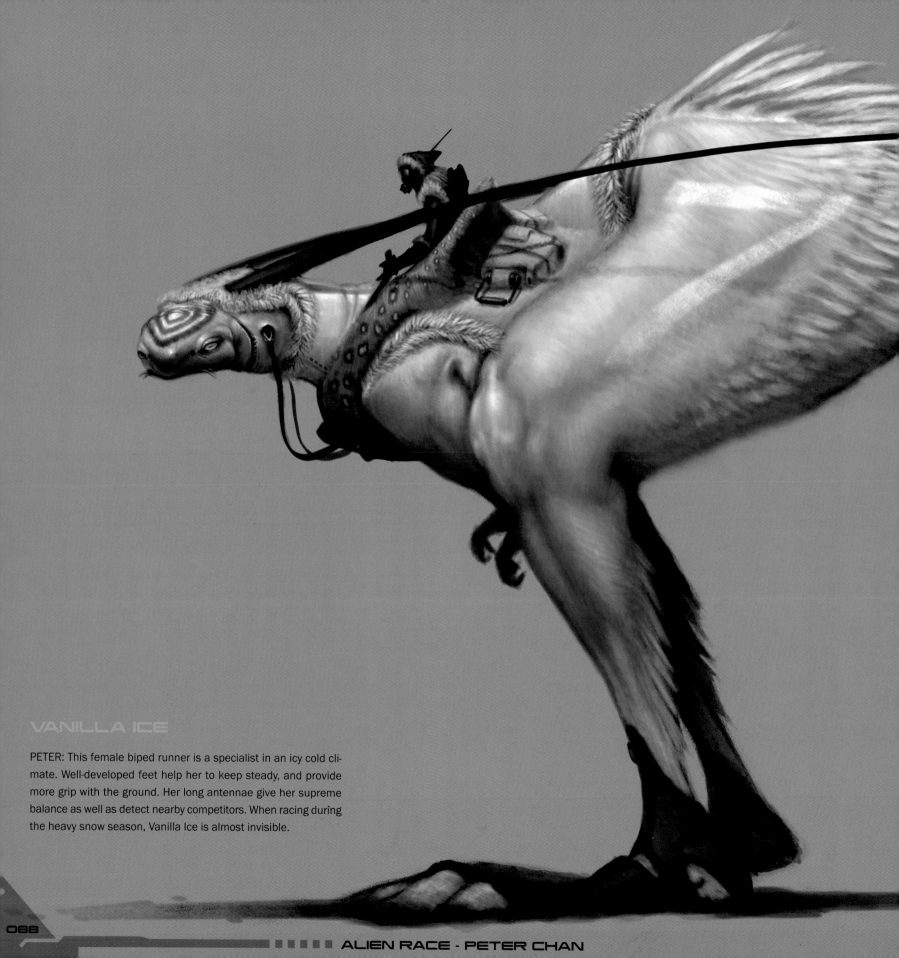

VANILLA ICE

PETER: This female biped runner is a specialist in an icy cold climate. Well-developed feet help her to keep steady, and provide more grip with the ground. Her long antennae give her supreme balance as well as detect nearby competitors. When racing during the heavy snow season, Vanilla Ice is almost invisible.

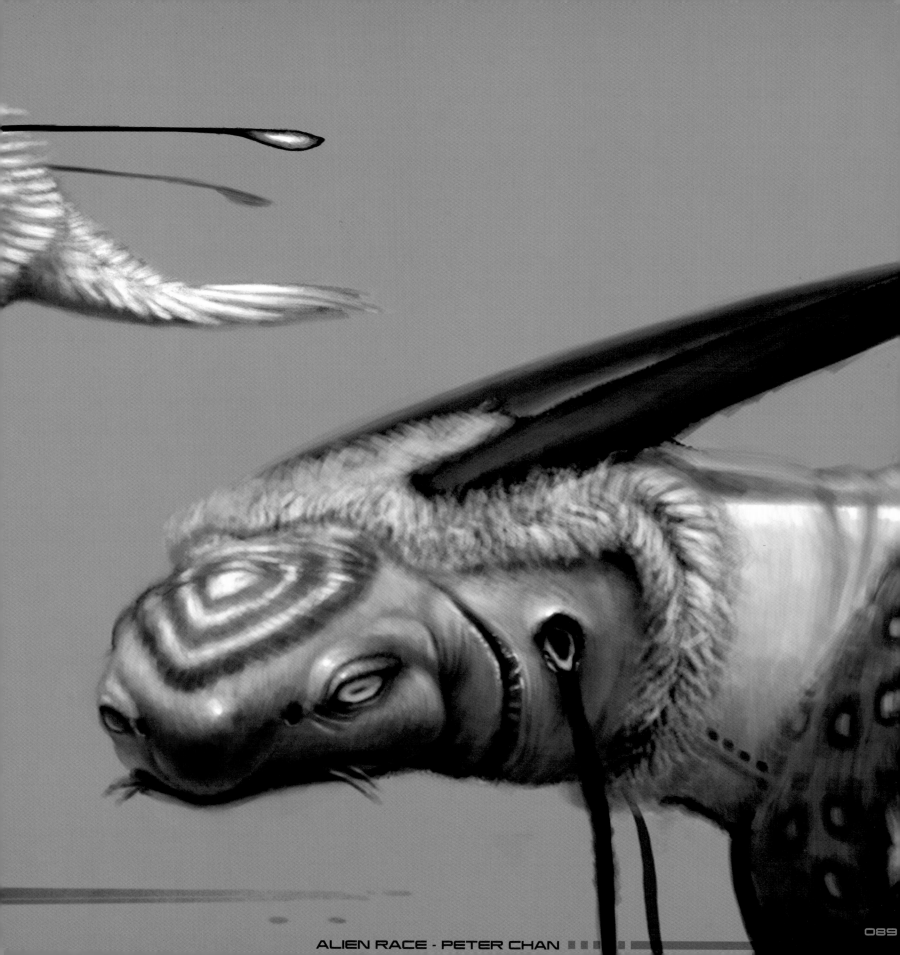

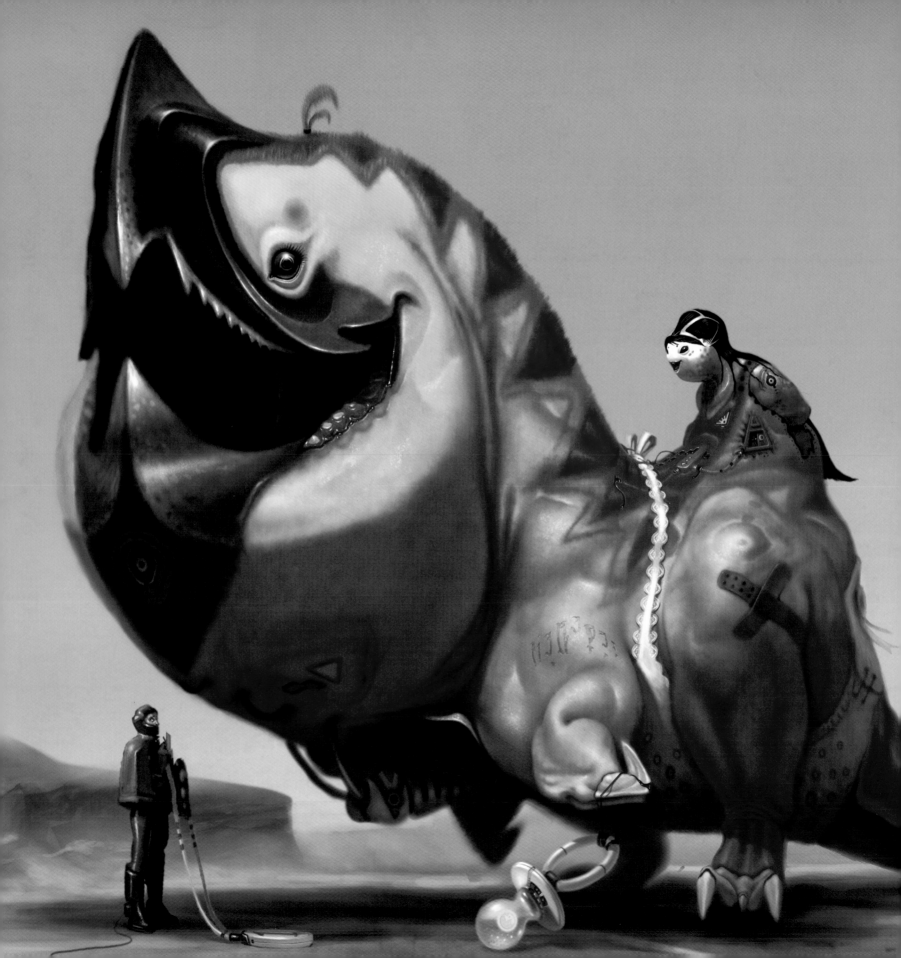

PETER: This bird-like creature has a long lineage of participating in the galactic *Alien Race*. A native of the planet "dorocoro," this species can grow to 4-stories tall, but at the young age of 2 is best suited for the race. Baby Fat has the ability to perform short bursts of powerful sprints and his stocky body and head can knock other racers out of their saddles.

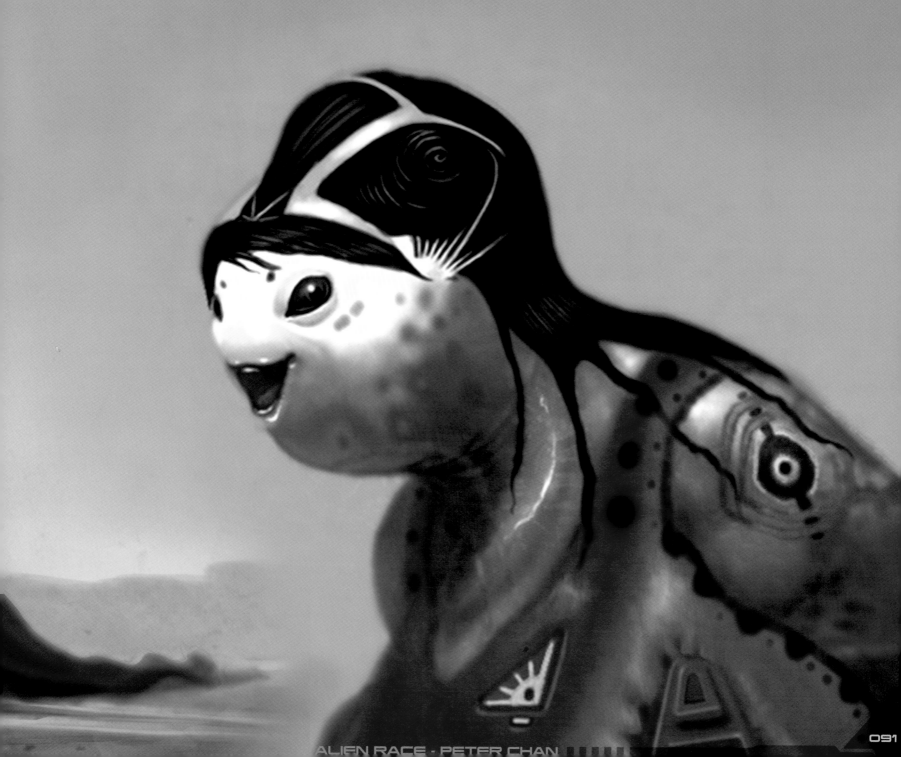

ALIEN RACE · PETER CHAN

SCOTT: The design below achieves the relationship of the rider to his creature through the use of some very hi-tech reins. The reins slim down to cables that control the appliqués on the sides of creature's head. These sci-fi devices control the movements of the large creature by stimulating certain regions of its brain, which gives this small rider the ability to control the big biped.

I really like the relationship of cowboys to their horse's movement via the reins, but didn't want these reins to appear too familiar. There are many types of reins throughout the book but I think this particular direction is a nice way to go for several of the very large creatures. The image on the facing page was an afternoon paintover of the stylized orange sketch from page 82.

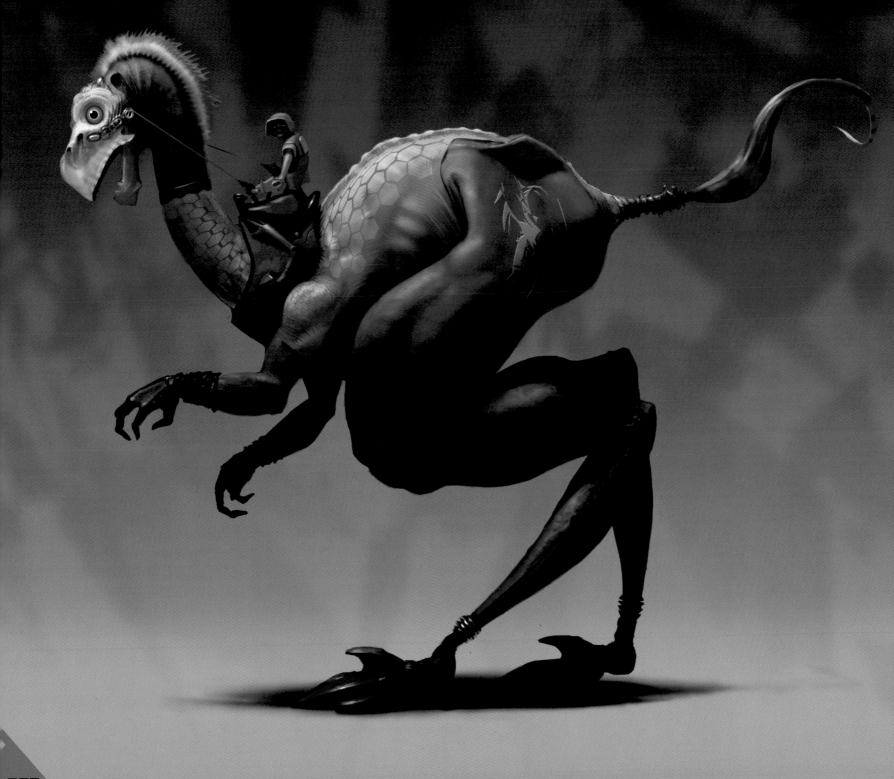

ALIEN RACE · SCOTT ROBERTSON

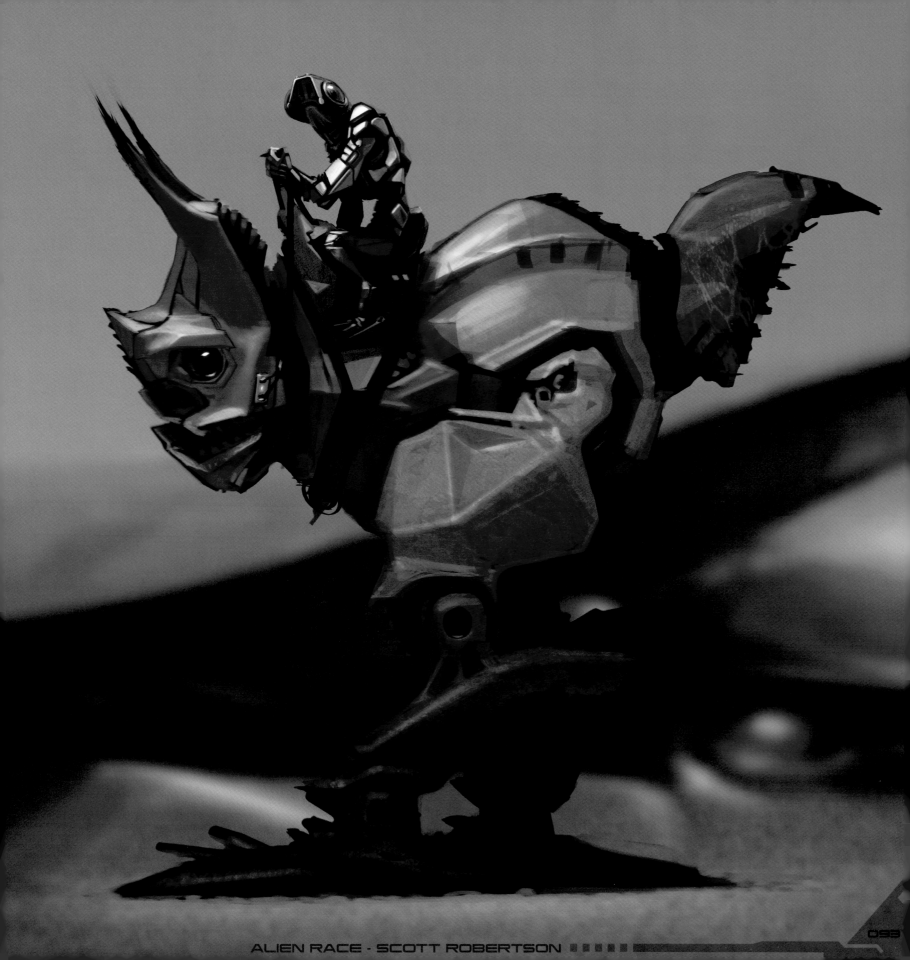



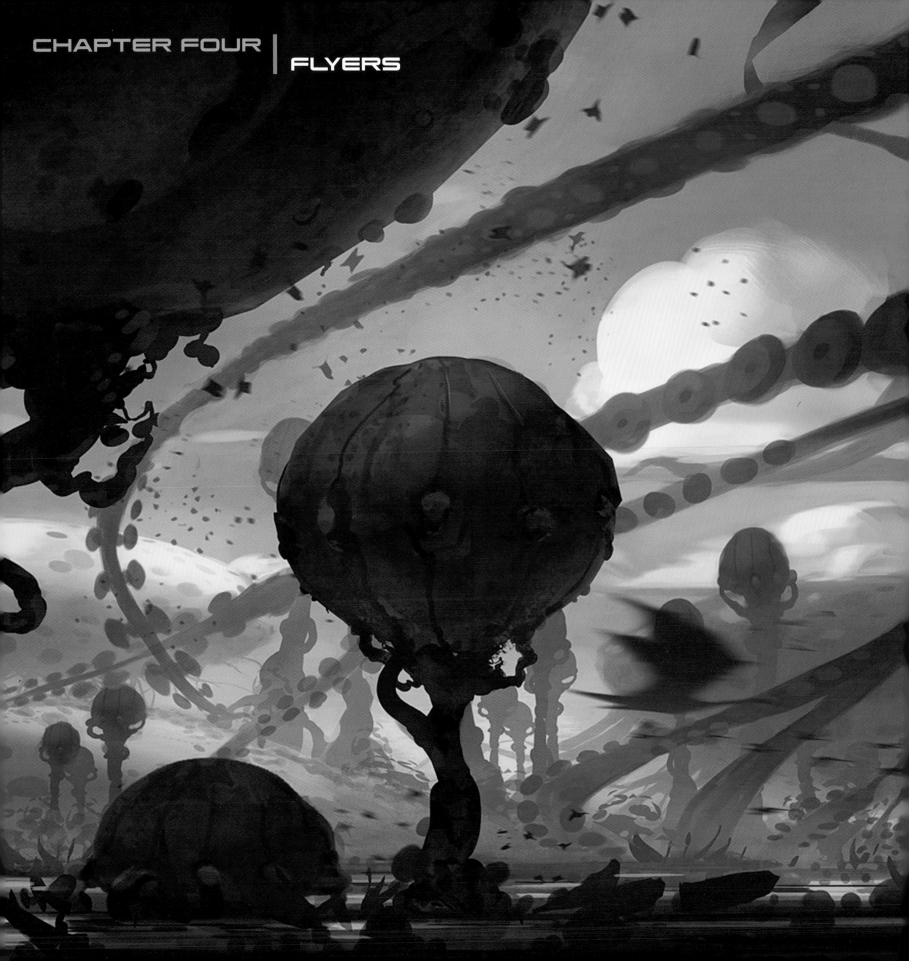

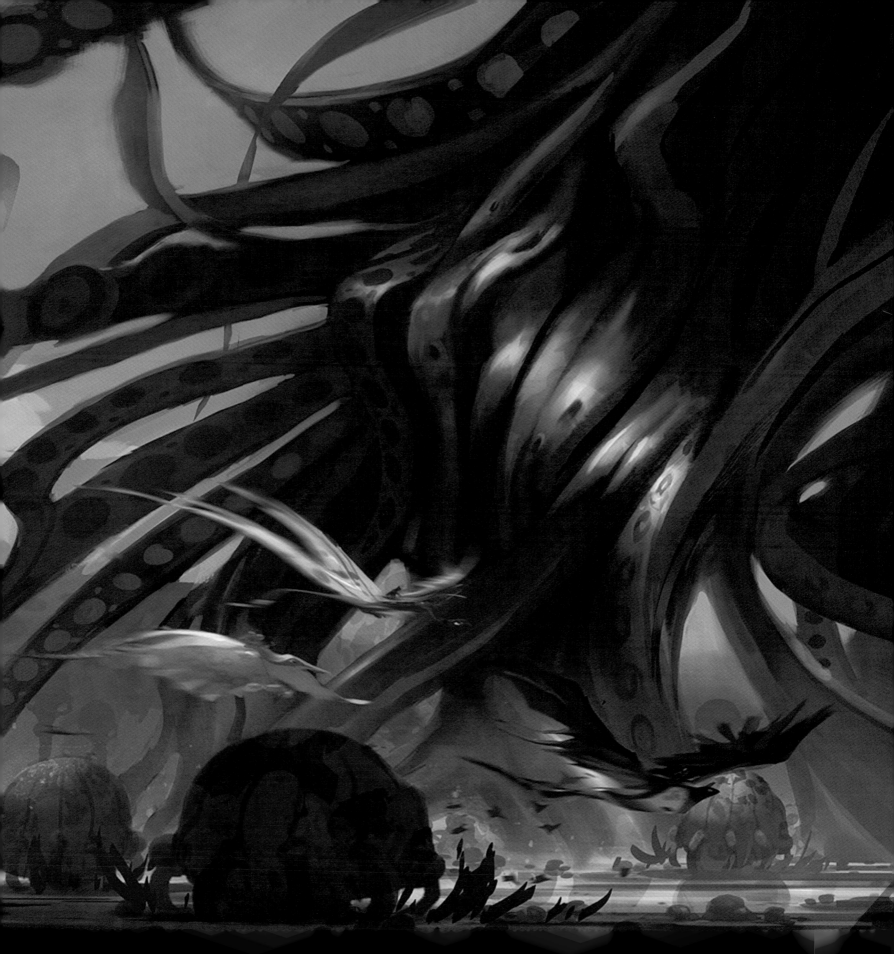

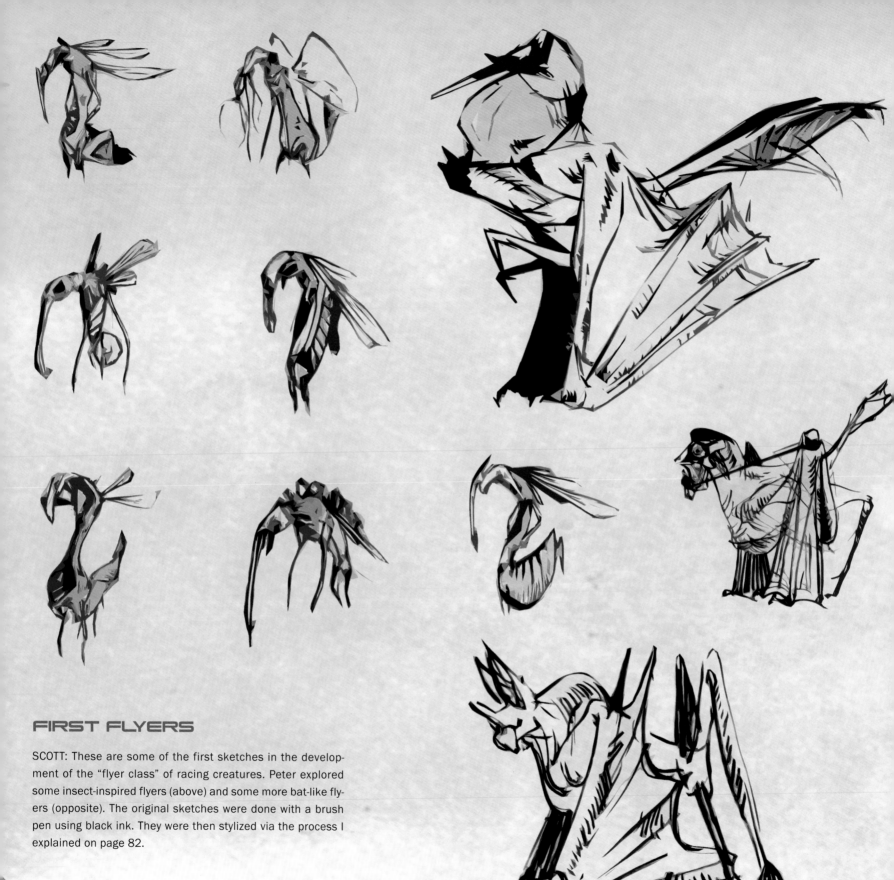

# FIRST FLYERS

SCOTT: These are some of the first sketches in the development of the "flyer class" of racing creatures. Peter explored some insect-inspired flyers (above) and some more bat-like flyers (opposite). The original sketches were done with a brush pen using black ink. They were then stylized via the process I explained on page 82.

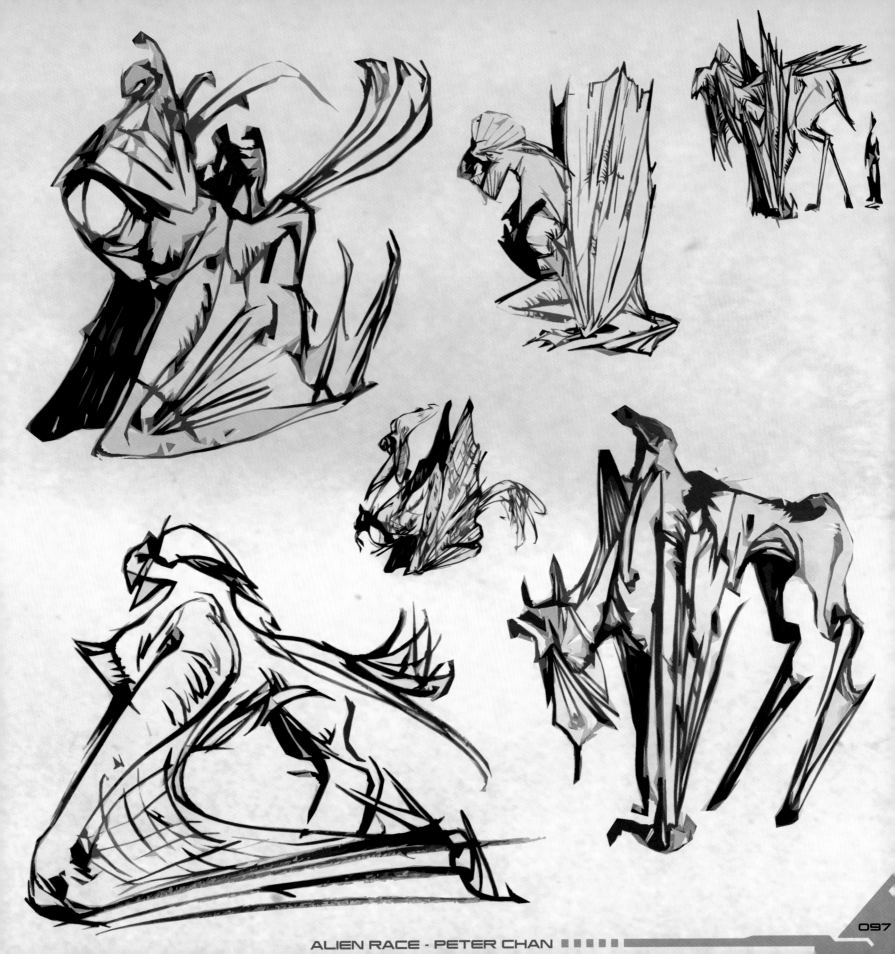

ALIEN RACE - PETER CHAN ▌▌▌▌▌

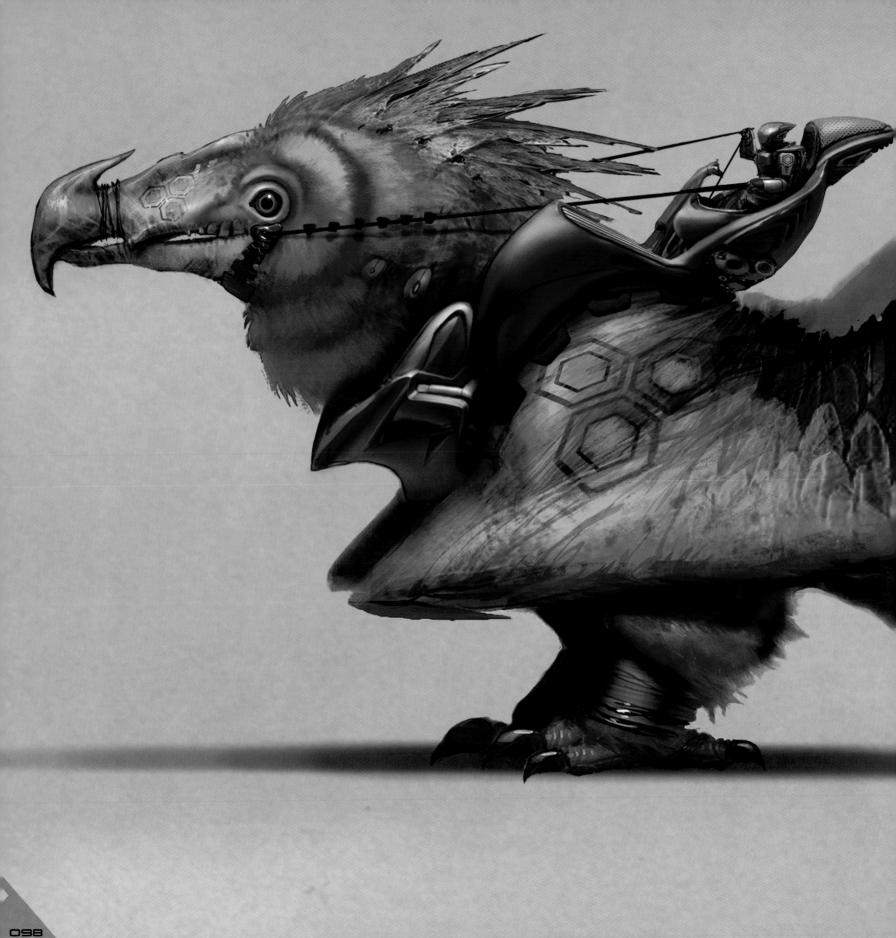

SCOTT: Here are a couple of flyers for the race. Lots of attitude on the facing page; not a flyer I would like to race against! The design below features some of the very strong colors bioengineereed into many of the racers to play up the festive nature of some alien entrants.

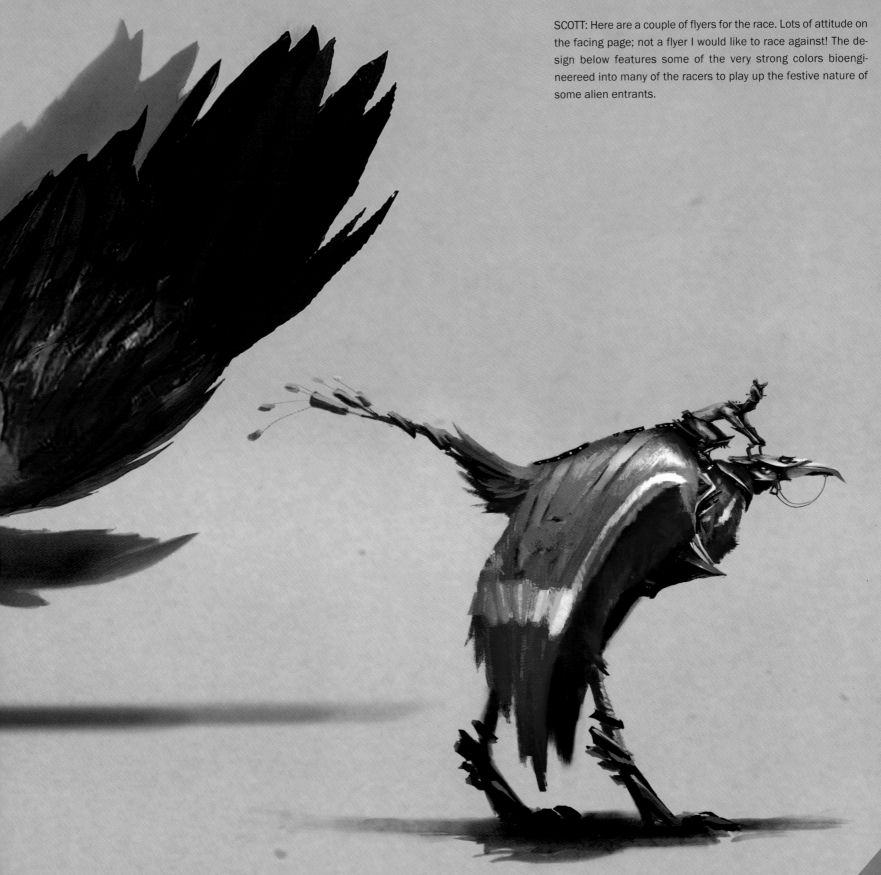

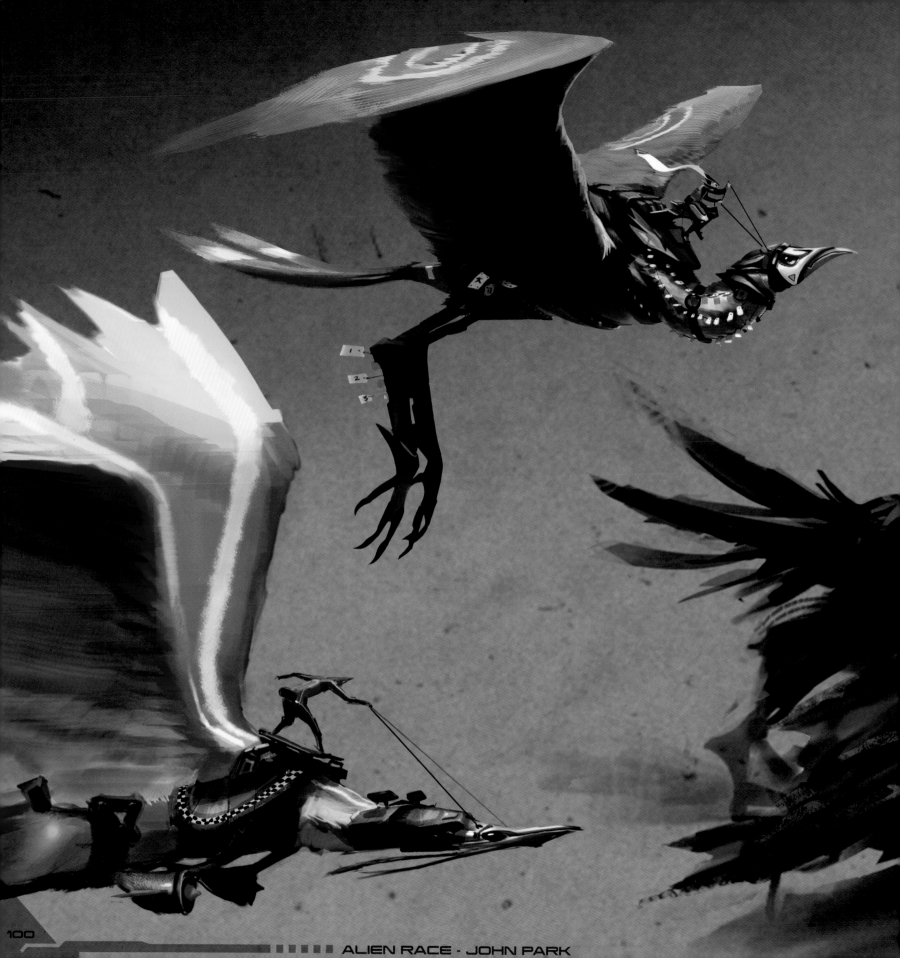

ALIEN RACE · JOHN PARK

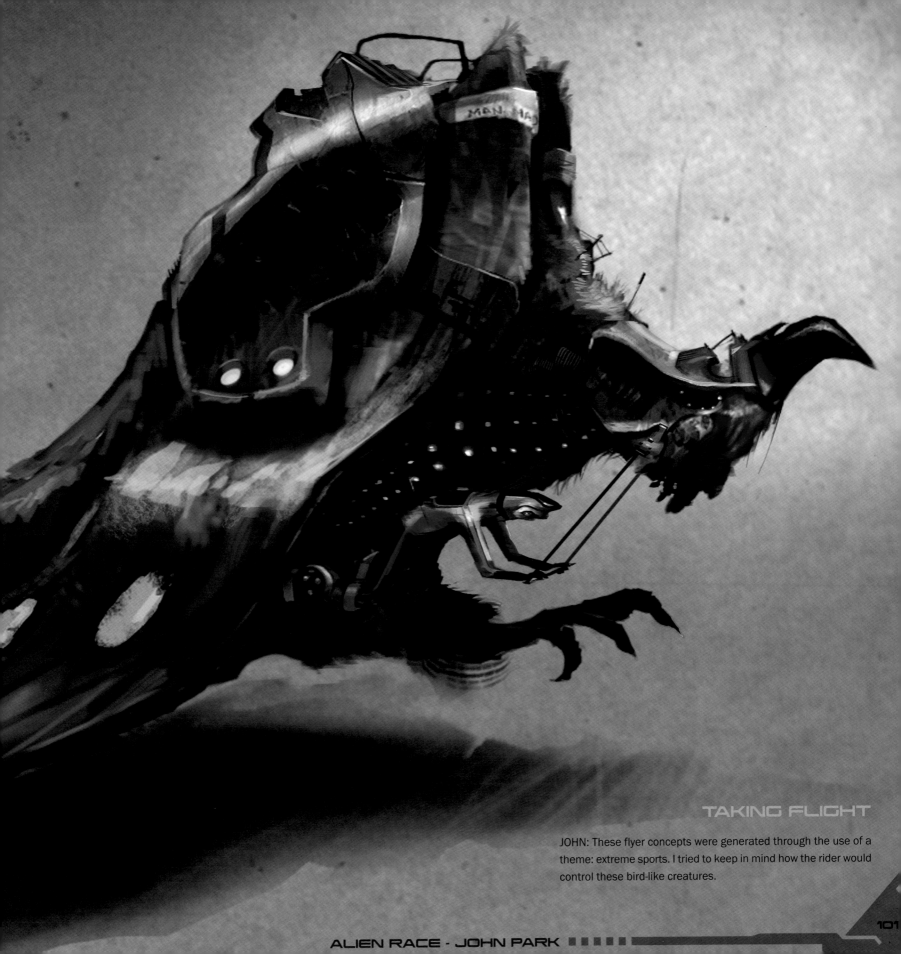

TAKING FLIGHT

JOHN: These flyer concepts were generated through the use of a theme: extreme sports. I tried to keep in mind how the rider would control these bird-like creatures.

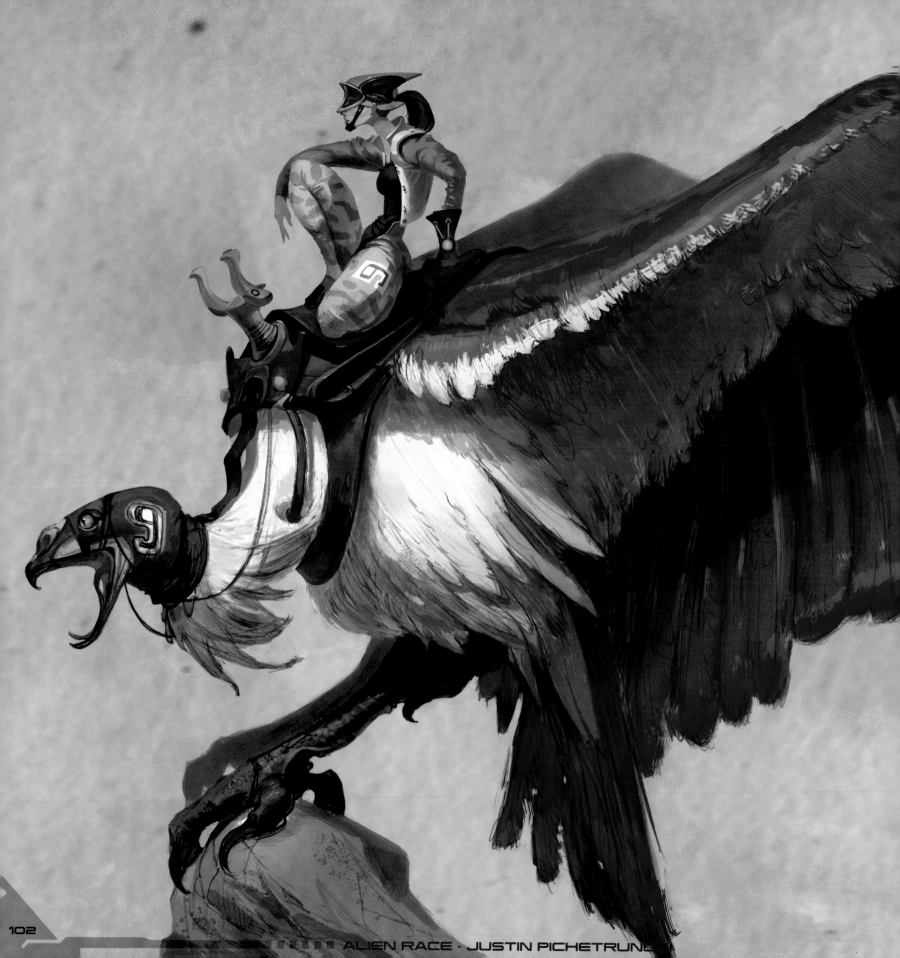

ALIEN RACE · JUSTIN PICHETRUNG

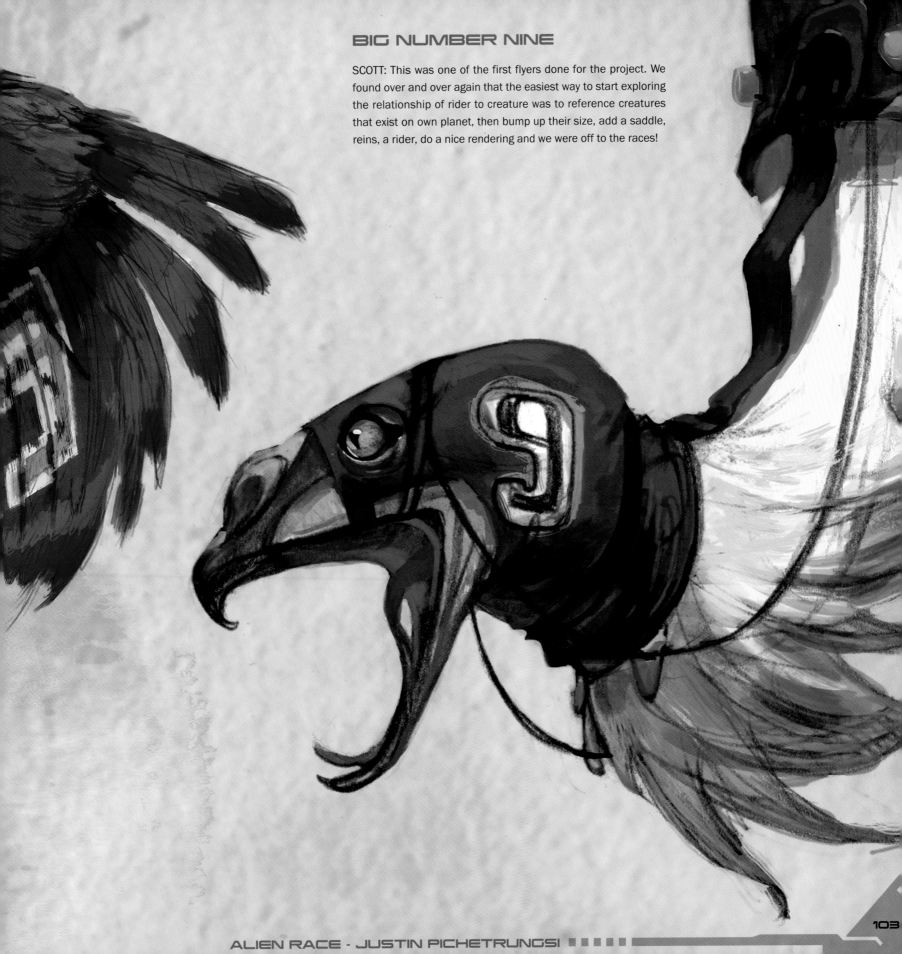

## BIG NUMBER NINE

SCOTT: This was one of the first flyers done for the project. We found over and over again that the easiest way to start exploring the relationship of rider to creature was to reference creatures that exist on own planet, then bump up their size, add a saddle, reins, a rider, do a nice rendering and we were off to the races!

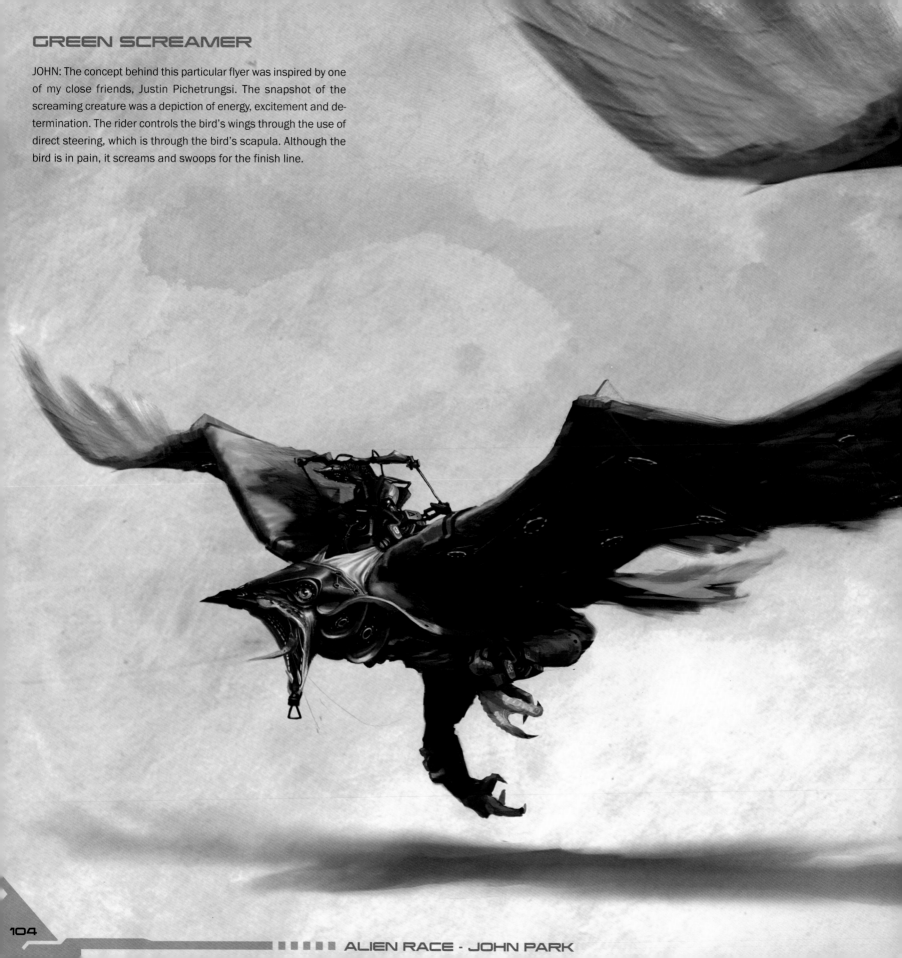

# GREEN SCREAMER

JOHN: The concept behind this particular flyer was inspired by one of my close friends, Justin Pichetrungsi. The snapshot of the screaming creature was a depiction of energy, excitement and determination. The rider controls the bird's wings through the use of direct steering, which is through the bird's scapula. Although the bird is in pain, it screams and swoops for the finish line.

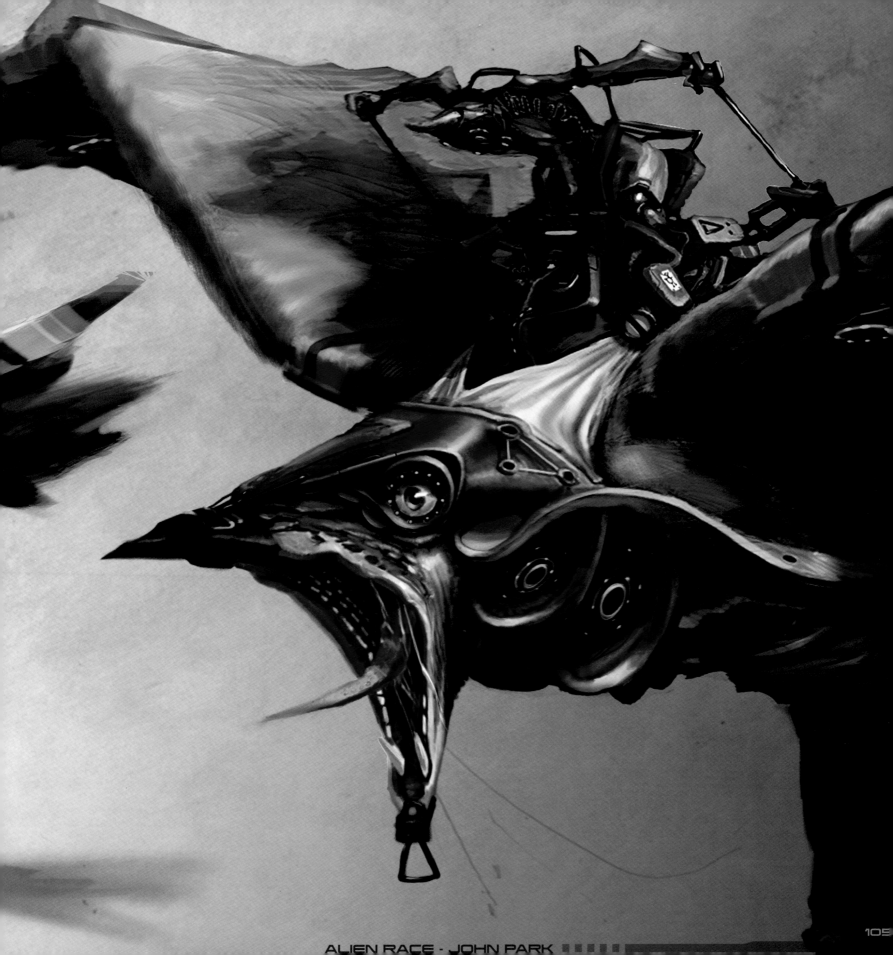

ALIEN RACE · JOHN PARK ▮▮▮▮▮▮

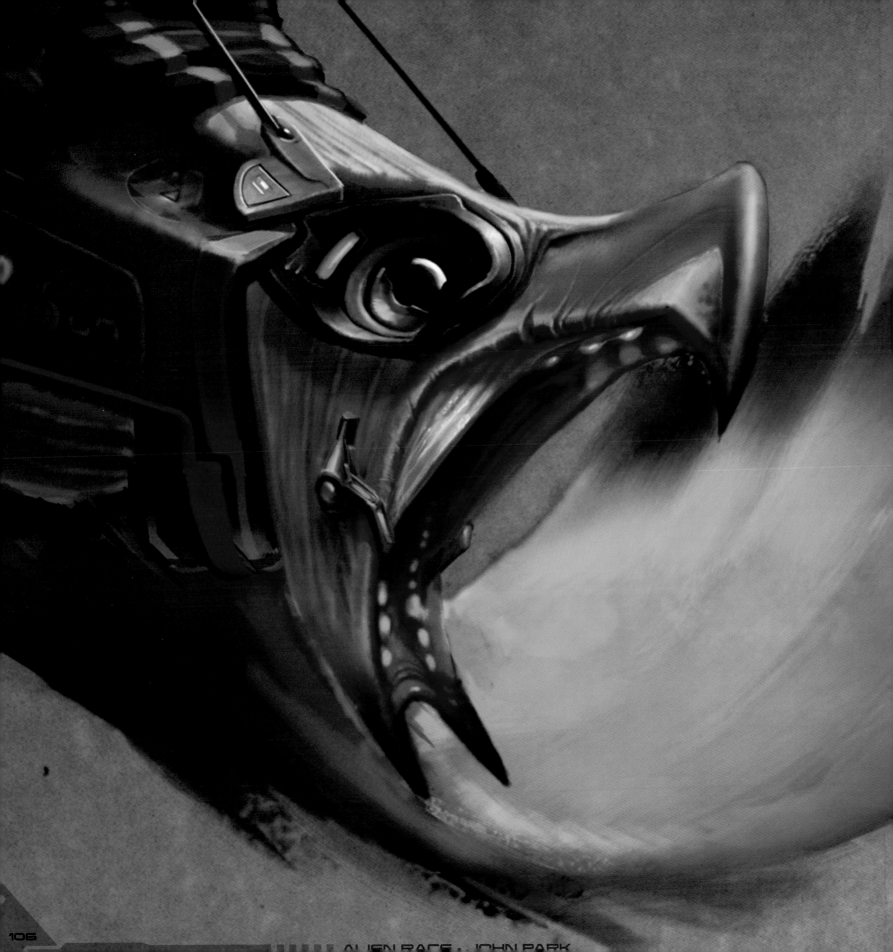

ALIEN RACE : JOHN PARK

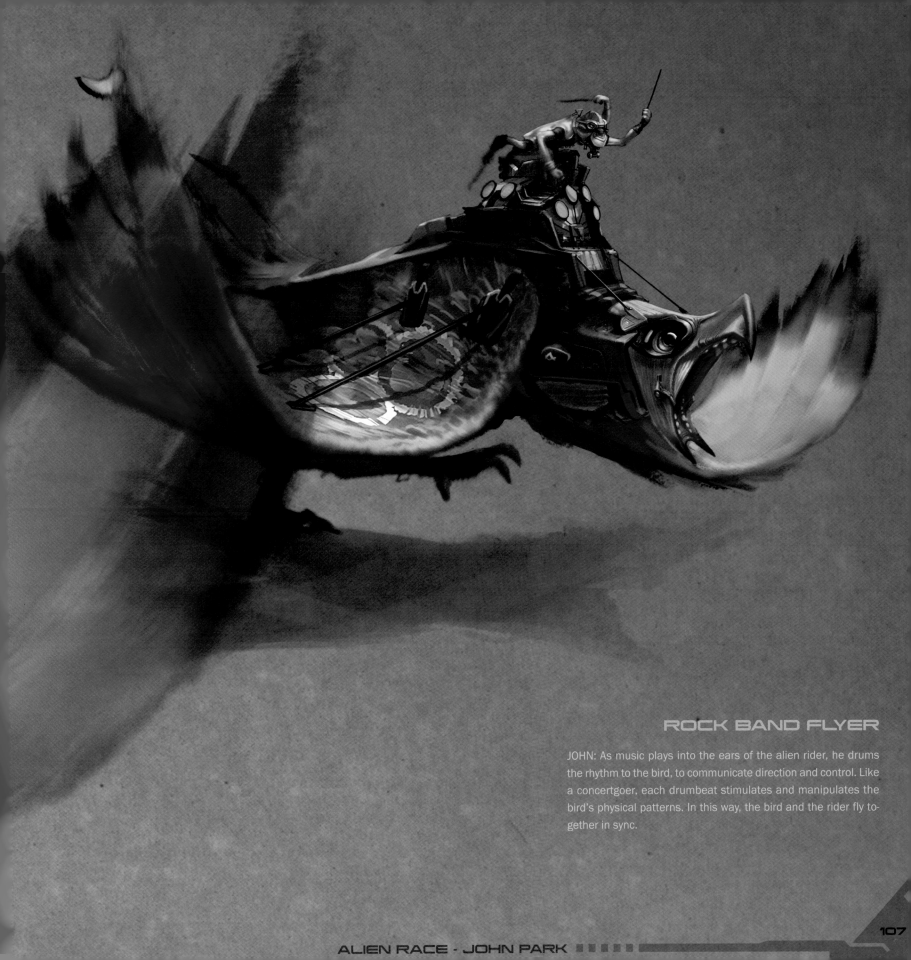

## ROCK BAND FLYER

JOHN: As music plays into the ears of the alien rider, he drums the rhythm to the bird, to communicate direction and control. Like a concertgoer, each drumbeat stimulates and manipulates the bird's physical patterns. In this way, the bird and the rider fly together in sync.

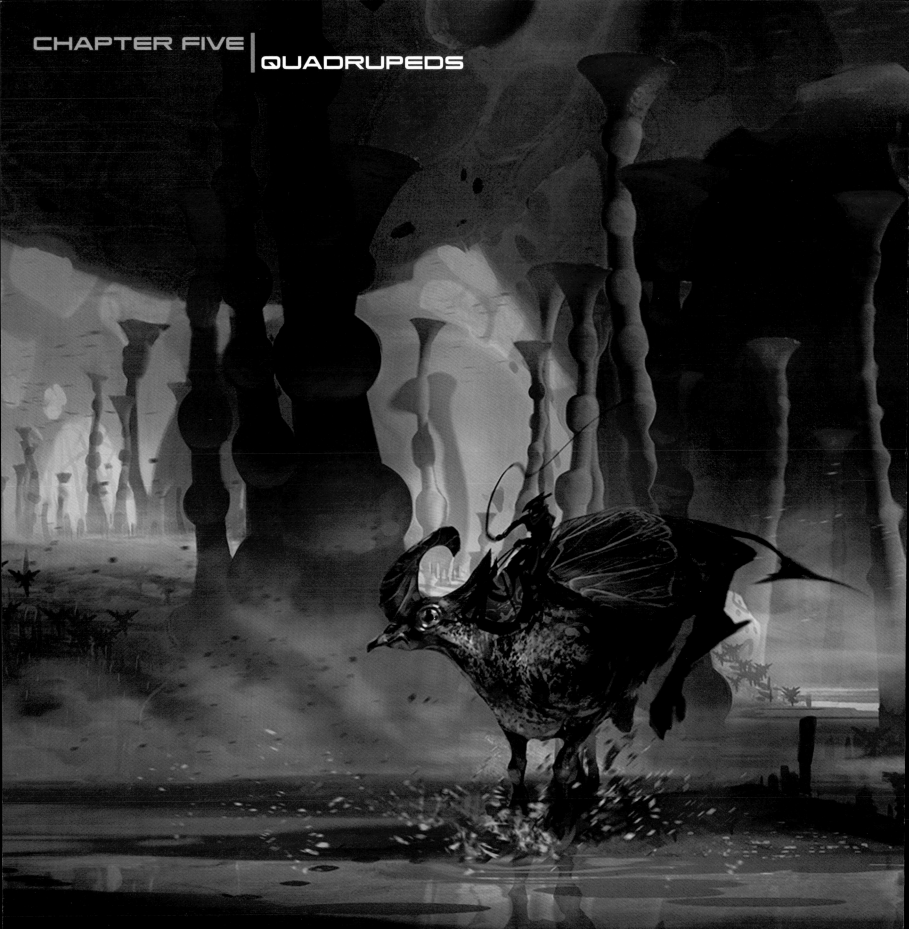

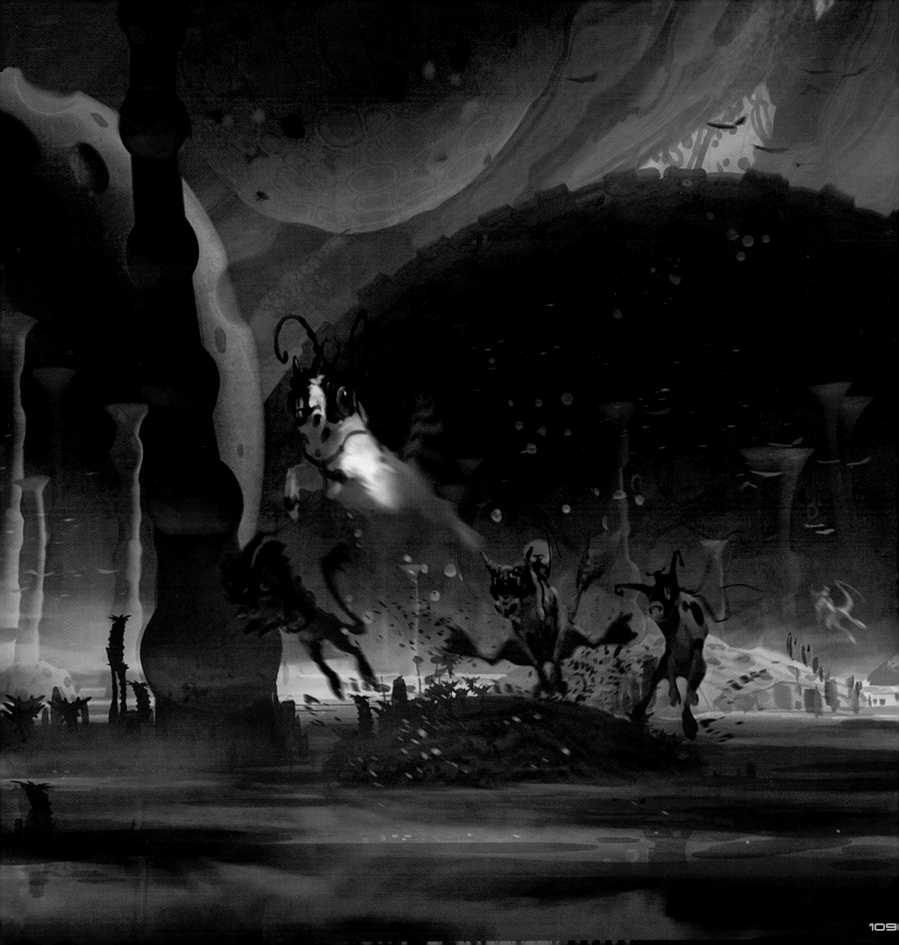

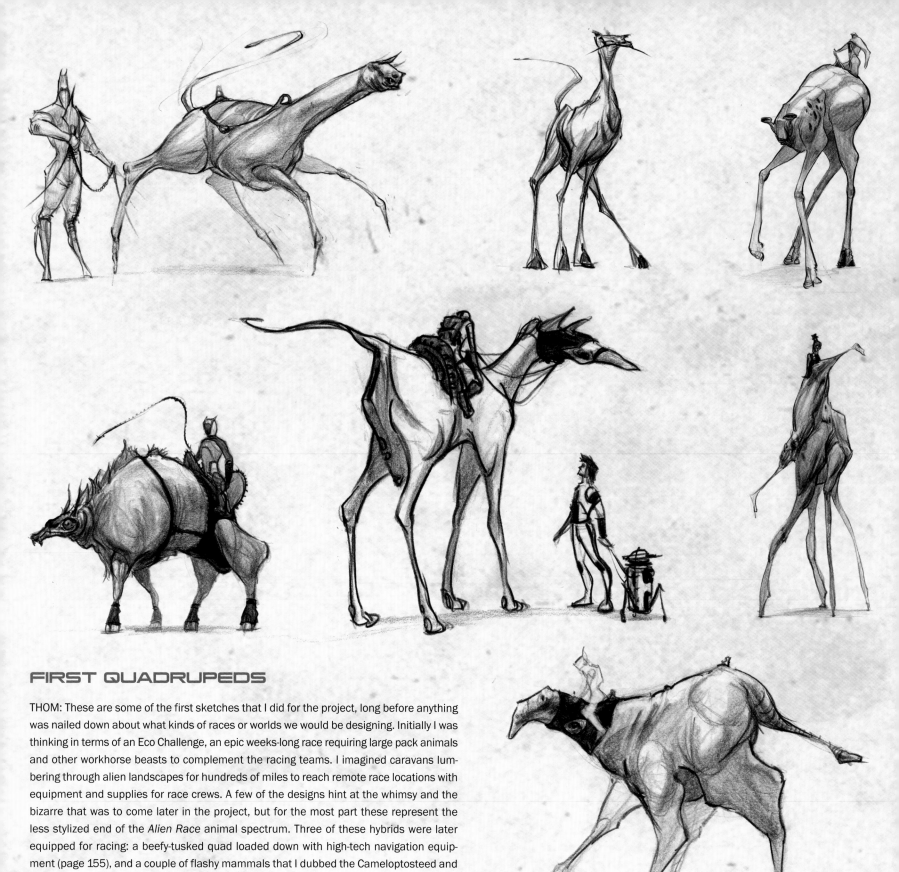

# FIRST QUADRUPEDS

THOM: These are some of the first sketches that I did for the project, long before anything was nailed down about what kinds of races or worlds we would be designing. Initially I was thinking in terms of an Eco Challenge, an epic weeks-long race requiring large pack animals and other workhorse beasts to complement the racing teams. I imagined caravans lumbering through alien landscapes for hundreds of miles to reach remote race locations with equipment and supplies for race crews. A few of the designs hint at the whimsy and the bizarre that was to come later in the project, but for the most part these represent the less stylized end of the *Alien Race* animal spectrum. Three of these hybrids were later equipped for racing: a beefy-tusked quad loaded down with high-tech navigation equipment (page 155), and a couple of flashy mammals that I dubbed the Cameloptosteed and the Hundstrider (pages 114 and 115).

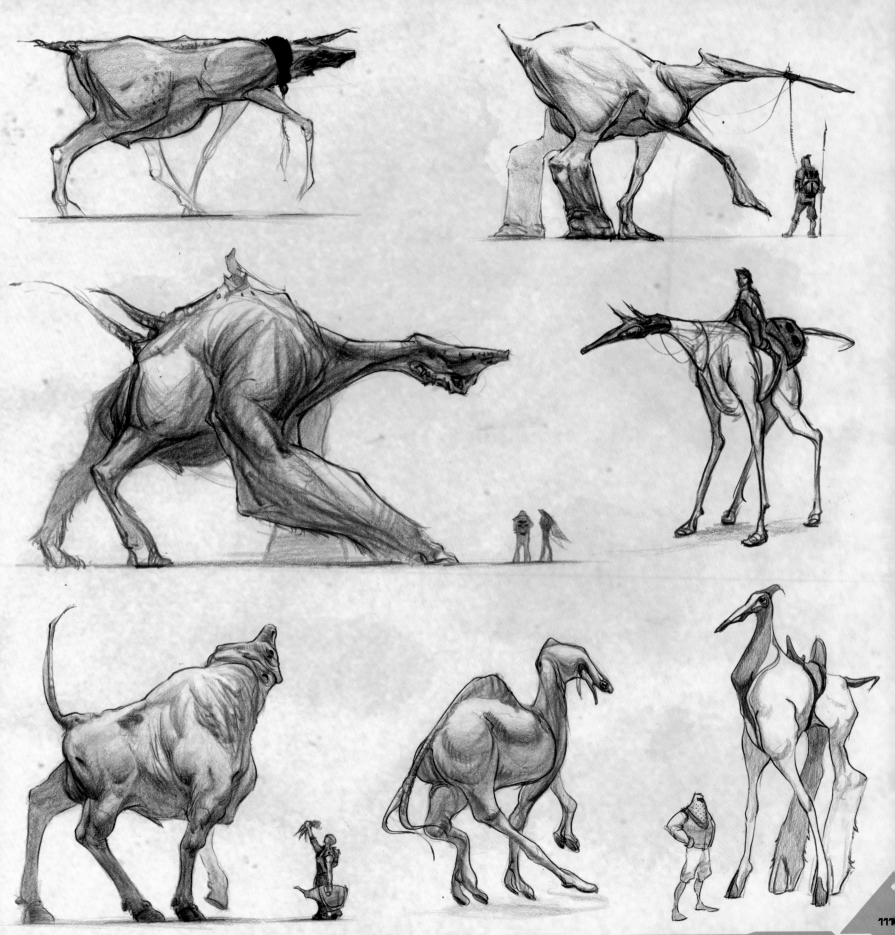

ALIEN RACE - THOM TENERY

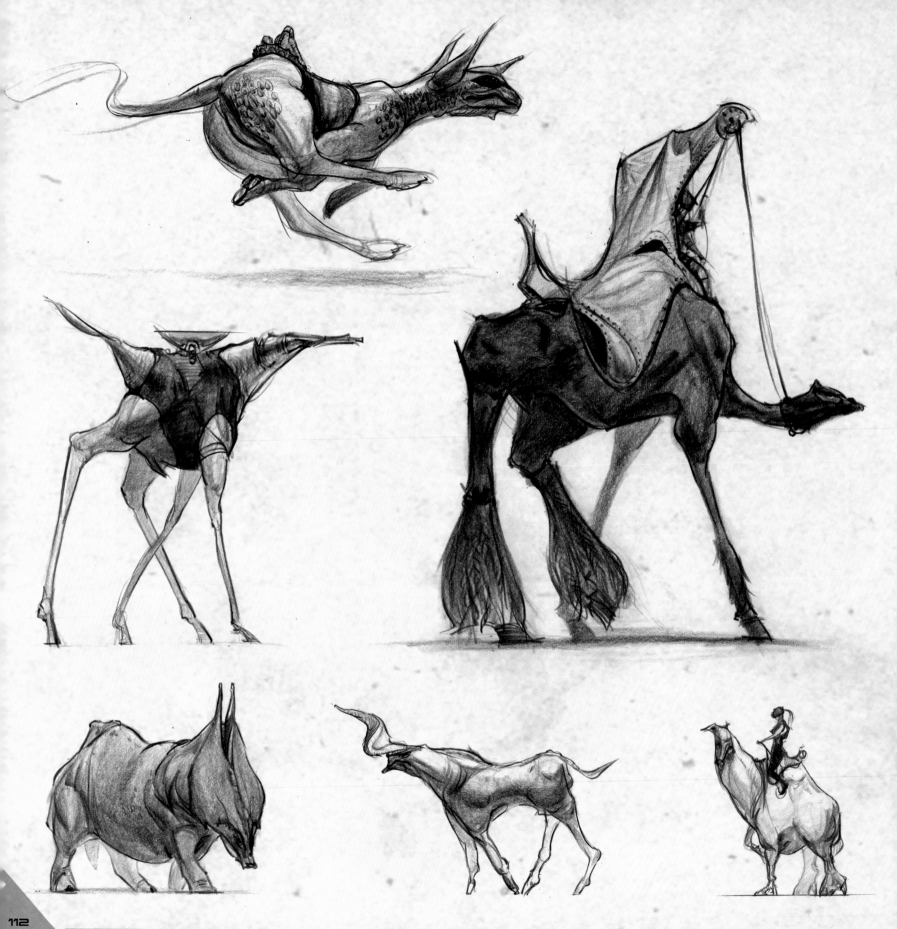

ALIEN RACE - THOM TENERY

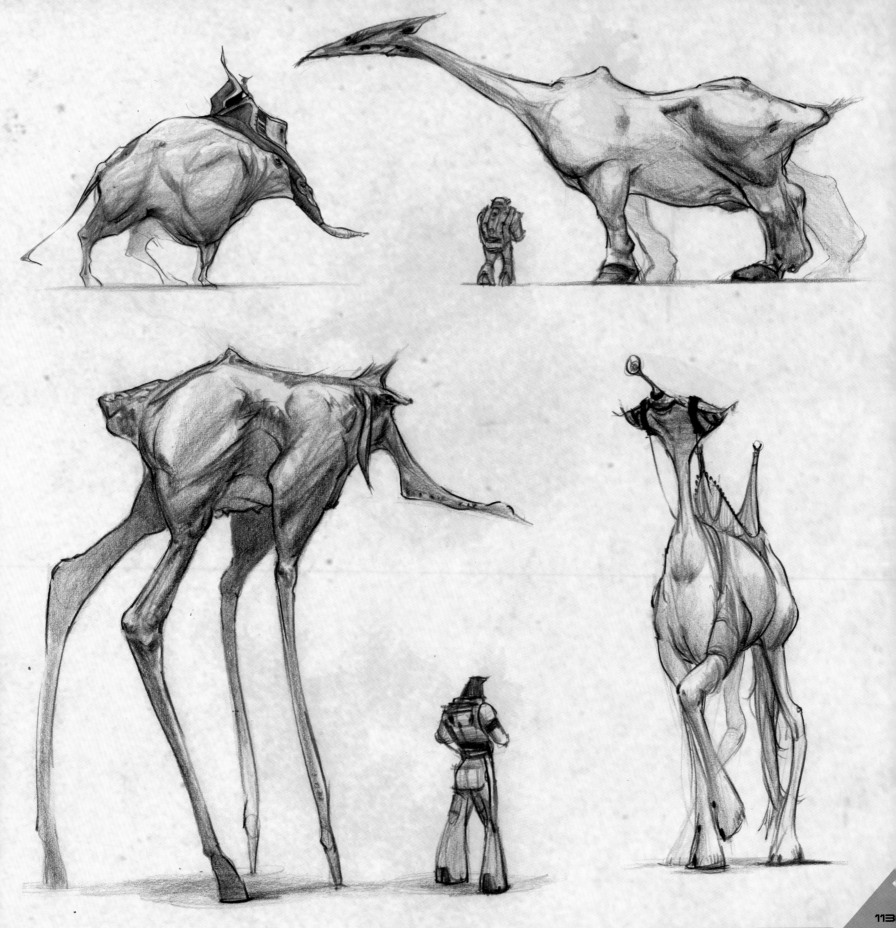

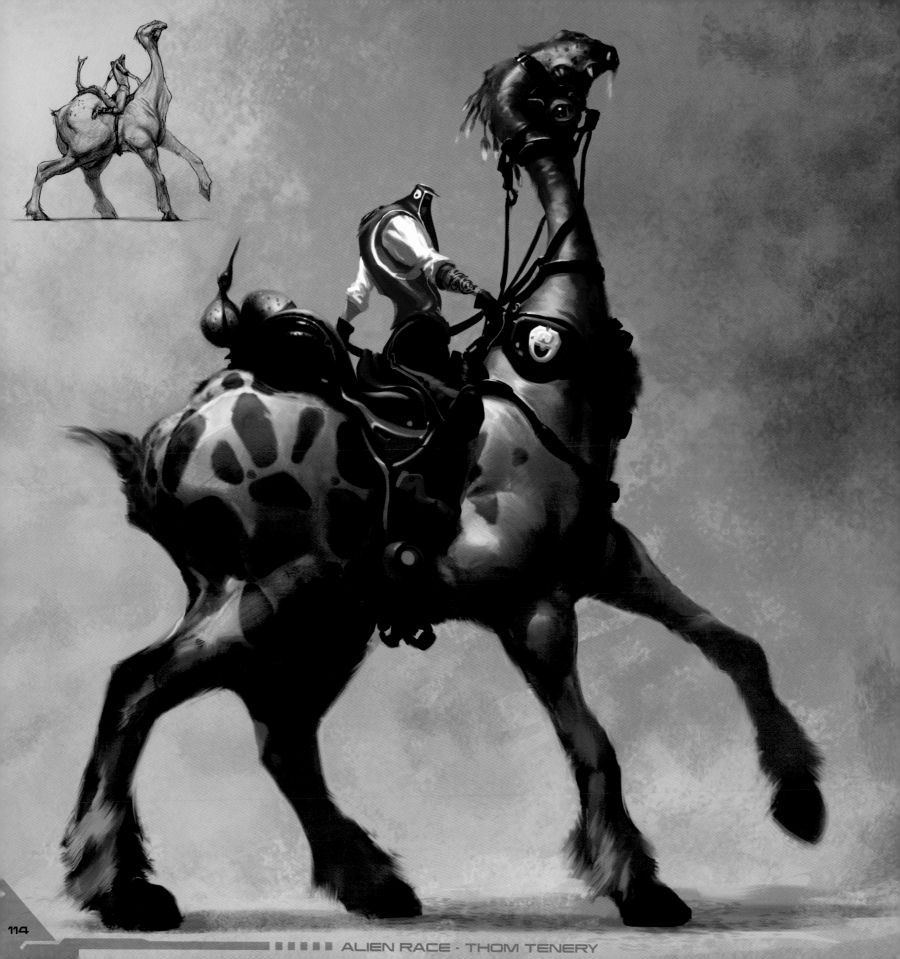

ALIEN RACE · THOM TENERY

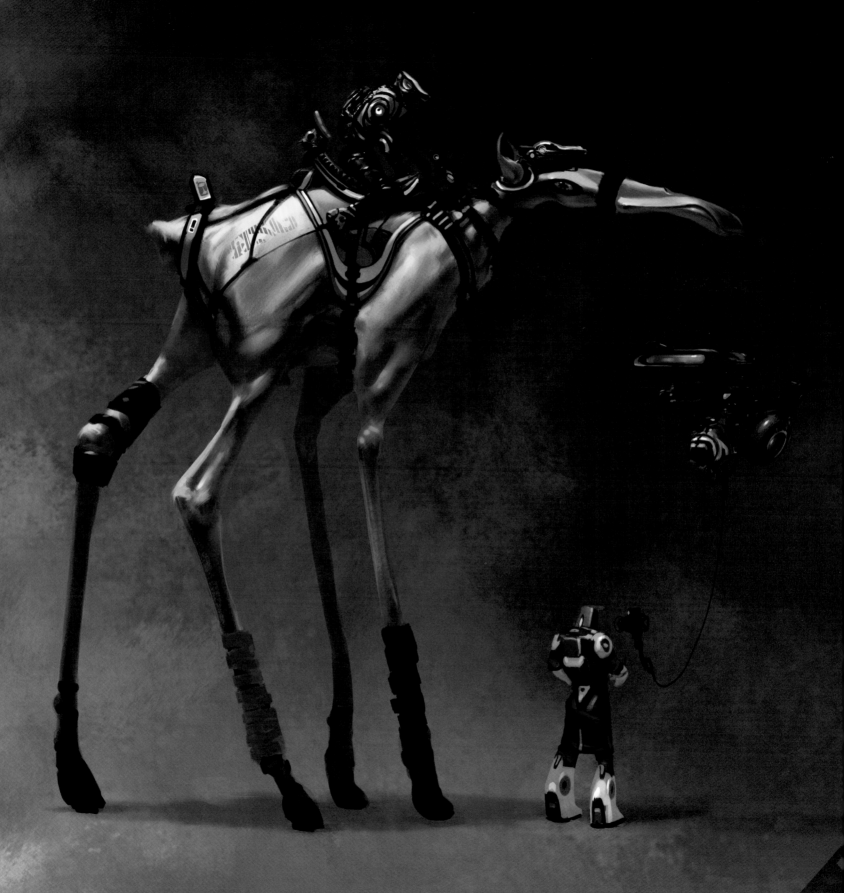

ALIEN RACE · THOM TENERY

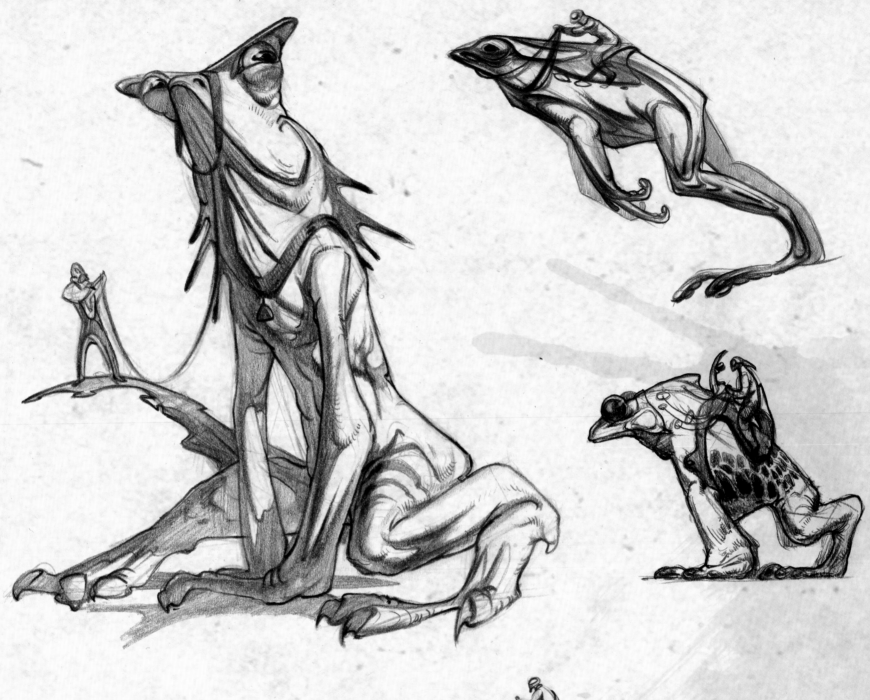

## MEGA FROGS

SCOTT: In the same "go big" theme as Justin's flyer in the last chapter, meet the mega frogs! These early pencil sketches were again exploring the style of some Earth-inspired racing creatures. Later down the line we ruled out this "hopping" class of racing creature but the sketches are great and I thought they deserved a place in the book.

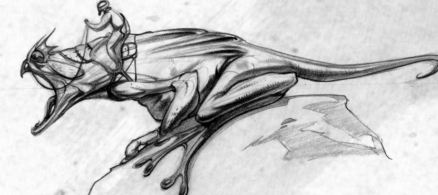

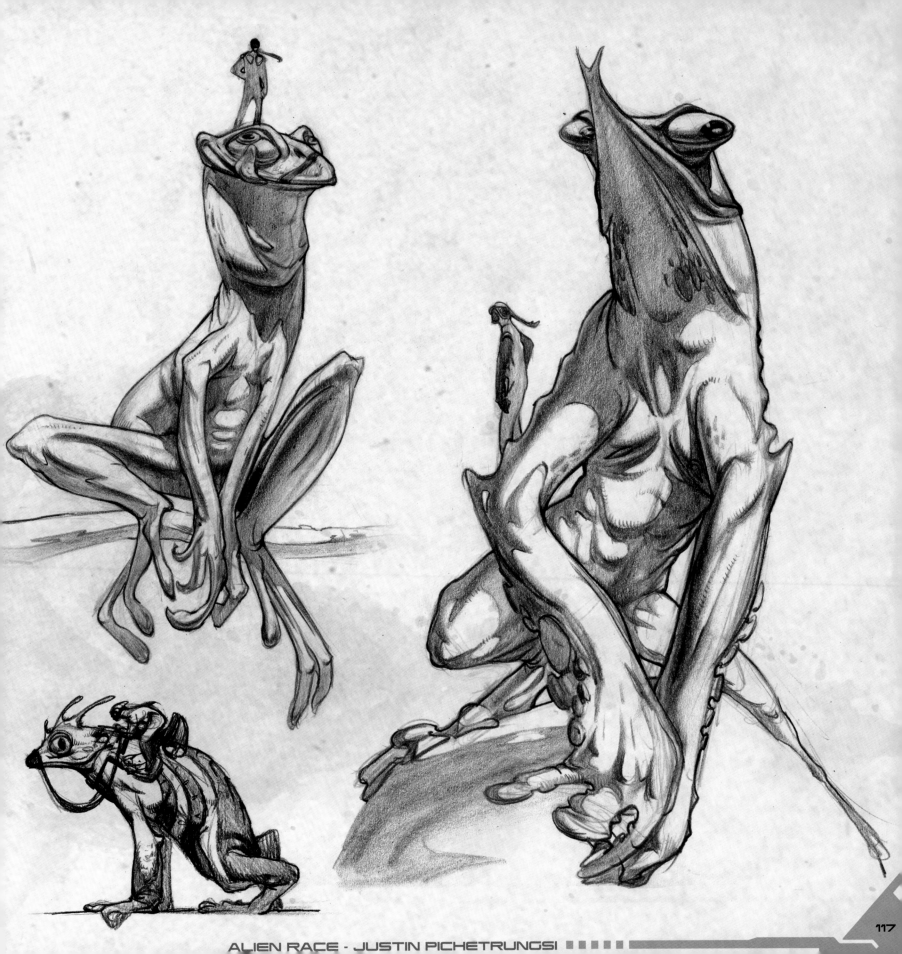

ALIEN RACE · JUSTIN PICHETRUNGSI

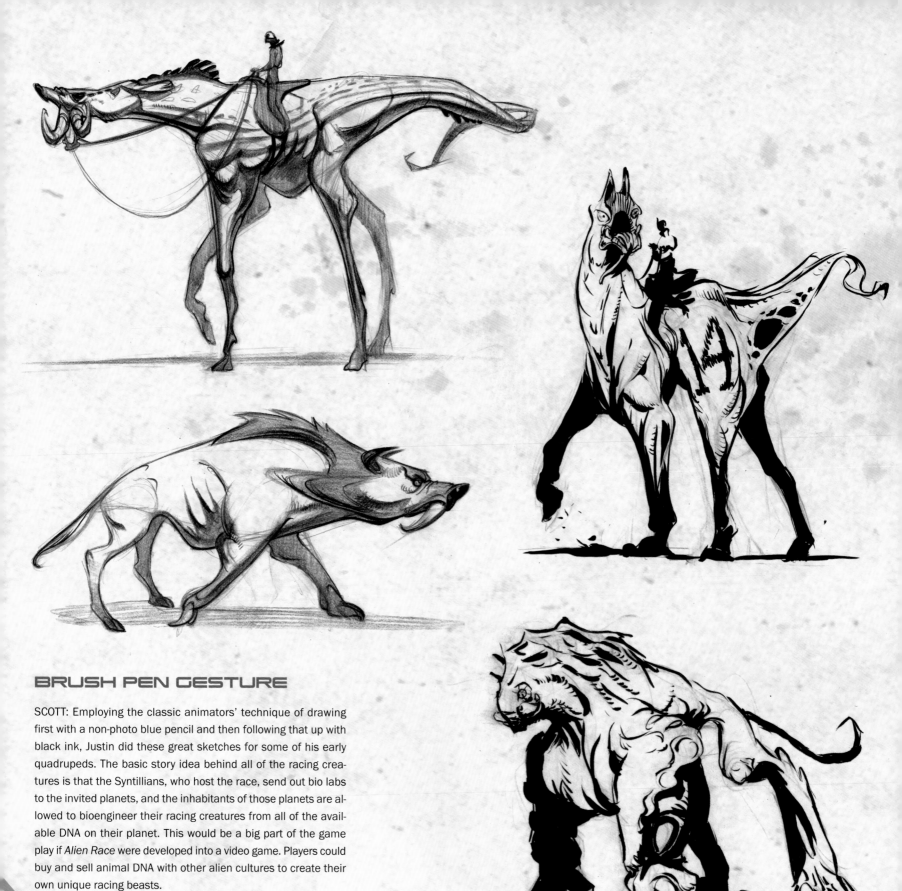

## BRUSH PEN GESTURE

SCOTT: Employing the classic animators' technique of drawing first with a non-photo blue pencil and then following that up with black ink, Justin did these great sketches for some of his early quadrupeds. The basic story idea behind all of the racing creatures is that the Syntillians, who host the race, send out bio labs to the invited planets, and the inhabitants of those planets are allowed to bioengineer their racing creatures from all of the available DNA on their planet. This would be a big part of the game play if *Alien Race* were developed into a video game. Players could buy and sell animal DNA with other alien cultures to create their own unique racing beasts.

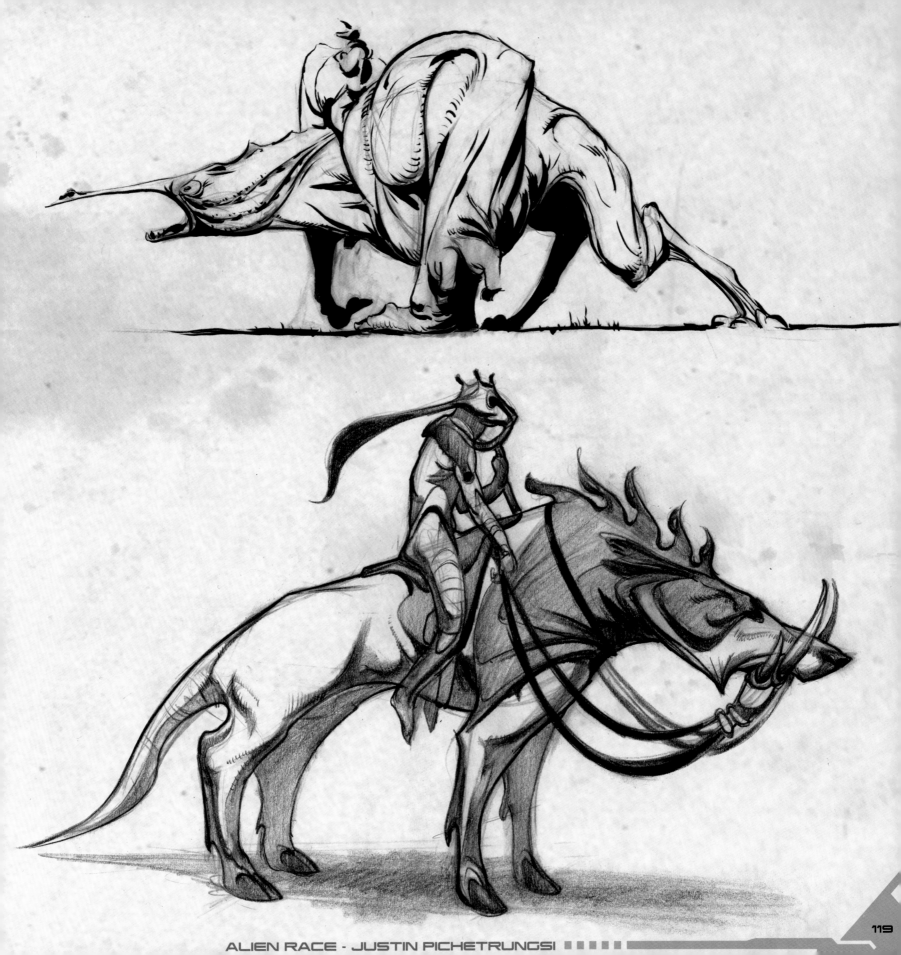

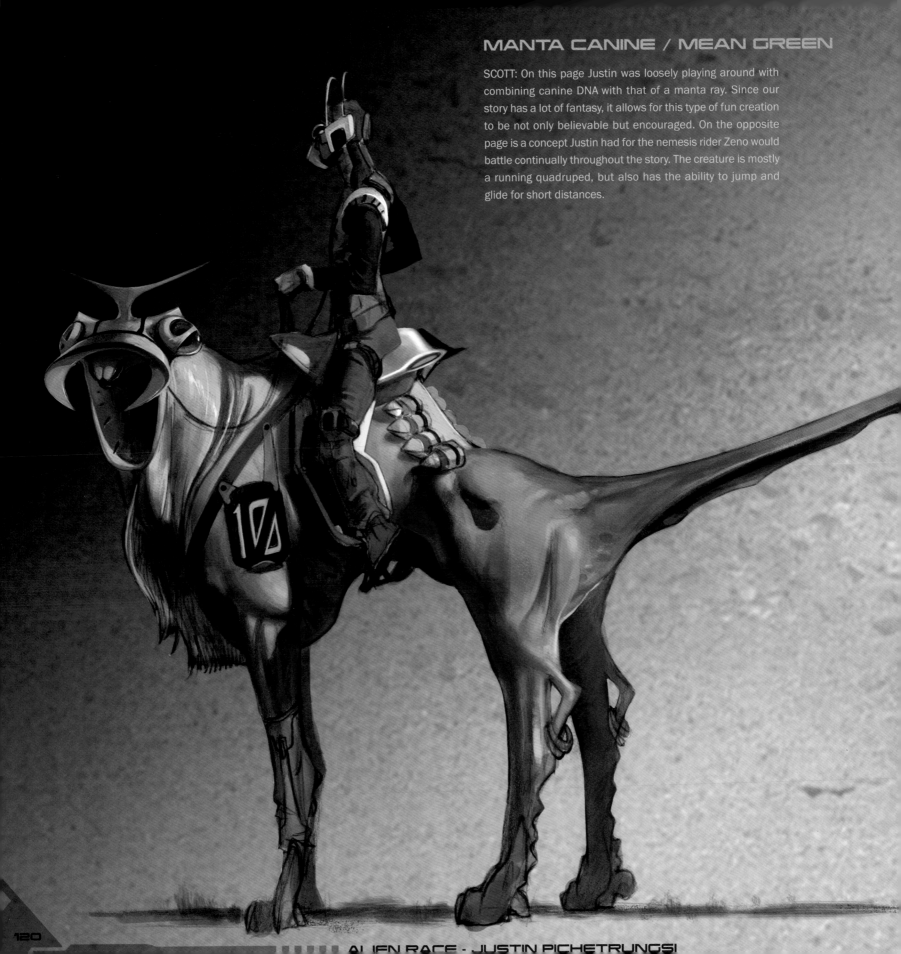

## MANTA CANINE / MEAN GREEN

SCOTT: On this page Justin was loosely playing around with combining canine DNA with that of a manta ray. Since our story has a lot of fantasy, it allows for this type of fun creation to be not only believable but encouraged. On the opposite page is a concept Justin had for the nemesis rider Zeno would battle continually throughout the story. The creature is mostly a running quadruped, but also has the ability to jump and glide for short distances.

ALIEN RACE · JUSTIN PICHETRUNGSI

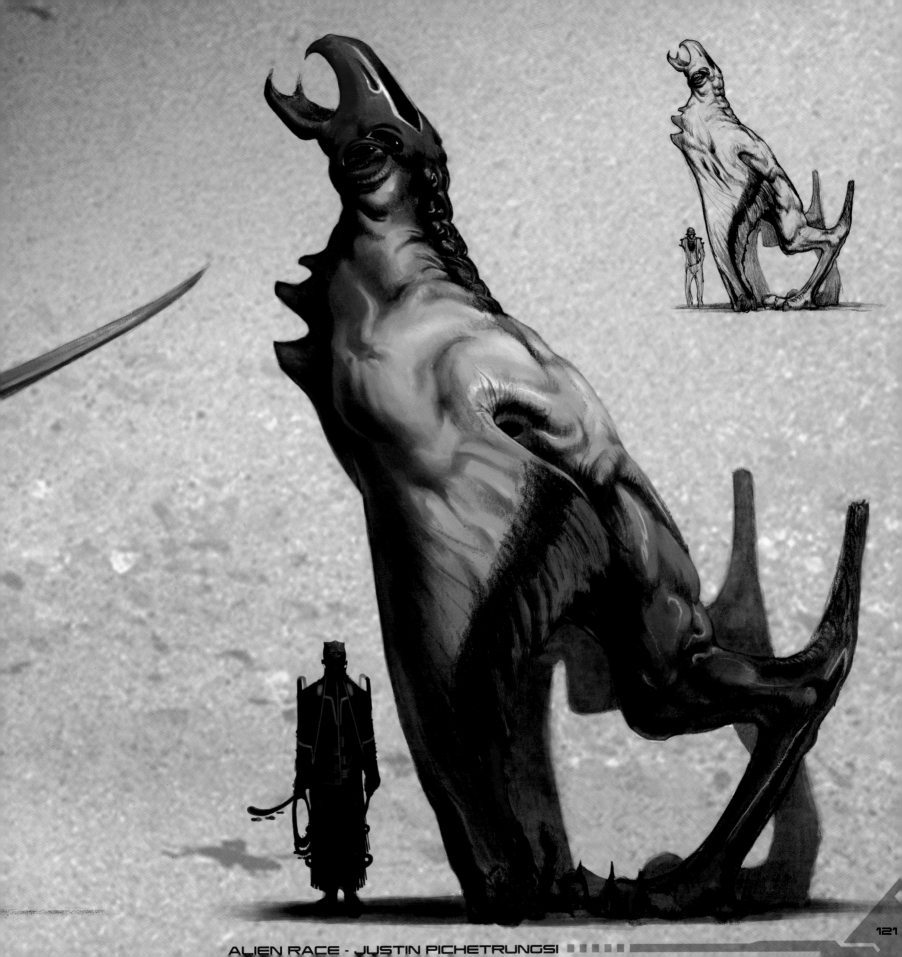

ALIEN RACE - JUSTIN PICHETRUNGSI ▪▪▪▪▪

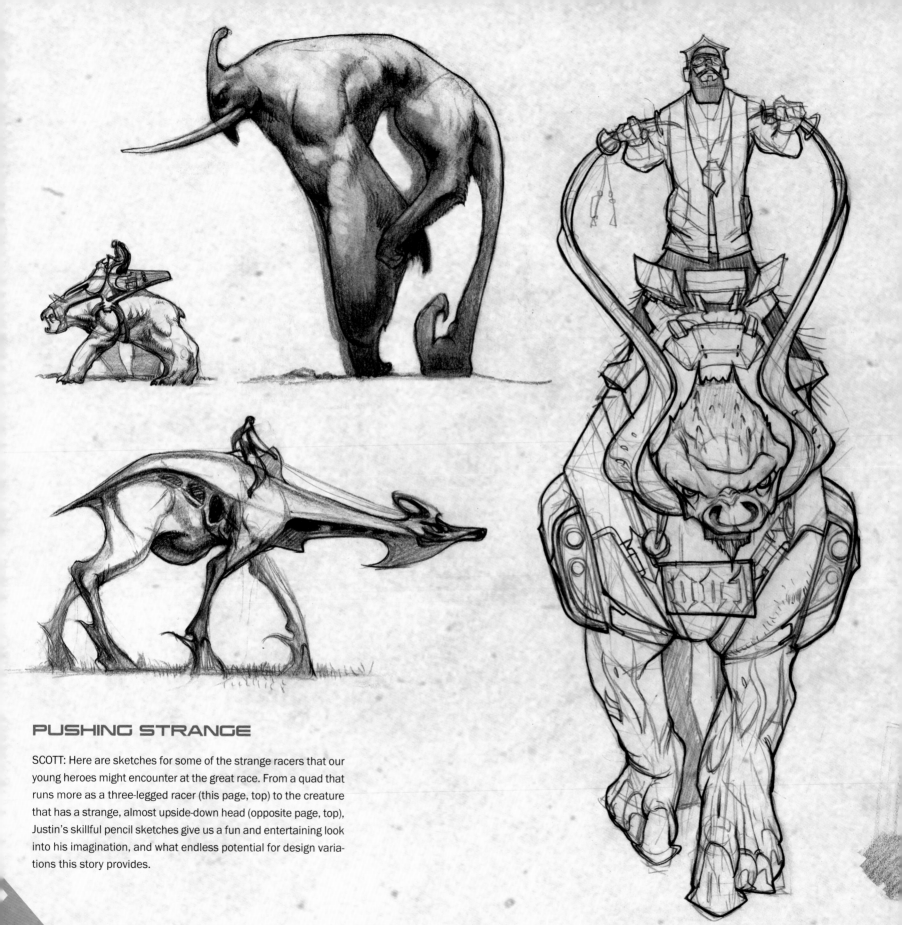

# PUSHING STRANGE

SCOTT: Here are sketches for some of the strange racers that our young heroes might encounter at the great race. From a quad that runs more as a three-legged racer (this page, top) to the creature that has a strange, almost upside-down head (opposite page, top), Justin's skillful pencil sketches give us a fun and entertaining look into his imagination, and what endless potential for design variations this story provides.

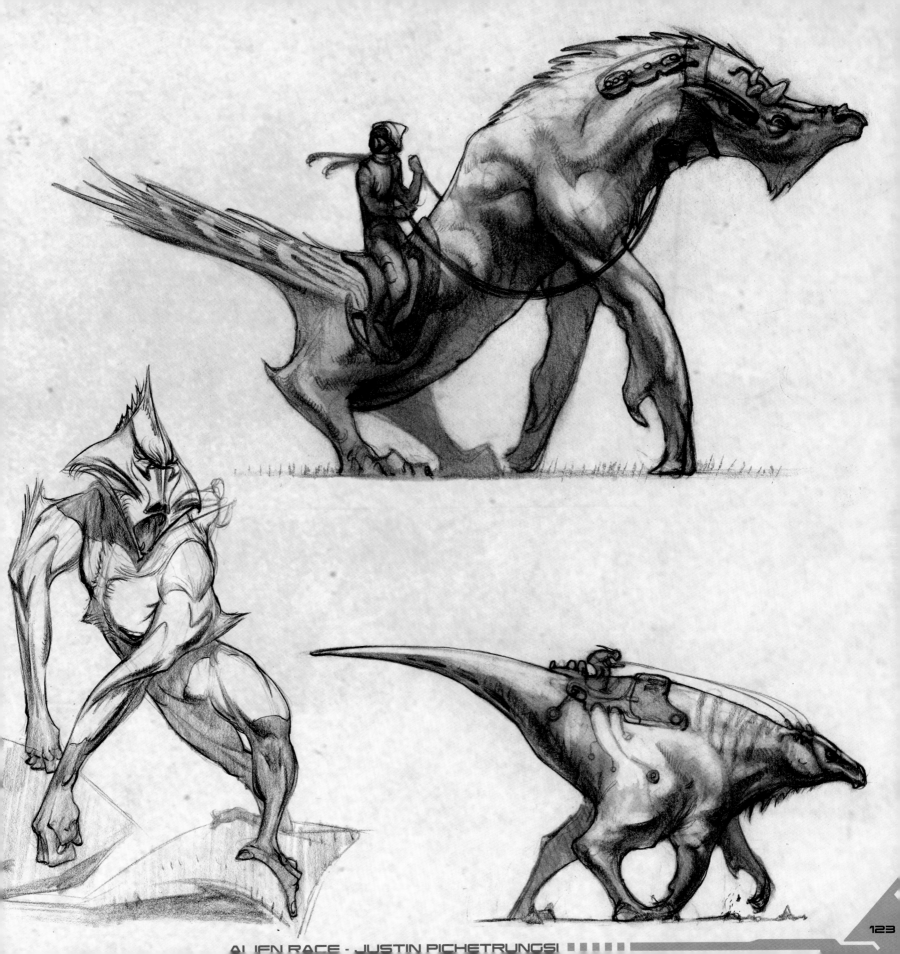

# PHOTOSHOP - ARTISTIC CUTOUT FILTER

SCOTT: These sketches are further investigations of the artistic cutout filter of Photoshop applied to some very simple art, as explained on page 82. The drawings on the facing page started as scanned marker sketches, the drawing below-right was a black ink brush-pen sketch, and the one directly below, the alien on a kind of "speed cow," was originally a pencil and watercolor sketch. I was looking through my early sketches where I was teaching myself how to draw animals, and I thought that by abstracting these a bit they might make for a nice addition to the book as a way to demonstrate how even very simple work can be abstracted and stylized to help find new design directions. A refined and rendered version of the sketch below-right can be seen on page 139. I'm a big fan of manipulating my own work to allow for the "happy accident" to lead me down a different design path than the one I first took while doing the original sketch.

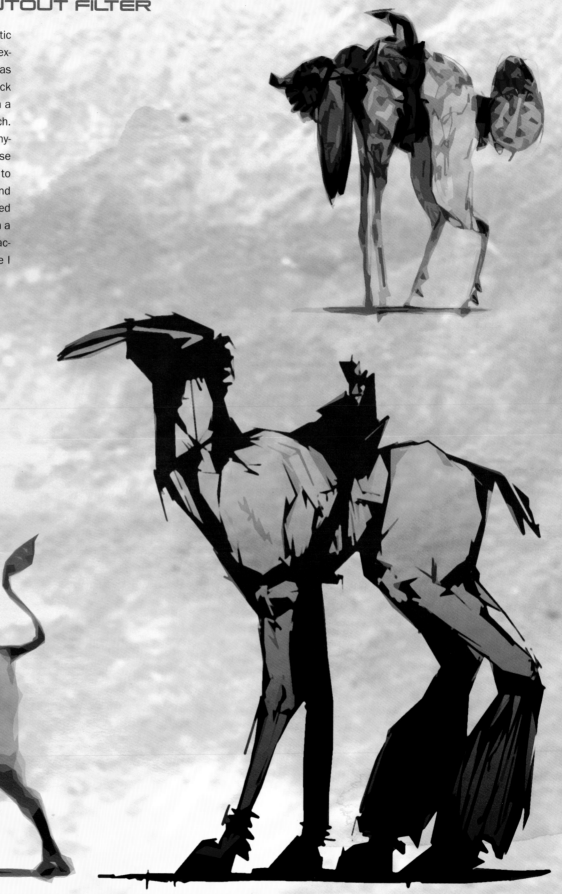

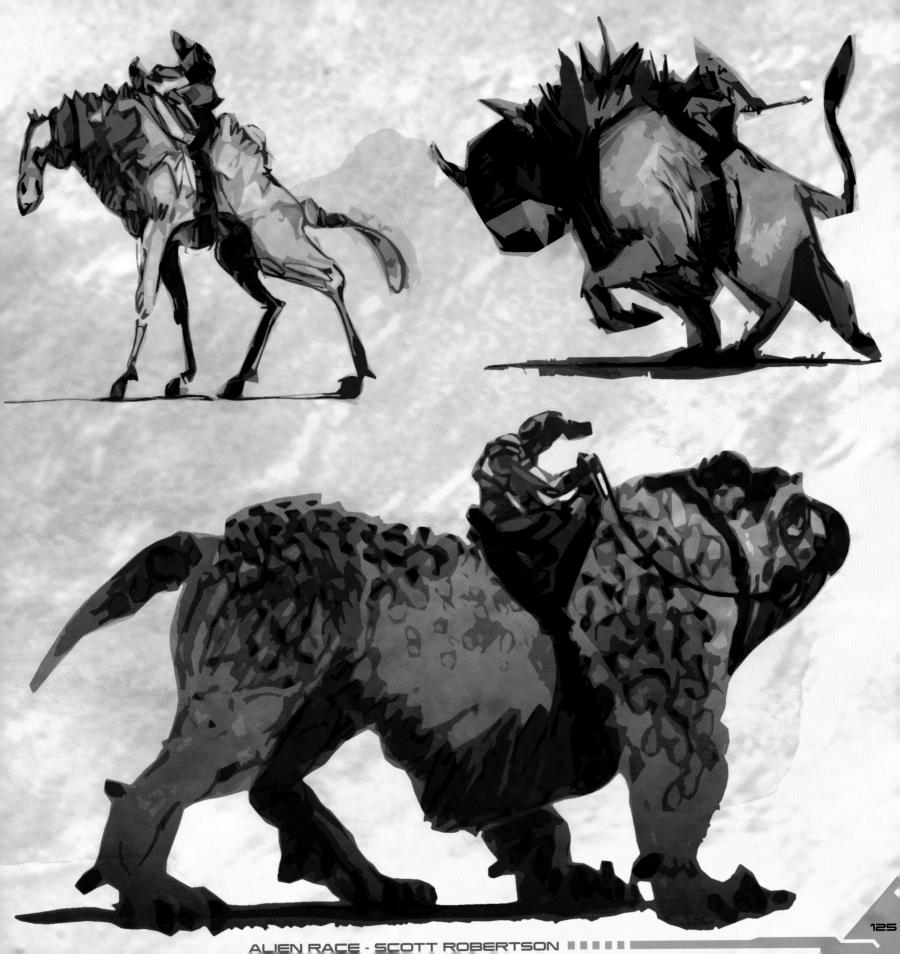

ALIEN RACE · SCOTT ROBERTSON ▌▌▌▌▌

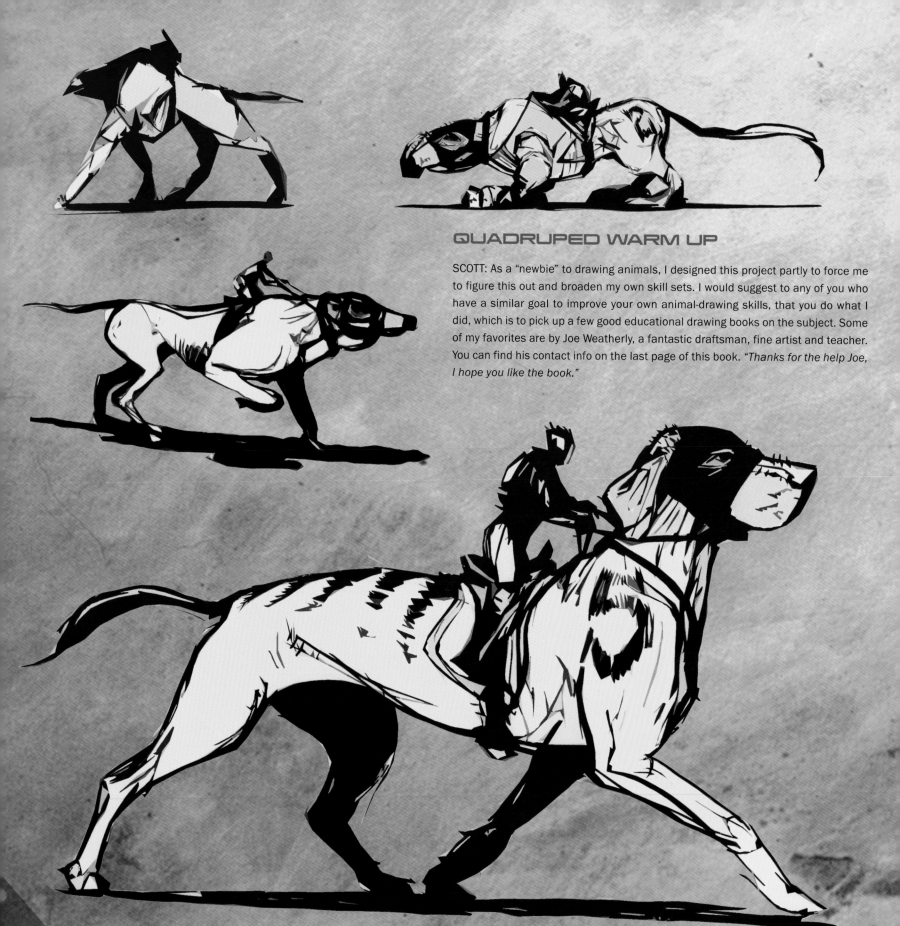

## QUADRUPED WARM UP

SCOTT: As a "newbie" to drawing animals, I designed this project partly to force me to figure this out and broaden my own skill sets. I would suggest to any of you who have a similar goal to improve your own animal-drawing skills, that you do what I did, which is to pick up a few good educational drawing books on the subject. Some of my favorites are by Joe Weatherly, a fantastic draftsman, fine artist and teacher. You can find his contact info on the last page of this book. *"Thanks for the help Joe, I hope you like the book."*

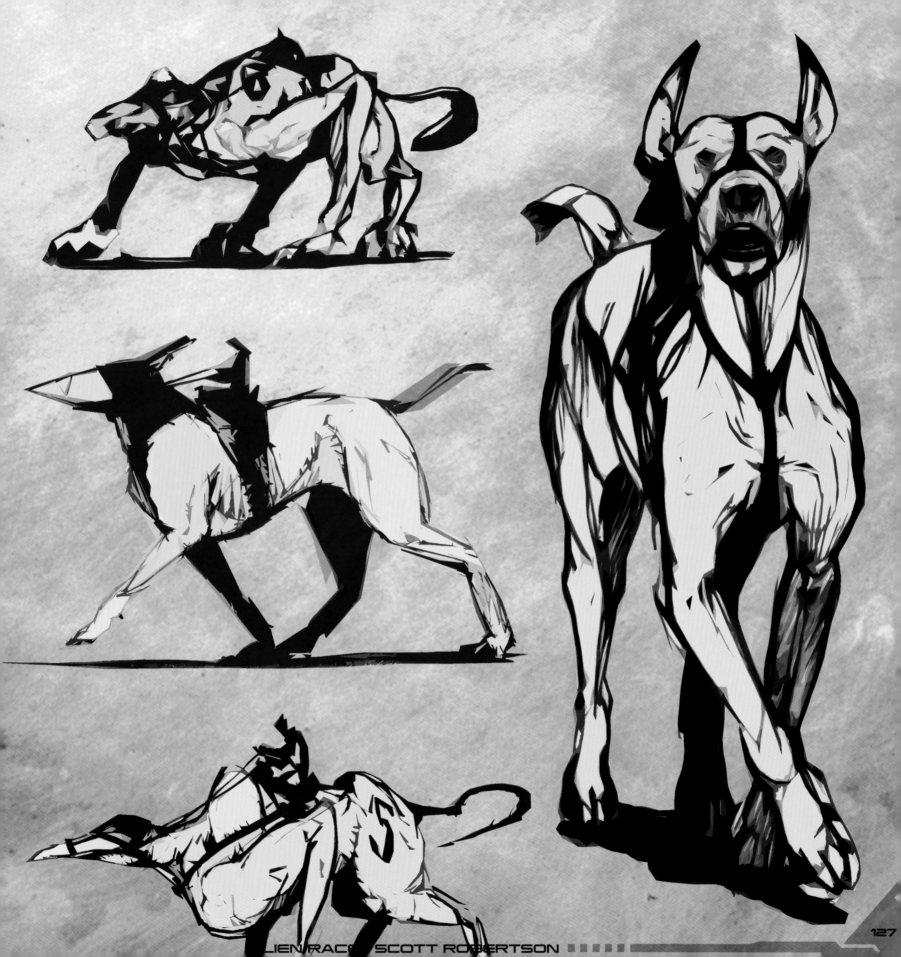

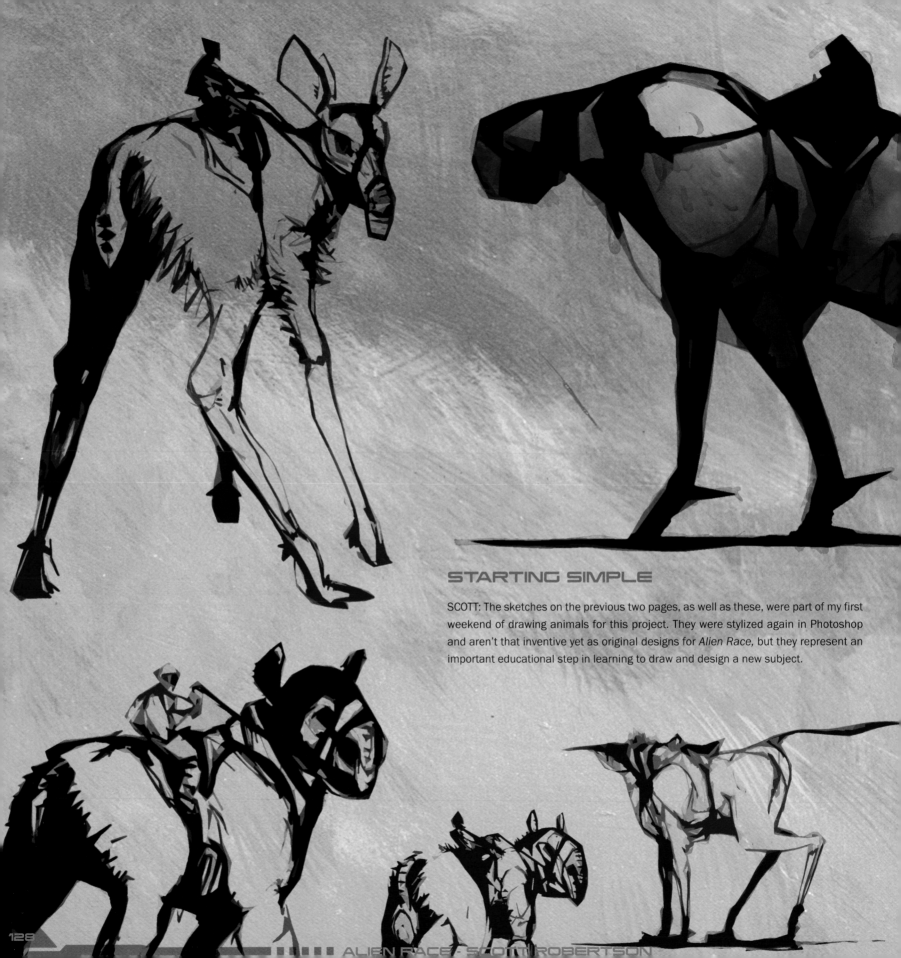

## STARTING SIMPLE

SCOTT: The sketches on the previous two pages, as well as these, were part of my first weekend of drawing animals for this project. They were stylized again in Photoshop and aren't that inventive yet as original designs for *Alien Race*, but they represent an important educational step in learning to draw and design a new subject.

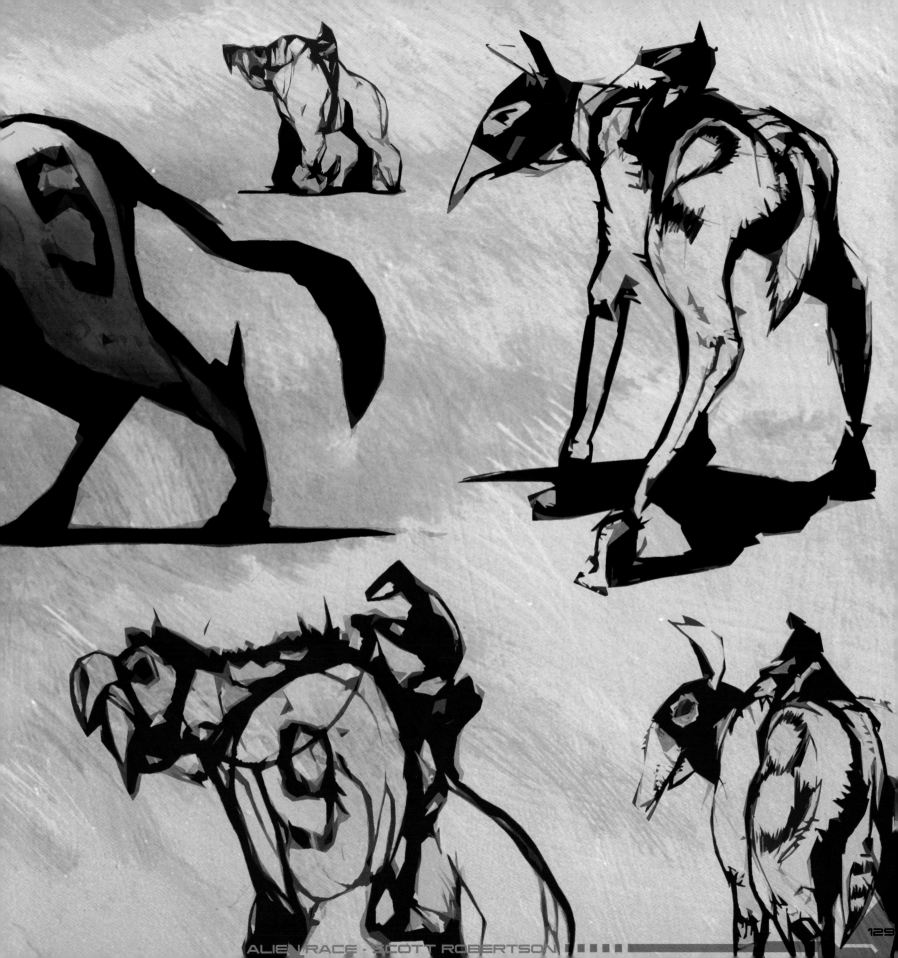

ALIEN RACE - SCOTT ROBERTSON

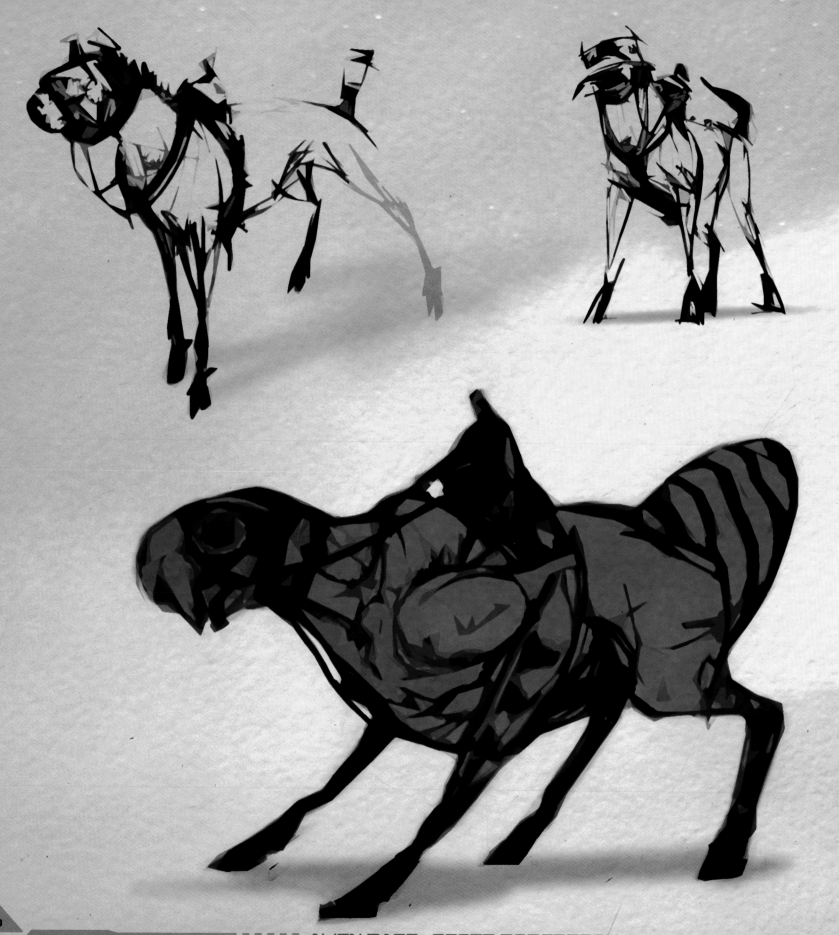

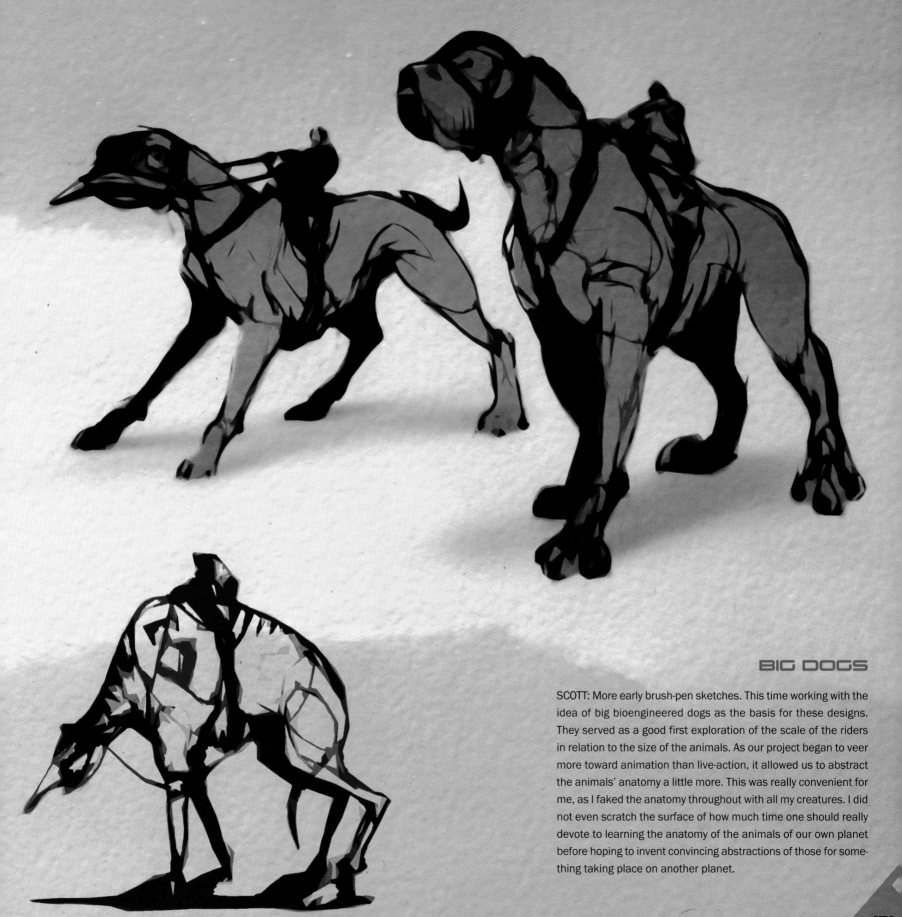

## BIG DOGS

SCOTT: More early brush-pen sketches. This time working with the idea of big bioengineered dogs as the basis for these designs. They served as a good first exploration of the scale of the riders in relation to the size of the animals. As our project began to veer more toward animation than live-action, it allowed us to abstract the animals' anatomy a little more. This was really convenient for me, as I faked the anatomy throughout with all my creatures. I did not even scratch the surface of how much time one should really devote to learning the anatomy of the animals of our own planet before hoping to invent convincing abstractions of those for some-thing taking place on another planet.

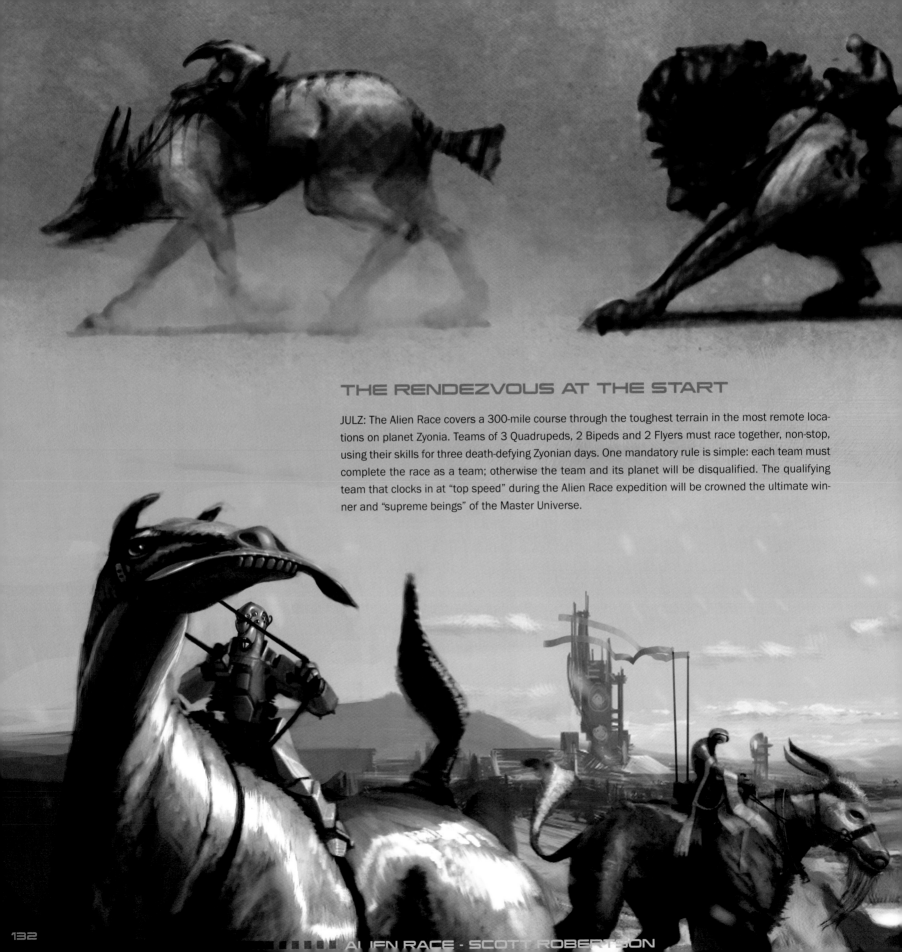

## THE RENDEZVOUS AT THE START

JULZ: The Alien Race covers a 300-mile course through the toughest terrain in the most remote locations on planet Zyonia. Teams of 3 Quadrupeds, 2 Bipeds and 2 Flyers must race together, non-stop, using their skills for three death-defying Zyonian days. One mandatory rule is simple: each team must complete the race as a team; otherwise the team and its planet will be disqualified. The qualifying team that clocks in at "top speed" during the Alien Race expedition will be crowned the ultimate winner and "supreme beings" of the Master Universe.

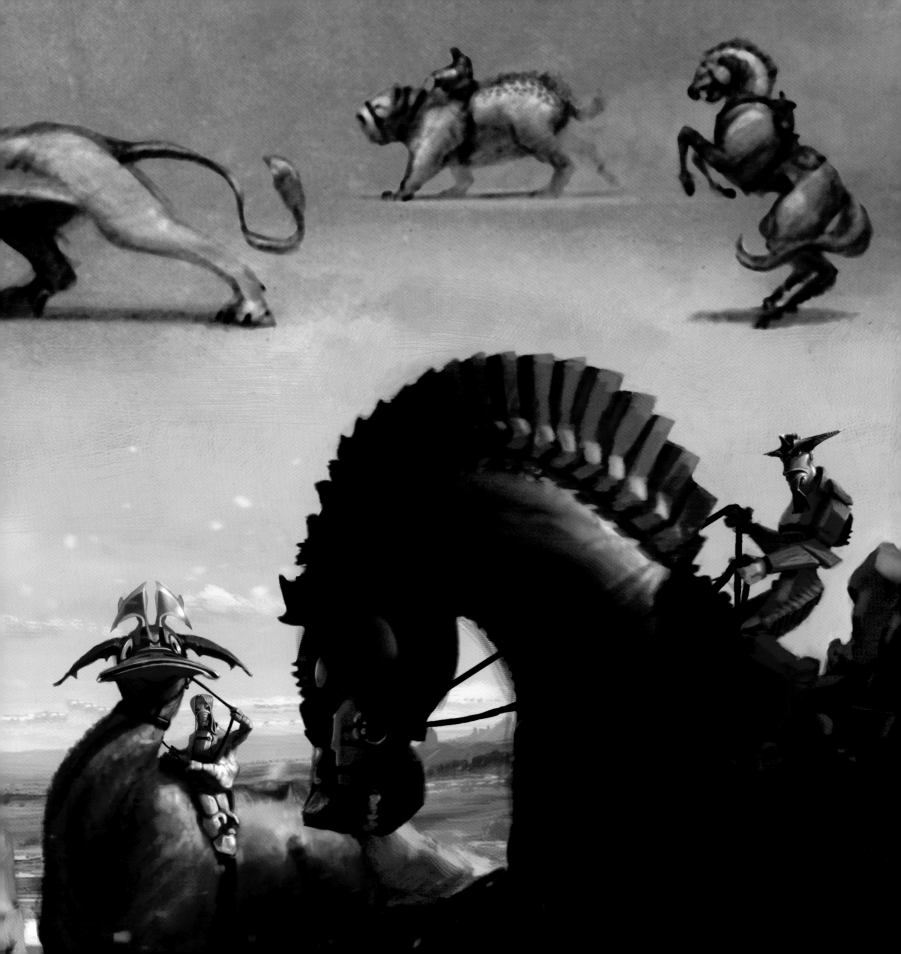

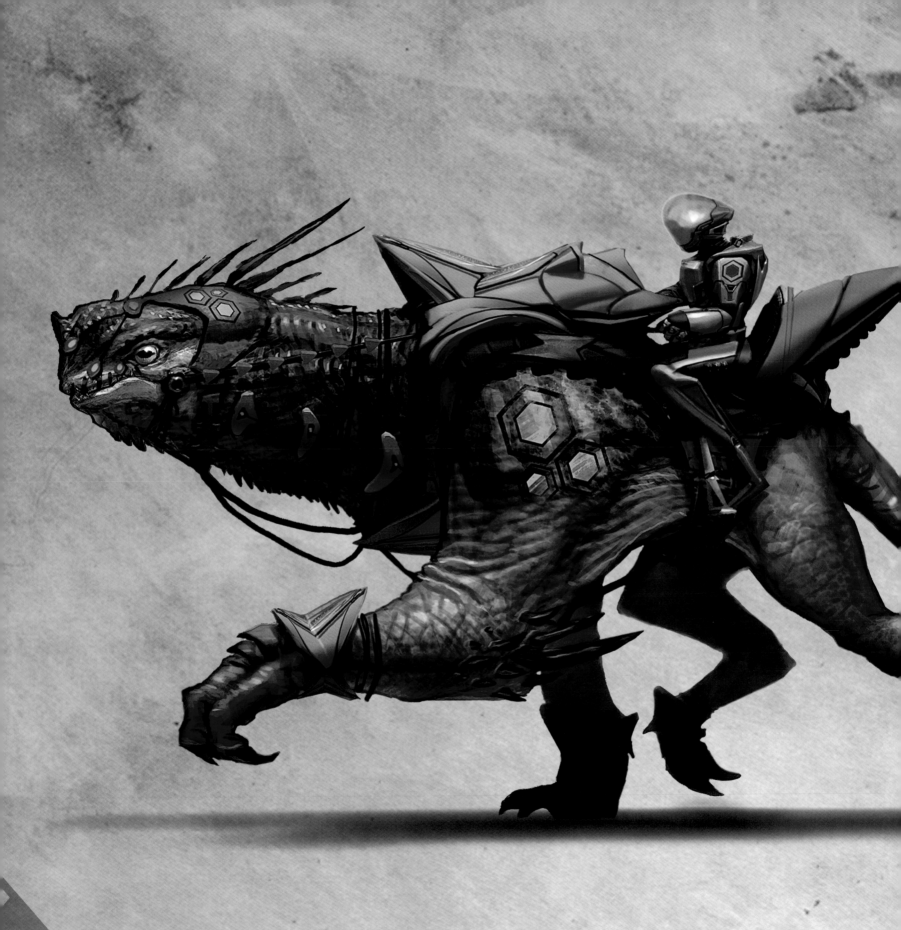

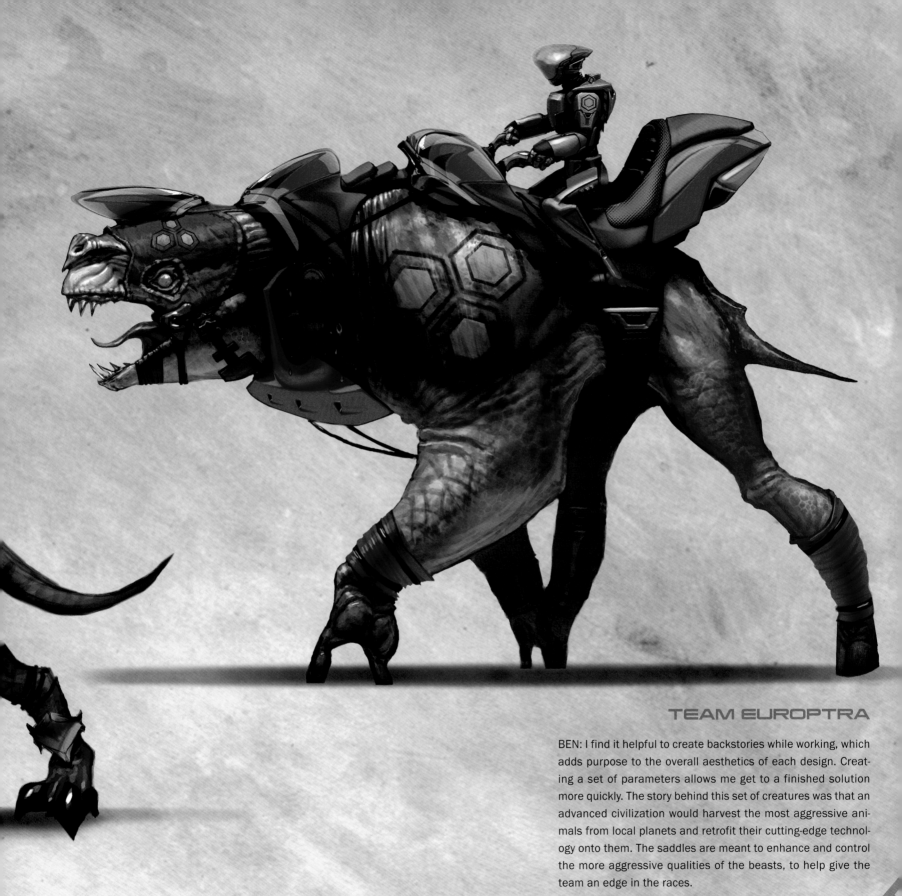

## TEAM EUROPTRA

BEN: I find it helpful to create backstories while working, which adds purpose to the overall aesthetics of each design. Creating a set of parameters allows me get to a finished solution more quickly. The story behind this set of creatures was that an advanced civilization would harvest the most aggressive animals from local planets and retrofit their cutting-edge technology onto them. The saddles are meant to enhance and control the more aggressive qualities of the beasts, to help give the team an edge in the races.

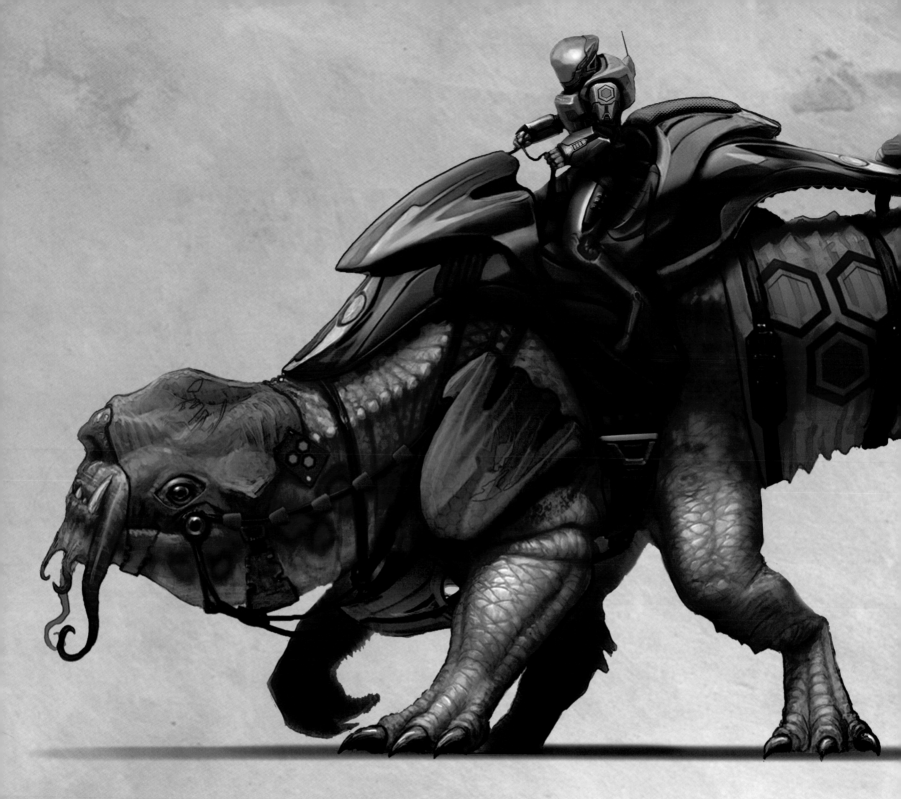

## DARSHIAN

BEN: My thoughts on the concept of *Alien Race* were that of a bizarre, futuristic MotoGP. After looking at real-world motorcycles and horse-racing saddles, I took some of the basic mechanics and functionality of the rider/vehicle relationship and extrapolated it into something (hopefully) new, yet believable. Looking at many of the aggressive, streamlined forms found in modern racing bikes, I attempted to translate a similar form language into the saddles on my creatures.

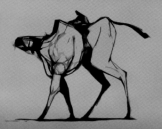
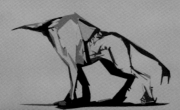
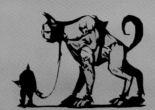
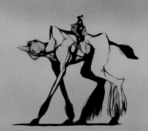

# THE CHALLENGE

SCOTT: While painting this piece I imagined the alien rider on this page to be a grumpy, arrogant, older past champion, engaged in some pre-race taunting of an earthling rider. This does not sit well with the earthling and he responds with his own universal hand gesture.

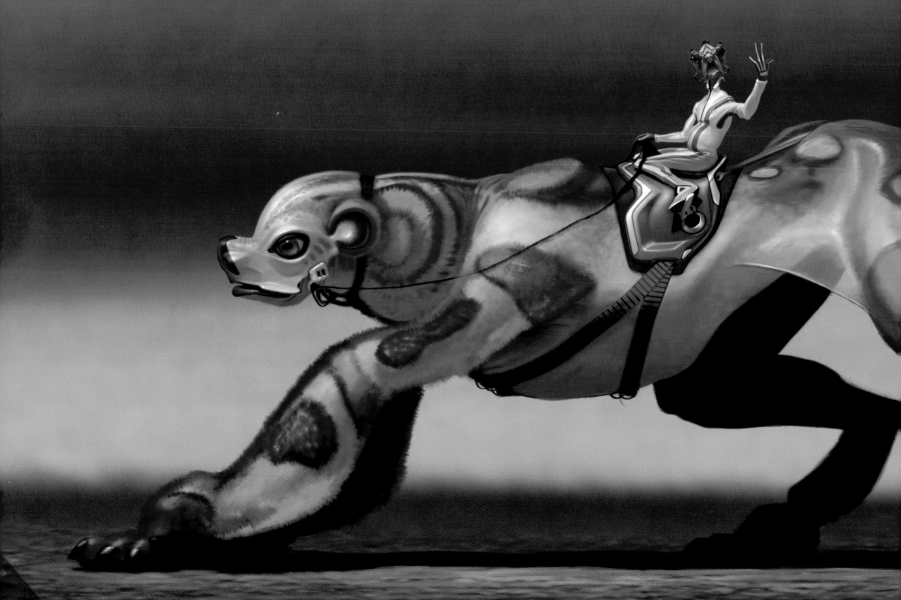

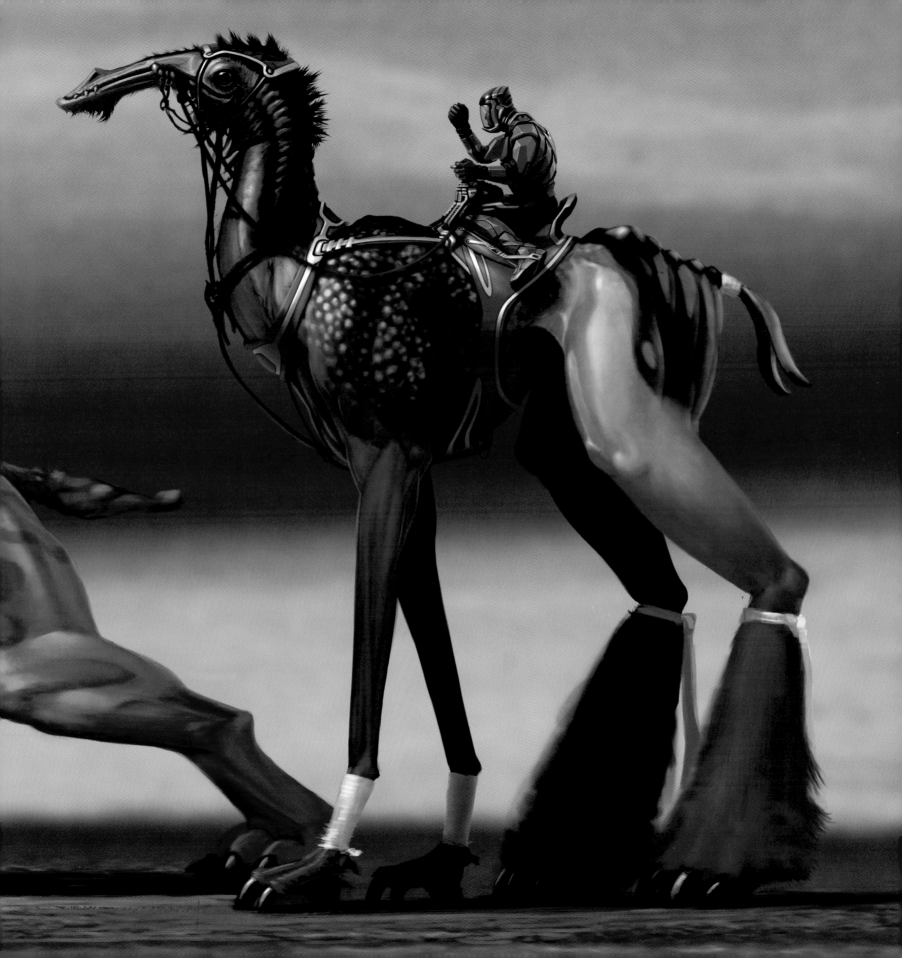

# ANTIGUS

SCOTT: Below, a horse-inspired design with a fully armored rider atop. Strong colors and graphics set apart both the rider and the creature from the field of other competitors. This quadruped, named Antigus, has a very long, hinged tail that unfolds to help with balance as it runs around sharp corners. The odd hooves, more like big toes, provide excellent grip. That ability, coupled with the articulating tail, make this one formidable racer!

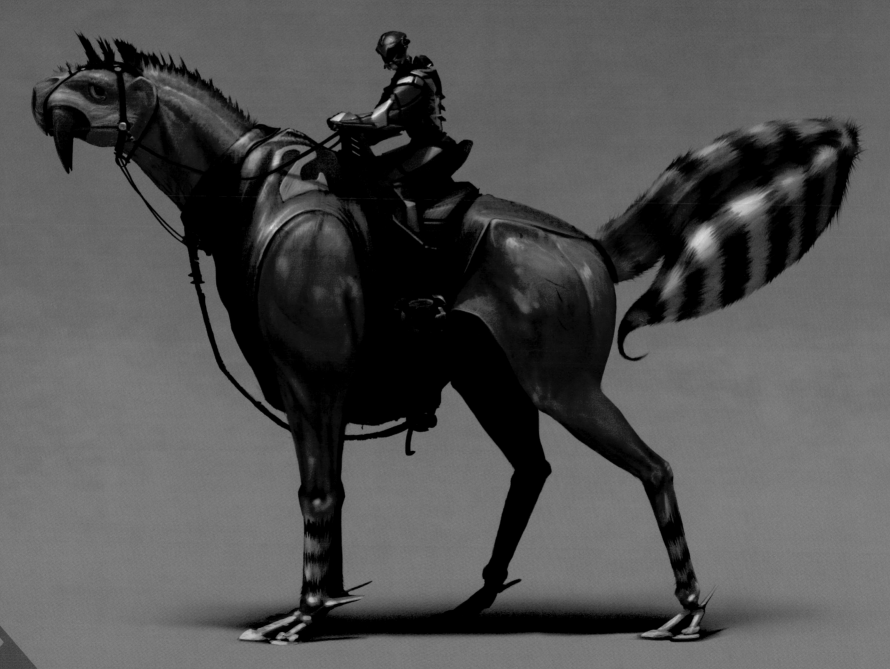

ALIEN RACE · SCOTT ROBERTSON

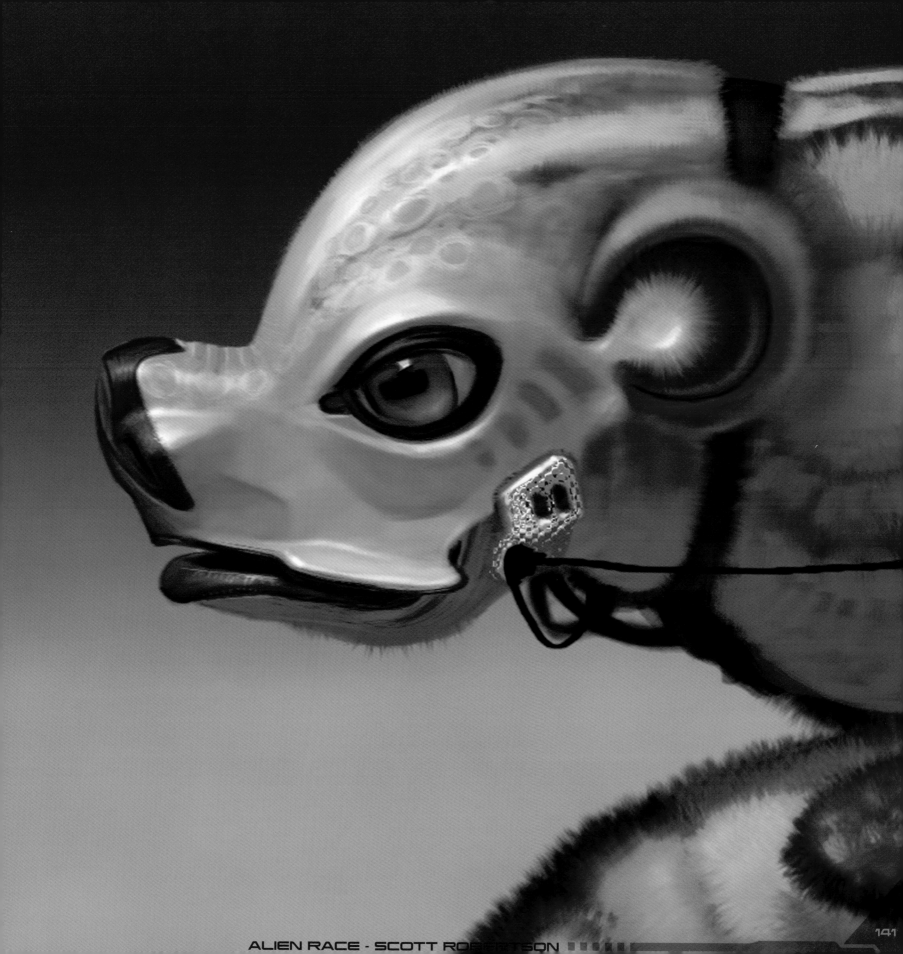

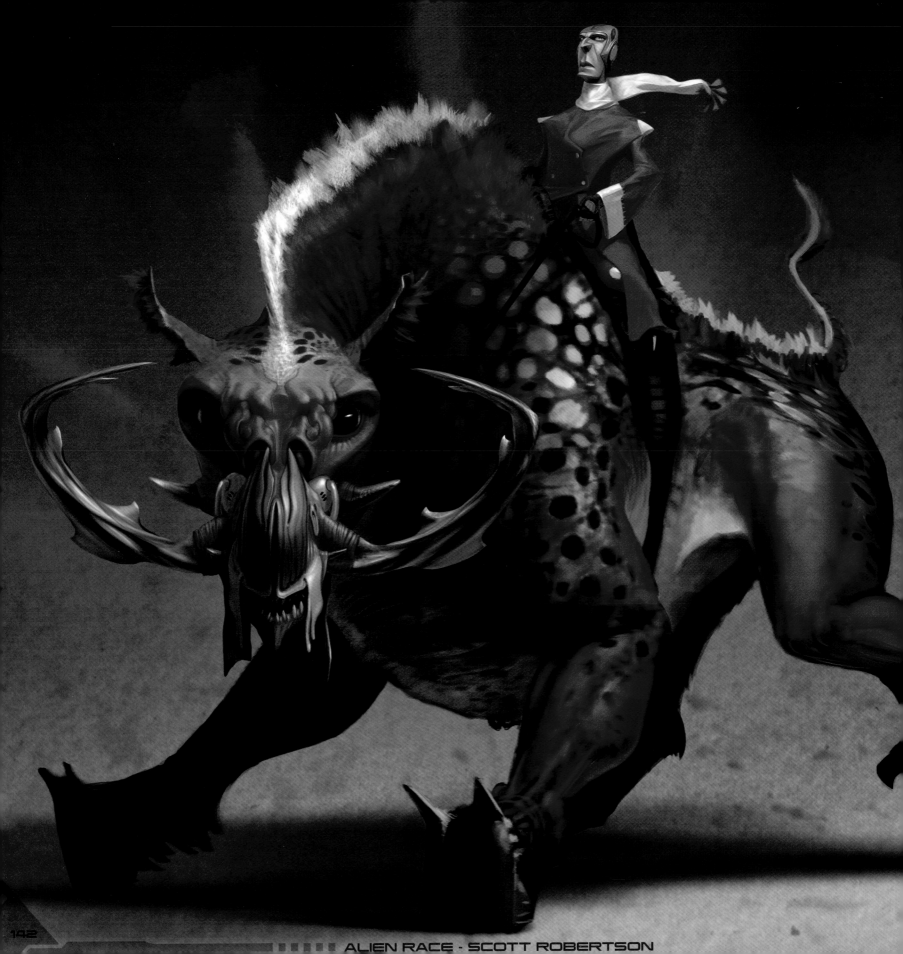

ALIEN RACE · SCOTT ROBERTSON

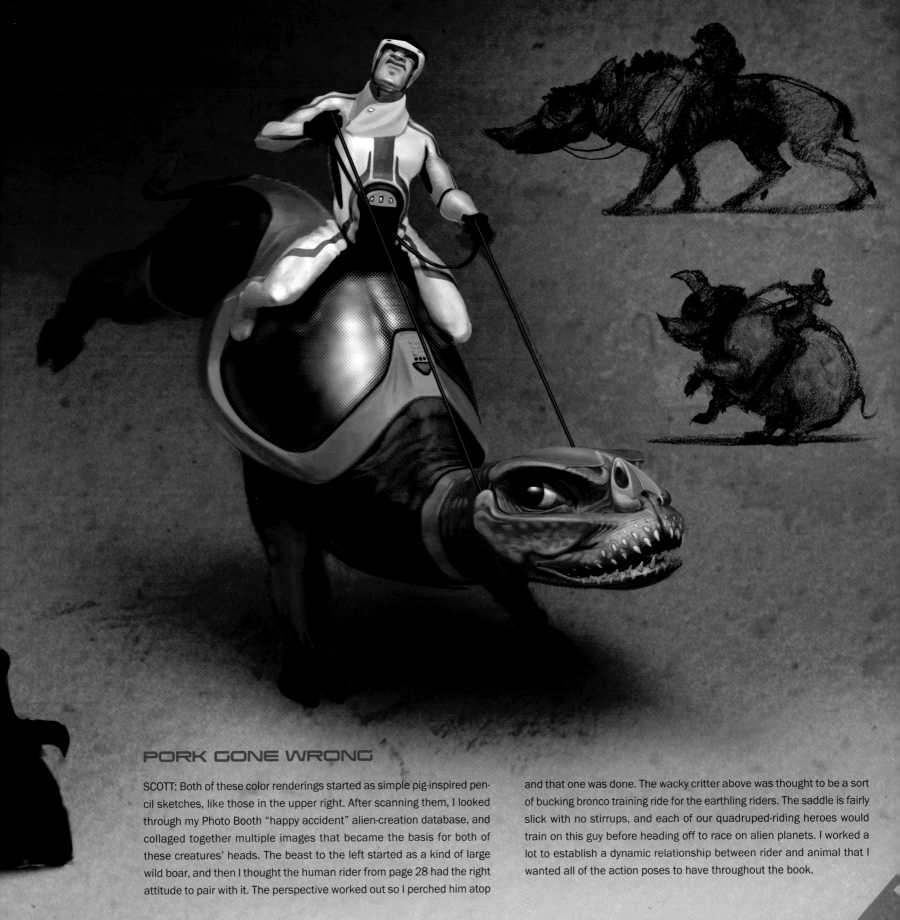

## PORK GONE WRONG

SCOTT: Both of these color renderings started as simple pig-inspired pencil sketches, like those in the upper right. After scanning them, I looked through my Photo Booth "happy accident" alien-creation database, and collaged together multiple images that became the basis for both of these creatures' heads. The beast to the left started as a kind of large wild boar, and then I thought the human rider from page 28 had the right attitude to pair with it. The perspective worked out so I perched him atop and that one was done. The wacky critter above was thought to be a sort of bucking bronco training ride for the earthling riders. The saddle is fairly slick with no stirrups, and each of our quadruped-riding heroes would train on this guy before heading off to race on alien planets. I worked a lot to establish a dynamic relationship between rider and animal that I wanted all of the action poses to have throughout the book.

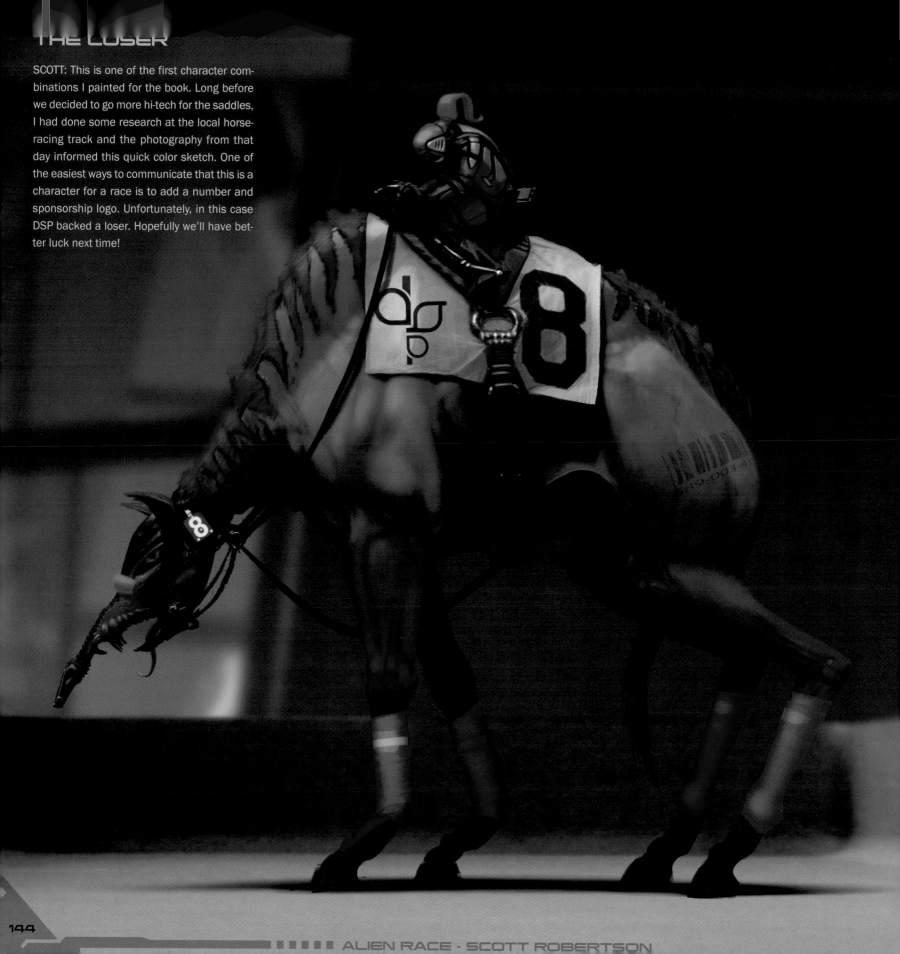

SCOTT: This is one of the first character combinations I painted for the book. Long before we decided to go more hi-tech for the saddles, I had done some research at the local horse-racing track and the photography from that day informed this quick color sketch. One of the easiest ways to communicate that this is a character for a race is to add a number and sponsorship logo. Unfortunately, in this case DSP backed a loser. Hopefully we'll have better luck next time!

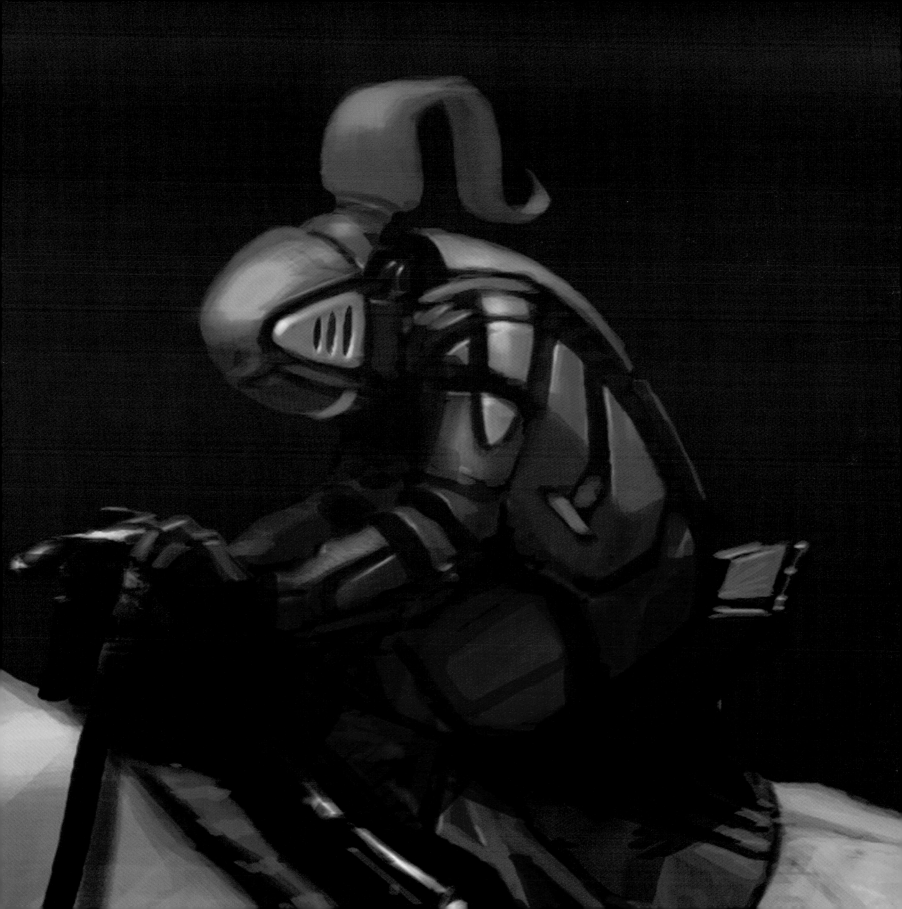

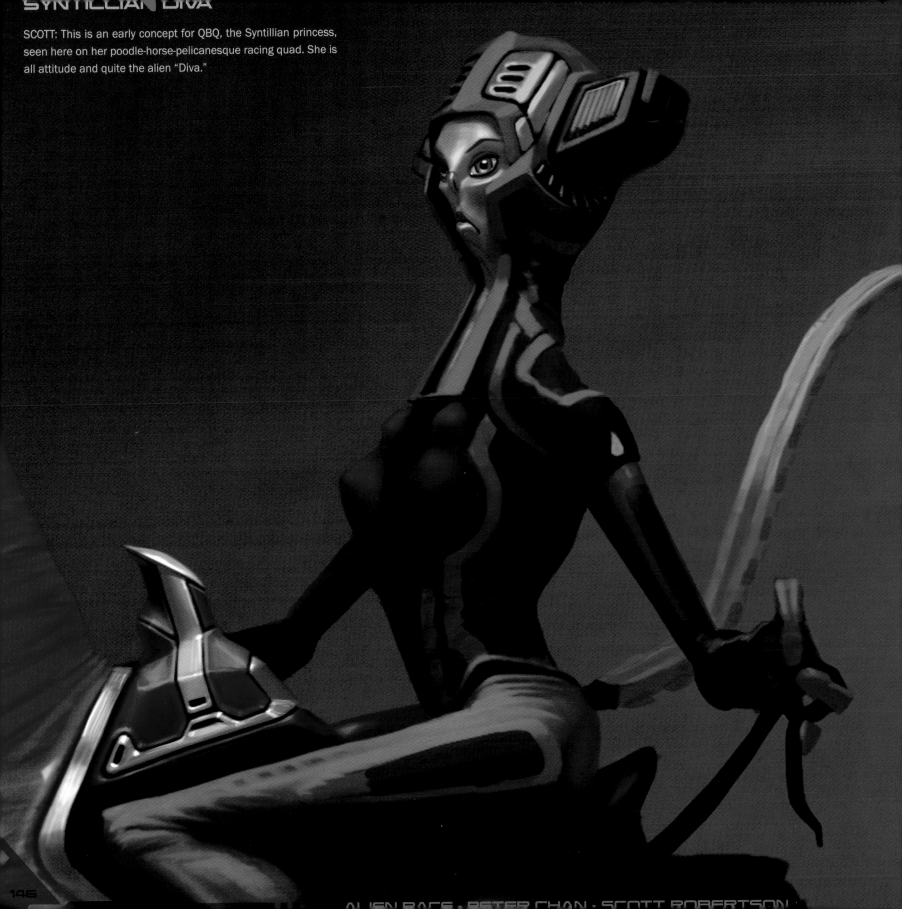

# SYNTILLIAN DIVA

SCOTT: This is an early concept for QBQ, the Syntillian princess, seen here on her poodle-horse-pelicanesque racing quad. She is all attitude and quite the alien "Diva."

ALIEN RACE · PETER CHAN · SCOTT ROBERTSON

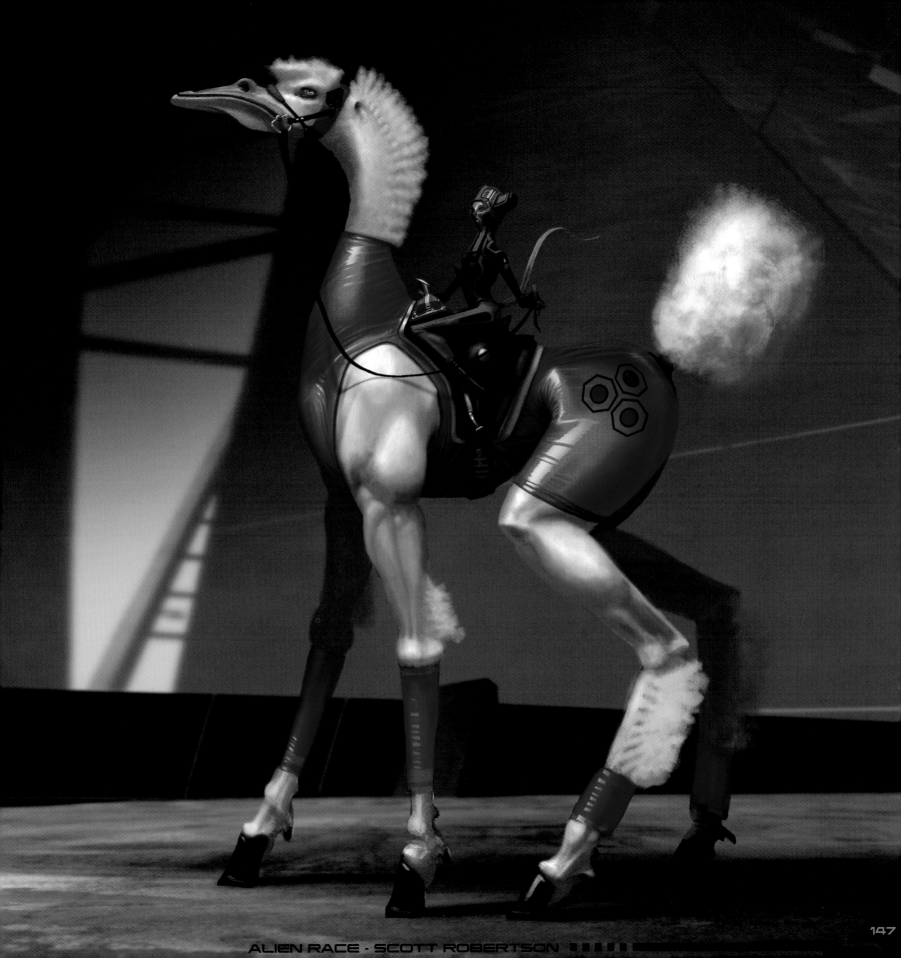

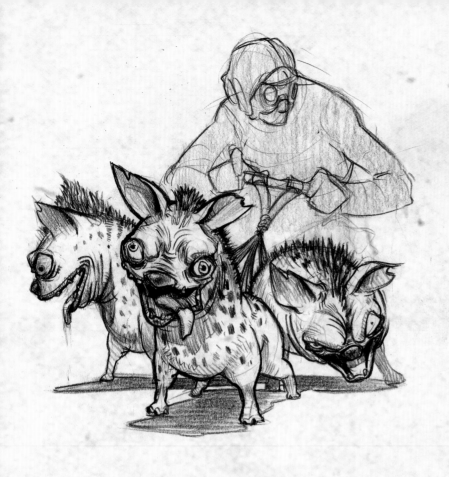

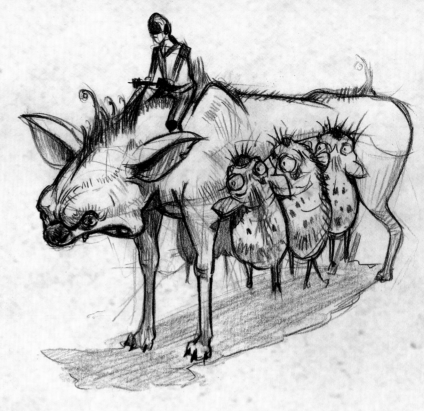

## EARLY QUADRUPEDS

PETER: Here are some explorations of hyena-based creatures. My favorite is probably the mother with the babies hanging onto her side. I thought it would be so fun if those babies were used as gadgets, where they roll off and bite other racers.

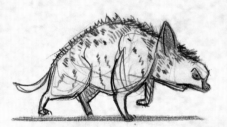

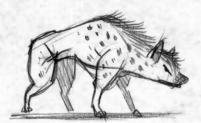

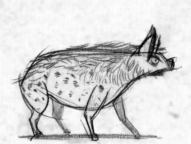

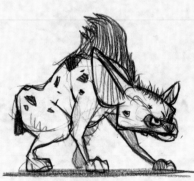

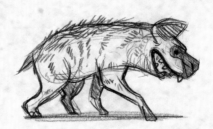

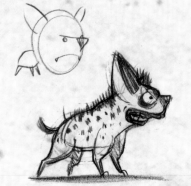

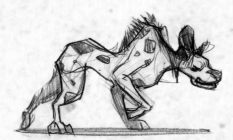

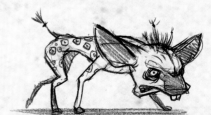

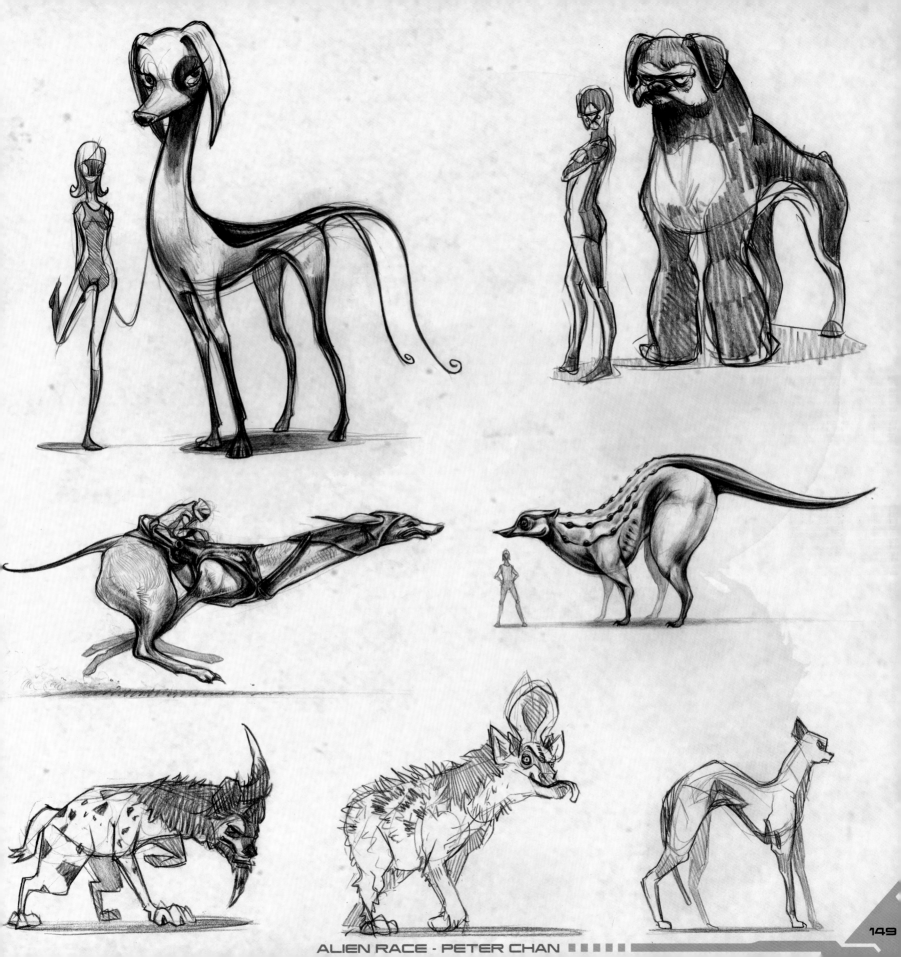

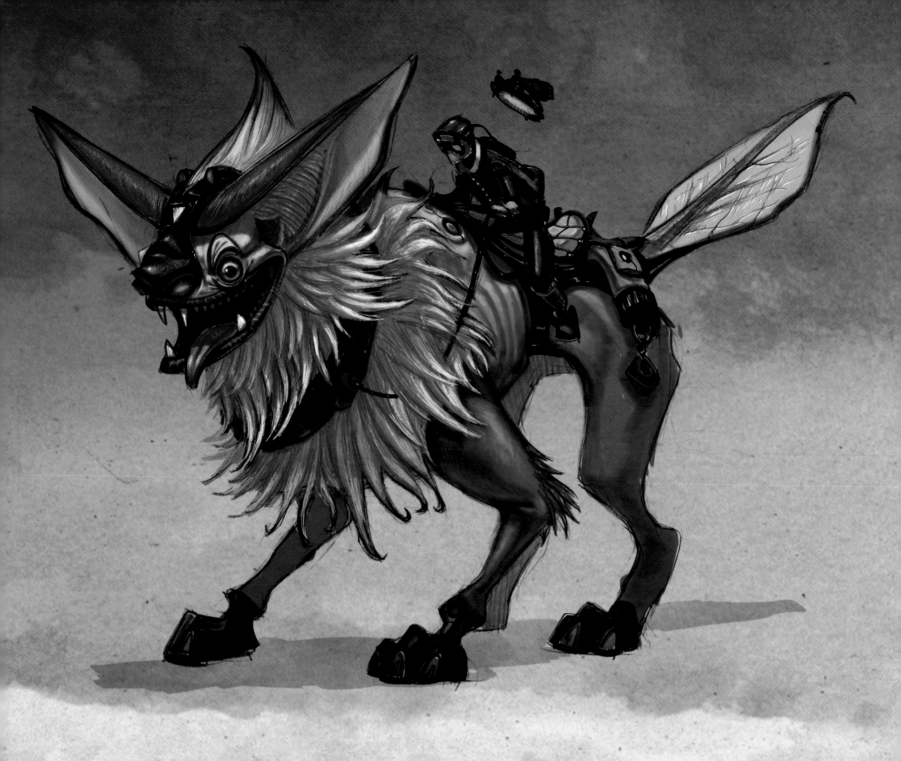

# BAT-DOG / RED BULL

PETER: These were early style explorations of the look of the creatures. I was playing around with a more cartoonish look, putting more emphasis on the creatures' personalities and expressions.

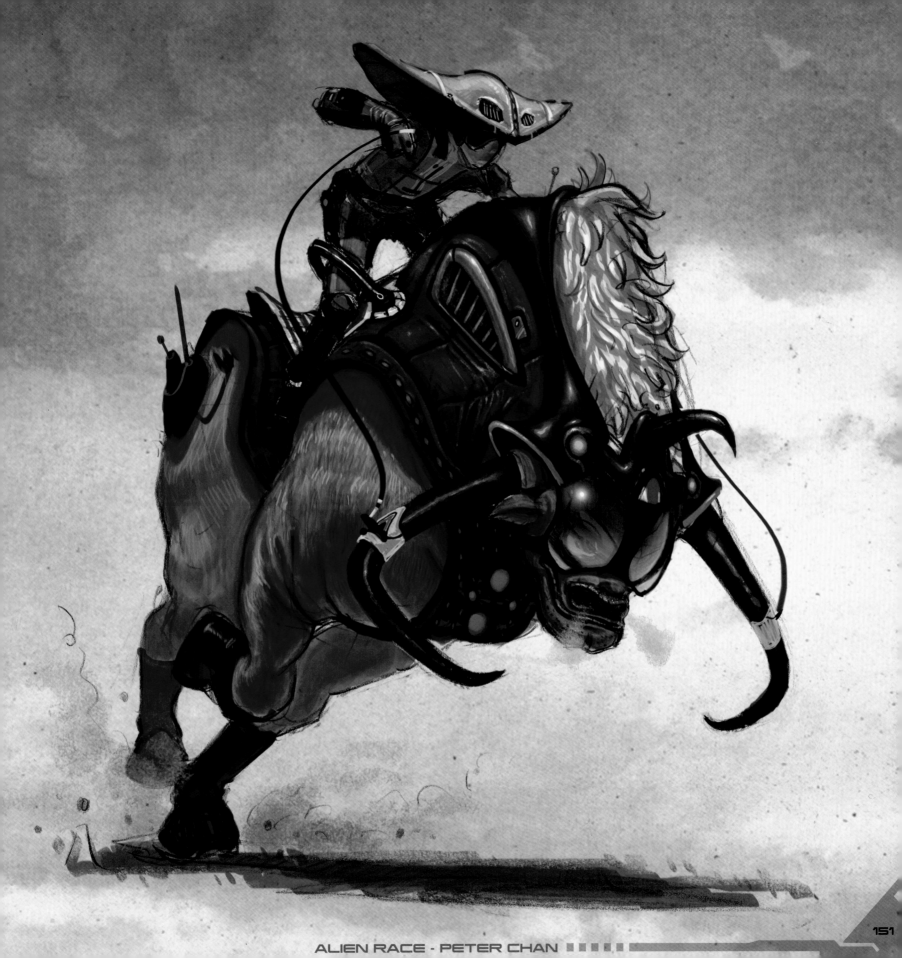

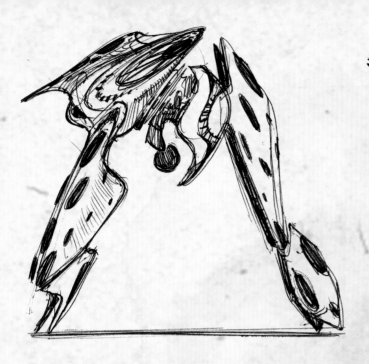
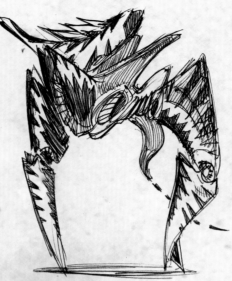
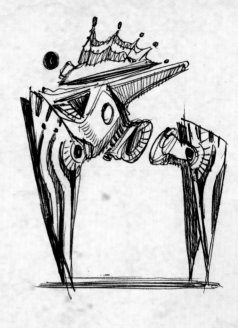
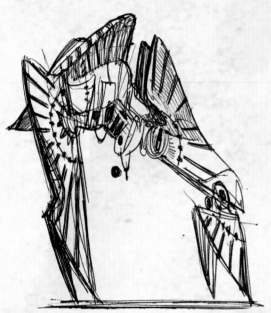
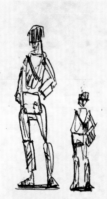
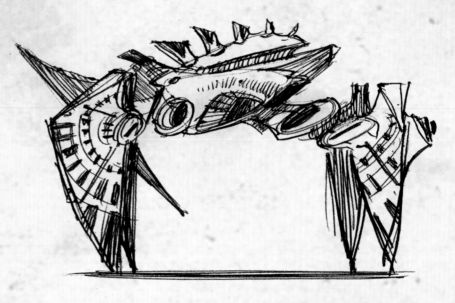

## ALIEN QUADS

PETER: Having done mostly animal-like creatures so far, I wanted to explore some hard-shelled, insect-carcass-based creatures. The most challenging part was to make them feel like they could race and move naturally instead of a like robots.

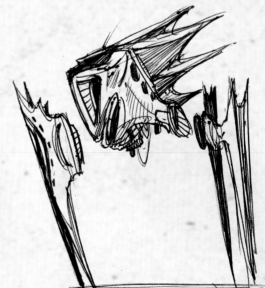

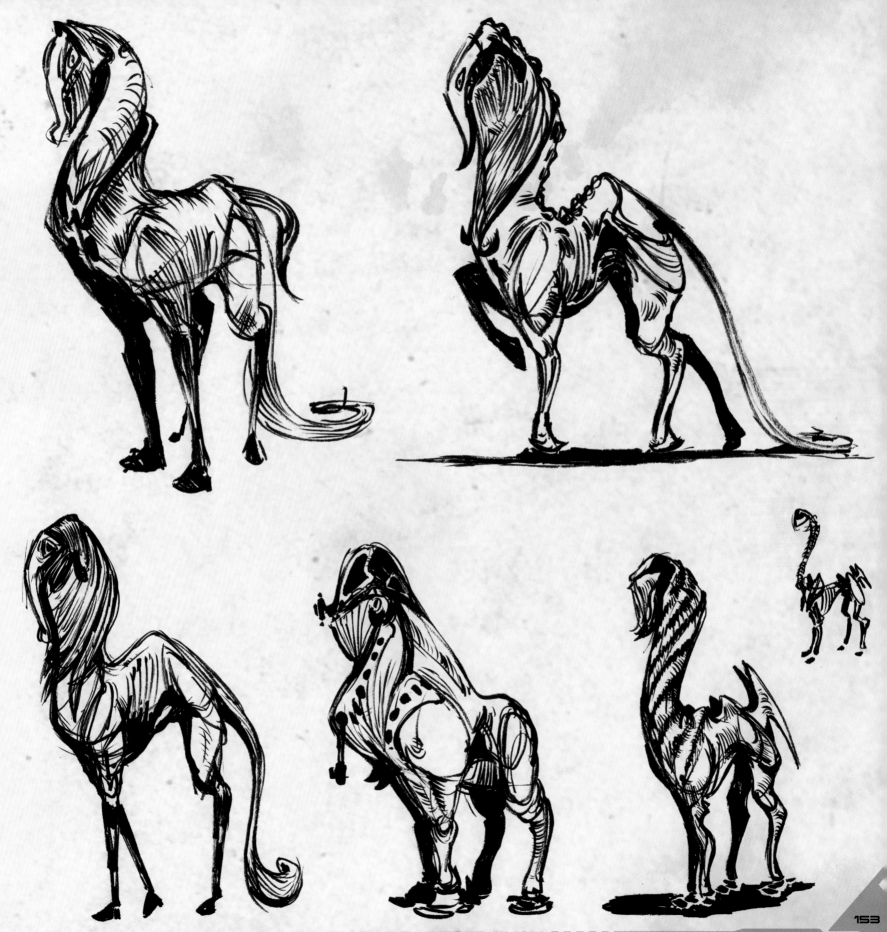

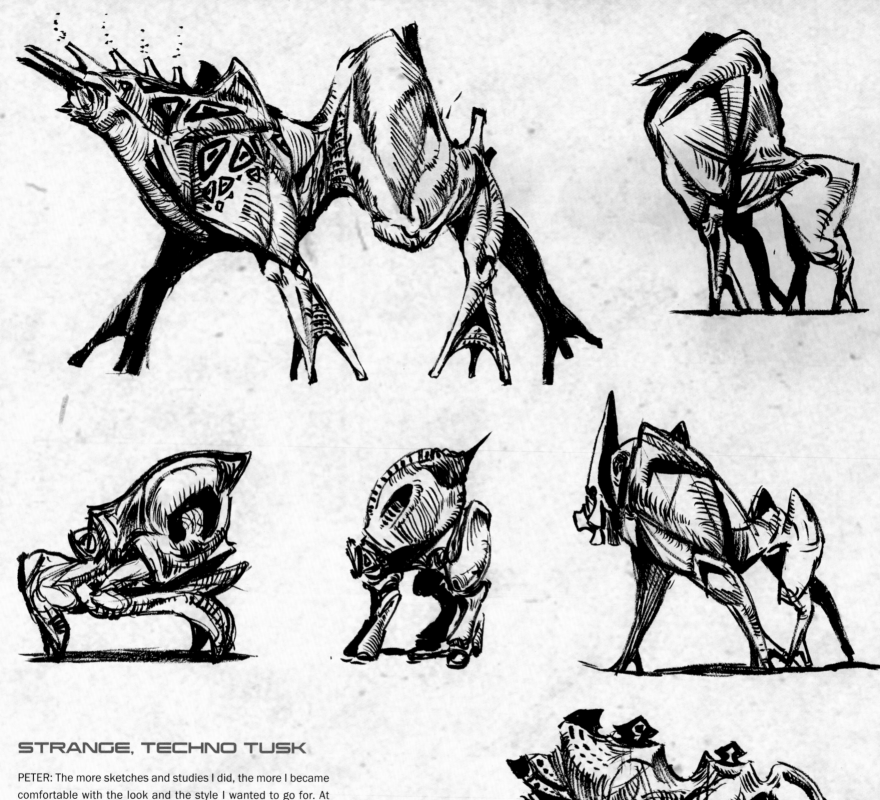

## STRANGE, TECHNO TUSK

PETER: The more sketches and studies I did, the more I became comfortable with the look and the style I wanted to go for. At this point, I definitely wanted to push the bulky, muscular aspects of the creatures.

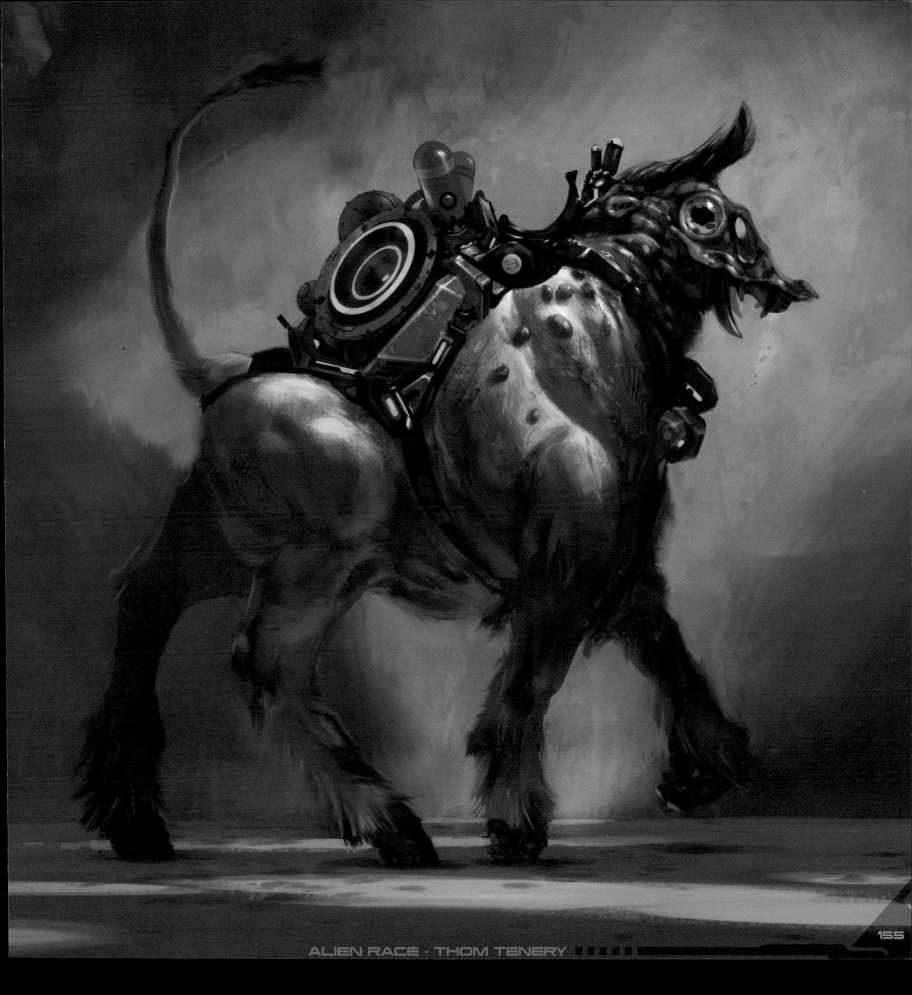

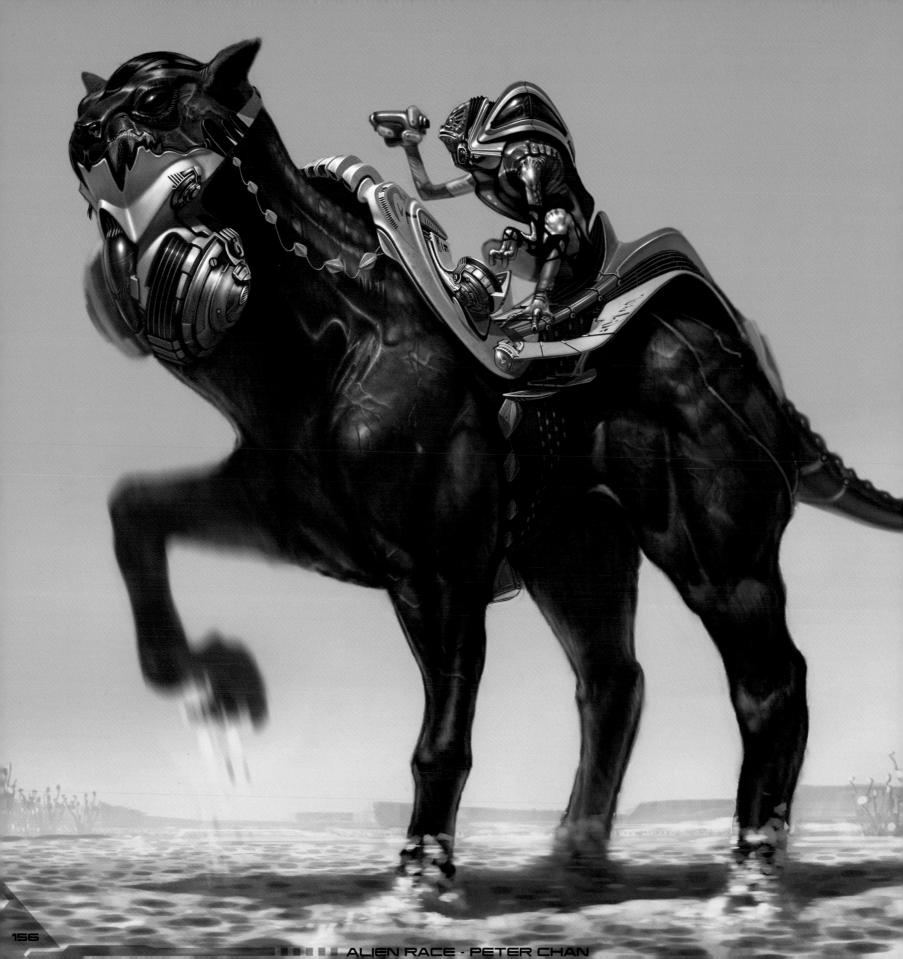

ALIEN RACE - PETER CHAN

PETER: The royal family of Kaomsh has participated in every in-
tergalactic race for the past 5 centuries, but has failed to achieve
results that live up to the expectations of the king. This year, the
newly crowned prince is determined to win with his specially bio-
engineered stallion, Gold Rush. Gold Rush has swift and accurate
reflexes that give him an advantage in overcoming most obsta-
cles and traps. The breathing apparatus on the lower part of his
jaw benefits him in the changing climates and protects him from
pollutants in the air.

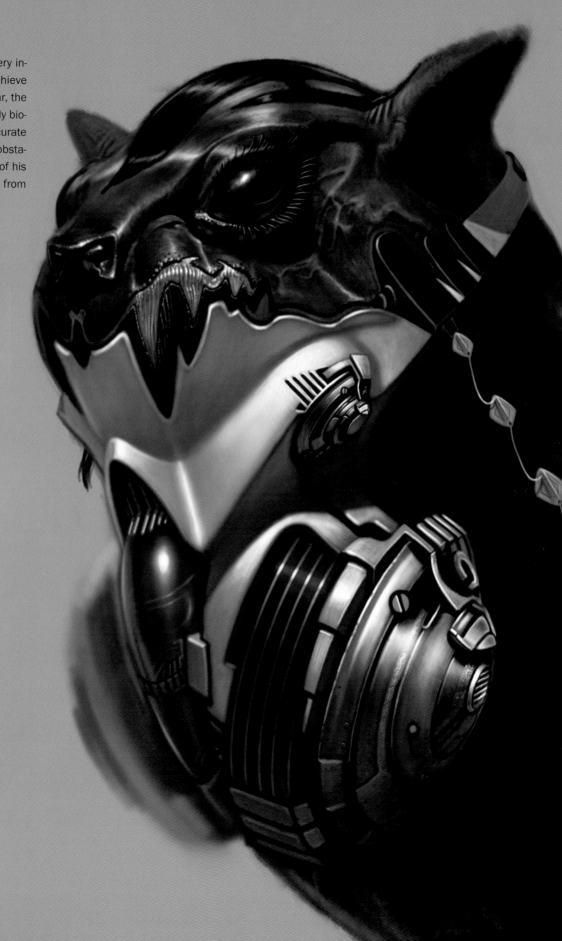

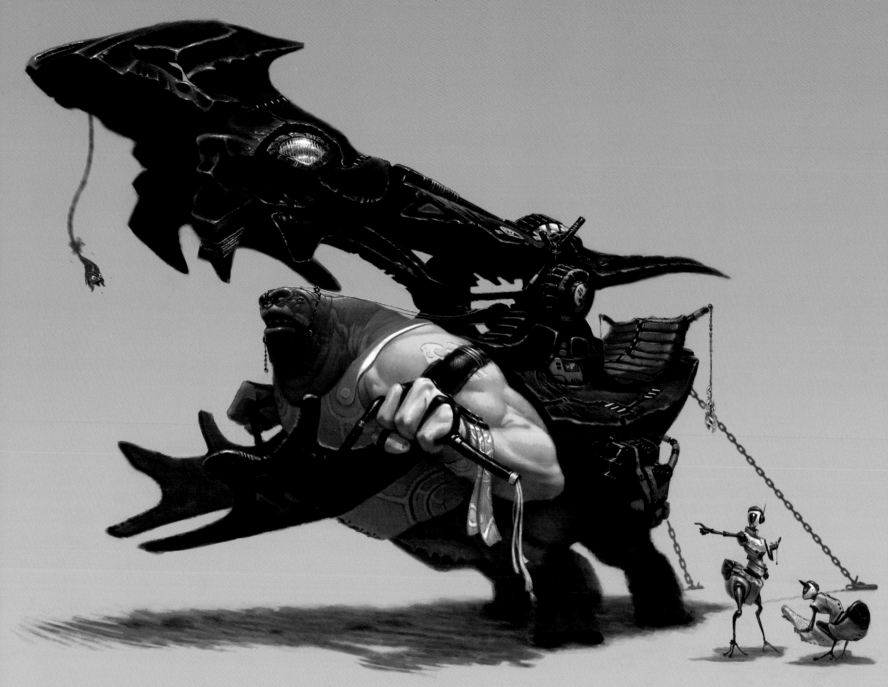

## MELLOW YELLOW

PETER: Mellow Yellow was engineered to have a very powerful build with high stamina, however his lack of intelligence and drive to win often prevent him from fully taking advantage of his capacity and strength. Hopefully in this year's race, a specially selected dual rider and his intimidating new "bone skull" gear will aid him to capitalize on his true potential. The powerful jaw of the "bone skull" creates 100 tons of snap that can clear paths, creating short cuts that are otherwise unreachable.

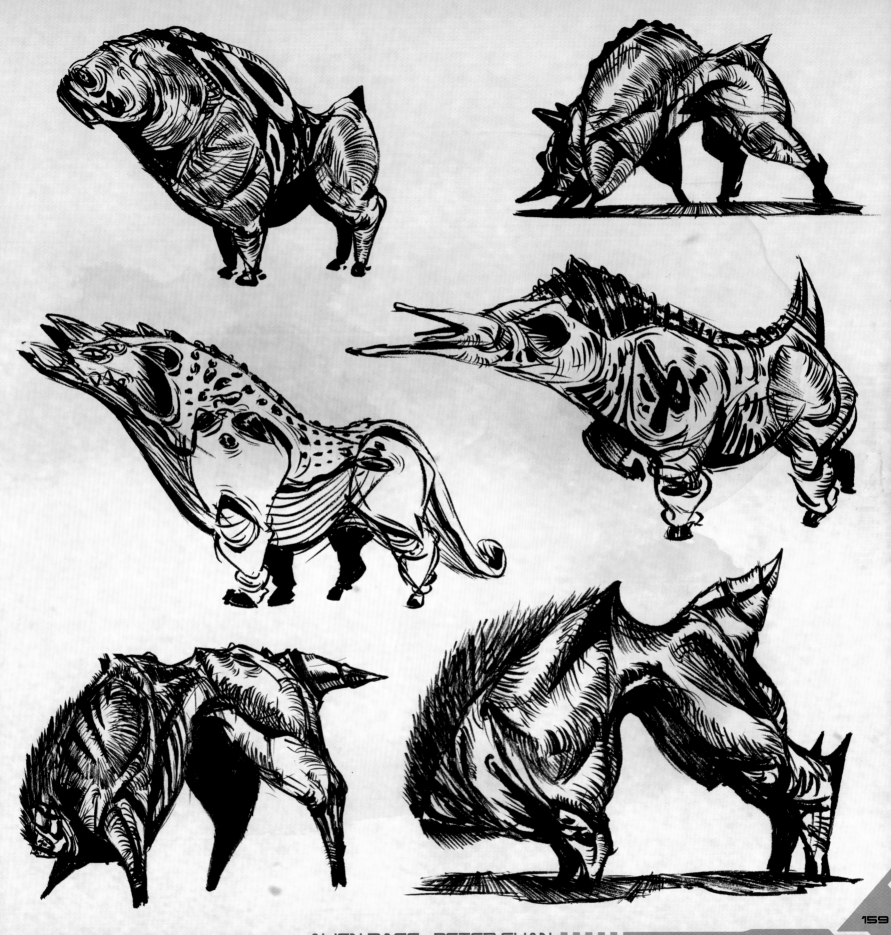

# GREEN BERETTA

PETER: Decades after the war, this tribe of mercenaries reached a peace treaty with their enemies. Now having no violent use for their war equipment and trained warriors, they decided to enter the race with the advantage of already being equipped and trained for any kind of combat or strategic situation. The characteristics of Green Beretta are that they are very aggressive, violent, and calculated. They do not believe in mistakes under any circumstances. Many expect this duo to take the race with ease...so put your hard-earned money on Green Beretta!

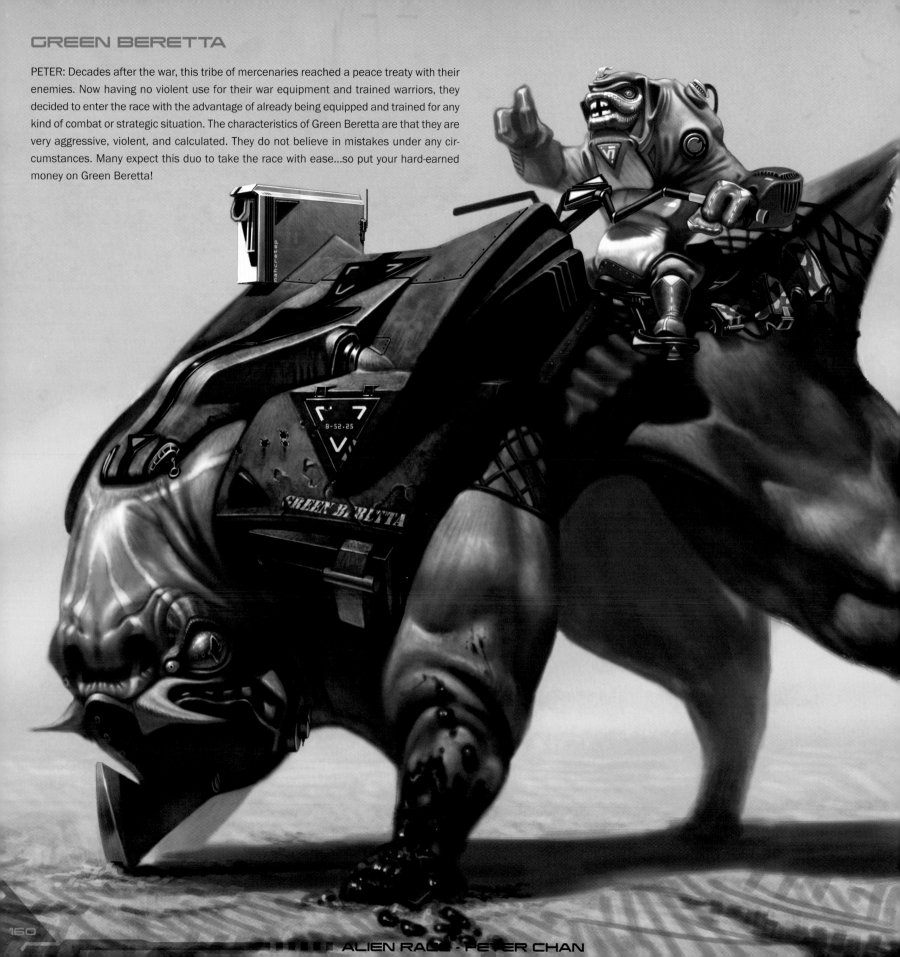

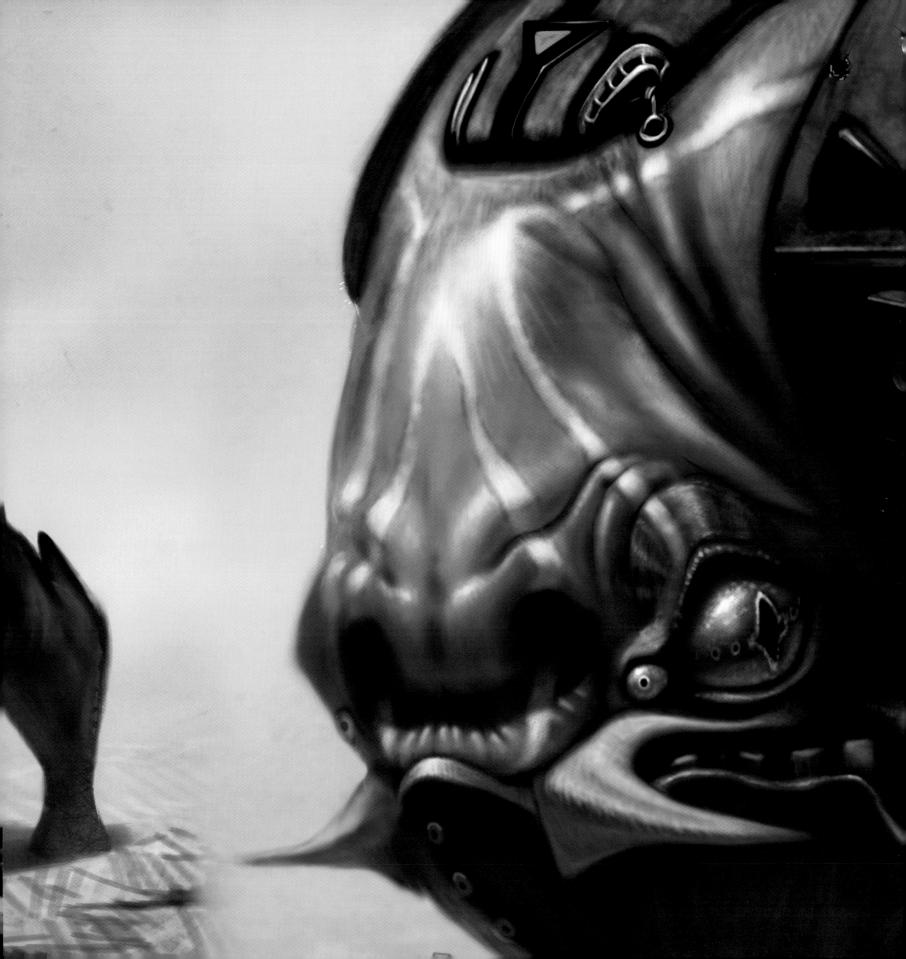

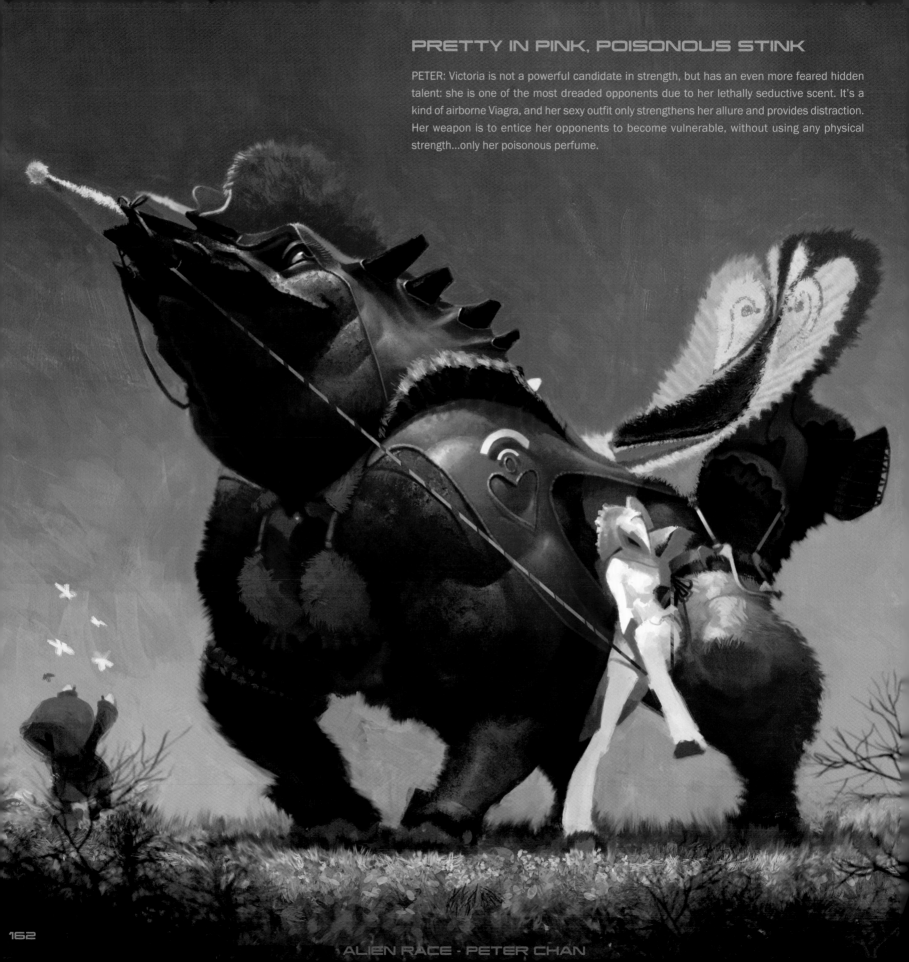

# PRETTY IN PINK, POISONOUS STINK

PETER: Victoria is not a powerful candidate in strength, but has an even more feared hidden talent: she is one of the most dreaded opponents due to her lethally seductive scent. It's a kind of airborne Viagra, and her sexy outfit only strengthens her allure and provides distraction. Her weapon is to entice her opponents to become vulnerable, without using any physical strength...only her poisonous perfume.

# ELECTRO SHOCK

PETER: Electro Shock is an oversized bioengineered bull. He is engineered through Earth's most advanced race-car technology, making him more speed machine than actual animal. His veins run with high voltage electrical cables that generate a maximum amount of nitro, allowing his speed to be paramount. One of the most anticipated performances is Electro's ability to generate magnetic shields, which protect him from harm, as well as temporarily paralyzing aggressive racers. Electro Shock is Earth's last secret weapon that could claim the galactic racing trophy once and for all.

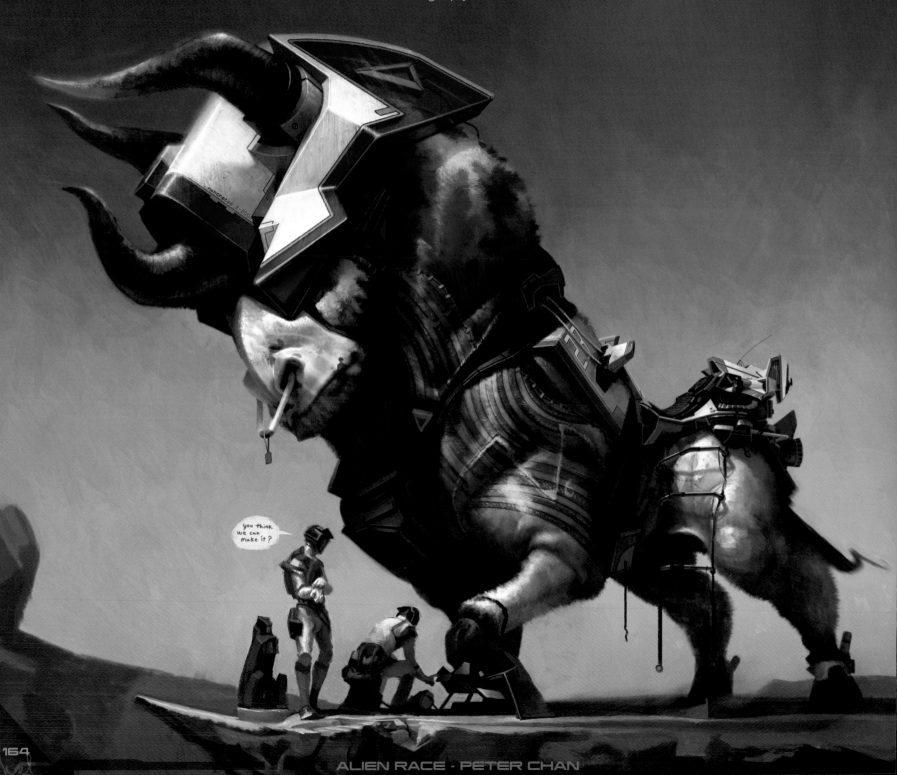

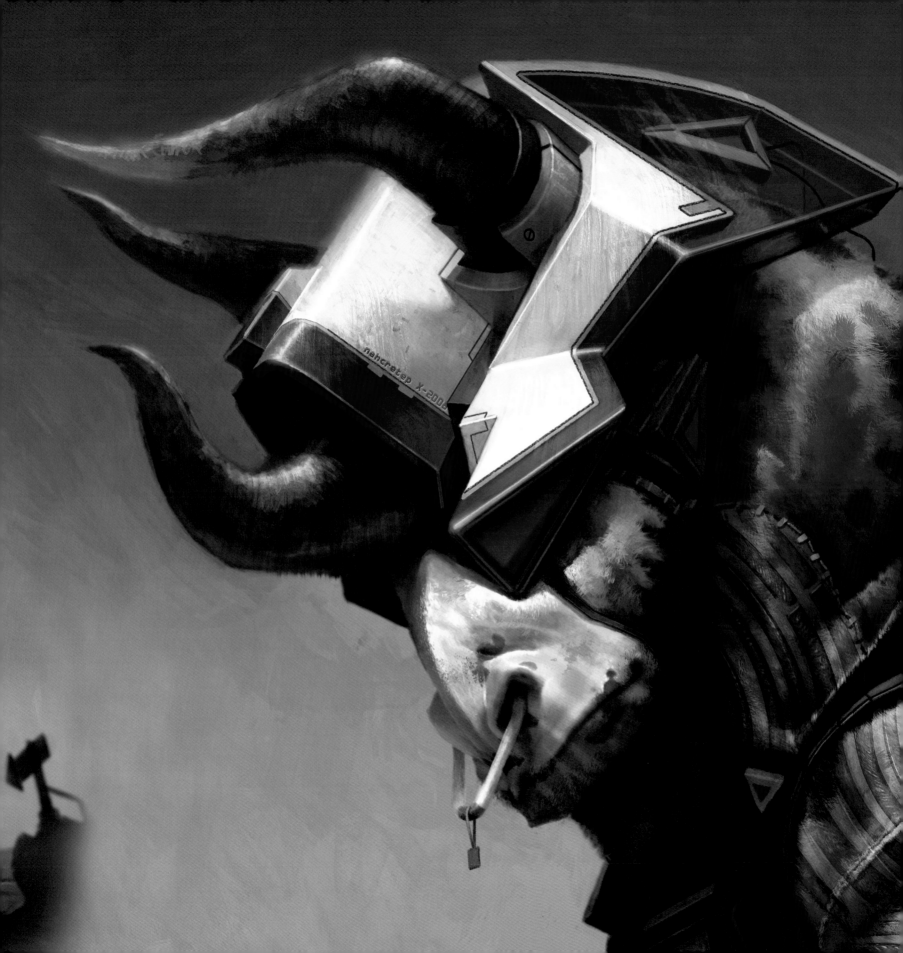

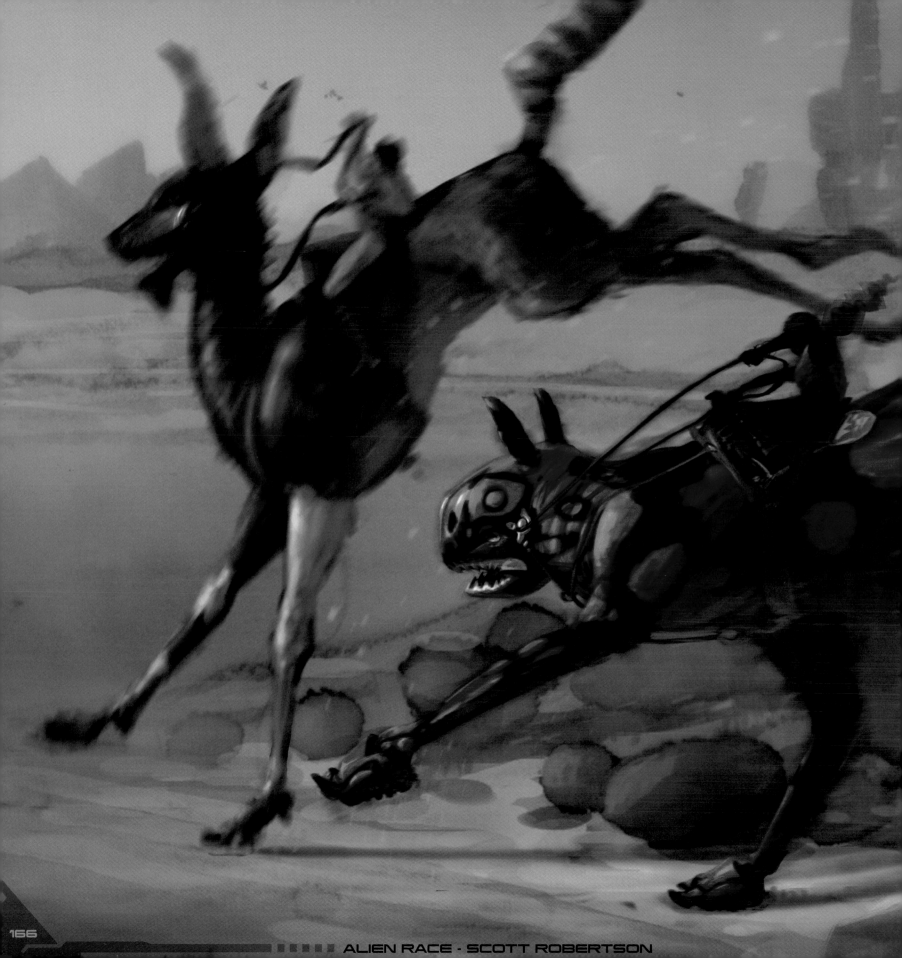

ALIEN RACE · SCOTT ROBERTSON

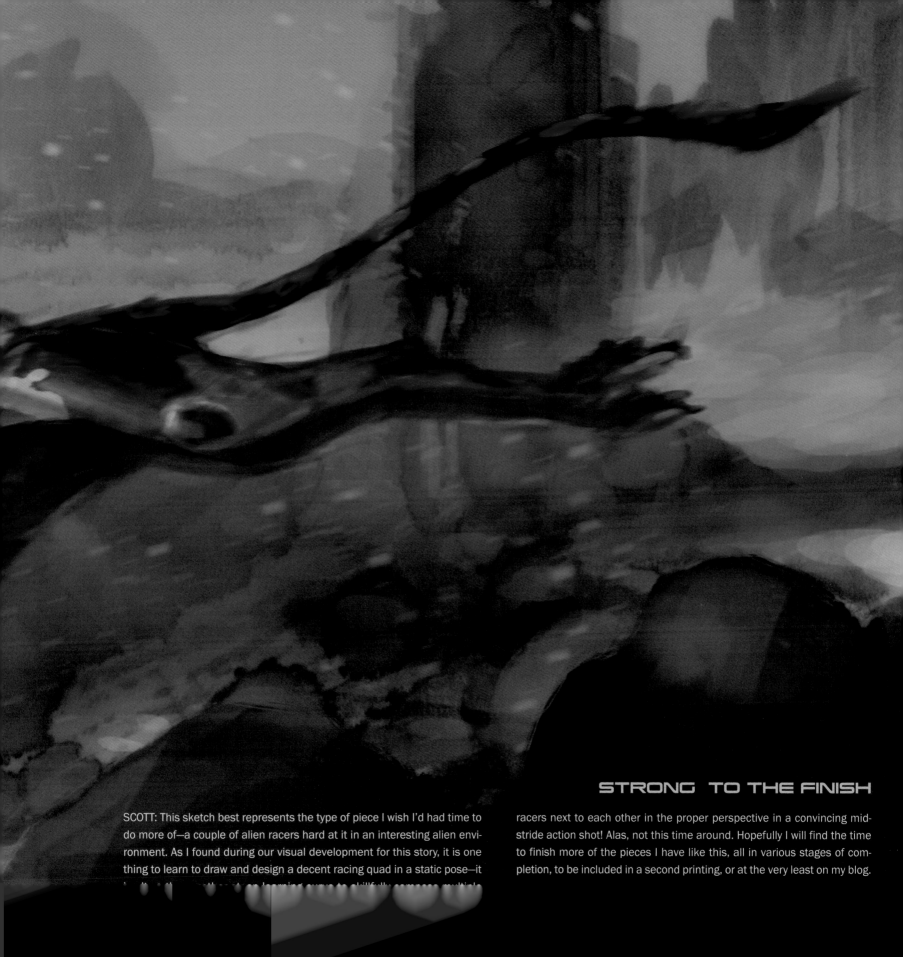

## STRONG TO THE FINISH

SCOTT: This sketch best represents the type of piece I wish I'd had time to do more of—a couple of alien racers hard at it in an interesting alien environment. As I found during our visual development for this story, it is one thing to learn to draw and design a decent racing quad in a static pose—it

racers next to each other in the proper perspective in a convincing mid-stride action shot! Alas, not this time around. Hopefully I will find the time to finish more of the pieces I have like this, all in various stages of completion, to be included in a second printing, or at the very least on my blog.

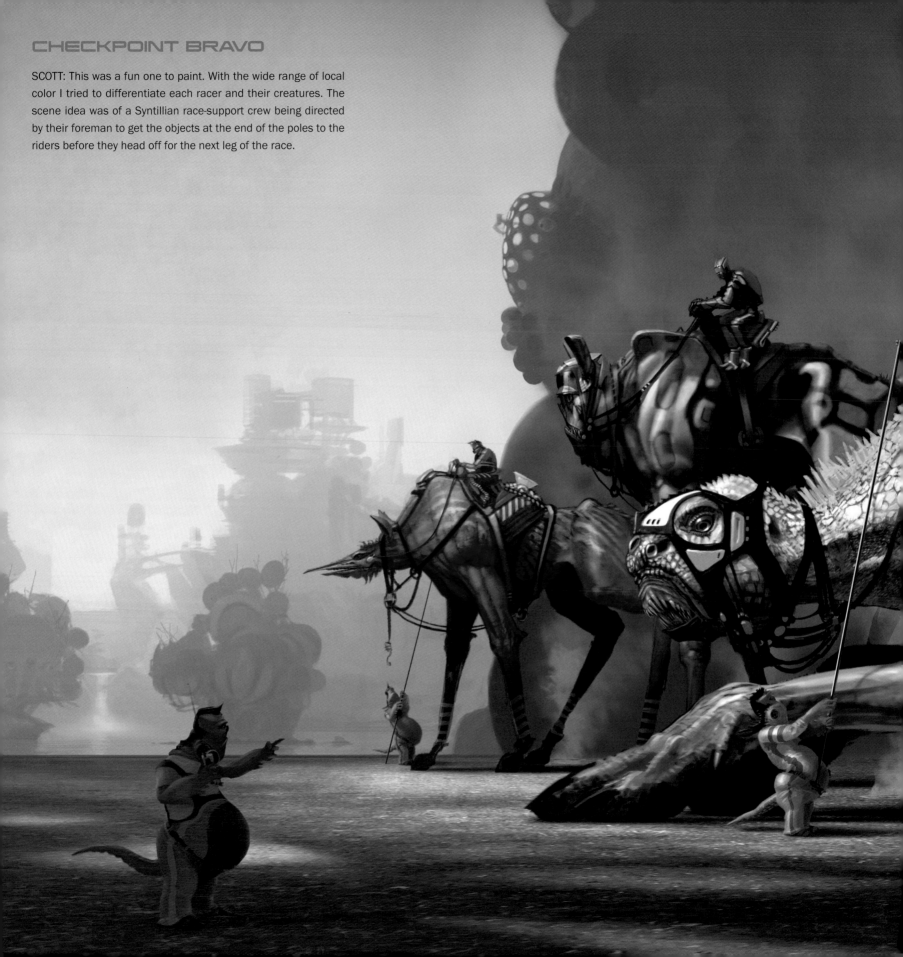

# CHECKPOINT BRAVO

SCOTT: This was a fun one to paint. With the wide range of local color I tried to differentiate each racer and their creatures. The scene idea was of a Syntillian race-support crew being directed by their foreman to get the objects at the end of the poles to the riders before they head off for the next leg of the race.

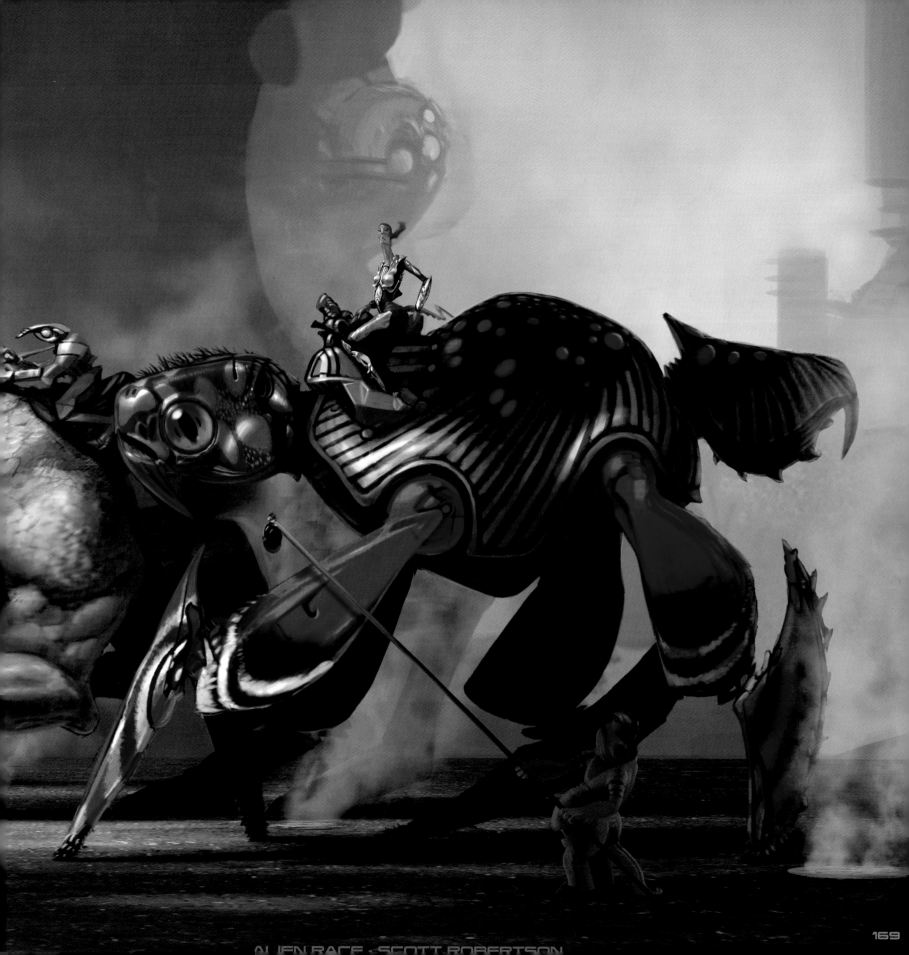

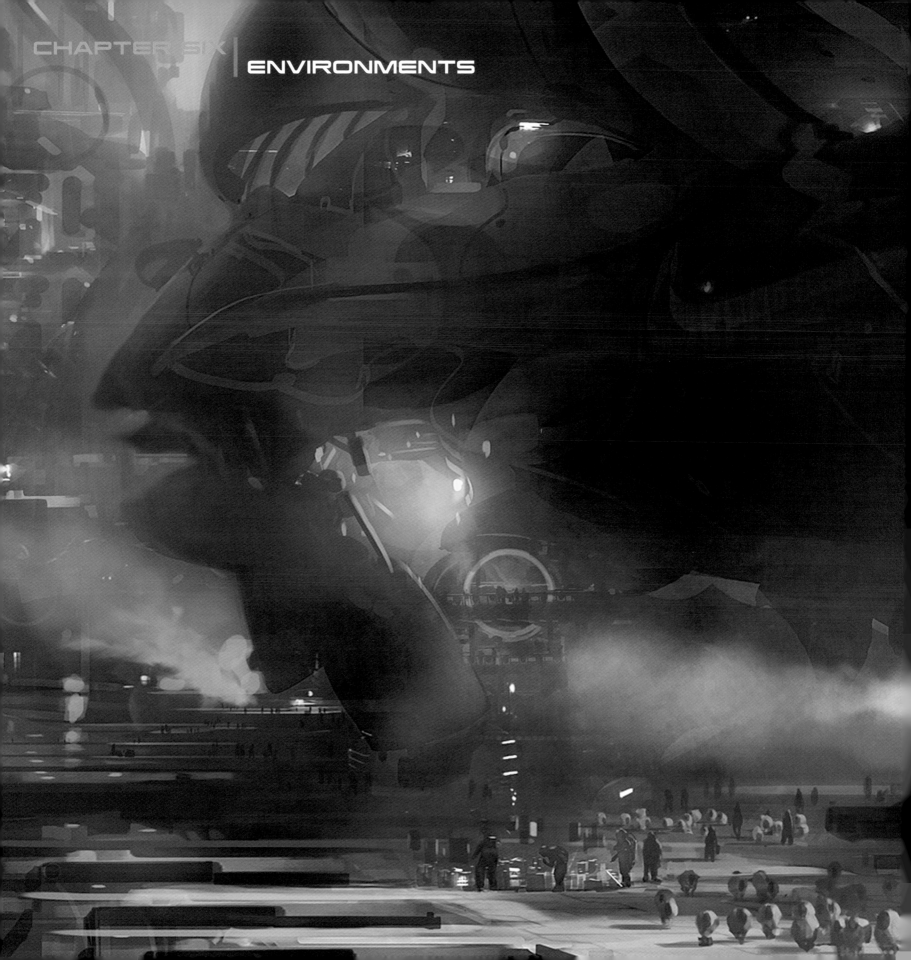

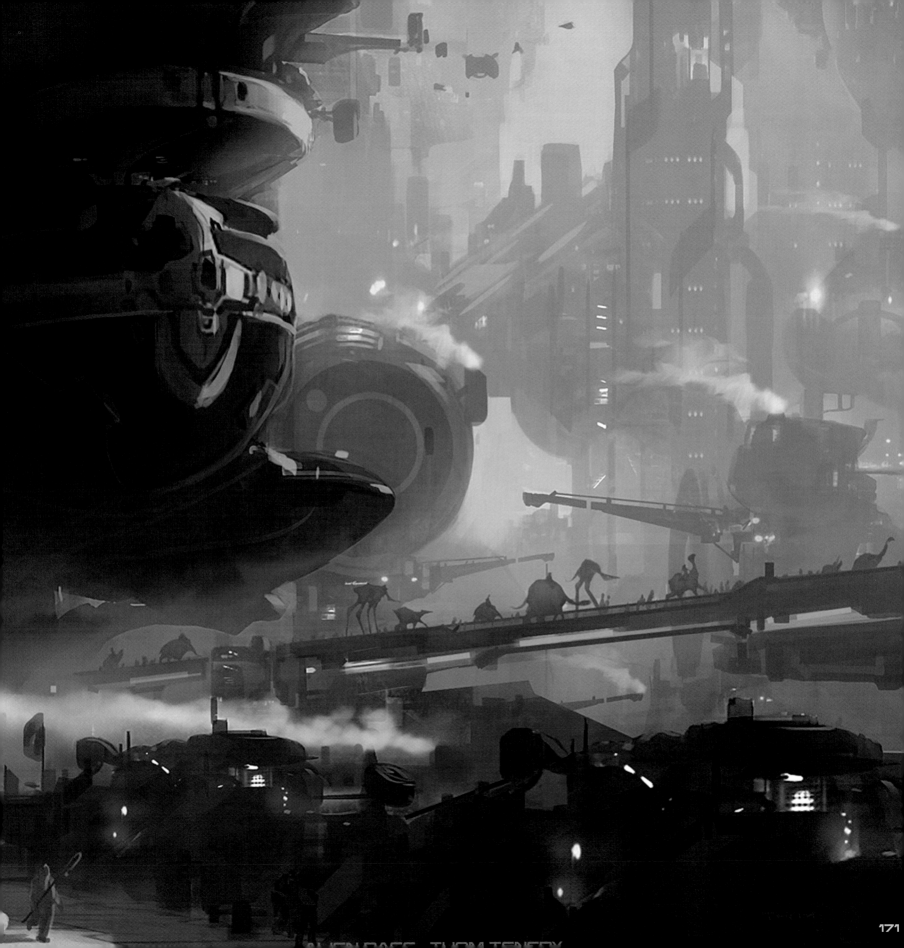

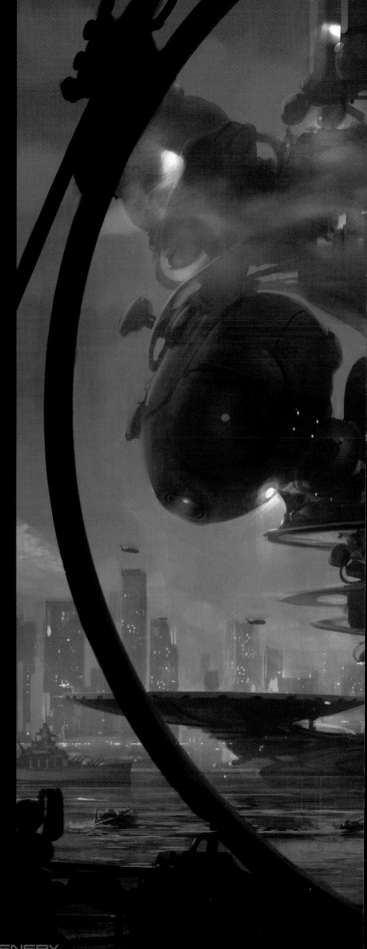

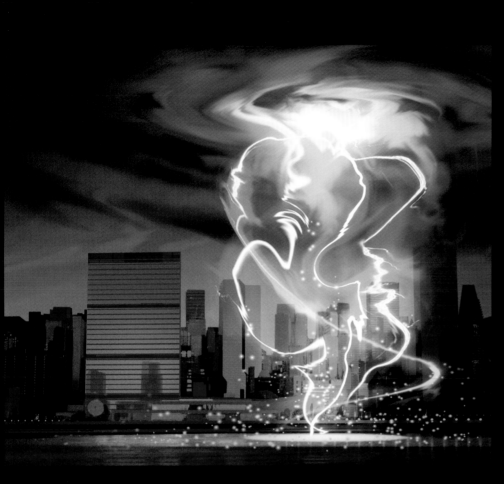

## BIO LAB ARRIVAL

THOM: A slow swirling vortex of unnatural weather over the East River was the first indication that this would be no ordinary day in New York City. Hundreds of taxi drivers felt their hair stand on end and heard their car radios crackle and buzz just before the event. Tendrils of green light emerged from the clouds, searching out the perfect location to root a structure. A chaos of light and smoke and inconceivable alien energies preceded the arrival of the bio lab. Everything humankind knew about the universe was about to change....

From the vantage point of a soldier aboard one of the first military vessels ordered to investigate, we can see the alien bio lab towering over the United Nations Building like some colossal, mechanical vegetation growing from the East River. The world's military forces keep their distance, awaiting the U.N.'s decision. The ship's cat hasn't the faintest idea what his animal brethren are in for.

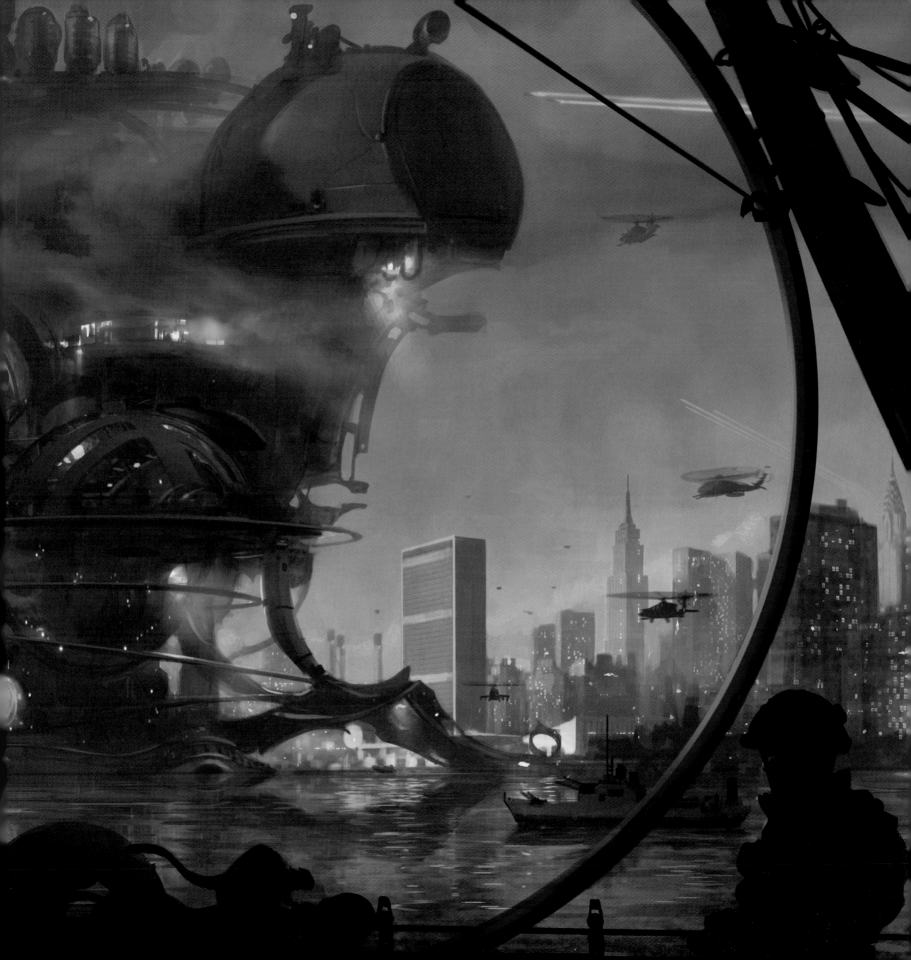

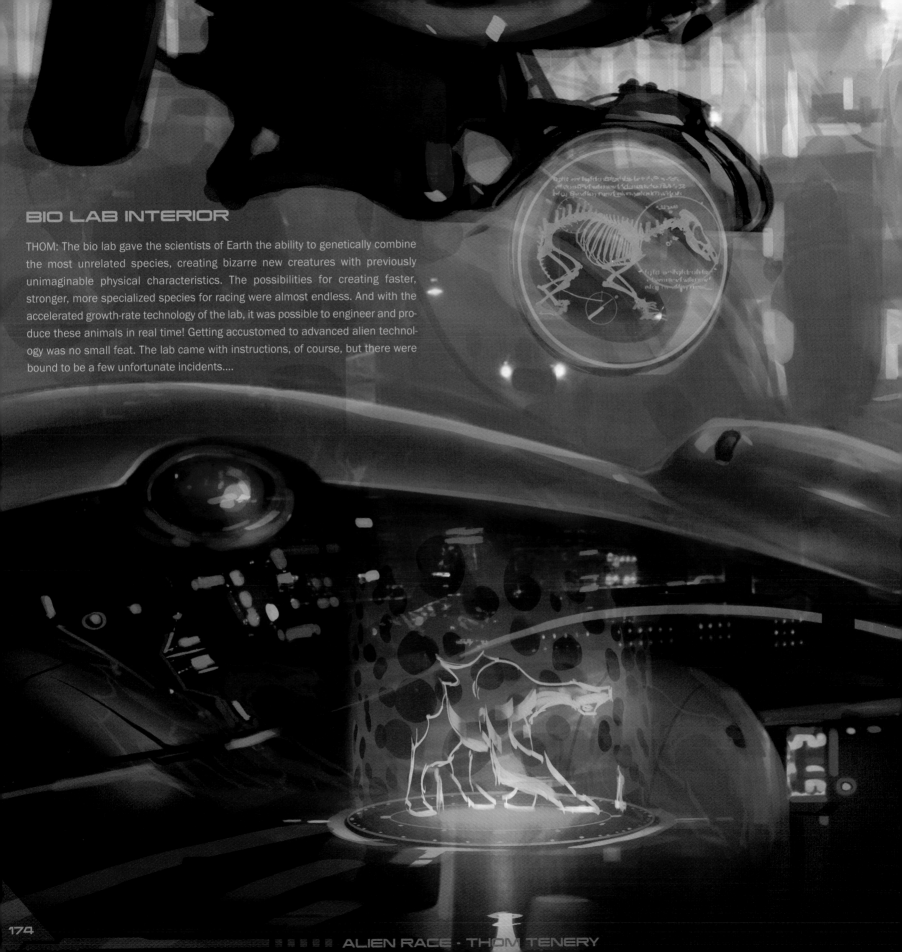

## BIO LAB INTERIOR

THOM: The bio lab gave the scientists of Earth the ability to genetically combine the most unrelated species, creating bizarre new creatures with previously unimaginable physical characteristics. The possibilities for creating faster, stronger, more specialized species for racing were almost endless. And with the accelerated growth-rate technology of the lab, it was possible to engineer and produce these animals in real time! Getting accustomed to advanced alien technology was no small feat. The lab came with instructions, of course, but there were bound to be a few unfortunate incidents....

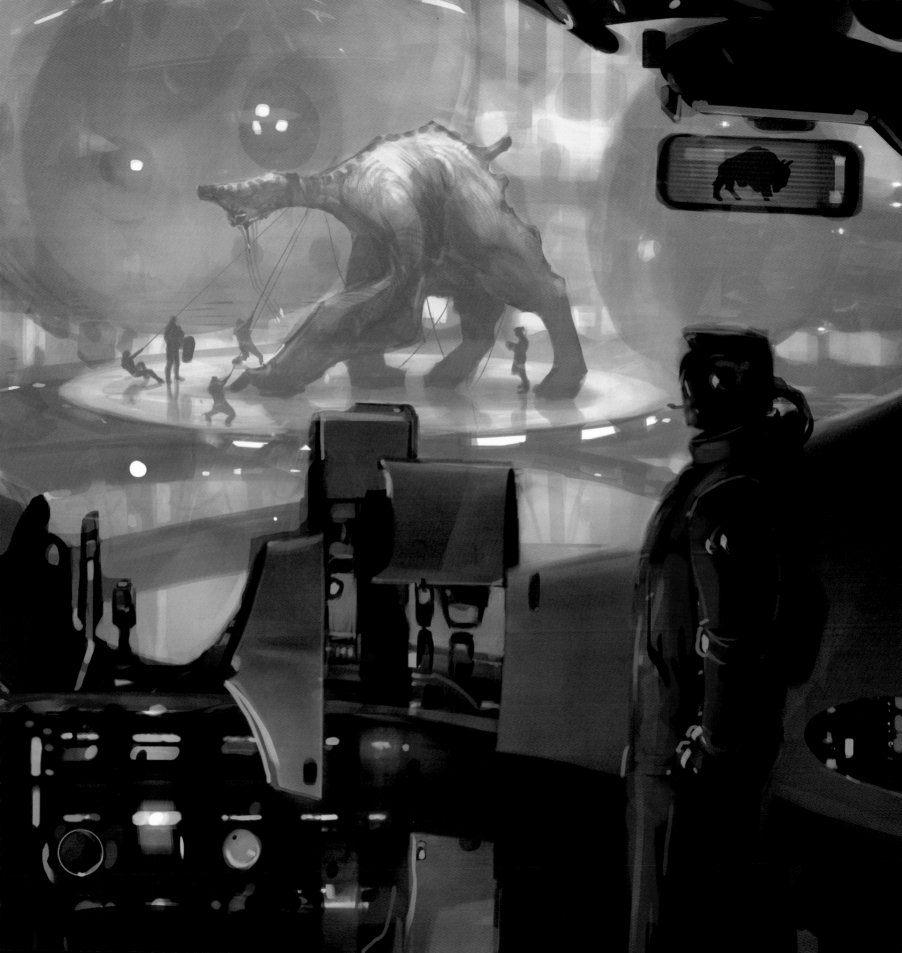

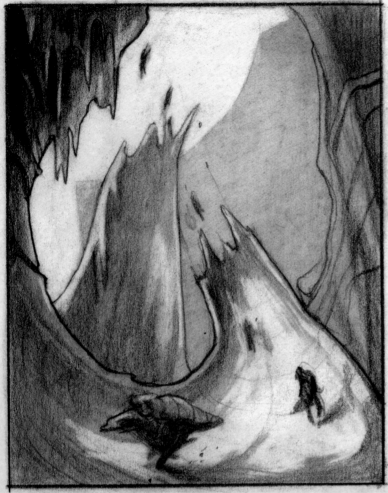

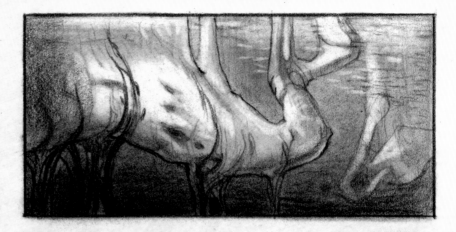

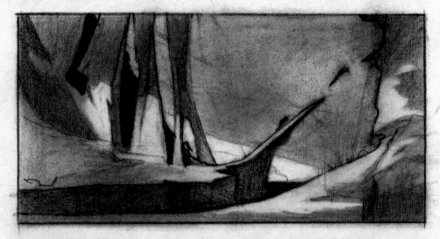

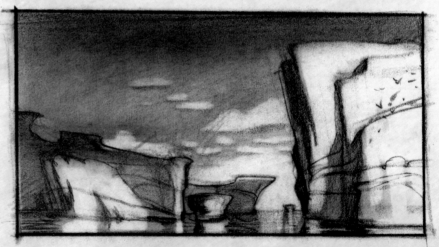

# ICE TRACKS

SCOTT: Some of the very first environment sketches for the project were done in pencil to explore the possibilities of the racing action in various unique environments. Above are a few sketches that depict fast racing action taking place through odd, naturally formed tunnels. They even go underwater occasionally and then break open above the water to form spectacular jumps.

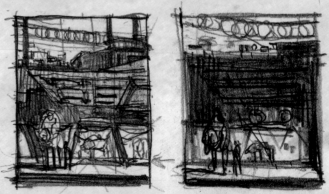

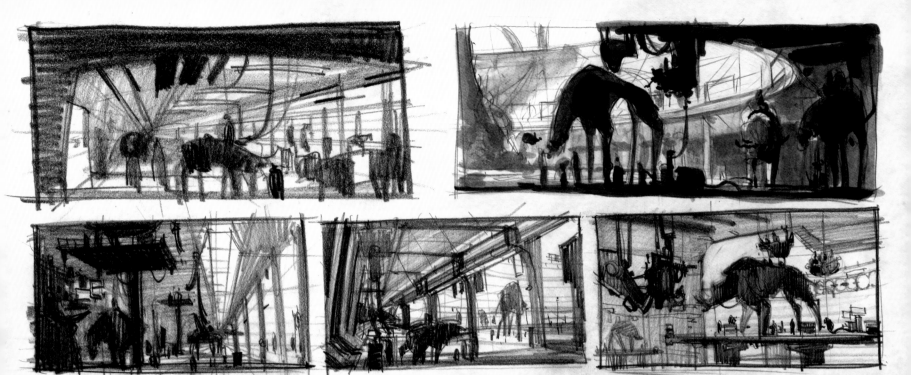

## COLISEUM

SCOTT: We thought that a really fun place to visit, whether via a video game, movie or book, would be a fantastic alien racing stadium on the planet Zyonia. Above are the thumbnail sketches that led to the final line drawing below, where we see the stadium from underneath the seating area and a wide variety of racers getting ready for the next heat.

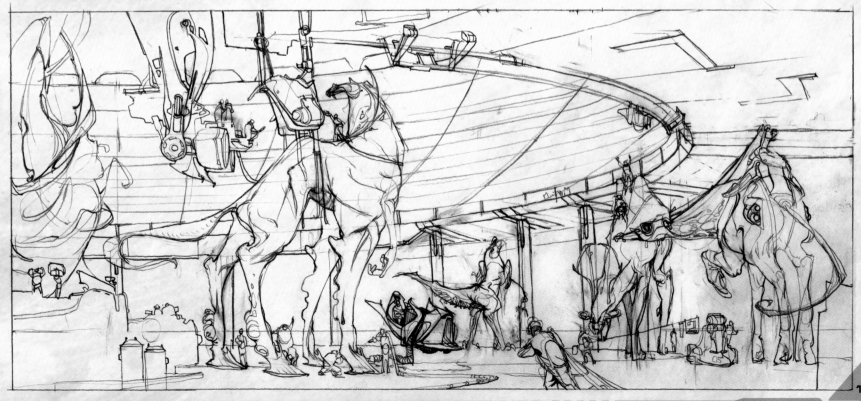

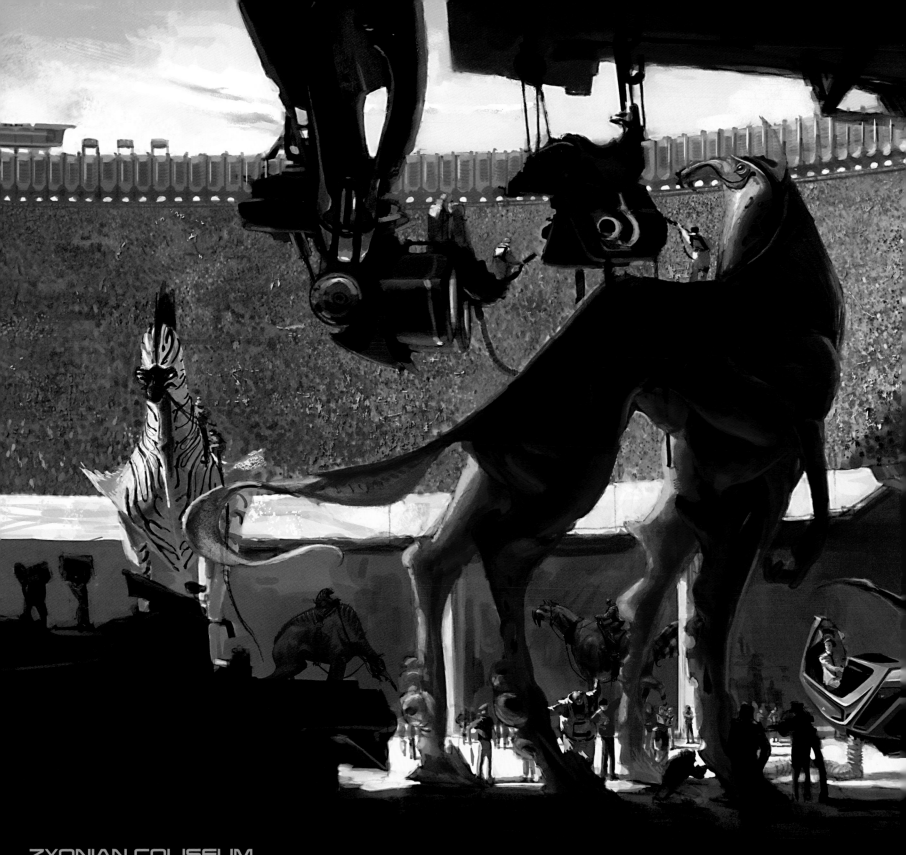

## ZYONIAN COLISEUM

SCOTT: This is definitely one of the most awe-inspiring locales in our
story, the Zyonian Coliseum, with hundreds of alien racers gathered

from throughout the Master Universe, preparing for battle in front of
the adoring Syntillian race fans.

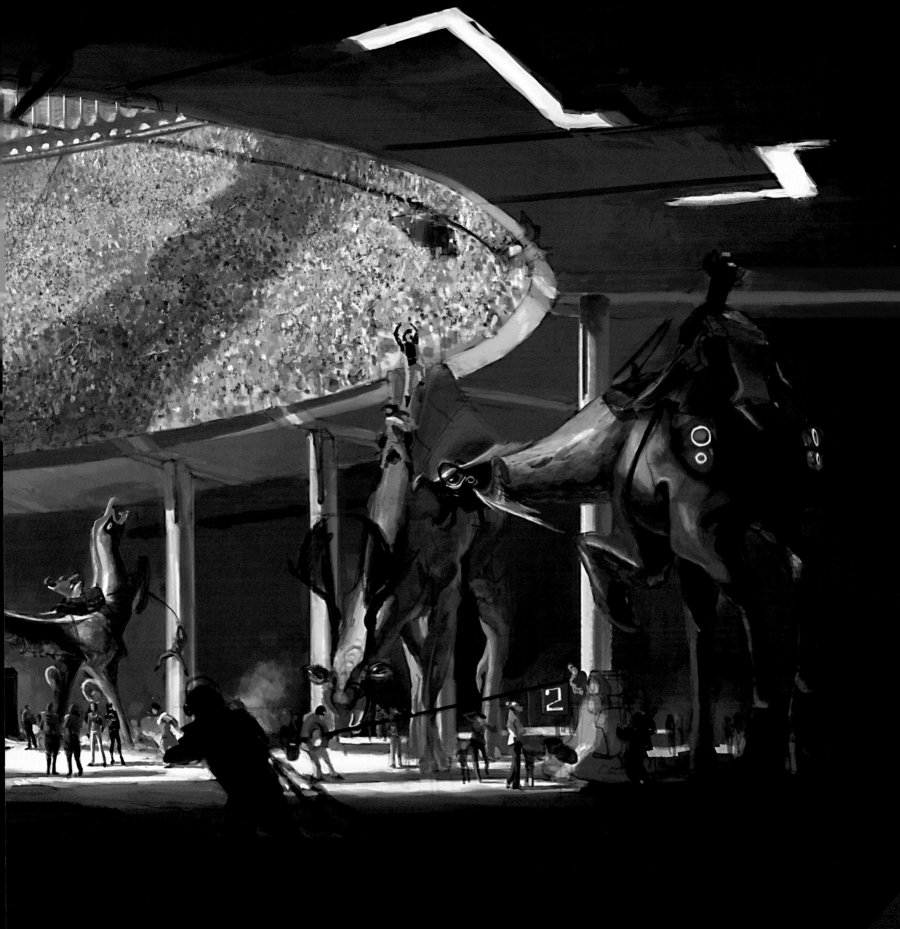

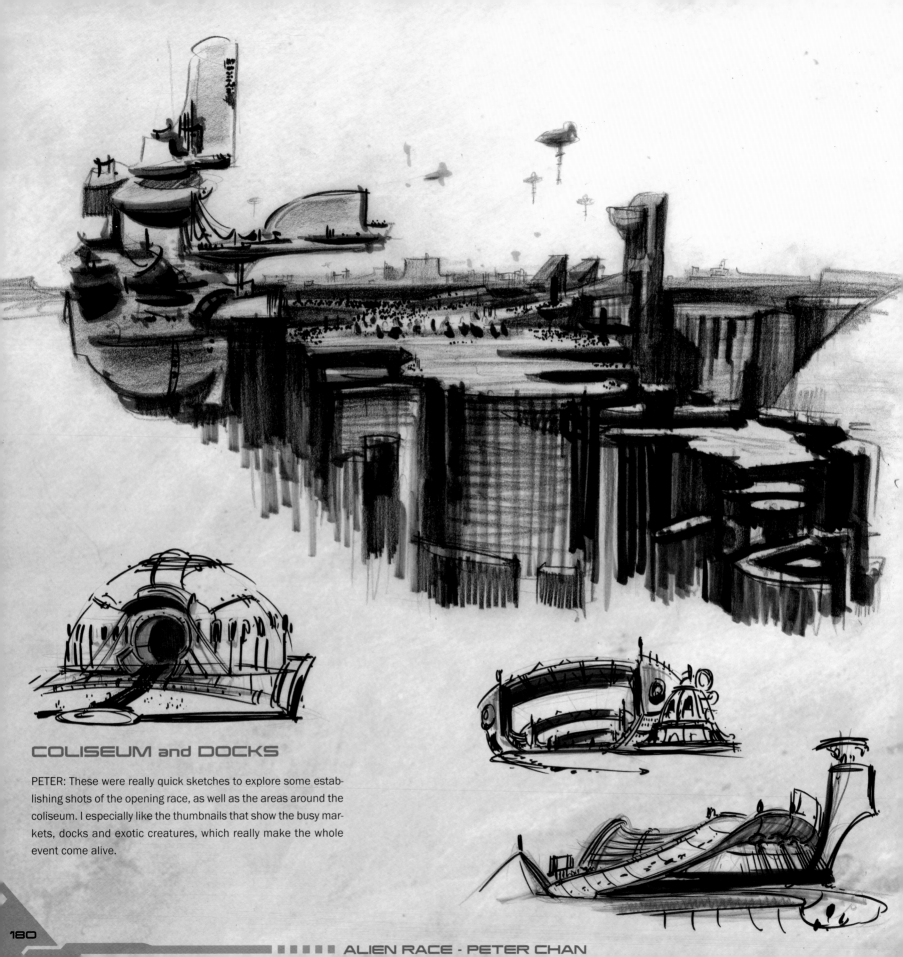

## COLISEUM and DOCKS

PETER: These were really quick sketches to explore some establishing shots of the opening race, as well as the areas around the coliseum. I especially like the thumbnails that show the busy markets, docks and exotic creatures, which really make the whole event come alive.

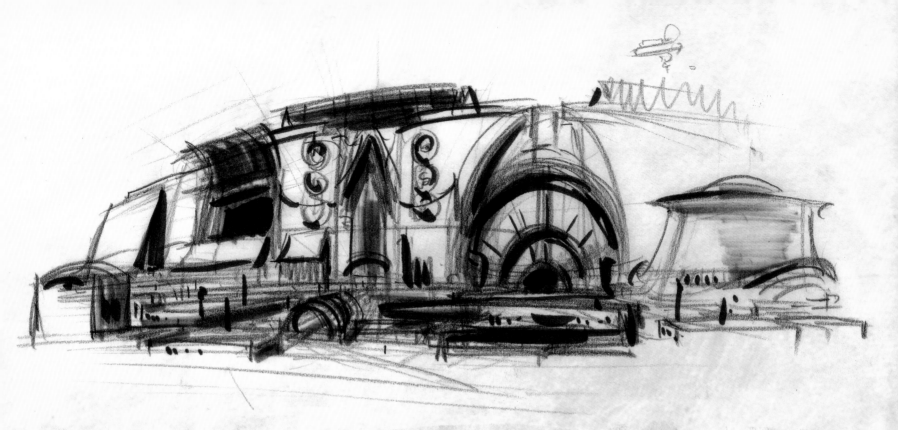

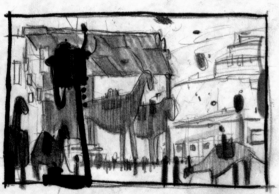
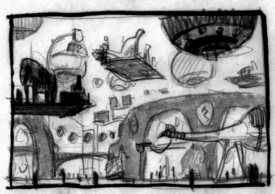
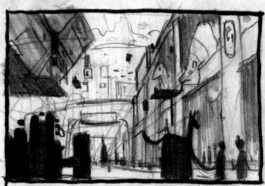

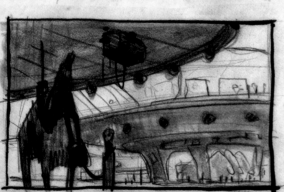
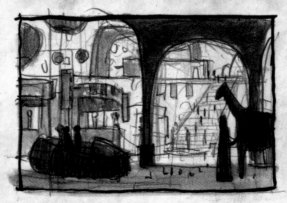
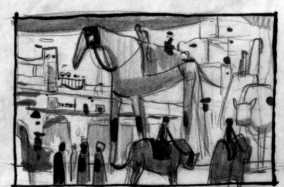

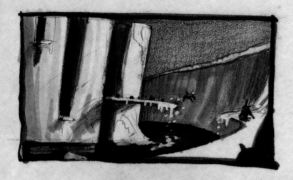 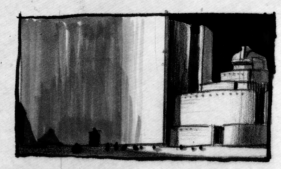 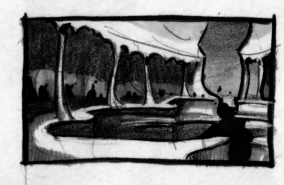

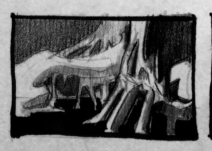  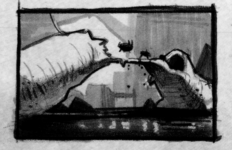 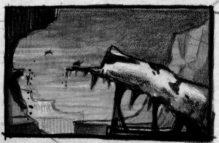

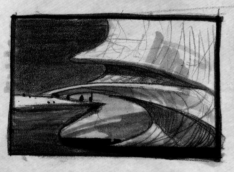   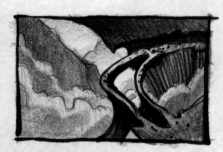

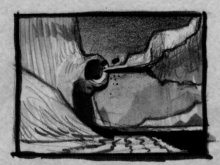 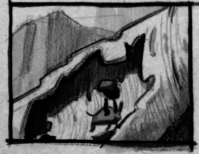 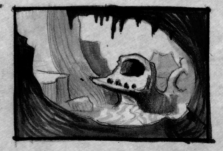 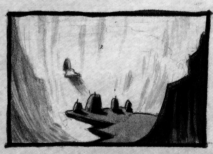

# SUB-ZERO TERRAIN

PETER: These sketches focus a bit more on the different terrains of a single racecourse. I was interested in what kinds of movements or actions could occur through various obstacles: from flat ground, sharp turns and precarious ledges, to a grand finish.

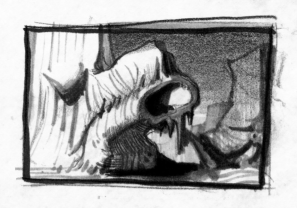 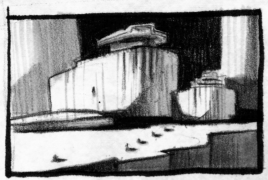 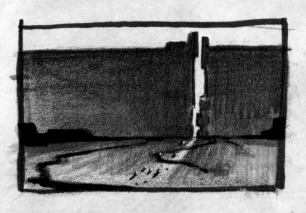

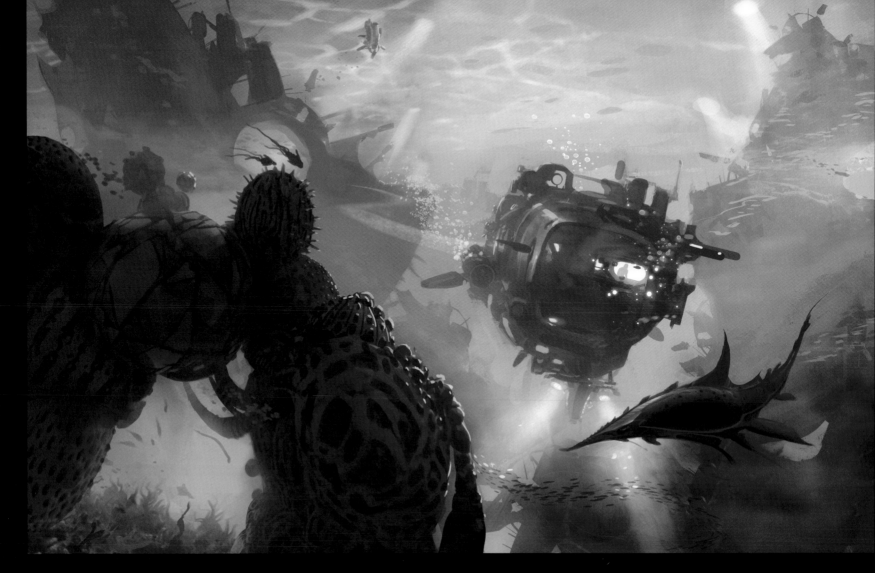

## SEARCH FOR DNA / SKY SPORES

THOM: We had a lot of fun exploring the potential that Photoshop custom brushes bring to the design process. It is a great advantage to have a library of custom brush shapes on hand for the purpose of encouraging "happy accidents." This scene depicts an underwater expedition to capture an animal with a particularly aggressive temperament, for breeding a fiercer racer. The sketch for this scenario came together in about five minutes. One of the first marks I made resembled a large fish head full of sharp teeth. That fish head eventually became the tower of rock in the background, but the initial shapes inspired the narrative that was then fleshed out as a more finished illustration. With just a few brushstrokes an entire world suggested itself. Opposite, the sky atolls provide a particularly dangerous environment for the flyers. At this time every year at high altitudes, the Cococabbages release millions of spores into the tropical winds. Flyers must dodge the spiked spores as they tumble through the sky toward the turquoise waters below.

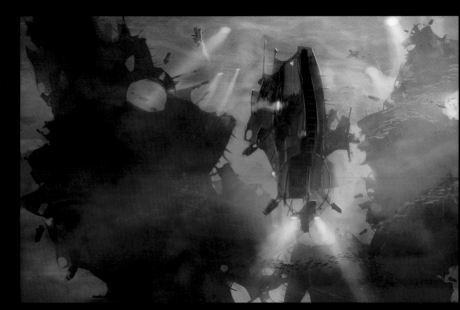

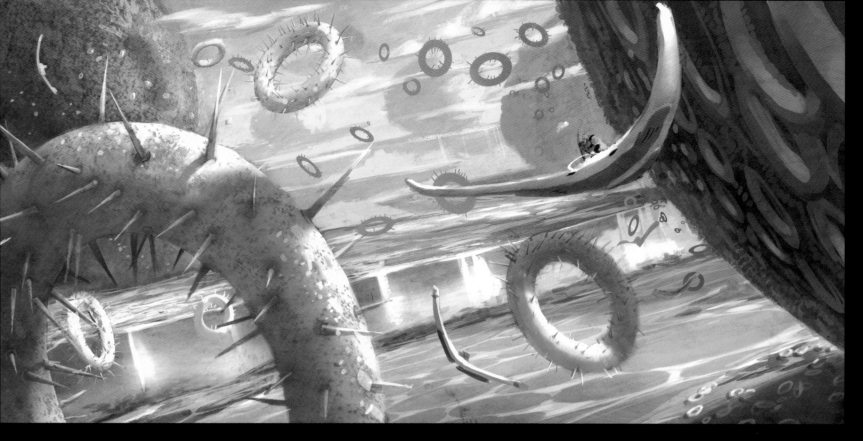

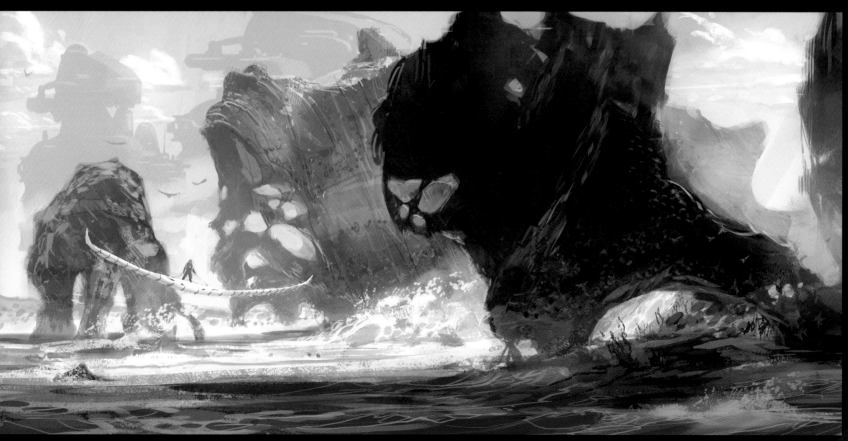

ALIEN RACE - THOM TENERY

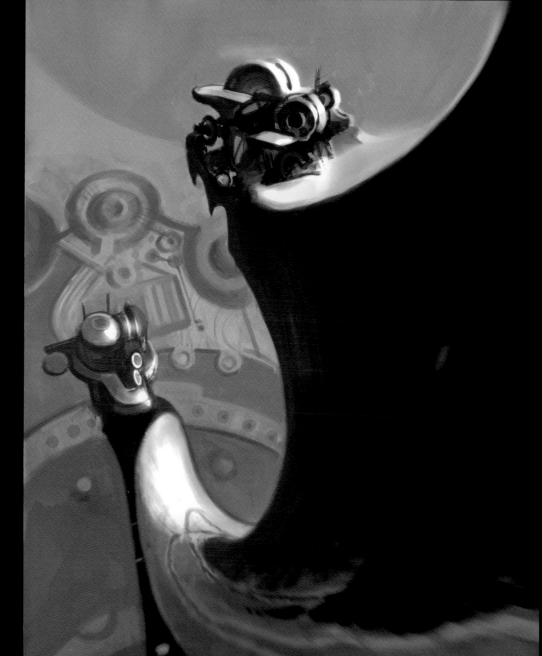

# SLOPE OF DEATH

PETER: Wanting to design a cool video-gaming experience, I thought an extreme downhill sliding race would add a lot of excitement. This shot went through an interesting process, starting with pushing the shapes toward more of an animation style, then finishing them off with a little more refinement. Both shots worked well in showing the steep downhill course leading to the coliseum way at the bottom.

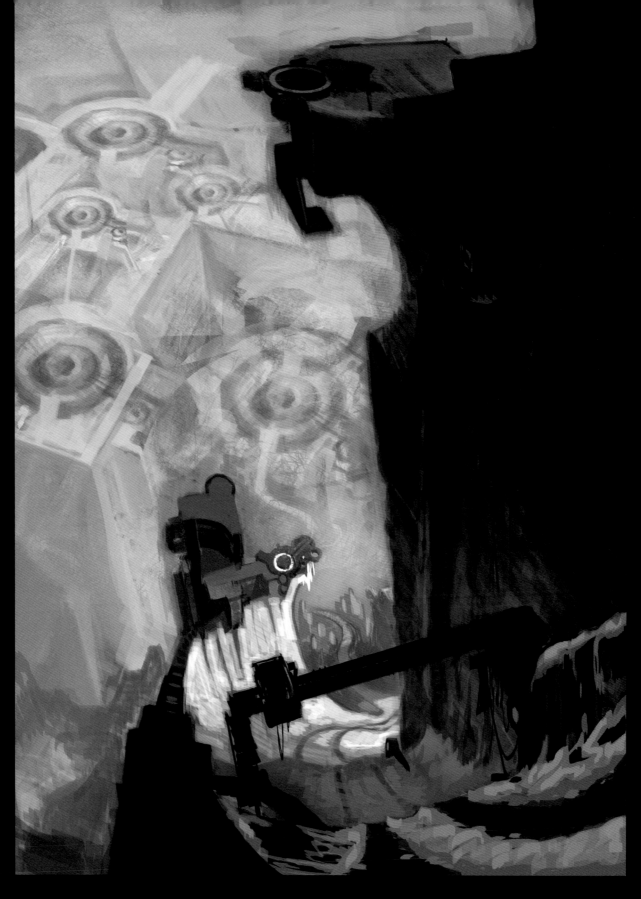

ALIEN RACE · PETER CHAN

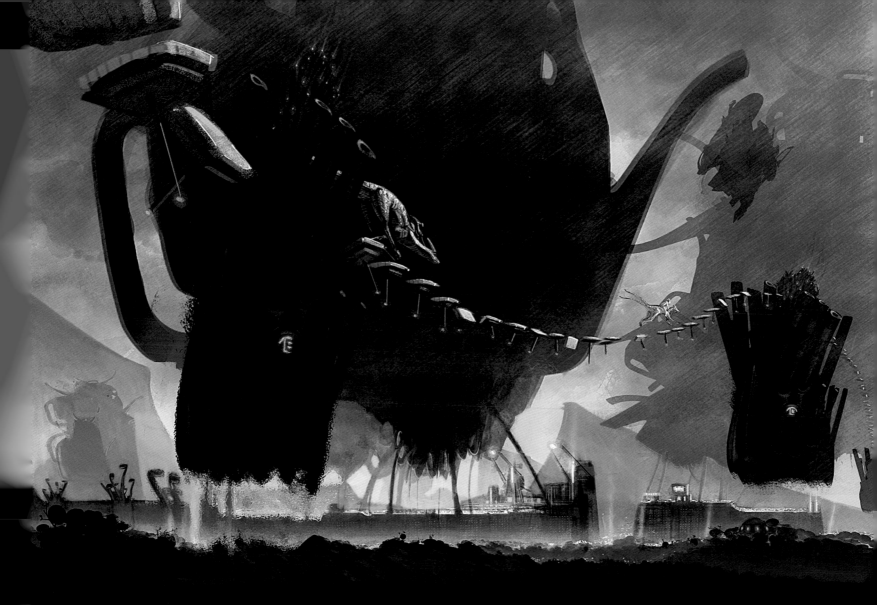

## THE TIPPING POINT

PETER: I wanted to add even more challenges to the race. During the final stretch, the course narrows to a series of small floating platforms that constantly tilt left and right. One misstep and you're out of the game!

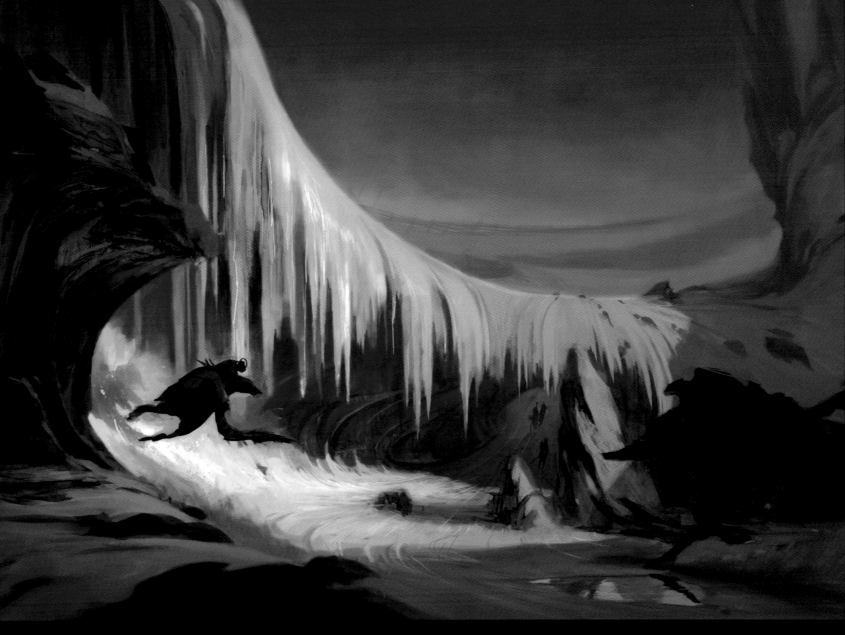

## GAZIDORE GLACIER

JULZ: The racers are feeling much better now at the top of the
Gazidore Glacier, but the celebration stops abruptly when it's
realized the only hope they have to "get back on track" is all
downhill from here.

ALIEN RACE - JUSTIN PICHETRUNGSI

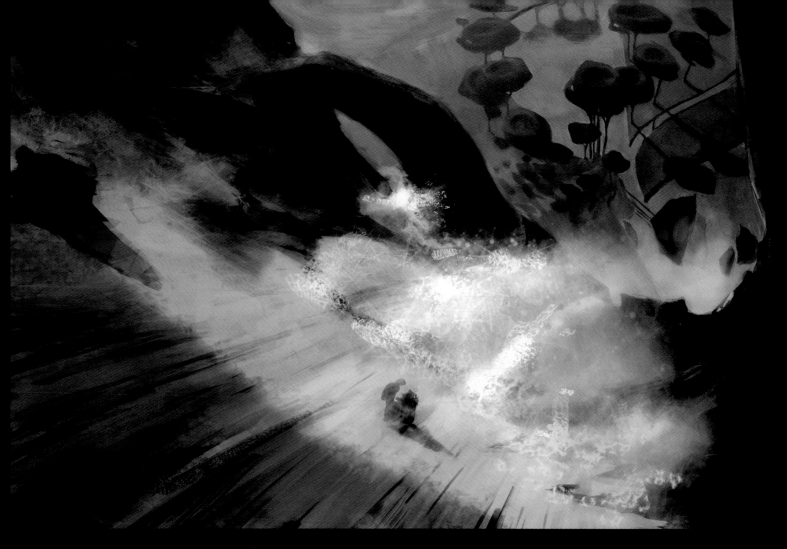

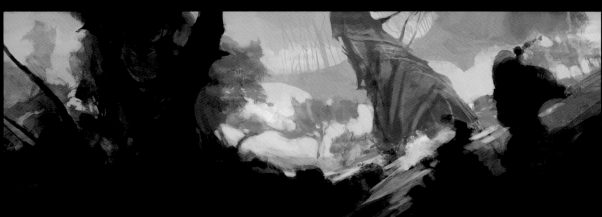

# DOWN THE FALLS and ALONG THE CLIFFS

JULZ: The Alien Race is considered to be the most extreme race in the Master Universe. A death-defying race that covers a 300-mile course through the toughest terrain in the most remote locations on planet Zyonia.

ALIEN RACE · JUSTIN PICHETRUNGSI

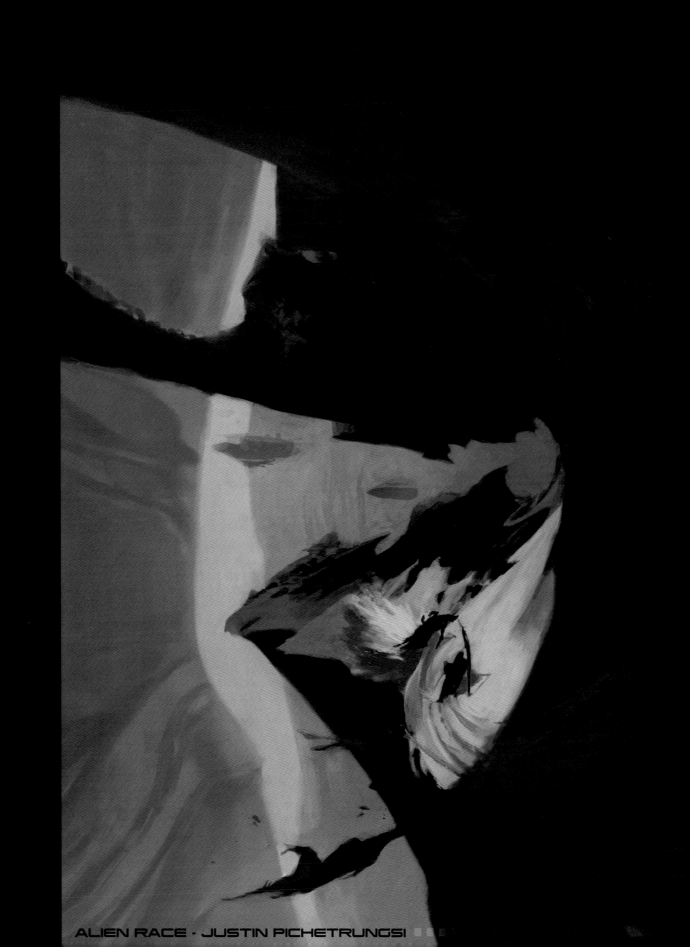

ALIEN RACE · JUSTIN PICHETRUNGSI

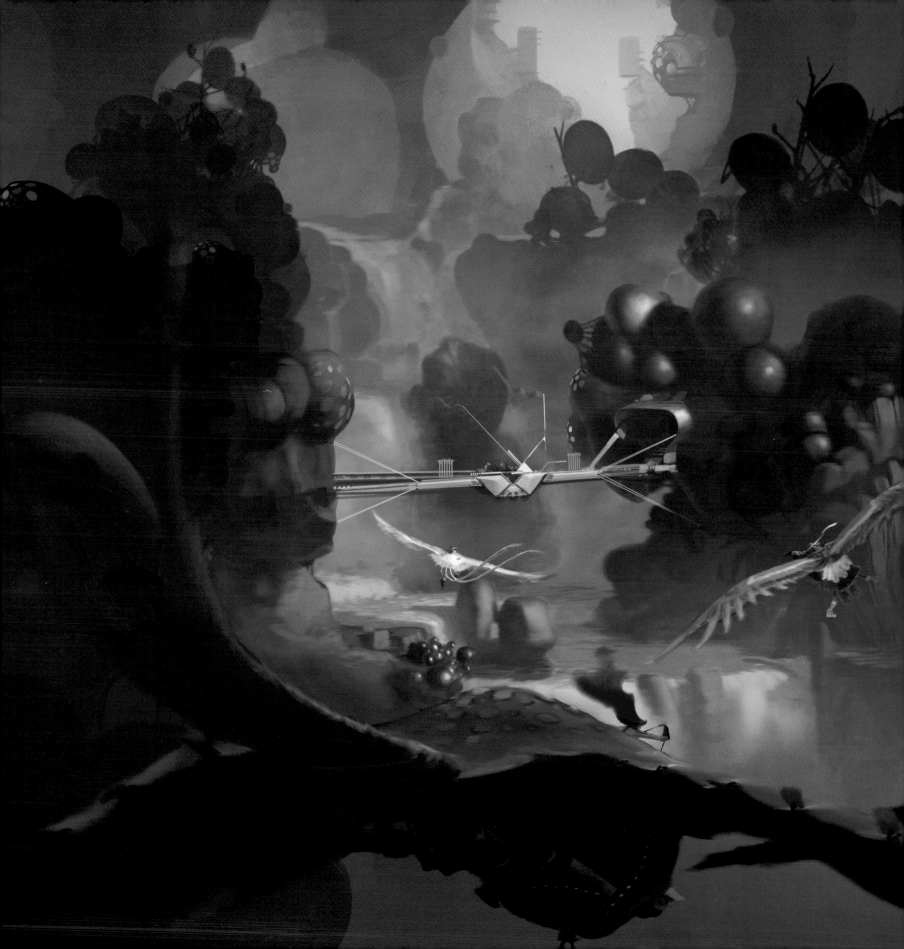

## FLYING THROUGH THE GROTTO

SCOTT: Above are a few speed paintings for various environments our racers might encounter. They all started out as images I captured from some layered marker sketches, employing the techniques I share on my educational DVD "Creating Unique Environments." The odd orb shapes to the left were created with a custom brush in Photoshop, and I imagined them to be old gourd-like plants that might serve as dwellings for the aliens living in this large system of old waterworks on Zyonia. John detailed out the flying racers in the piece. Again it was very fun to work as a team on a rendering, with John bringing a fresh set of eyes, energy and of course strong skills to the final painting.

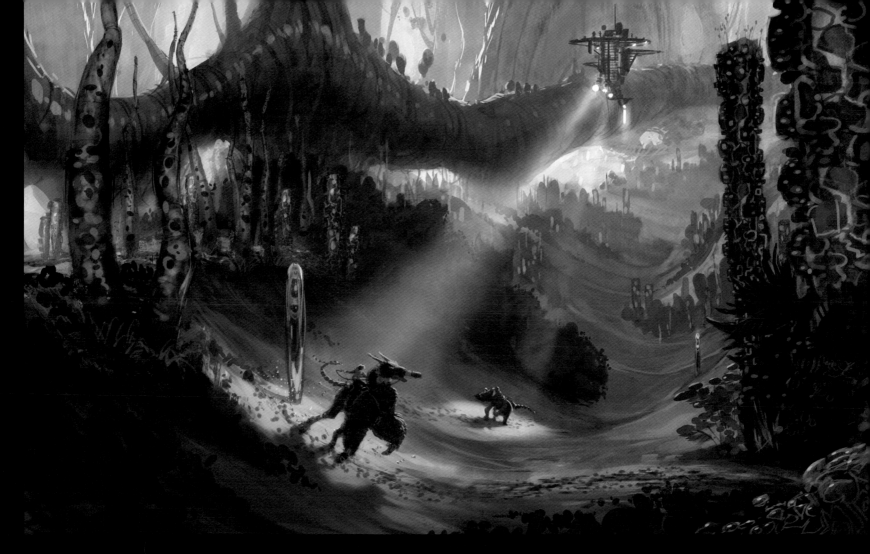

# SPOTLIGHT THE LEADERS!

THOM: Natural lanterns lining the forest floor provide ideal lighting for this racecourse. Light levels here are still too low, however, for camera bots and observation vehicles. One of the viewing barges spotlights the race leader rounding a red marker.

ALIEN RACE - THOM TENERY

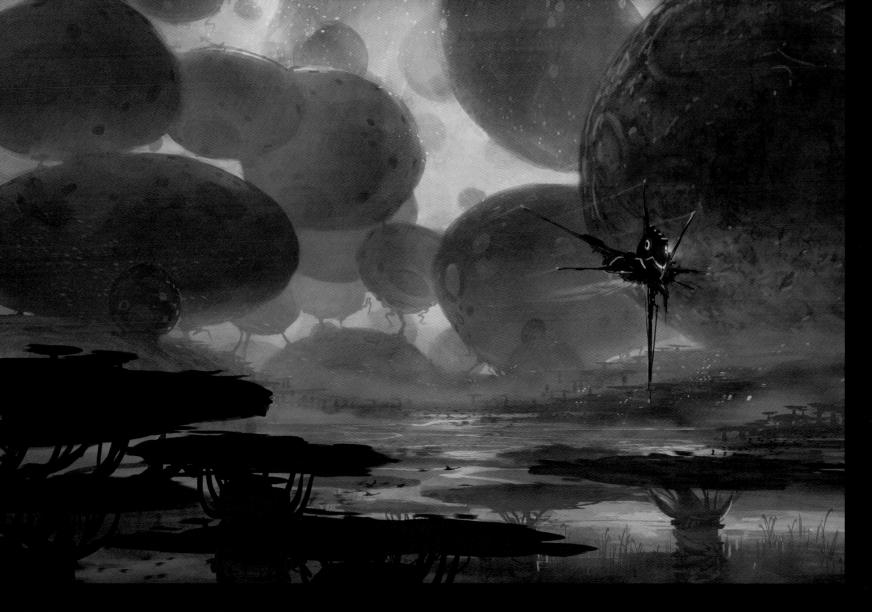

## IRON ORB FOREST

THOM: A medical vessel rushes away from the iron orb forest. To a distant viewer the plants of this forest look like weightless balloons bobbing harmlessly above the landscape. But to a flyer navigating between these 10-ton, methane-filled gasbags, it's a different matter altogether. Thick stalks keep the orbs anchored to the planet's surface, but they are in constant, unpredictable motion. A mistimed pass could easily result in a squashed racer.

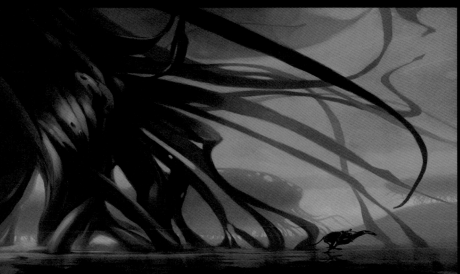

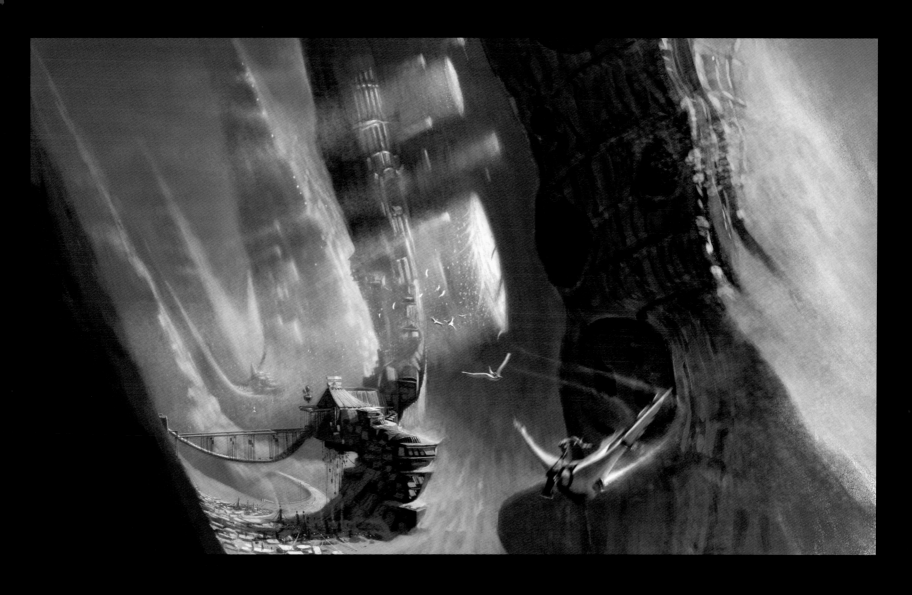

## THROUGH THE CLAMSHELLS

PETER: With this flying course I really wanted to showcase an environment that racers might not see on the ground. The idea behind it was that an ocean has dried up over the centuries, leaving behind gigantic clamshells as mountain ridges. An indigenous tribe has settled in this remote location, taking advantage of the rich minerals left behind and using the shells as protection from the constant snowstorms that plague this high altitude.

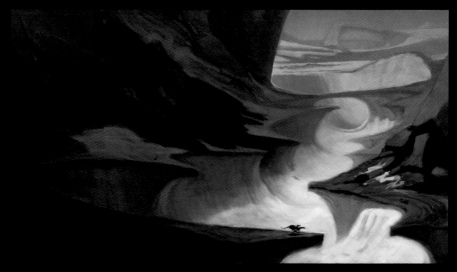

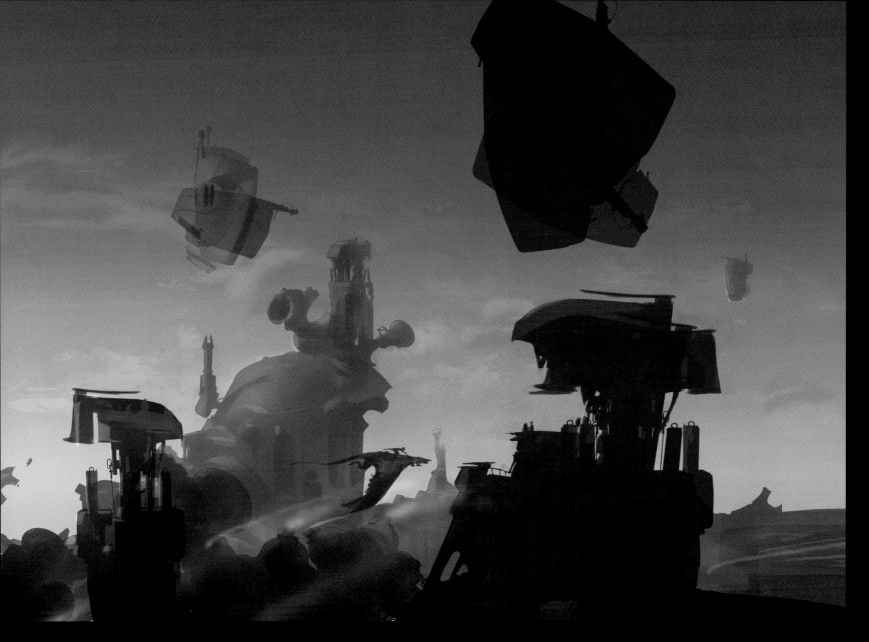

# CHECKPOINT ALPHA

SCOTT: Set in a remote industrial region of Zyonia, a racer flies through "checkpoint alpha" as large airships surround it, holding hundreds of the Syntillian upper class who watch on and eagerly await the outcome of today's race.

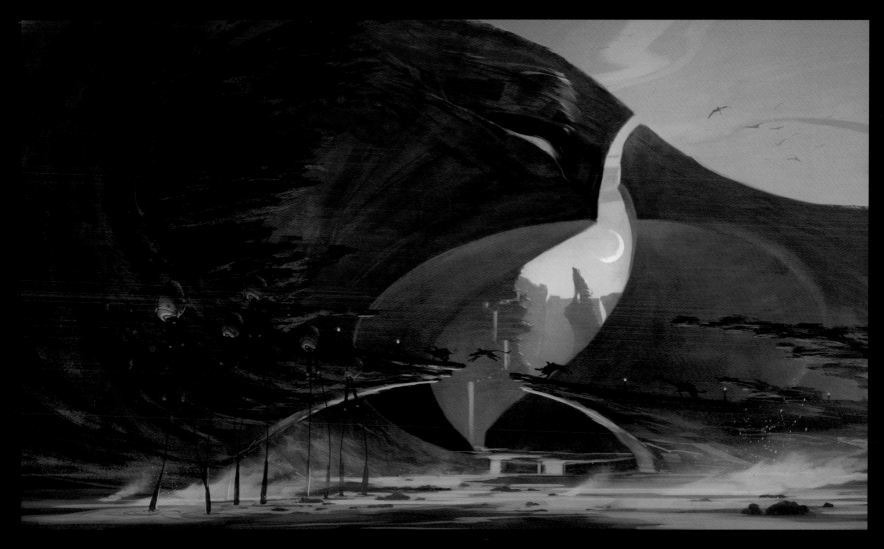

# BIOLUMINESCENCE

THOM: Stilt walkers have a fantastic view of the racers as they wade through the bioluminescent rivers of this remote canyon, its glowing falls just visible in the distance. Flood-sculpted walls of rock make for an unpredictable winding path along narrow ledges and across natural bridges.

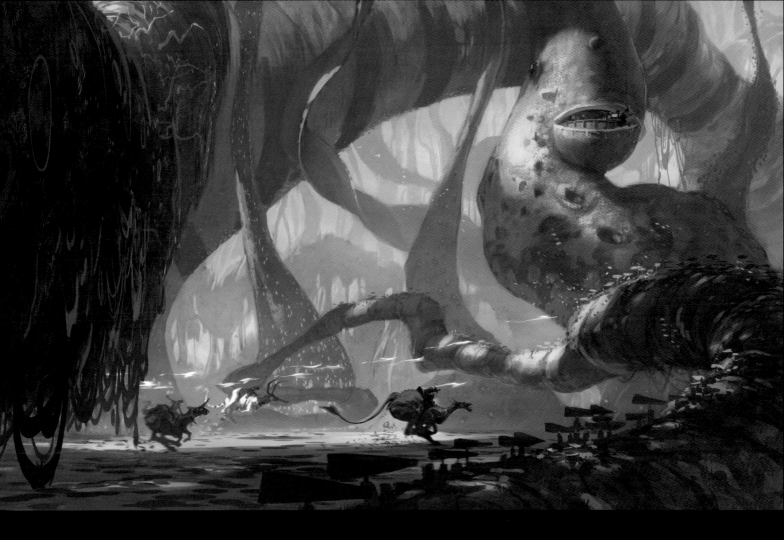

## ENTERING THE SWAMP

THOM: The jungle course takes racers into a dense tangle of mega-root and twist-wood. All of the high-speed ducking and jumping antics are recorded from camera outposts like this one in the upper right, nestled in tree holes throughout the jungle.

To the left, this quick sketch was the impetus for the illustration on the next page.

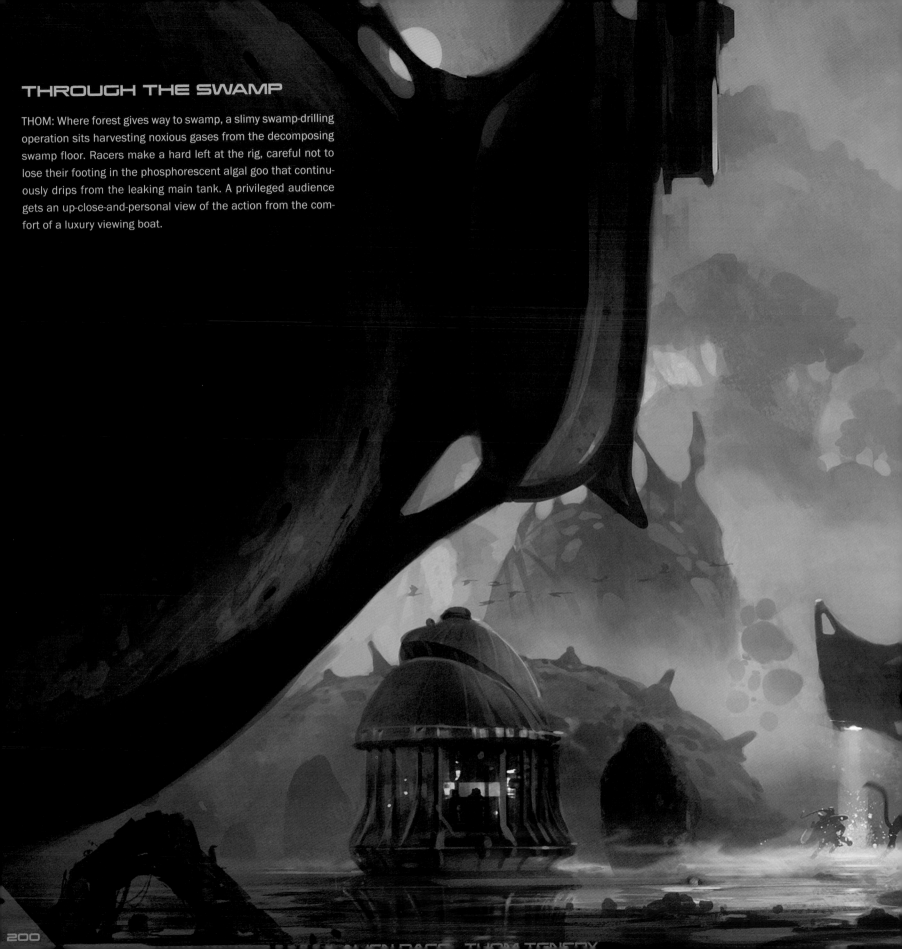

# THROUGH THE SWAMP

THOM: Where forest gives way to swamp, a slimy swamp-drilling operation sits harvesting noxious gases from the decomposing swamp floor. Racers make a hard left at the rig, careful not to lose their footing in the phosphorescent algal goo that continuously drips from the leaking main tank. A privileged audience gets an up-close-and-personal view of the action from the comfort of a luxury viewing boat.

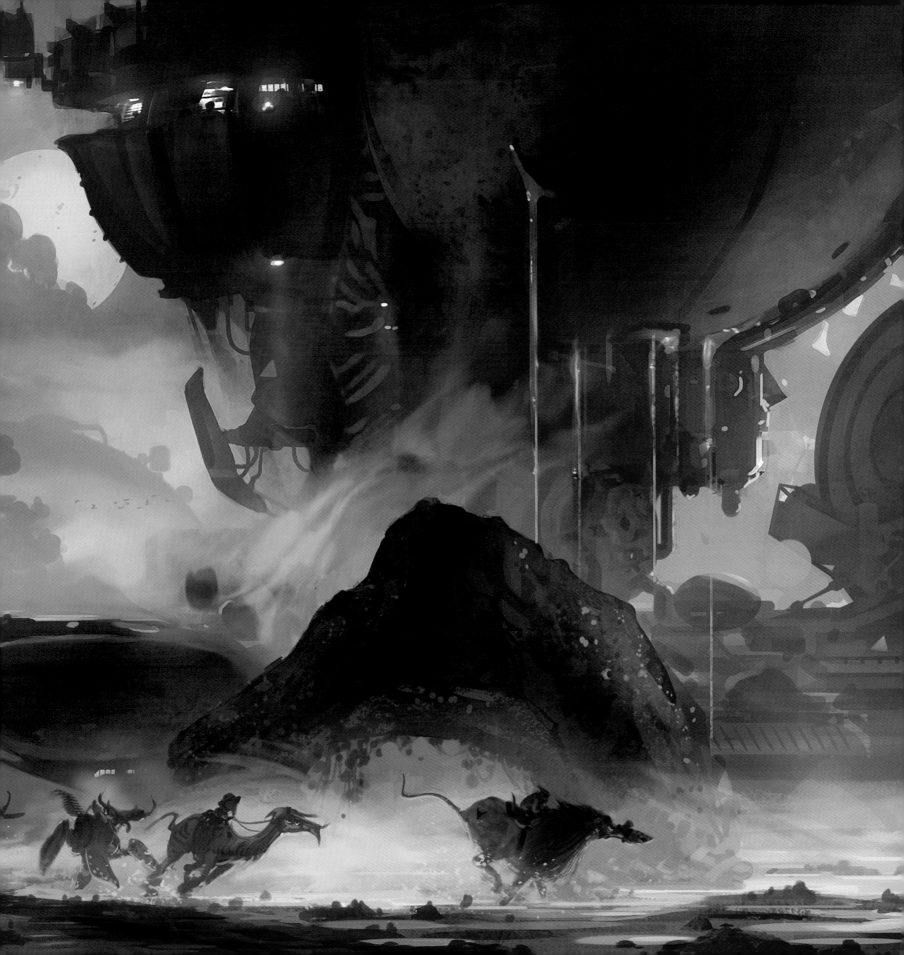

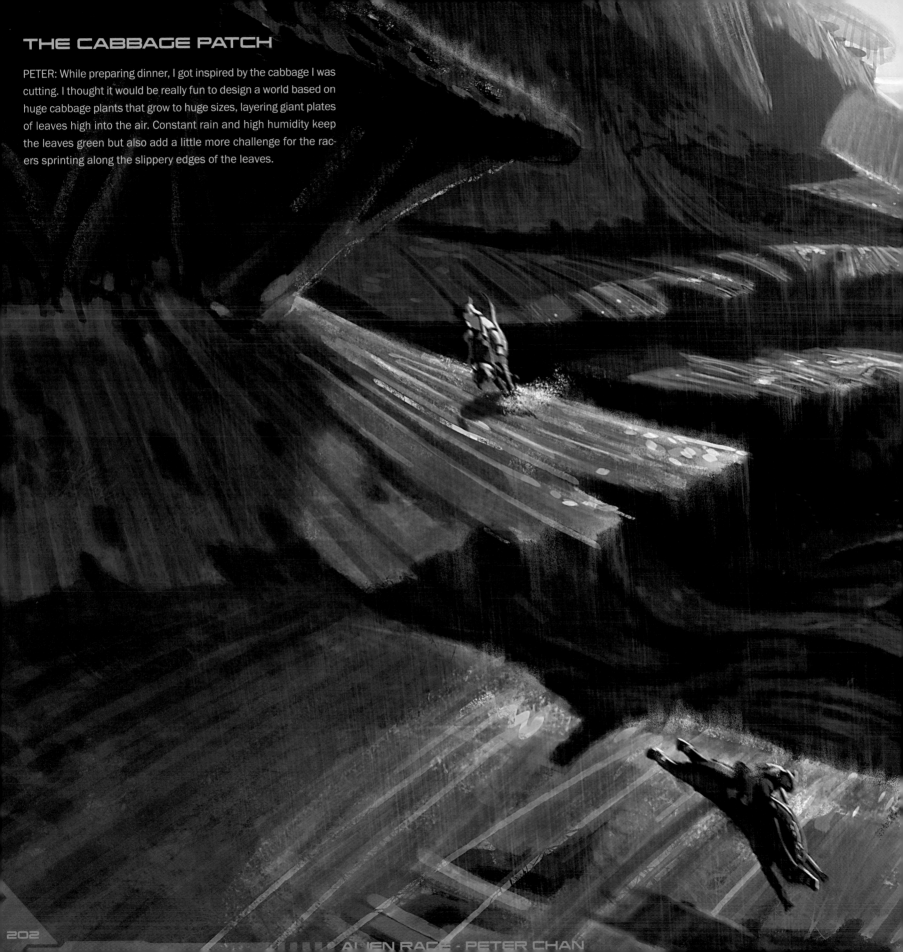

# THE CABBAGE PATCH

PETER: While preparing dinner, I got inspired by the cabbage I was cutting. I thought it would be really fun to design a world based on huge cabbage plants that grow to huge sizes, layering giant plates of leaves high into the air. Constant rain and high humidity keep the leaves green but also add a little more challenge for the racers sprinting along the slippery edges of the leaves.

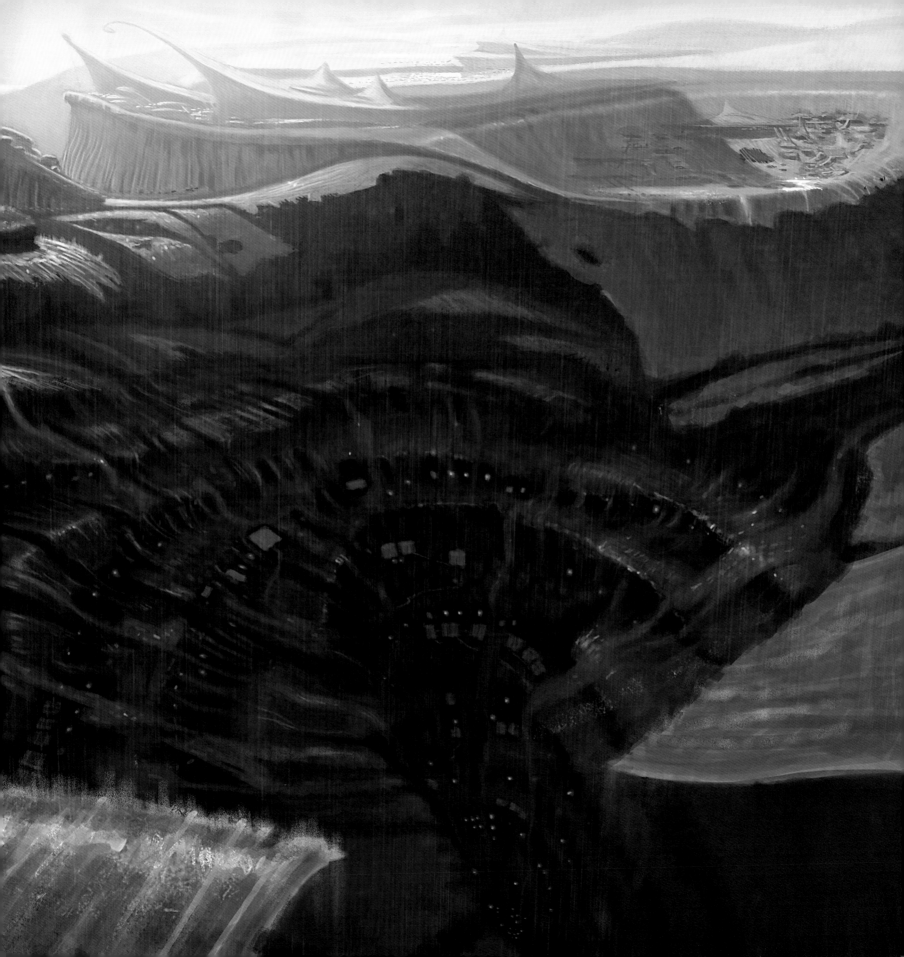

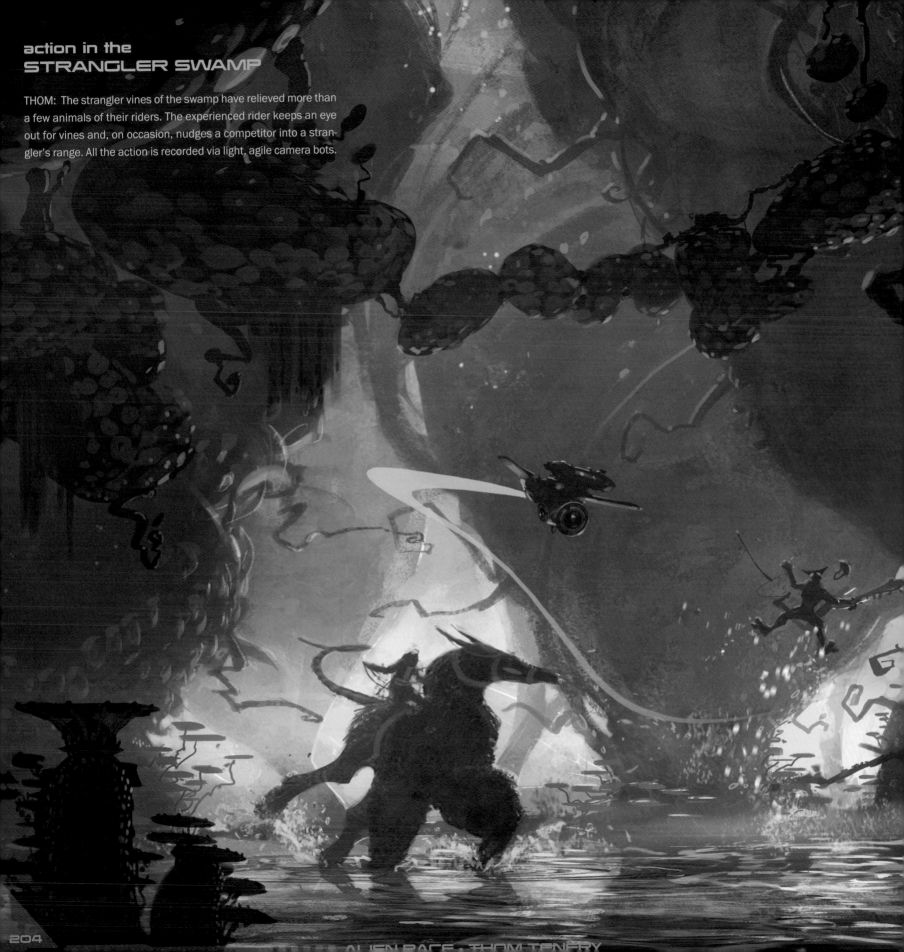

# action in the
# STRANGLER SWAMP

THOM: The strangler vines of the swamp have relieved more than a few animals of their riders. The experienced rider keeps an eye out for vines and, on occasion, nudges a competitor into a strangler's range. All the action is recorded via light, agile camera bots.

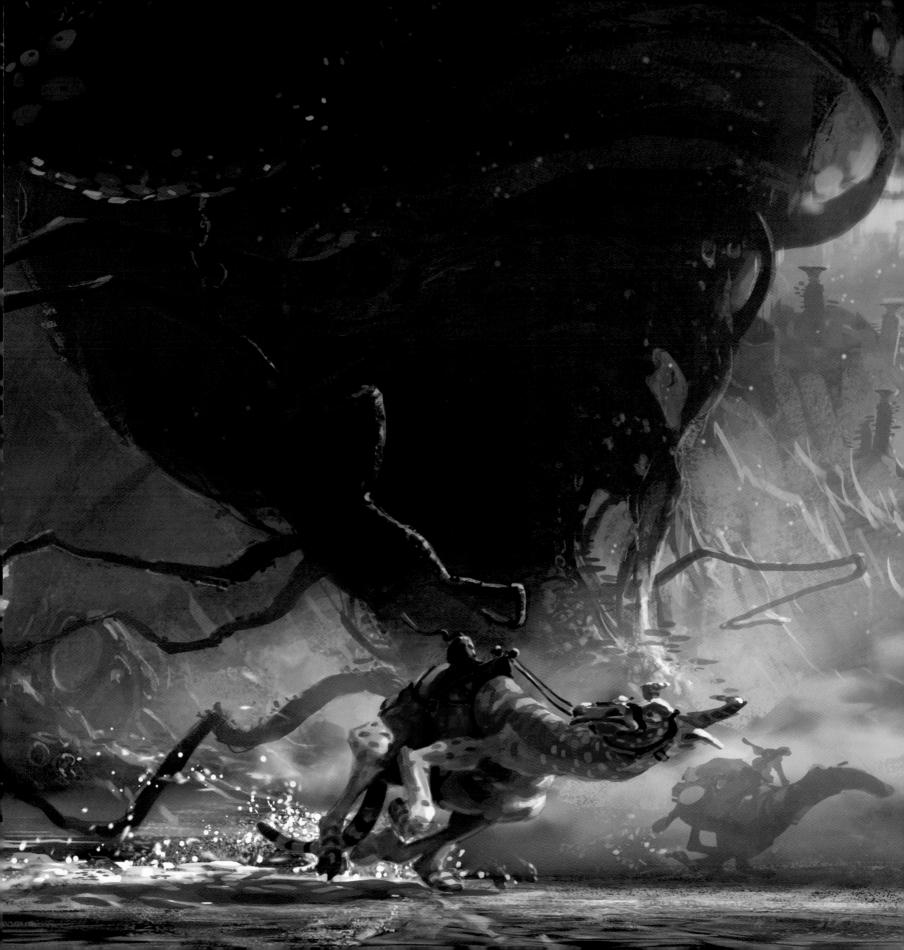

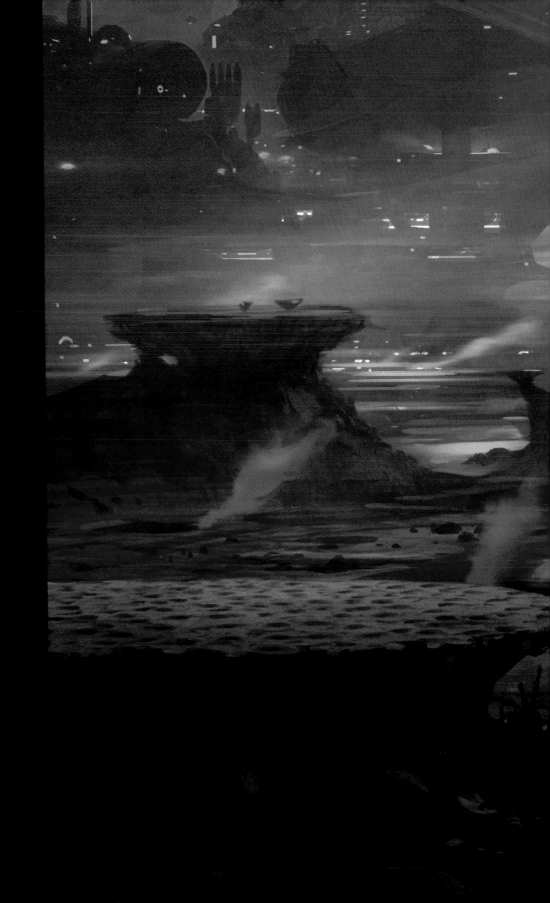

## DANGERS of CACTICON

THOM: The megalopolis of Cacticon is powered entirely by geothermal energy. The city rises above a vast field of geothermal vents, geysers and cascading hot springs. It is surrounded on all sides by this superheated landscape, perpetually shrouded in an atmosphere of steam. The scalding surface of the Sulfuria Plains has taken its toll on some of the racers. An overheated hornicorn brings up the rear, limping but still keeping pace with the ratamapogs and doodiboars huffing their way toward the next race milestone.

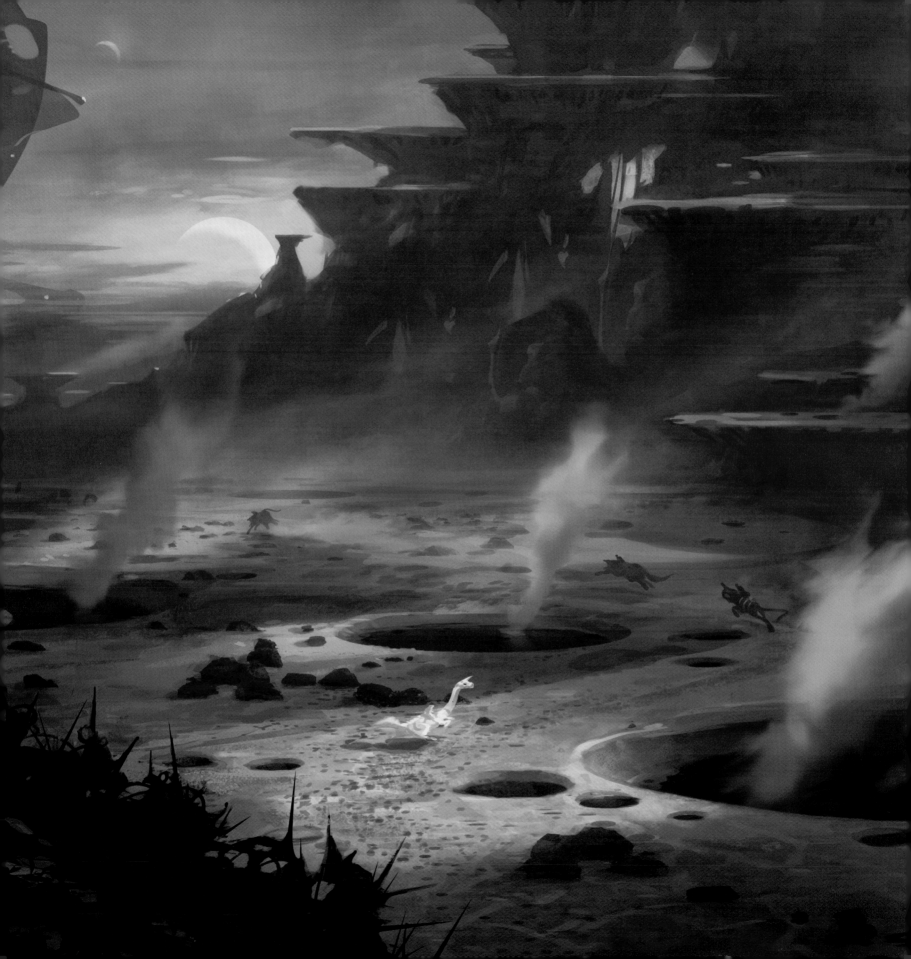

# ZYONIAN CORE

JULZ: Racers head straight for the "core of Zyonia" and toward the treacherous and dense cavernous terrain against their aggressive competitors.

ALIEN RACE · PETER CHAN

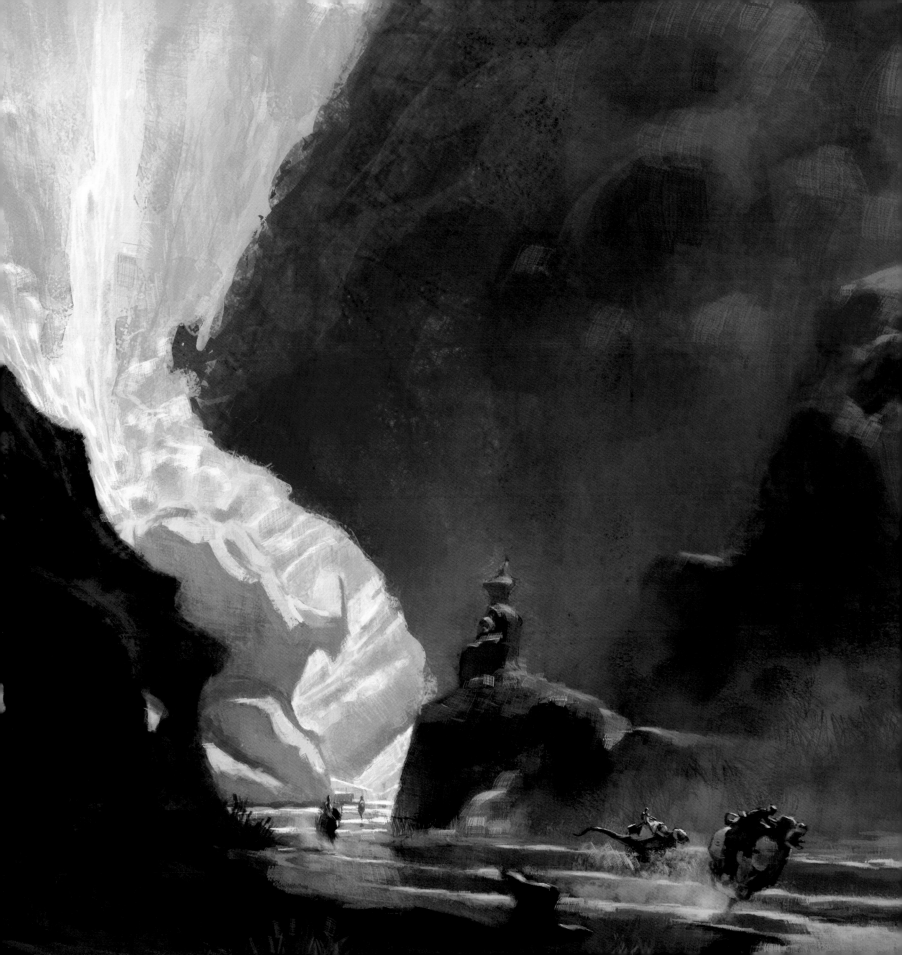

# FLYING FISH

PETER: Having designed so many scenes of the racecourses with extreme conditions, I decided to chill out a little and work on something a bit more playful. The large structure spanning the water is a piece of commissioned sculpture dedicated to the first winner of the galactic race. The artist referenced the indigenous fish that live in the ocean below for the artwork, now owned by the evil alien, Emperor Kinnik. This amazing piece of art also serves as a museum exhibiting historical facts about the race. There is also a deck and a restaurant where aliens can hang out and enjoy the view.

SCOTT: Peter's painting on the next 2 pages concludes this first edition of the visual development of the *Alien Race* adventure. We hope you have enjoyed the sharing of our design processes, illustrative techniques and visions of this unique story with you. If you are an art and design student or a working professional we hope it will encourage you to gather together your friends and colleagues to create and illustrate your own imaginary stories. With a bit of luck, I hope that someday we can further enjoy *Alien Race* in other mediums beyond that of the printed page.

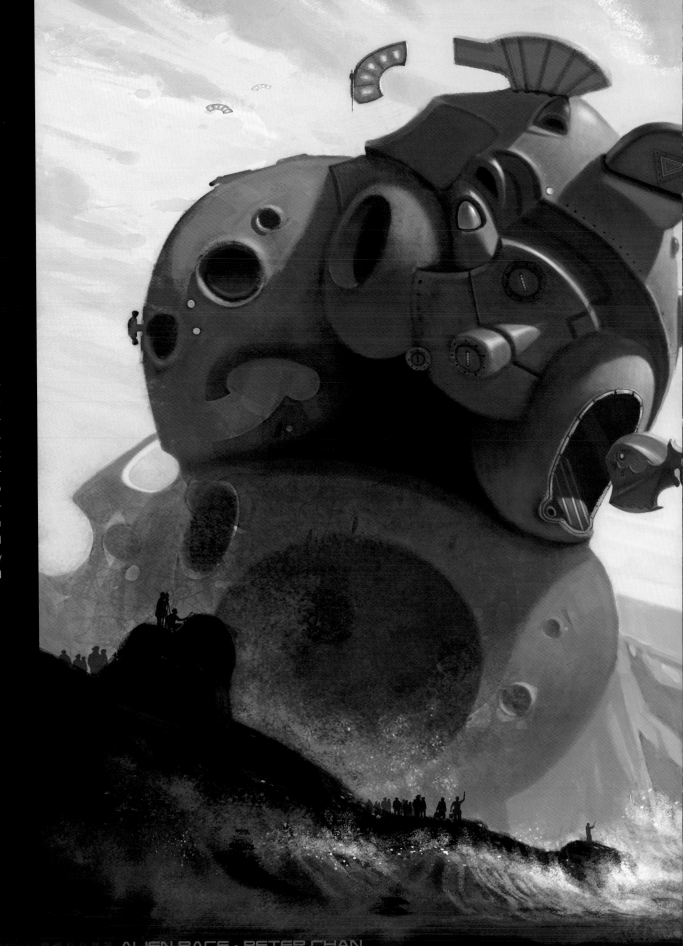

ALIEN RACE · PETER CHAN

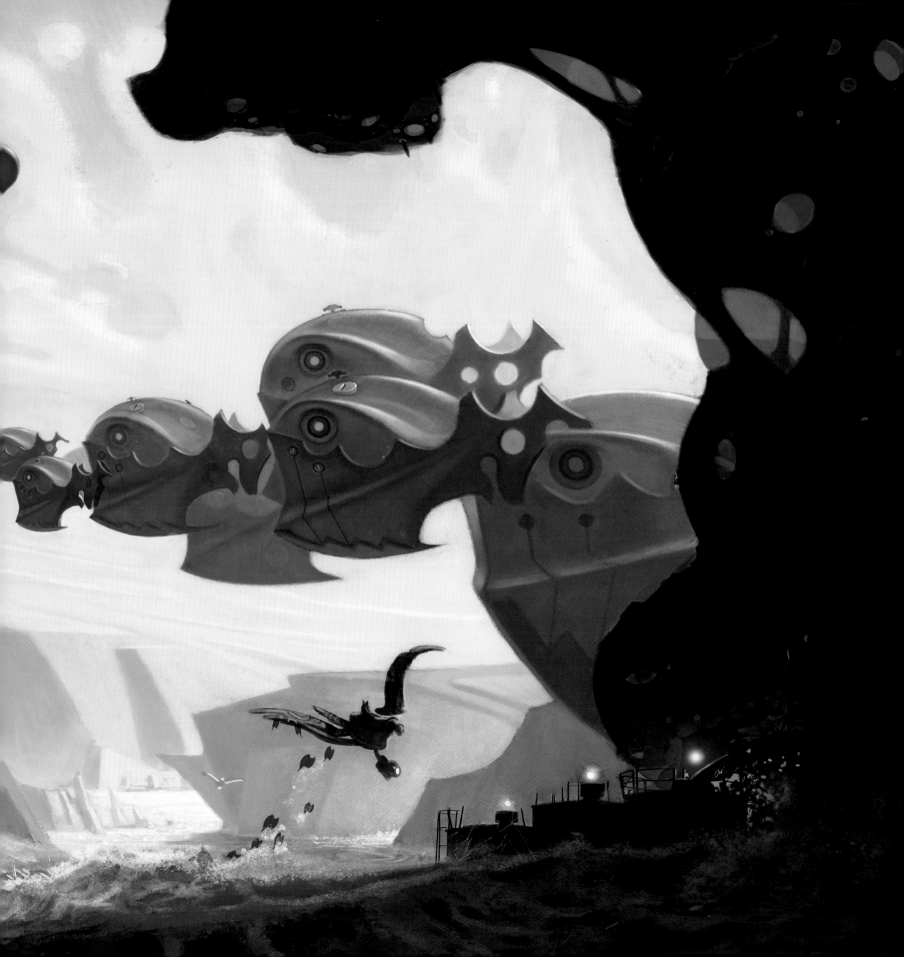

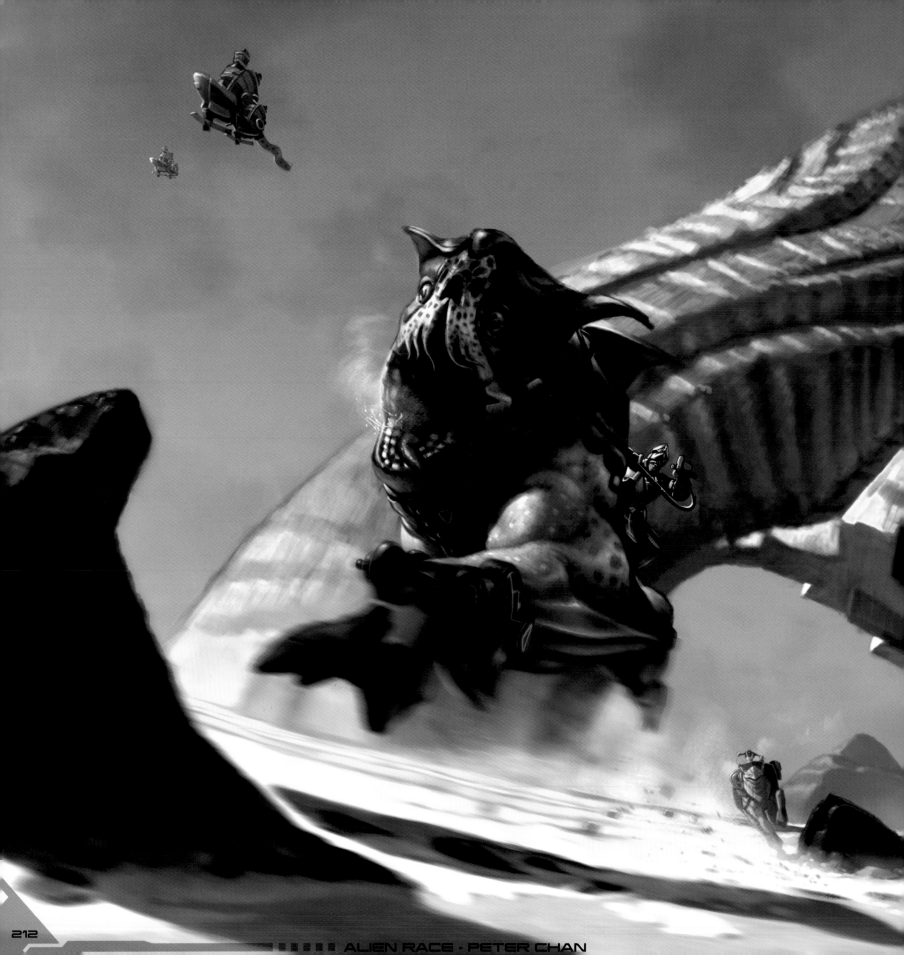

ALIEN RACE · PETER CHAN

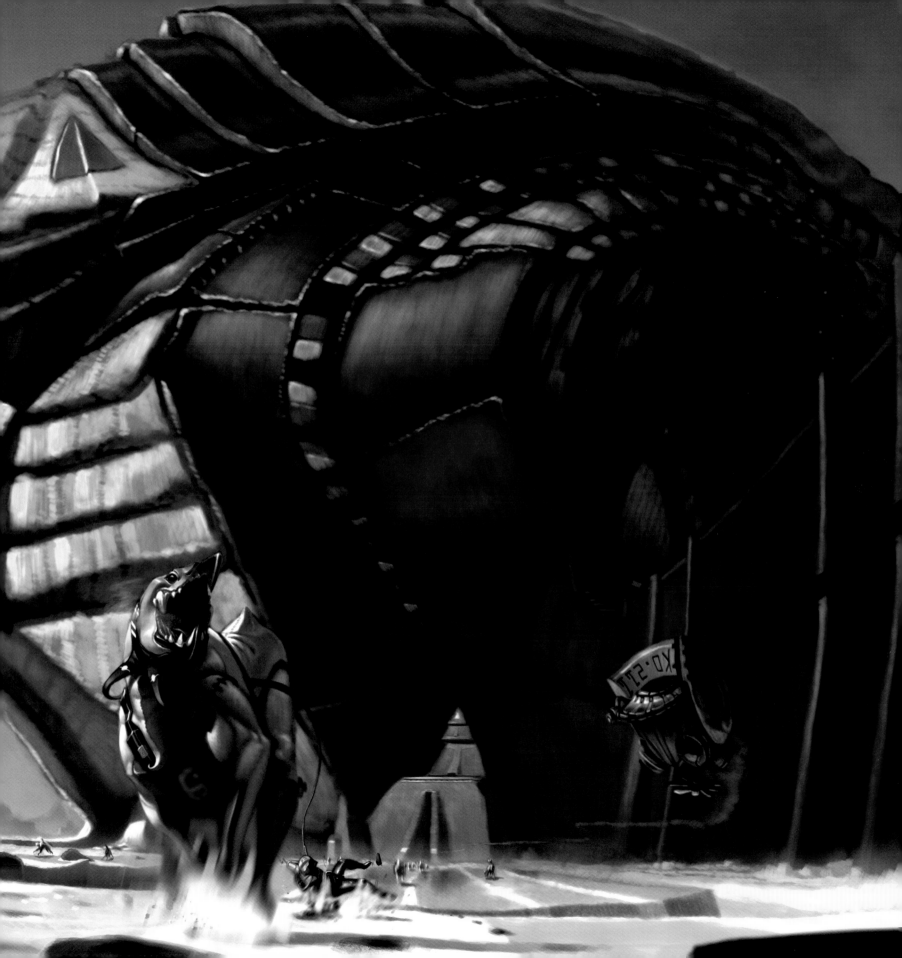

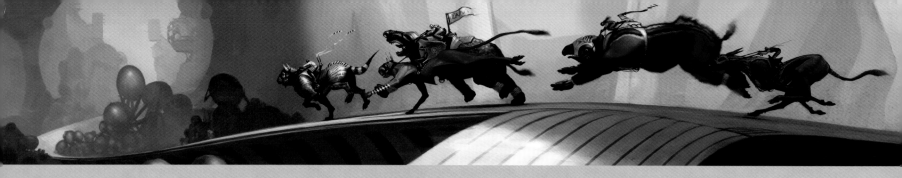

## peter chan

Peter Chan was born in Taiwan in 1980 and moved to Hong Kong at the age of 10. Interested in drawing and painting, Peter attended Interlochen Arts Academy in Michigan, U.S.A. where he began to focus his skills in fine arts. Afterwards, he received his B.F.A. in Furniture Design from the Rhode Island School of Design. It is not until Peter went to Art Center that he found his passion in the entertainment industry. Peter now works as a concept artist in Los Angeles, and feels very lucky to be drawing and painting everyday with great people!

## john park

At a young age, John's creative process began by doodling images from his imagination. He started attending Saturday High at Art Center for high school students, then transitioned into product design at Art Center College of Design. During his early educational terms at Art Center one of his greatest mentors, Scott Robertson, inspired John to commit to entertainment design. Now John is an entertainment design student at Art Center with a few terms left, ready to take on the next challenge ahead.

jparked.blogspot.com
E-mail: Jpforjohnpark@aim.com

## justin pichetrungsi

Justin was born in Los Angeles in 1986. At an early age, Justin started recording his experiences and surroundings through drawing, including his doctor visits, family vacations, trains, etc. Inspired by his grandfather, a painter in Thailand, he was determined to pursue the visual arts. Justin took classes in painting, figure drawing and comic book design in his teen years. Later, he attended Saturday High classes at Art Center College of Design, where he was subsequently accepted. For two summers, he interned at Design Studio Press, where he worked on various video games. Justin recently graduated from the Entertainment Design department at Art Center.

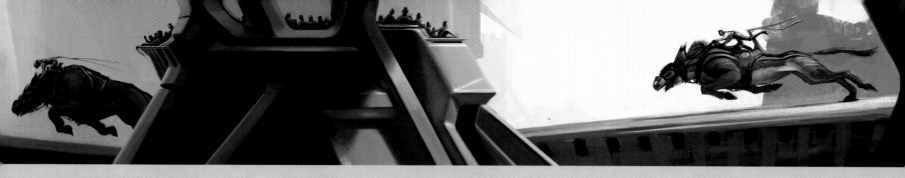

## ben mauro

Ben Mauro is a Los Angeles-based artist and designer. He studied industrial design and entertainment design at Art Center College of Design in Pasadena, California. He is currently working on freelance projects and looking for design opportunities in the entertainment industry.

Website: www.artofben.com
E-mail: Benmauro@gmail.com

## thom tenery

Thom Tenery holds a Bachelor of Science degree in Architecture and studied entertainment design and illustration at Art Center College of Design. Eight years of architectural and interior design, along with a passion for art, science fiction and film, led him to a career in concept design. When not roaming the stacks of used bookstores he can be found immersed in the visual development of his own worlds. Thom is currently a concept artist at ID Software.

## scott robertson

Scott Robertson started his secondary education at Oregon State University, then transferred to Art Center College of Design in Pasadena, California. He graduated in 1990 with honors and a B.S. degree in Transportation Design. After Art Center he immediately opened a consulting firm in San Francisco, where he designed a variety of consumer products. In 1995, he began teaching at Art Center College of Design, first with a year-and-a-half stint at Art Center Europe in Vevey, Switzerland and then in Pasadena, California. Scott's clients have included the BMW subsidiary Designworks/USA, Bell Sports, Raleigh Bicycles, Mattel Toys, Patagonia, *Minority Report* feature film, Nike, Universal Studios, Rockstar Games, Sony Online Entertainment, Buena Vista Games and THQ to name a few. Dedicated to art and design education, he founded the publishing company Design Studio Press in 2002. He has authored or co-authored 8 books furthering design, drawing and rendering education and has co-produced 41 educational "how to" DVDs with The Gnomon Workshop. Scott himself has instructed on 9 DVDs, focusing on drawing and rendering techniques for industrial and entertainment designers. He continues to teach at Art Center and serves as Chair of the Entertainment Design department. Scott is married to film editor Melissa Kent.

Website: www.drawthrough.com
Blog: www.drawthrough.blogspot.com

## SPECIAL THANKS

SCOTT: First of all, special thanks goes out to Julz Chavez for helping with the brief story at the beginning of this book and for the added narrative passages throughout. Of course a big thanks to the core developers of this book: Peter, John, Justin, Ben and Thom—my fantastic Art Center College of Design, entertainment design students...well done, guys! Thanks to Melissa, my wonderful wife, for all the continued support, especially when it comes to the written word!

Thanks to Joe Weatherly, (The Weatherly Guide to Drawing Animals, www.joeweatherly.net) for getting me quickly up-to-speed just barely enough to help out my team with the artwork for this book. Thanks to Neville Page for the design input and the foreword. And lastly, but definitely not least, thanks for the words of encouragement from the Design Studio Press readers. First and foremost, this book is for you, onward to the next!

## OTHER BOOKS AND RESOURCES

ISBN 1-933492-04-X

ISBN 0-9726-6762-8

ISBN 0-9726-6769-5

ISBN 1-9334-9209-0

Instructional DVDs by Design Studio Press
and The Gnomon Workshop:
authored by Scott Robertson

To order these DVDs and to view other
DVDs we offer, please visit:
www.designstudiopress.com
www.thegnomonworkshop.com

ISBN 1-9334-9202-3

ISBN 1-9334-9201-5

ISBN 0-9726-6764-4

ISBN 1-9334921-7-1

To learn more about entertainment design at Art Center College of Design please visit:
**www.artcenter.edu**
To view more Art Center entertainment design student work please visit:
**www.accdentertainmentdesign.com**

To order additional copies of this book
and to view other books we offer, please visit:
**www.designstudiopress.com**

Or you can write to:

Design Studio Press
8577 Higuera Street
Culver City, CA 90232

For volume purchases and resale inquiries,
please e-mail: **info@designstudiopress.com**

To be notified of special sales discounts throughout
the year please sign up to our mailing list at:
**www.designstudiopress.com**

tel 310.836.3116
fax 310.836.1136